ABSOLUTE BEGINNER'S GUIDE

TO

Digital Photography

Joseph Ciaglia, Barbara London, John Upton, Ken Kobré, and Betsy Brill
with Peter Kuhns

800 East 96th Street,
Indianapolis, Indiana 46240

Absolute Beginner's Guide to Digital Photography

Copyright © 2004 by Que Publishing

International Standard Book Number: 0-7897-3120-7

Library of Congress Catalog Card Number: 2004100876

Printed in the United States of America

First Printing: April 2004

07 06 05 04 4 3

Trademarks

All terms mentioned in this book that are known to be trademarks or service marks have been appropriately capitalized. Que Publishing cannot attest to the accuracy of this information. Use of a term in this book should not be regarded as affecting the validity of any trademark or service mark.

Warning and Disclaimer

Every effort has been made to make this book as complete and as accurate as possible, but no warranty or fitness is implied. The information provided is on an "as is" basis. The authors and the publisher shall have neither liability nor responsibility to any person or entity with respect to any loss or damages arising from the information contained in this book.

Bulk Sales

Que Publishing offers excellent discounts on this book when ordered in quantity for bulk purchases or special sales. For more information, please contact

U.S. Corporate and Government Sales
1-800-382-3419
corpsales@pearsontechgroup.com

For sales outside of the U.S., please contact

International Sales
1-317-428-3341
international@pearsontechgroup.com

Executive Editor
Candace Hall

Acquisitions Editor
Karen Whitehouse

Development Editor
Karen Whitehouse

Managing Editor
Charlotte Clapp

Project Editor
George Nedeff

Copy Editor
Karen Whitehouse

Indexer
Mandie Frank

Production Editor
Seth Kerney

Publishing Coordinator
Sharry Lee Gregory

Interior Designer
Anne Jones

Cover Designer
Dan Armstrong

Page Layout
Eric S. Miller

Contents at a Glance

Part I **Digital Quickstart** .**1**

1 Quickstart to Digital: Pix to Print in Seconds3

2 Advantages & Disadvantages of Digital Cameras11

3 Film Basics .29

Part II **Digital Basics** .**43**

4 The Importance of Lenses .45

5 Exposure and Focus .63

6 Getting Your Pix Onscreen .71

7 Files & File Formats .81

8 File Recovery: Finding "Lost" Images .97

Part III **Image Editing** .**111**

9 Basic Editing with Photoshop Elements and iPhoto113

10 Editing with Selection Tools .133

11 Advanced Selection Tools .151

12 The Importance of Selections .173

13 The Importance of Filters .191

14 The Importance of Brightness/Contrast .205

15 The Importance of Levels & Curves .219

16 The Importance of Layers & Masks .235

17 The Importance of Channels .255

Part IV **Digital Output** .**267**

18 Printers and Printer Resolution .269

19 Preserving Your Images .285

20 Color Theory .293

21 Lighting .307

Part V **Using Your Digital Pictures** .**323**

22 The Portrait .325

23 Digital Photography & the Web .337

Glossary .347

Index .353

Table of Contents

I Digital Quickstart1

1 Quickstart to Digital: Pix to Print in Seconds 3

What Do You Mean by "Digital Photography"? 4

Why Flash Media Is Important . . 5

Photography and the Internet . . 6

Is Digital Photography Expensive? 7

Is Traditional Photography Really Less Expensive? 7

2 Advantages and Disadvantages of Digital Cameras 11

Capture Delays 13

Sensor Resolution and Crummy Lenses 14

The RGB Color Space 15

The CCD Image Sensor 17
CCD and Color: Using a Color Mask 18
CCD Competition: Low-Cost CMOS Image Sensors 20
What About Foveon? 20

Aliasing and Other Imager Problems 21

Highlights and CCD Sensitivity . 23

Digital Camera Technologies and Standards 23
EXIF 2.2 24
Exif Print 26
PictBridge 26

Direct Print 27
Design Rule for Camera File Systems 27
Digital Print Order Format 27

3 Film Basics 29

Choosing a Color Film 30

Types of Color Film 31
Negative Film 31
Reversal Film (Slide Film, Transparency Film, or "Chromes") 31
Professional Film 31
Films for Specialized Color Balance and Exposure Times . . . 32

Selecting and Using Film 32
Color Balance and Film 33
Do You Need a Film for a Special Purpose? 34
Storing Film Properly 35
Film Speed 35
Film Speed Rating Systems 36
Film Speed and Grain 37

How Film Responds to Light . . . 41

II Digital Basics43

4 The Importance of Lenses 45

Lens Focal Length 46
Normal Focal-Length Lenses . . . 47

Focal Length and Digital Cameras 49
Long Focal-Length Lenses 49
Short Focal-Length Lenses 51
Special-Purpose Lenses 52

Automatic Focus **54**
 Types of Autofocus 55
 Center-Weighted Autofocus Lock .
 56

Focus and Depth of Field **58**
 Controlling Depth of Field 58
 Lens Focal Length, Aperture,
 and Light 60

5 **Exposure and Focus** **63**

Digital Cameras and Color
 Balance **64**
 Color Balance and Film 66
 Color Balance and Slide Film . . 66

Exposure Latitude **66**

Film Latitude **67**

6 **Getting Your Pix Onscreen** **71**
 Working with Scan Software . . 73

Making a Scan Step by Step . . . **74**
 Determining the Samples per
 Inch of a Scan 76
 Scanning for Internet Output . . 77
 Scanning for Inkjet and Dye-
 Sublimation Output 78
 Scanning for Laser and Offset
 Printing 79

Alternatives to Scanning **79**

7 **Files and File Formats** **81**

Photoshop Elements and
 Photoshop: File Format
 Compatibility **84**

JPEG File Format **86**
 How JPEG Works 88
 The Replacement for JPEG:
 JPEG2000 90

TIFF File Format **91**

Photoshop File Format **95**

8 **File Recovery: Finding "Lost"**
 Images **97**

Using PC Inspector File
 Recovery **99**

Recovering Lost Images from
 Flash Media **100**
 Recovering Specific Images . . . 102
 Partially Corrupt Files 102

Filesystems at Work: The File
 Allocation Table (FAT) **103**
 What Happens to Lost Data . . 106

Preventative Maintenance:
 Defragmenting Flash Media **107**
 Formatting Flash Media 108
 Formatting in the Camera . . . 108

Another Disaster Point: USB . . **109**

III **Image Editing** **111**

9 **Basic Editing with Photoshop**
 Elements and iPhoto **113**

Finding an Image on Your
 Computer **114**

Editing with Photoshop
 Elements **116**
 Printing Resolution 116
 Resizing an Image Step
 by Step 116
 Resampling an Image 118

Rescan or Resample a Photo . . **119**
 Resampling 101 120

Modifying an Image in Elements **121**
Perspective Correction in Elements 121
Rotating an Image in Elements 122
Unlimited Transformations in Elements 124

Editing with iPhoto **126**
Working with the Print Dialog Box in iPhoto 127
Resizing an Image Step by Step 130

10 Editing with Selection Tools . . **133**

Introduction to Selection Tools **136**
Toolbox Options 137
Fly-Out Menus 137

The Most Popular Selection Tools **138**
Using the Magic Wand Tool . . 140
Using the Lasso Tool 142
Using the Rectangular Marquee Tool 143
Using the Elliptical Marquee Tool 144

Introduction to Image Editing . **145**

Color Balance 101 **148**

11 Advanced Selection Tools **151**

The Polygonal Lasso Tool **153**

Magnetic Lasso **154**

Single Row and Single Column Marquees **155**

Quick Mask Mode **156**

The Amazingly Versatile Pen Tools **157**

Saving Selections **163**

When Your Software Tools Quit Working **163**
The Power of the Color Range Command 164
Modifying Selections 165
Feathering and Antialiased Selections 168
Don't Forget the Crop Tool . . . 170

Photoshop Elements Workarounds for Pen and Quick Mask . . . **170**

12 The Importance of Resolution . **173**

Understanding Different Terms for Resolution **174**

Input Resolution **176**
Digital Cameras and Resolution 176
Resolution of Film: How Many Pixels? 178
Scanner Software and Resolution 180
Understanding Bit Depth 183
12- and 16-bit Scan Rates . . . 184
How Can a 48-Bit Scan Help Me? 184
Drawbacks to 48-Bit Images . . 185

Output Resolution **186**
Digital Methods for Increasing Resolution 186
Printing Press Output and Resolution 188

13 The Importance of Filters **191**

Sharpening Prints **192**

Degrees of Unsharp Masking . 193
An Exercise with Unsharp
Mask 194

Taking Advantage of Blur 197
Removing Moiré Patterns and
Halftone Dots 197
Using Blur to Add an Artistic
Touch 198
Noise Filters: Despeckle and
Dust & Scratches 200

**14 The Importance of Brightness/
Contrast 205**

Introduction to Histograms . . . 207
Correcting Brightness and Contrast
for Dark Images 207
Correcting Brightness and Contrast
for Low-Contrast Images 209

**Using Histograms to Diagnose
Exposure Problems 210**
Setting Brightness and Contrast
with the Black Point and the
White Point 212
Black-Point and White-Point
Setup 214
Brightness and Contrast
Exercise 215

**15 The Importance of Levels and
Curves 219**

**Using Levels to Fix Your
Images 220**
Levels Dialog Box 221
How Can Color Images Use Gray
Values? 222
Working with Histograms and
Levels 222
Fixing an Image 223
The Purpose of Levels Triangles 224
The Output Levels Section . . . 225

Correcting Images with Curves 226
Curves for People in a Hurry . . 226
Understanding the Curves
Dialog Box 227
Getting Information About the
Image 230
Color Corrections with Curves 231

**Accessing Levels and Curves
Adjustment Layers 231**

**16 The Importance of Layers and
Masks 235**

**Adjustment Layers Are a Different
Kind of Layer 236**

Creating Image Layers 237
Blending and Opacity
Experiment 238

**Harmonizing the Elements
of a Collage 239**
Scale and Resolution in a
Collage 240
Managing Layers 240
Creating an Extended Family . 241

**Preventing Color Banding and
Data Loss in Adjustment
Layers 242**

**Making a Composite Image
Step by Step 244**
Visualize the Image 244
Inspect Each Component 244
Adjust All the Components . . 245
Select a Component and
Copy It 246
Copy the Selection and Paste
It into the Background Image . 247
Flatten the Image When
Finished 247

**Advanced Selection Techniques:
The Pen Tool** **247**
Drawing a Straight Line 248
Other Uses for Paths 249
The Purpose of Clipping Paths 252

**Layer Masks: Attaching a Mask
to a Layer** **252**
Masking an Adjustment Layer . 253

17 The Importance of Channels . . **255**

**Using Masks to Create
Selections** **257**

Seeing Through a Mask **259**
Removing an Object from an
Image and Pasting into Another
Image 260
Using a Mask Created from an
Image to Create Special Effects
in Another Image 262
Alpha Channels: Where Masks
Are Stored 263

**Troubleshooting: Keeping Track
of Layers, Channels, and
Masks** **265**
The Image-Editing Software
Stops Working 265
The Last Command Did Not
Work the Way It Should Have
Worked 265
I'm Still Not Getting the Results
I Want 265
A Command Is Grayed Out or Is
Missing from the Menu 266

IV Digital Output**267**

18 Printers and Printer Resolution 269

Printer Technology **270**
Software Dithering and Error
Diffusion 272

**The Correct Settings for Printing
Images** **273**

**What Resolution Are My
Images?** **273**
Ink and Resolution: Tips for
Quality and Saving on Cost . . 275

**Third-Party Ink and Printer
Resolution** **276**
ICC Profiles 277
Epson Printers and Big Brother 280
Paper and Resolution: Tips for
Quality and Saving on Cost . . 281

**Why Do Images Look so Good
on the Monitor?** **282**

Printing Big Pictures **282**

19 Preserving Your Images **285**

Photo Papers **286**

Plain Papers **287**

Archival Issues with Paper **288**

**What About Dye-Sublimation
Printers?** **288**

**Saving Your Images on
CD-ROM** **288**
The Advantages of a CD-ROM 289
Make Your Own Photo Gallery
on CD-ROM 290

20 Color Theory **293**

**Three Image Layers Create
Color Images** **295**
Film Development Process . . . 295
Printing Process 296

**Making Your Prints Match the
Monitor—Gamuts and
Color Management** **297**
Printing Without Color
Management 299

Printing in RGB and CMYK . . . 302
Multiple Printers: About Paper 305

21 Lighting 307

**Degree of Diffusion: From Hard
to Soft Light** 308

Available Light: Outdoors 310

Available Light: Indoors 312

Qualities of Artificial Light . . . 313

**The Main Light: The Dominant
Source** 315

**The Fill Light: To Lighten
Shadows** 319

V Using Your Digital Pictures . 323

22 The Portrait 325

**Converting Color to Black and
White** 328
Color to Black and White:
Using Grayscale or Desaturate 328
Color to Black and White:
Using Channels Plus Grayscale 330
Fixing Red Eye 330

**23 Digital Photography and
the Web** 351

**Making Images for the
Internet** 352

Creating a Web Photo Gallery . 353
Compressing Images for the
Internet with JPEG 356

**The Internet: Resource and
Gallery** 357
Exploring the Web 357
Your Own Virtual Gallery 358

Glossary 361

Index. 369

About the Authors

Joseph Ciaglia is an educator, landscape photographer, and author of Prentice Hall's *Introduction to Digital Photography*. He enjoys shooting panoramic landscapes of the American West using a combination of film and digital techniques.

Peter Kuhns is a validation analyst, technical writer, and aspiring photographer. Mr. Kuhns has co-written game titles and Windows-related books. He is currently researching wireless and handheld computing.

Barbara London and **John Upton** are the authors of *Photography*, now in its eighth edition. It is a major college textbook that has dominated introductory college courses in photography since its publication and now in its eighth edition. Barbara London has published many critically acclaimed five-star photography books for beginning and intermediate photographers, including *A Short Course in Photography*.

We Want to Hear from You!

As the reader of this book, *you* are our most important critic and commentator. We value your opinion and want to know what we're doing right, what we could do better, what areas you'd like to see us publish in, and any other words of wisdom you're willing to pass our way.

As an executive editor for Que Publishing, I welcome your comments. You can email or write me directly to let me know what you did or didn't like about this book—as well as what we can do to make our books better.

Please note that I cannot help you with technical problems related to the topic of this book. We do have a User Services group, however, where I will forward specific technical questions related to the book.

When you write, please be sure to include this book's title and author as well as your name, email address, and phone number. I will carefully review your comments and share them with the author and editors who worked on the book.

Email: feedback@quepublishing.com

Mail: Candace Hall
 Executive Editor
 Que Publishing
 800 East 96th Street
 Indianapolis, IN 46240 USA

For more information about this book or another Que Publishing title, visit our Web site at www.quepublishing.com. Type the ISBN (excluding hyphens), or type in the title of a book in the Search field.

Preface

This book is about digital photography, which includes every operation from taking the picture to delivering the print. In 23 chapters you will learn about cameras, film, scanners, portraiture, printing, and presentation.

Did I just say the word "film?" This beginner's guide is about digital photography, not digital cameras. A big difference not so apparent to amateurs. Most beginners think "digital photography" simply means donating the old instamatic and buying a digital Canon. This book will show you that digital cameras are great (because they are so convenient), but even an old Pentax 35mm film camera can get you started.

Digital photography is also known as the "Digital Darkroom," because you no longer need to build a darkroom in your basement, and mess around with smelly chemicals. The digital darkroom includes digital cameras and traditional cameras. Yes that's right. Digital photography replaces the traditional darkroom, not necessarily the camera you've been using all these years.

If you have a digital camera, photography is just that much easier. But if you haven't broken down and shelled out several hundred (to several thousand!) for a new digital camera, not to worry. You can be a "digital photographer" too. Editing your images, printing pictures, and showing your work to the world has nothing to do with the camera you use or the medium on which you captured your subjects. How your get your pictures on the hard drive is up to you. Fortunately, this book explains the entire acquisition and editing process.

Some printers today can "speak" the language of digital cameras. You no longer even need a computer to move from digital images to prints!

Be sure to check out the full-color online gallery of digital photographs, including photographs featured in this book, at the companion Web site www.quepublishing.com. Type the ISBN (excluding hyphens), or type in the title of the book in the Search field and click on the Web Resources link.

PART

I

DIGITAL QUICKSTART

Quickstart to Digital: Pix to Print in Seconds3

Advantages and Disadvantages of Digital
Cameras .11

Film Basics .29

IN THIS CHAPTER

- What Do You Mean by "Digital Photography"?
- Turning Ideas into Prints Quickly
- Is Digital Photography Really Less Expensive?
- Is Traditional Photography More Expensive?

1

QUICKSTART TO DIGITAL: PIX TO PRINT IN SECONDS

You are fortunate to be part of a revolution that only began about five years ago: the digital imaging revolution. This is not some fad that fades into the background. In fact, on September 10, 2003, Kodak, the largest film company on the planet, announced it was no longer investing money in the development of traditional film technologies.

The company that single-handedly invented the business of photography acknowledged the shift away from film. Kodak, which profited for over a hundred years to the tune of tens of billions of dollars, was admitting in a single statement that film—its cash cow—is no longer a growing business. Fortunately for us something more exciting is taking its place: digital!

This chapter will introduce the relatively new hobby known as digital photography. Read the next few pages to learn how you can begin taking and printing digital pictures almost immediately without burning through your savings account. The rest of this book will show you how to take better pictures, import the images, and correct them before printing.

What Do You Mean by "Digital Photography"?

In digital photography, integrated circuits, which are sensitive to light, record images as a grid of pixels rather than using the silver and light-sensitive dyes that film use. These integrated circuits are called *CMOS (complementary metal oxide semiconductor)* sensors or *CCDs (charge-coupled devices)*. These circuits are the backbone of digital cameras. In other words, everything revolves around these "chips," which record light and then translate them into ones and zeros.

When a CCD is charged with electricity, the sensors in the CCD become sensitive to light. The CCD chip is made up of millions of sensors that can record light similar to conventional film (see Figure 1.1).

FIGURE 1.1

From silver to silicon—digital photography relies on grids of sensors.

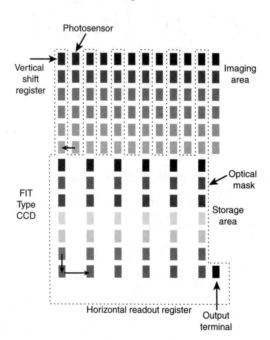

Two scientists at Bell Labs invented the CCD in 1969. Bell Labs toyed with it, but gave up after a few years. The Japanese (specifically Sony) began experimenting with the technology early and developed an industry around it. Today most

professional photographers have already converted to new chip-based cameras. It took more than 30 years for these optimistic researchers to achieve their goals!

If you just purchased your first digital camera or inherited one, you are ready to join the digital revolution. If you don't have a camera yet, fortunately you now can find one below the $100 mark.

The emphasis in digital photography is on speed, which is one of the benefits of digital film. After taking a picture, you can have a print in seconds. Gone are the days of waiting a week or even an hour for your photos to be ready.

The fastest, least expensive way to get rolling with digital photography doesn't even involve a PC or a fancy color printer. In some cases, you don't even need a digital camera! The choices for the budding photographer are now greater than ever.

Why Flash Media Is Important

The key to joining the "digi" revolution is a *digital media card*, also called *digital film*. Digital film is simply *flash memory*, a special form of memory that isn't erased when it's unplugged.

Digital cameras use one of these types of media:

- Memory Stick
- Memory Stick Duo
- SD (Secure Digital)
- MMC (MultiMedia Card)
- CF (Compact Flash)
- Smartmedia
- xD (Extreme Digital)

Flash media is important for two reasons: It isn't fragile and you can use it to print photos anywhere. This is the secret to ubiquitous, inexpensive digital photography— printers are now everywhere.

Decent digital cameras use SD, CF, Smartmedia, xD, or Memory Sticks to store images. You can remove this memory, and then stick it in a commercial digital printer at the camera store or your local warehouse club. Fortunately, only the cheapest "toy" cameras have no removable media (they must rely on a cable connection to a PC). With these types of flash media, you can take your pictures everywhere and print wherever it's cheapest.

Here are the steps to inexpensive digital photography:

1. If you already have a camera, determine what kind of digital flash media it uses, such as CF, SD, Smartmedia, or a Memory Stick.

2. Fill up the flash memory by taking some pictures. Be sure to have plenty of batteries on hand (rechargeable batteries last longest).

3. Remove the digital media and take it to a camera store. You don't even need the camera.

4. At the camera store, insert the flash media into a printer and print away. Most professional store printers will automatically color-correct the image, provide simple editing features, or both.

There are of course many more ways to create and print digital images. This is simply one of the less expensive ways to get in on the act. The rest of this book explores taking better pictures and also printing and displaying your own digital images.

Photography and the Internet

Another choice for instant photography is the Web. The goal of most photographers is to capture a moment or a memory and display it to others. The Web is perfect for achieving this goal because everyone can access the Web worldwide. If all you have is a camera and a PC, you can share images immediately after taking them.

Take some pix and get them up on the Net using one of the free Web page construction sites offered by Yahoo! or AOL. Every major site includes features for adding photos and building a Web gallery for displaying images (see Figure 1.2).

FIGURE 1.2

A Web-based gallery enables you to proudly display your images in minutes.

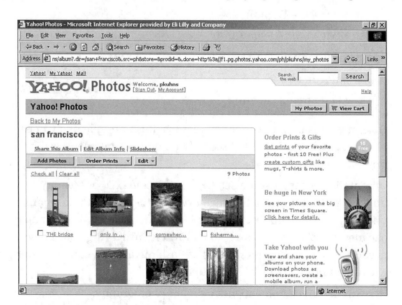

Is Digital Photography Expensive?

Cost is a huge consideration in this hobby/profession. Digital photography is just like driving—a Mercedes CL500 does exactly what a new Hyundai does. Both travel at highway speeds, have heat and air conditioning, and include seat belts. However, one costs $80,000 U.S.—the other can be had for around $8,000 U.S.

Digital photography is very much the same. You can buy a two-megapixel camera on eBay for under $100, a closeout Epson printer for $150, and glossy photo paper at the local warehouse club for $25. Or, you can go the high-ticket route by spending $3,000 on a Canon, $1,800 on a wide-format HP printer, and buy only the finest Galerie paper from Ilford (approximately $5 per print). Which raises the question....

Is Traditional Photography Really Less Expensive?

Film technology, which has been perfected over the past 100 years, is being overrun by a technology that has only been around for 5 years. Usually a new technology overtakes a more traditional technology for one of two reasons: cost or convenience. Digital is not necessarily less expensive, but is more convenient.

Traditional photography is in many ways less expensive than digital photography. Suppose you are about to take your first photography class and you need all the equipment. You have nothing required for the class, and you need to spend as little as possible. Table 1.1 illustrates how much this equipment would cost.

Table 1.1 Entry Costs for Digital Versus Film Photography

Type of Photography	Camera (35mm)	Film	Developing	Prints	Total
Film (Developed & printed by yourself)	Used Pentax K1000 with used zoom lens ($150)	10 rolls color film from drug store ($20)	Developing chemicals ($10), used enlarger kit trays ($100–$110)	Photo paper, 100 sheets 8×10 ($40), and chemicals ($20–$60)	$340
Film (Store-developed & printed)	Used Pentax with used zoom lens ($100)	10 rolls color film from drug-store ($20)	10 rolls developed and printed at the drugstore ($50)	Prints included in developing ($0)	$170
Digital (Print yourself)	eBay 2-megapixel camera ($100)	128MB CF or SD card ($30) and batteries ($12–$42)	Used computer and new flash media adapter ($500)	Printer ($100) and 100 sheets of photo paper ($25) and ink ($50–$175)	$817

Table 1.1 Continued

Type of Photography	Camera (35mm)	Film	Developing	Prints	Total
Digital (Store-printed)	eBay 2-megapixel camera ($100)	128MB CF or SD card ($30) and batteries ($12–$42)	Visit printer at warehouse club ($0)	Print 100 4×6 prints on dye-sublimation printer ($30)	$172

For someone starting from scratch (no computer, no camera) who is serious about editing images, traditional photography can be much less expensive. In addition, the equipment for traditional photography is much more sturdy (a solid Pentax versus a cheap plastic CCD camera), the camera won't become obsolete for quite a while, and most important, the camera will keep working when its batteries run out. Not so for digital.

Most people have their own computer, which, of course, is the largest expense. If this is the case, the biggest cost outside the camera is printer ink. You can even get around this cost by printing at warehouse clubs or at free-standing kiosks. You can read more about the true cost of ink in Chapter 18, "Printers and Printer Resolution."

note

One major benefit of digital photography is that it has finally lowered the cost of traditional film and developing. Remember when a roll of film cost at least $5 per 24-exposure roll, and developing that roll cost $7? Photography was expensive! Today some drugstore chains are giving away film to lock you into their developing, which only costs $3 with coupon. And warehouse chains now sell five rolls of film in "bulk packs" for $7. Thank you digital!

IF YOU LEARN ONLY ONE THING IN THIS BOOK...

Get closer. To set yourself apart from the billions of amateur photographers and their common full-length portrait snapshots, put yourself in the story by getting closer.

Almost all amateur photos are the same: people smiling at the camera from 6–12 feet away. All nationalities are guilty of this monotony, but Americans seem to have mastered it. When you take a picture of anything or anyone, move in closer to the subject or the action. Eighty percent of the time the background doesn't matter, the person's legs don't matter, and framing the subject in the center doesn't matter. All that matters is a person's expression and what his or her eyes convey. If you can't get closer, use a telephoto lens. Get closer and see how your images improve.

THE ABSOLUTE MINIMUM

This chapter shows you how to jump into the digital photography hobby quickly without burning through your savings account. Keep these important points in mind if you're shopping for a camera or eager to print your first series of images:

- A digital camera is all you need to "go digital."
- The least expensive form factor for "digital film" is Compact Flash (CF).
- The most prolific form of digital film is Secure Digital (SD).
- Use in-store printers to print your photos. This is by far the best way to get your pix in print.

The rest of the book will show you how to take better pictures, import the images, and correct them before printing. You will also learn how to present your images, which is important for those who are serious about photography and the memories they capture.

In This Chapter

- The Advantages and Disadvantages of Digital Cameras
- The RGB and sRGB Color Space
- CCDs and CMOS Chips: How They Work
- Lens Quality and Resolution

2

Advantages and Disadvantages of Digital Cameras

Convenience and customization are the two most important advantages of digital camera technology—but this new medium does retain some drawbacks.

Most professional photographers would admit that digital photography has come far enough in technology and resolution that it matches film—the dozens of Nikon F5s and Canon EOS1s at the used camera store is one clue. This means digital photography has reached the quality most professionals require of their work. The technology itself has some shortcomings, however:

- **Resolution.** Consumer-level digital cameras are not capable of higher resolutions than what you would receive from a 35mm camera with a third-rate lens.

- **Color space**. Digital cameras rely on a *color space*, or mathematical representation of all colors. Most cameras use the sRGB (Red, Green, Blue) color space. Other color space definitions exist though that often are superior.

- **Aliasing**. Software and low resolution sensors work together to degrade the resolution of an image by blurring pixelation.

- **Highlight disaster.** Some digital cameras cannot handle highlights in an image, resulting in bright white streaks.

This chapter focuses on the lesser-known advantages and disadvantages of digital cameras. You will learn how a quality digital camera improves a digital suite, and how a low-quality camera hinders your photography.

- **Delays**. Forget action or sports photography with a consumer-level digital camera. Stopping action at the exact moment you desire is something of a guessing game and a very expensive digital SLR (Single-Lens Reflex) is necessary.

- **Wide-angle lenses**. CCDs in digital SLRs are smaller than the standard 35mm film frame. The result is a magnification of lenses, so that a 35mm becomes a 55mm. Wide-angle is difficult unless you buy an exotic (that is, expensive) lens.

- **Prints**. Blame it on genetics or culture, but digital prints do not command the same respect as regular prints.

- **Battery drain**. Digital cameras drain batteries faster than any electronic device. With a small LCD screen, constant auto-focus, and flash, normal alkaline batteries barely survive a "roll" of 36 pictures.

- **Price**. Low-end digital cameras currently match instamatic cameras in price, but above this consumer level, a serious SLR digital camera body costs two to three times as much as a traditional camera body.

As you can see, digital cameras aren't perfect. Fortunately, technology is rapidly overcoming these drawbacks. You owe it to yourself to research these issues, in case your dream camera has a drawback.

Capture Delays

By far the biggest problem with consumer-level digital cameras is the delay. Unlike most film cameras, some consumer digital cameras have a significant delay when you depress the shutter (see Figure 2.1). When you take a picture with fixed-focus 35mm film cameras, the picture is taken immediately. This isn't always the case with digital cameras. It may take several seconds before the camera can capture the image because the camera must perform the following actions:

- Autofocus on the subject.
- Open the shutter when autofocus is finished to expose the sensor to light.
- Accumulate enough charge on the sensor.
- Close the shutter.

FIGURE 2.1

Any type of fast action is almost impossible to capture with a consumer-level digital camera.

At this point the image is captured, but processing must occur before the image will appear on the built-in camera screen—which creates a significant (and insanely annoying) delay before you can take your next shot.

For this reason, you really cannot use consumer-level digital cameras for any type of sports photography or photography involving uncontrollable or moving subjects. This, of course, includes children and pets. If you already own a camera with significant delays, determine how long it actually takes to take a photo. Chances are it takes less than two seconds, but even this small delay makes action photography impossible.

The camera should be an extension of you. It should feel as effortless as riding a bike. This is currently only possible with digital SLRs, which fortunately are as fast as film SLRs. But any delays will affect your photography. Your pictures will *not* be the same. Your goal should be to find a camera that has no delay, or at least a delay you don't notice. With no delay, you will be able to use the camera much more often.

Sensor Resolution and Crummy Lenses

Lens quality and pixel resolution affect the resolution of a digital camera. Four-, five-, six-, and higher megapixel cameras with quality lenses can match the resolution of amateur 35mm photographs. Digital cameras with fewer pixels (such as a CCD of 2–3.2 megapixels) are fine for snapshots, but just don't have the resolution of film. If film-like resolution is required, definitely consider a camera with a chip of five or more megapixels.

Surprisingly more important than the CCD is the lens. In fact, the quality of the lens is so important that you should seriously consider only the finest lens manufacturers for your digital camera. Companies that produce the best lenses include the following:

- Carl Zeiss—Considered the best optics on the planet. (www.zeiss.com/)
- Nikon—Exclusively on Nikon cameras. (www.nikonusa.com)
- Canon—Appear on Canon cameras. (www.canonusa.com)
- Leica—Leica lenses are considered the sharpest among 35mm photographers. (www.leica-camera.com/index_e.html)
- Schneider—An American company that manufactures lenses for Kodak. (www.schneideroptics.com/)

Look for ultra-low dispersion glass, fluorite (a mineral) glass, apochromatic lenses, and aspherical lenses. These technologies, which add significantly to the cost of a lens, can even be found on instamatic digital cameras, such as those from Kodak (Schneider) and Sony (Carl Zeiss).

You might encounter a number of different terms when shopping for a lens:

- **APO (apochromatic)**—These lenses have special coatings that focus different wavelengths of light (red, green, and blue) more precisely. Nikon calls its APO technology ED, for Extra-Low Dispersion.
- **Fluorite**—This type of glass creates lenses that have no distortion whatsoever.
- **Aspherical**—These lenses are ground into nonspherical shapes that enable more compact lenses to be manufactured. Aspherical lenses also reduce coma, which is common in wide-angle lenses. *Coma* occurs when rays of light pass

through a lens far from its center. The rays do not focus on a point inside the camera, but instead create a cone of light, which looks like a comet tail.

The RGB Color Space

All digital cameras rely on a color space definition to capture color. This definition, which is part of a processing algorithm, forces light values captured by the camera sensor into a defined *color space*. Essentially, the camera can only capture specific colors, not the entire spectrum of color. Generally, this is not significant because the human eye cannot really discern colors accurately.

There are several color space definitions in use today. Each has its advantages and disadvantages:

- **RGB**—Within the color model RGB are a number of color spaces, such as Apple RGB, Adobe RGB (1998), and sRGB. Each RGB color space defines color through three axes (R, G, and B), but differ in gamut and other characteristics. RGB can be thought of as three grayscale images (usually referred to as channels) representing the light values of red, green, and blue. Combining these three channels of light produces a wide range of visible colors. The three colors combined generate white, unlike the CMYK color space, which generates black. For this reason, the RGB color space is called an *additive* color space.

- **sRGB**—sRGB is currently the standard color space for cameras and computer monitors. This standard was created by Microsoft and HP in 1996 as a standard for computer monitors and software. The sRGB standard includes three important areas: colorimetric RGB definition, the equivalent gamma value of 2.2, and a set of well defined viewing conditions. This results in a color space that is equal among all devices, from the digital camera to the printer. The only problem is that standardization means much fewer colors are possible.

- **YUV**—A television standard used in Europe that enables backward compatibility with black-and-white televisions. A variant called YIQ is used in North American television systems. In addition, all DVDs rely on the YUV/YIQ color space.

 The engineers who invented the YUV color space needed a way to make color television broadcasts backward-compatible with black-and-white TVs. The color signal they came up with also needed to conserve bandwidth because three channels of RGB data would not fit into the limited broadcast signal space. The YUV color space uses RGB information, but it creates a black-and-white image (luminance) from the full color image and then subtracts the

three primary colors, resulting in two additional signals to describe color. Combining the three signals back together results in a full color image. Note that in either case, if the chrominance (color information) is ignored, the result is a black-and-white picture.

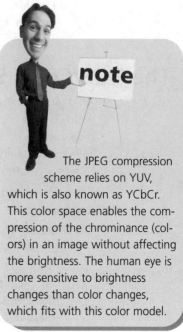

- **CMYK**—Color printers and large offset printers rely on the CMYK color space. This color space matches the color pigments cyan, magenta, and yellow. The color black (the K in CMYK) is included, but not required. The colors C, M, and Y absorb colors on paper, creating black. This differs from the RGB color space, which reflects white when the colors R, G, and B are combined. For this reason, the CMY color space is called a "subtractive model." The black (K) component is added so that true black can be printed on paper (versus a contrived black from the three colors).

The JPEG compression scheme relies on YUV, which is also known as YCbCr. This color space enables the compression of the chrominance (colors) in an image without affecting the brightness. The human eye is more sensitive to brightness changes than color changes, which fits with this color model.

As with the RGB color space, every color is represented by three values: C, M, and Y. These values are assumed to be in the 0–255 range.

- **CiéLAB**—LAB color mode splits color into three values:
 - **L** describes relative lightness
 - **A** represents relative redness-greenness
 - **B** represents relative yellowness-blueness

Adobe Photoshop software uses LAB color as its native color space because LAB color can be converted to another color space without doing damage to the colors' intensities or hues. Photoshop is just as talented at working with images in the other color spaces, of course. The RGB color space is actually related closely to LAB color. The CiéLAB model was adopted worldwide as the master color space definition in 1991.

The color models described here are the most common color spaces. Digital cameras rely on the RGB color space, which has a few issues. One is that the RGB color space is device-dependent. In other words, when the camera captures an image, it may not appear the same on the monitor (another RGB device). This, of course, could cause problems for serious color photographers.

As you use Photoshop and digital photography more often, you will need to ensure that you have the most accurate color setup by tweaking Color Settings. Most digital cameras rely on sRGB. Only the higher-end cameras provide the richer Adobe RGB color space. Always try to use Adobe RGB if your camera can capture in that color space. These color spaces matter significantly when printing with a high-end inkjet printer. You can read more about this in Chapter 18, "Printers and Printer Resolution. "

The CCD Image Sensor

The CCD (charge-coupled device) image sensor was invented in 1969 and introduced to the public in 1974. The CCD sensor is the most common sensor used for TV cameras because it provides high-quality, low-noise images. When reading from such a sensor, the pixel values (charges) are transported across the sensor, line by line, and then shifted into an analog-to-digital converter, turning each pixel's value into a digital value (see Figure 2.2).

FIGURE 2.2

A light-sensitive image sensor shifts pixel values along rows to the processor.

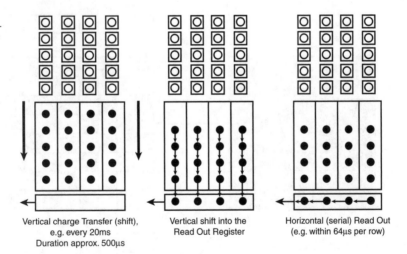

Vertical charge Transfer (shift),
e.g. every 20ms
Duration approx. 500µs

Vertical shift into the
Read Out Register

Horizontal (serial) Read Out
(e.g. within 64µs per row)

This amazing invention has two specific problems: manufacturing and power drain. Producing CCD sensors is very expensive, as special laboratories and machines are required to manufacture these sensors.

CCD sensors also consume power at a rapid rate. Even though the CCD chips in consumer-level cameras are only 1/3-inch across, they still drain power quickly.

CCD and Color: Using a Color Mask

CCDs are monochromatic devices. They simply measure the amount of voltage acquired by each pixel. To capture color, a filter must be placed in front of the CCD that separates visible light into primary colors. This filter is called a *mask*, or *array*. The most popular mask in use today for digital cameras is called a Bayer mask. CCD sensors that use a Bayer mask can only acquire one color per pixel (see Figure 2.3).

FIGURE 2.3

The Bayer pattern exists on most digital camera sensors. Individual pixels are literally painted with red, green, and blue colors.

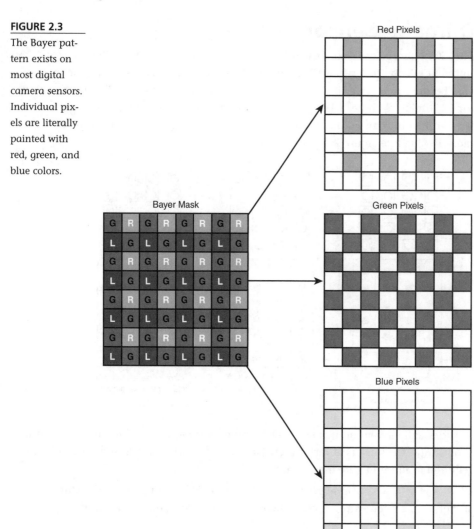

Green pixels outnumber red and blue by a ratio of 2:1. The reason for this is that human vision is most sensitive to green, which is why 50 percent of the pixels in a CCD are dedicated to this color.

A Bayer mask isn't the most efficient way to capture color for several reasons:

- Three pixels are required for each "virtual" pixel. Three separate pixels devoted to red, green, and blue are combined in software to create a virtual pixel in the center of these sensors. The end result is a virtual pixel that represents the light and color at that point in the CCD. The problem is that pixels are wasted in this system, and the space between pixels adds up over the width of the CCD. In addition, only a percentage of green is captured. The lost part of green results in a loss of sharpness.

- A square shape isn't the most efficient. By placing three pixels together to create a virtual pixel in the center, the amount of space between the actual pixels and the virtual pixel is sizable. Fuji has developed a SuperCCD technology using hexagonal pixels to reduce this blank space, but even this technology results in a loss of sharpness.

- Software interpolation—software must combine imperfect red, green, and blue values into an imperfect color. During this software-driven interpolation, color artifacts and mosaic problems can appear (see Figure 2.4). Programmers have been successful at reducing common mosaic problems, but this issue still occurs.

FIGURE 2.4

Color artifacts and mosaic patterns occur with Bayer mask cameras.

■ In addition, the inaccurate sensors used with a Bayer mask require "blur filters" to reduce color artifacts. The random appearance of artifacts and the requisite blur filters force the software to reduce sharpness.

CCD Competition: Low-Cost CMOS Image Sensors

The CMOS (Complementary Metal Oxide Semiconductor) image sensor is an inexpensive sensor replacement for CCDs that does away with a few disadvantages of CCDs, but introduces its own issues.

CMOS sensors produce medium-quality images that are more susceptible to noise than a CCD sensor. Each pixel on a CMOS sensor can be read individually, however, which makes it more flexible in manufacture and cost than CCD sensors.

Another benefit of CMOS sensors: They are built using the same equipment as CPU chips, such as the Pentium 4 chip. Because they use common equipment, CMOS sensors are less expensive to manufacture and benefit from innovations in CPU technology.

The flexibility of CMOS sensors is also the reason why they aren't as precise as CCDs. Each pixel on a CMOS sensor has several transistors located next to it, making it possible for photons to hit the transistors instead of the photo-diode. This makes the CMOS sensor less sensitive to light than the CCD sensor.

CMOS technology consumes much less power than CCD chips: as little as 1/100th of the power needed by a CCD sensor. This is why CMOS sensors appear on mobile phones. On professional digital SLRs however, which often have large high-power batteries, the CCD sensor is the best choice.

What About Foveon?

A CMOS-based technology called Foveon was announced in 2001 that uses layers of sensors to capture red, green, and blue at every pixel location (see Figure 2.5). This technology relies on a triple-layer CMOS sensor array that captures blue light first, then green, and finally red. The technology takes advantage of light's penetrating power. Red light can penetrate silicon much more easily than green or blue. As a result, the red layer is on the bottom of the three-layer stack.

Blue light, which has the shortest wavelength and combines with electron "holes" in silicon, is captured first. The green layer is in the middle.

Every sensor in the Foveon technology is essentially an eye that captures exactly the color and brightness of the light it receives. Currently Sigma makes two cameras with this technology. By the time you read this, more camera manufacturers may have licensed Foveon in their cameras.

FIGURE 2.5
Foveon's
three-layer
technology.

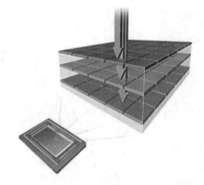

Aliasing and Other Imager Problems

The following images demonstrate problems that occur with low-resolution sensors and poor camera software. The images have been magnified so that you can see the pixelation and artifacts.

The original image direct from the camera has red, green, and blue intensities (see Figure 2.6) in ratios of 1:2:1, which gives it a distinct green cast. There is twice as much green data. Each channel is adjusted in software to make it clearer.

After decreasing the green intensity by 50 percent (see Figure 2.7), the color balance of the raw Bayer mask data is about right.

FIGURE 2.6
The CCD mask
creates a red,
green, and blue
image.

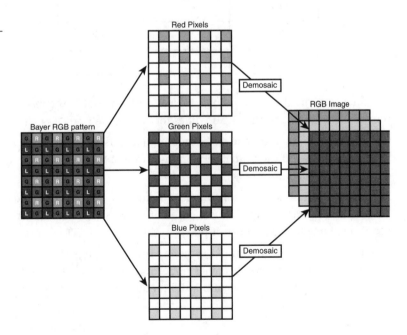

FIGURE 2.7

Decrease green by 50 percent to achieve color balance.

The next step is to interpolate the CCD data. Interpolation is a mathematical process of estimating a missing value by taking an average of known values at neighboring points. The camera processor includes filter software that interpolates these pixels to approximate the correct color for each pixel. The following grid provides a simple example of how this is achieved. Note that the pixel in the center does not really exist. It is created using the color data in the pixels around it—a drawback of the Bayer mask method.

1	2	1
2	4	2
1	2	1

The filter software then interpolates the red and blue data. The result is a rough version of the color image with RGB values for every pixel.

Camera software then goes to work on the image, using an unsharp mask to recover some resolution and then interpolate non-square pixels, resulting in something that approximates the final image.

The actual processors in digital cameras are much better at removing artifacts and pixelation. Each manufacturer uses different software to maximize the color and detail available to the number of pixels in the camera CCD.

The drawback to this amount of processing is that detail is lost to compensate for the mask. The loss of detail becomes noticeable along the edges of dark and light areas, such as in this example of a building against the bright sky.

Highlights and CCD Sensitivity

A smaller but noticeable problem with CCD cameras is with highlights. Chrome reflections, the sun, and any bright sources of light result in bright vertical streaks on digital images. This problem is called *blooming* (see Figure 2.8). The pixels where the highlights occur "wash out" and spill over into adjacent pixels in the array. The result is sharp vertical streaks. This occurs often in CCD astronomy and images of chrome. Newer, more advanced CCDs on today's digital cameras can overcome this CCD problem using an anti-blooming gate designed to bleed off overflow from a saturated pixel. Less expensive cameras, however, produce a bright spot and a vertical streak.

FIGURE 2.8

One form of blooming unique to Fuji's Super HAD hexagonal sensors.

Digital Camera Technologies and Standards

The most beneficial part of digital photography is the instant results. Every photographer benefits from being able to check whether a picture came out. The obvious second largest benefit to digital is, of course, no film! This means no high prices on the front end and no high cost of developing on the back end. But did you know a number of technologies included in every digital camera also enable you to obtain even faster, better prints and lower costs?

This section discusses several not-so-well-known technologies you may have seen advertised with digital cameras. The acronyms and catchy logos probably made as

much sense to you as instructions for setting your VCR clock. This, of course, meant you forgot them immediately. However, technologies and standards such as EXIF, DPOF, and DCF come in handy when you need to move images from the camera.

EXIF 2.2

The Exchange Image Format is a digital camera standard for recording important exposure and camera information in JPEG files created when an image is captured. Digital cameras have adopted the EXIF 2.2 (also called the "Exif Print") standard, which was developed by the Japan Electronics and Information Technologies Industries Association (JEITA).

The EXIF standard creates an image "header" in JPEG images that includes important exposure information, camera information, and thumbnail images of the photo that was just created.

Some or all of the following EXIF information is recorded with each picture:

- White balance
- Flash
- Exposure mode (auto, manual, bracket)
- Exposure time
- Light source
- Subject distance
- Subject area
- Captured scene type (portrait, landscape, night scene)
- Digital zoom
- Custom rendered (special effects)
- Contrast
- Saturation
- Sharpness
- Gain control

tip

The EXIF 2.2 standard also uses the sYCC format, which is larger (in colors) than the sRGB standard color space. The beauty of this larger color space is that EXIF images do not get "clipped" when an image is edited onscreen in the sRGB format. Instead, smart applications like Photoshop ask whether you'd like to keep the existing color profile.

You can view EXIF data in Photoshop or Photoshop Elements in several places:

1. Open Photoshop or Photoshop Elements and choose Window, File Browser.
2. Click once on an image in the file browser and then look at its metadata (data about data) in the left side of the browser window. If you don't see the file information in the left side of the file browser, click the double arrows to display the other half of the file browser (see Figure 2.9).

FIGURE 2.9

Click the double arrows in Photoshop Elements or Photoshop to display the directory tree and EXIF data.

3. Click All at the bottom of the browser window and select EXIF (see Figure 2.10). The EXIF information will appear in the browser window.

FIGURE 2.10

Select EXIF in the image browser to view image data.

4. You can also view an images EXIF metadata by choosing File, File Info in Elements or Photoshop. Click and choose EXIF in the Section drop-down list.

The most helpful information is probably the date the image was created and the X and Y sizes, which tell you how large the image is in pixels.

Exif Print

Exif Print is another name for the EXIF 2.2 standard, but it's a little snazzier! The Exif Print standard records exposure information and information about the camera and thumbnails in a JPEG image when it is created.

The Exif Print standard ensures cameras include the following data in every JPEG, in the following order:

- Number of pixels
- Compression mode
- Date taken
- Device name
- Color space
- Thumbnail image (160×120)
- Image data

For a more detailed list of data included in an EXIF image, see the preceding section on EXIF 2.2.

PictBridge

PictBridge is a printer standard that enables cameras to connect directly to printers with no PC necessary. This standard relies on Exif Print information, which includes detailed information about the camera that captured the image. A camera can connect directly to a PictBridge printer using a USB cable and then print an accurate color print of the image with no need for a PC.

Direct Print

Direct Print is a Canon corporation standard similar to PictBridge that enables Canon cameras and Direct Print-compatible cameras to connect to Canon printers directly via USB cables.

Design Rule for Camera File Systems

The *Design Rule for Camera File Systems (DCF)* is a standard for file naming and the storage of digital camera images. DCF created a file structure and file-naming system for cameras. The result is the confusing *DCIM* directory (folder) name on your digital camera media. The DCF standard also dictates how images are named when a picture is taken, resulting in the somewhat confusing naming convention for digital images. Most likely you've seen files named something like DSCF0026.JPG—this is because of the DCF naming standard.

The good thing about the DCF standard is that all cameras use it. You can pop an SD card out of your Kodak digital camera and put it in a Nikon digital camera and continue shooting. Nothing will be overwritten because each camera stores images in its own folder.

Digital Print Order Format

Digital Print Order Format (DPOF) is a standard created by Panasonic, Kodak, and Fuji that enables cameras to store edited photo information and printing information on the camera prior to printing. A simple text file is stored on the camera's storage media that travels with the images and provides additional details about the image, such as cropping, color correction, and the number of prints the user would like to make. DPOF-enabled cameras can even attach an email to an image that can be sent automatically when the camera is synced to the computer.

THE ABSOLUTE MINIMUM

Now you know what some disadvantages are to this relatively new medium. The two you'll notice first and most often are battery drain and shutter delay. For this reason remember this: Research and read reviews before purchasing!

Do your homework before buying your next digital camera. Research and always look at battery life and shutter delay. The Web has a number of wonderful camera review sites that you can rely on (They haven't sold out yet). Sites such as the following are just a few:

- www.dpreview.com
- www.steves-digicams.com
- www.photo.net

In addition, magazines such as *Popular Photography* and *Shutterbug* are excellent resources.

IN THIS CHAPTER

- Selecting and Using Film
- Special-Purpose Film
- Film Speed and Grain
- How Film Responds to Light

3

FILM BASICS

Today's digital cameras evolved from film cameras and require the same understanding of sensitivity, color, and resolution. Many of the same rules that apply to traditional photography also govern digital. In addition, a number of "digital photographers" still use film. They just rely on scanners to get their images onto the hard drive.

If you leapfrogged traditional film photography entirely, you will understand digital better by learning the history of film. If you inherited or purchased traditional film equipment, the more you know about film, the better your scans and edits will be on the computer.

This chapter discusses negative and positive film and the terms that are used to measure and describe film technology.

I THOUGHT THIS WAS A BOOK ABOUT DIGITAL...

Film photographers can be digital photographers, too. Just get the image from the negative sleeve onto the hard drive or on screen.

The digital darkroom is just that: a place where images are developed and prints are made. Once the image is onscreen, the digital experience begins. Digital cameras just make image transfer that much easier. Traditional photographers with a decent scanner or images on a CD can accomplish the same magic onscreen and in print.

Choosing a Color Film

Film speed influences the appearance of prints and slides. Like black-and-white films, color films are available in a range of ISO ratings, which is a standard for determining film speed. ISO films are graded on a scale. By doubling the number, you double the sensitivity. Film with an ISO rating of 50 is twice as sensitive as ISO 25 speed film.

Color films with low ISO ratings are sharper, more vivid, and less grainy than high-speed films. Slow films also often have lower contrast, which reduces the undesirable effects of overexposure.

Even within the same speed range, different films produce different color effects. Some films have a warm or red-yellow overall color tint, whereas others look cool or bluish. You can make a comparison by exposing two films under identical conditions.

Comparison testing is important with slide film. When slide film is projected on a screen, color problems are obvious, so it is important to know how the film will respond to your subject matter. Magazines such as *Popular Photography* regularly feature comparisons between films. In addition, film manufacturers publish technical data sheets for their film.

Data sheets can be found at camera stores that cater to professional photographers. You can also find these data sheets on the manufacturers' Web sites, usually in the Professional section.

The best resource, though, is the forums. Photographers post messages in online discussion groups (forums) in which they describe their experience with films they have tried. Some of these excellent forums for digital and film photographers are listed here:

- www.photo.net
- www.imaging-resource.com

■ www.dpreview.com

■ www.pcphotoreview.com

■ www.largeformatphotography.info

Types of Color Film

In digital photography, there is essentially only one kind of film. You could say that file formats differ widely, such as RAW, JPEG, and TIFF, but this is just a software issue.

You could also say that high-speed CF cards are much different from memory stick media. However, they both store the same information, so again, it's not a real difference. Slide film, however, works much differently from negative film. The differences reveal advantages and disadvantages to each format.

Negative Film

Negative film produces an image that is the opposite of the original scene in color and density. It can be printed on paper in a darkroom to make a positive or scanned into a computer for editing and printing. It is usually easier to work with negative film if the final medium is a print. Color negative film has a considerable tolerance for under- and overexposure (exposure latitude), and, when scanned, is superior to reversal film for photographs of very contrast-laden scenes.

Reversal Film (Slide Film, Transparency Film, or "Chromes")

Reversal film can be projected for viewing, printed on reversal paper in a darkroom, or scanned into a computer for editing and printing. Reversal film requires more precise exposure than negative film because it has less exposure latitude; errors in exposure or color balance may be difficult or impossible to correct in printing.

However, reversal film has advantages in cost and convenience over negative film, and images can be viewed directly. Reversal film, especially in large format sizes, is almost universally preferred by professionals because its images will be reproduced by offset printing presses. Reversal film often has "chrome" in its name (Agfachrome, Ektachrome, Fujichrome).

Professional Film

Sometimes the word "professional" in a film name is merely a marketing strategy. For color film, however, the word bears a little more weight. Professional films, for example, have *exposure latitude*—the amount of underexposure or overexposure they're capable of handling—that is much smaller than consumer-type film.

In addition, they are much more sensitive to temperature shifts. If you decide to experiment with professional film, store it in a refrigerator to retard aging and keep the color fidelity constant.

Negative or reversal "professional" film also is designed and manufactured for professionals who demand accurate color balance. A film's age and its ISO rating and color balance change during storage. Professional film is shipped with its qualities near their peak, and is refrigerated by camera stores to ensure that it is in the best condition.

Professionals usually buy large quantities of film, preferably all from the same manufacturing batch, and they shoot test rolls to determine its precise ISO and color balance. Professionals keep film refrigerated until it is used, and develop it as soon as possible. Conversely, amateur film may be shipped before it is ready, as the manufacturers anticipate that it will not be used immediately. It often improves after a few months of room-temperature storage.

The useful life of unopened film can be extended by refrigeration or freezing. However, once film is opened (you take it out of its plastic container), it is better kept at room temperature and should be exposed and developed promptly.

Films for Specialized Color Balance and Exposure Times

Each type of color film is intended for a specific type of light. Ordinary daylight film is color balanced for daylight and electronic flash. Type B tungsten film is balanced for 3,200° Kelvin (or K) studio quartz-halogen lights, although ordinary incandescent light bulbs are acceptable. There are a few films for special situations: Type A film is made for 3,400° K lights. Type L (for long) negative films are designed for long exposures (60 to 120 seconds) under tungsten light.

Selecting and Using Film

If you already own a 35mm film camera or a medium-format camera and aren't ready to invest in digital, you might want to stick with film. You can always purchase a decent flatbed scanner with a negative insert for less than $300 and scan your negatives. Fortunately, your choices for film are extensive, even after five years of creeping digital.

This section discusses black and white and color. Thanks to Photoshop and scanners, converting color to black and white has become child's play. However, black and white still has a place in the photographer's portfolio because of its latitude, contrast, saturation, and artistic element (see Figure 3.1). Most of the information on these two pages applies to both black and white and color.

Black and white still plays a major role in today's color, digital world.

©2004 Amanda J. Smith

Color Balance and Film

Daylight-balanced color films produce the most natural colors in the relatively bluish light of daylight or electronic flash. Tungsten-balanced color films give the best results in the relatively reddish light from incandescent light bulbs. Digital cameras must deal with lighting colors as well, but often their automatic white balance feature overcomes any color cast.

Thirty-five millimeter cameras use 35mm film, which is packaged in cassettes of 12, 24, or 36 exposures per roll. Some 35mm films can be purchased in 50- or 100-foot rolls, then bulk loaded into separately purchased cassettes. This reduces the cost per exposure and, if you use a great deal of film, can be worthwhile.

Medium-format cameras use roll film. Roll film is wound around a spool and is backed with a separate strip of opaque paper to protect the film from light. Depending on the camera, 120 roll film makes 16 6×4.5cm, 12 6×6cm, 10 6×7cm, or 8 6×8cm images. Each size applies to different cameras. Fuji makes a popular studio camera that takes 6×8cm images. Mamiya is the leader in 6×7cm cameras, Hasselblad leads with 6×6 cm cameras, and Pentax and Bronica make excellent 6×4.5cm cameras.

note

Thirty-five millimeter film is listed as "135 film" because 135 was the original Kodak product number for this film size. Other manufacturers later adopted the designation.

Most of these cameras accept another type of roll film called 220, which has paper only on the end; this reduces the thickness of the roll so that more film can be wound on the spool and more exposures made.

Sheet films, or *cut* films, are designed for large-format cameras, such as 4×5-inch and 8×10-inch cameras (also called *view cameras*). Sheet film is packaged 10 or more sheets to a box. Some film must be loaded in film holders before use, although you now can buy sheet film in disposable holders.

WHAT ABOUT APS FILM?

Advanced Photo System (APS) films were released a short time before digital photography took off. This red-headed stepchild of film is actually highly advanced. Every roll of APS film contains a magnetic layer that records the format in which you want the print, the date, frame number, and other data.

Do You Need a Film for a Special Purpose?

Aside from Polaroid film, which contains developing chemicals in each picture, a number of unusual film technologies exist.

- High-contrast films produce only two tones: the clear film base and black, without intermediate tones of gray.

- Infrared films respond to infrared wavelengths that the human eye cannot see. These are available in black and white and color.

- Chromogenic black-and-white films, such as Ilford XP2, produce a dye image rather than a silver one. They have excellent exposure latitude, which means you can expose individual frames at different film speeds. Frames exposed at about ISO 100 will have finer grain, but frames on the same roll of film can be exposed at speeds as high as ISO 800 and still produce printable negatives. This differs from conventional films, which require you to expose the whole roll at a single film speed. Chromogenic film must be developed as if it were a color negative (in Kodak's C-41 chemistry or Ilford's version of the same process), which is available at your corner drugstore.

Storing Film Properly

Store film away from heat. Heat affects any film badly, so don't leave it where temperatures might be high, such as in the glove compartment of a car on a hot day or near a heater in winter.

For long-term storage, refrigerate film. Refrigeration extends the life of film. Room temperature is fine for short-term storage, but for longer storage, especially in warm weather, a refrigerator or freezer is better for most films. Make sure that the dealer has refrigerated film if that is what the manufacturer recommends.

Protect film from moisture. The original film packaging should be moisture-proof, but if you refrigerate the film after opening the box, put the film in a moisture-proof container like a tightly closed plastic bag.

Let refrigerated film warm to room temperature before using it to prevent moisture from condensing on the film surface. One roll of film (or a 10-sheet box of sheet film) needs about an hour to warm up; a 100-foot roll of bulk-loaded 35mm film or a 100-sheet box of sheet film needs about four hours to warm up.

caution

Do not freeze or refrigerate Polaroid instant-picture film. In the freezer, the film's developing chemicals could separate or burst. In the fridge, even unopened Polaroid film can fail because of moisture.

Film Speed

The faster the film speed, the less light required to produce an image. Therefore, faster film can be used in dimmer light, with faster shutter speeds, or with smaller apertures. A fast film is useful indoors, for example, especially if you use only the existing light in the room and do not supplement it with electronic flash or photofloods. A slower film is good for brightly lit scenes, such as outdoors in bright sun. The faster the film, the higher its film speed number.

What film speed should you use? Faster films tend to produce grainier pictures, so theoretically you will get the best results by selecting the slowest film usable in each situation. In practice, however, it is inconvenient and unnecessary to work with several film speeds. Some photographers use a relatively fast ISO 400 film for almost all their work. One type of film might not be enough, but a fast ISO-rated film and a slower, finer-grain film are enough for most situations (see Figure 3.2).

Film Speed Rating Systems

A film speed number indicates how sensitive that film is to light. There are several rating systems for film speed. The most common in English-speaking countries are ISO (International Organization for Standardization) and EI (exposure index). ASA (American Standards Association) is an older rating system. All use the same numerical progression: The film speed rating doubles each time the light sensitivity of the film doubles.

The higher the number in a given system, the faster the film—and the less light you need for a correct exposure (see Table 3.1). An ISO or EI or ASA 200 film is twice as fast as an ISO 100 film (one stop faster), half as fast as an ISO 400 film (one stop slower). For a correct exposure, the ISO 200 film needs half as much light as (one stop less than) the ISO 100 film, twice as much light as (one stop more than) the ISO 400 film.

Table 3.1 Film Speed and Shutter Speed

Film Speed	Sample Exposure
ISO 100	f/2.8 aperture at 1/30 sec shutter speed
ISO 200	f/2.8 aperture at 1/60 sec shutter speed
ISO 400	f/2.8 aperture at 1/125 sec shutter speed
ISO 800	f/2.8 aperture at 1/250 sec shutter speed
ISO 1600	f/2.8 aperture at 1/500 sec shutter speed
ISO 3200	f/2.8 aperture at 1/1000 sec shutter speed

Film speed influences heavily how the film is used. Sports photographers that still shoot with film must use high-speed film because higher shutter speeds capture motion with no blur. Slower film speeds are used for portrait photography because maximum clarity is desirable (see Table 3.2).

Table 3.2 Some Typical Film Speeds and Their Uses

Film Speed	Uses	Grain
Slow: ISO 50 or less	Brightly lit subjects	Finest grain
Medium-speed: around ISO 100	General outdoor use	Medium-fine grain
Fast: around ISO 400	Indoor or dimly lit scenes, bright scenes with fast moving subjects	Medium grain
Extra fast: more than ISO 400	Very dark scenes, especially with moving subjects	Coarsest grain

Film Speed and Grain

The faster the film, the more visible its grain (see Figure 3.3). The light-sensitive part of film consists of many tiny particles of silver halide spread throughout the film's emulsion. A fast film is fast because it has larger crystals than a slower film. The

larger crystals more easily capture the few rays of light in a dark environment. When the fast film is developed, its larger crystals yield larger bits of silver. The advantage is that the film needs less light to form an image. The potential disadvantage is that these larger crystals in very fast films reproduce what should be uniform gray areas—not as smooth tones—but with distinctly visible specks or grain.

In general, each increase in speed also increases graininess. If maximum sharpness and minimum graininess are your desire, select slower rather than faster films.

Some newer films have reduced graininess. Recent advances in technology have changed what used to be a fairly direct relationship between film speed and grain. The silver halide crystals in T-grain or core-shell emulsions, such as in Kodak's Max or Ilford Delta films, have a flattened surface that exposes more of each crystal to light. The result is film with significantly reduced grain for its speed.

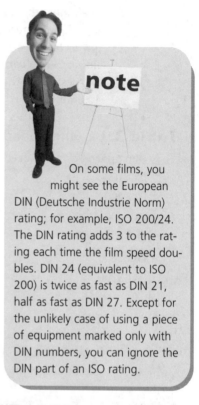

note

On some films, you might see the European DIN (Deutsche Industrie Norm) rating; for example, ISO 200/24. The DIN rating adds 3 to the rating each time the film speed doubles. DIN 24 (equivalent to ISO 200) is twice as fast as DIN 21, half as fast as DIN 27. Except for the unlikely case of using a piece of equipment marked only with DIN numbers, you can ignore the DIN part of an ISO rating.

FIGURE 3.3

The photo on the left was taken with film camera using ISO 800 speed film. The photo on the right was taken in low light with a digital camera at ISO 400.

Other factors also affect grain. Graininess is more obvious in areas of uniform tone—such as the sky—than it is in textured areas. Also, graininess becomes more apparent the more a picture is enlarged. That is why a print from a 35mm negative usually looks grainier than the same size print from a larger negative. Grain is also affected

by factors such as the film developer, the printing paper, and the type of enlarger used. Graininess also increases when the negative is overdeveloped or overexposed.

Fast-Speed Film: When Speed Is Essential

A fast film (ISO 400 or higher) is useful for stopping motion (see Figure 3.4). Because it requires less light than a slower film, you can use a faster shutter speed, which will record a moving subject more sharply than a slow shutter speed.

FIGURE 3.4
Action and sports photography is the last film stronghold. Digital cameras are only now fast enough for sports photography.

Fast film is an asset in dim light. Because fast film needs less light to produce a printable image, it makes photography easier indoors, at night, or in other low-light situations (see Figure 3.5). If you increase the development (ask your lab), you can *push* the film, which lets you expose at a film speed even higher than the one that is designated by the manufacturer.

How fast is fast? The film speed of Kodak's T-Max P3200 film, for example, starts at 800. Its speed can be pushed to 3200, and with a sacrifice of image quality, up to 25,000. A fast film might show increased grain and loss of image detail, especially if you push the film. But the advantages of fast film can outweigh its disadvantages when you need the speed.

Medium-Speed Film: The Best General Purpose Film

A medium-speed film around ISO 100 delivers better sharpness and detail than faster films (see Figure 3.6). It is useful when you want to show fine detail or want to enlarge a negative considerably with a minimum of grain. The film has smaller silver halide crystals and a thinner emulsion compared to fast films, which increases its capability to render detail sharply.

FIGURE 3.5

Low-light photo taken with ISO 1600-speed film.

FIGURE 3.6

Film with an ISO rating of 100–400 is usually fast enough for most outdoor photography.

If light is moderately bright, a film of medium speed still lets you use a relatively fast shutter speed, so you can hand-hold the camera or record moving objects sharply. The slowest film speeds would require a tripod to hold the camera steady during a longer exposure of the same scene. Medium-speed films are also useful if you want to maximize the depth of field by using a small aperture, which is not always feasible with a very slow film.

Slow-Speed Film: Maximum Detail

Slow-speed films of ISO 50 or less are mostly color. The reason is that grain has been reduced so much in black-and-white films that few are still available at speeds under ISO 100.

A slow-speed color film produces brighter colors and a crisper image than faster color films. The original Kodachrome film was rated at ISO 25; Fuji's hugely successful Velvia film is rated at ISO 50.

One exception to color-dominating, slow-speed films is the black-and-white recording film called Technical Pan 2415. Normally this ISO 25-rated film is used for recording text and other high-contrast applications. Develop this film with a special Technidol developer, however, and normal photographs are possible. The extremely fine grain and high resolution of this film enable you to blow up 35mm negatives to 20×30 inches with no apparent grain.

How Film Responds to Light

Recording an image on film involves a reaction between light and silver halide crystals (see Figure 3.7). The crystals, spread through the gelatin of the emulsion, are a compound of silver plus a halogen such as bromine, iodine, or chlorine. If a crystal were a perfect structure lacking any irregularities, it would not react to light. However, a number of electrically charged silver ions are also in the structure and move about when light strikes the emulsion, eventually forming an image. The crystal also contains impurities, such as silver sulfide, which play a role in the trapping of light energy.

An impurity (called a *sensitivity speck*) and the free-moving silver ions build a small collection of uncharged atoms of silver metal when the crystal is struck by light. This bit of metallic silver, too small to be visible even under a microscope, is the beginning of a latent image. The developing chemicals use the latent image specks to build up density, or the metallic silver required to create a visible image.

FIGURE 3.7

Black-and-white film construction illustrated.

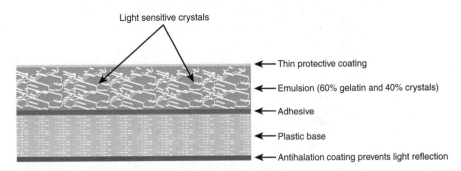

Light sensitive crystals

← Thin protective coating

← Emulsion (60% gelatin and 40% crystals)

← Adhesive

← Plastic base

← Antihalation coating prevents light reflection

Chromogenic film is somewhat different from conventional silver halide film. A chromogenic emulsion contains dye couplers as well as silver halides. During development, the presence of silver that has been exposed to light leads to a proportional buildup of dyes. The original silver is then bleached out, leaving the dyes to form the visible image. Most color materials use chromogenic development to produce the final color image, as do several types of black-and-white film.

In Figure 3.8, notice the darker parts of the original scene: Receive less light, develop less silver density, and show less detail.

note

You probably are familiar with the C-41 process, common at all 1-hour photomats and pharmacies. The C in C-41 means *chromogenic*.

FIGURE 3.8
Each of these images received one stop less light.

Eventually those parts of the negative become clear of silver and print as black. When a highlight area, like the sky, gets too much light, it blocks up with solid silver density, appears dark in the negative, and prints as white.

THE ABSOLUTE MINIMUM

This chapter focused on film, which you might not have expected to see in a digital photography book. However, film can easily become part of your digital workstream. If you have any doubts about its lifespan, film will survive the digital onslaught, just as theater survived radio, cinema survived television, and bookstores survived Amazon.

Whether you choose digital or film, keep in mind these important points when taking pictures:

- The speed of digital and film is measured using an ISO rating.
- Double the ISO speed and you double the film's sensitivity.
- ISO 800 film is recommended for indoor, low-light photography.
- Slide film has less perceptible grain and is better for scanning.

PART

DigiTAL BASiCS

The Importance of Lenses45

Exposure and Focus .63

Getting Your Pix Onscreen71

Files and File Formats81

File Recovery: Finding "Lost" Images97

IN THIS CHAPTER

- Lenses & Focal Length
- Focal Length & Digital Cameras
- Autofocus & Manual Focus
- Controlling Depth of Field

4

THE IMPORTANCE OF LENSES

Good photographers know their cameras and how they work. This chapter explains the science behind the most important part of that equipment: lenses. The more you know how to work with lenses, the better a photographer you will be. Fortunately, even beginners have been exposed to what this chapter covers:

- **Focal length.** You probably have heard the numbers surrounding lenses, such as a 28mm lens and a 400mm lens. You might have heard the terms *wide-angle* and *telephoto* used instead of these numbers.

- **Aperture and depth of field**. Open the lens to f2.8 and see depth of field disappear.

- **Focus**. Focus by hand or use autofocus.
- **Special lenses**. Use special lenses for close-ups, panoramas, and other special images.

Carpenters must know their tools to stay in business. The same can be said for professional photographers. Besides your creativity, nothing influences the quality of your imagery more than the lens. Studying the characteristics of lenses will make you a better photographer.

Lens Focal Length

The most significant difference among lenses is their focal length. A lens is often described in terms of its focal length (such as a 50mm lens) or its physical length (short, medium, long). Technically, *focal length* is the distance between the lens's rear nodal point and the focal plane when the lens is focused on infinity (a far distance from which light reaches the lens in more or less parallel rays).

The focal length controls *magnification*, or the size of the image formed by the lens. The longer the lens, you will find the size of objects in the image greater. A lens of longer focal length bends light rays less than a short lens does (see Figure 4.1). The longer the focal length, the less the rays are bent, the farther behind the lens the image is focused, and the more the image is magnified (see Figure 4.2). The size of the image increases in proportion to the focal length. If the subject remains at the same distance from the lens, the image formed by a 50mm lens will be twice as big as that from a 25mm lens.

FIGURE 4.1

A lens of short focal length bends light sharply.

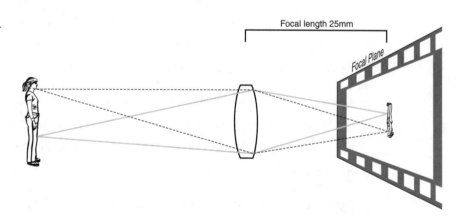

Focal length 25mm

Focal Plane

FIGURE 4.2

A lens of longer focal length bends light rays less than a short lens does.

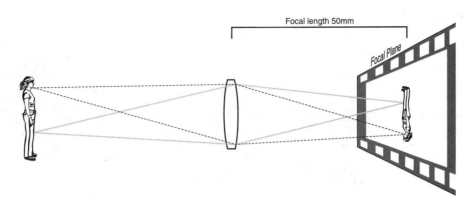

Focal length also controls the *angle of view*, the amount of the scene shown on a given size of film. A long-focal-length lens forms a larger image of an object than a short lens. As a result, the long lens must include on a given size of film less of the scene in which the object appears. If you make a circle with your thumb and forefinger and hold it close to your eye, you will see most of the scene in front of you—the equivalent of a short lens. If you move your hand farther from your eye, the circle will be filled by a smaller part of the scene—the equivalent of a longer lens. You will have decreased the angle of view seen through your fingers. In the same way, the longer the focal length, the smaller the angle of view seen by the lens.

The effect of increasing focal length while keeping the same lens-to-subject distance is an increase in magnification and a decrease in angle of view. Because the photographer did not change position, the size of the objects within the scene remained the same in relation to each other. Less is visible in the frame as lenses increase in focal length.

Normal Focal-Length Lenses

A normal focal-length lens, also called a *standard focal-length* lens, approximates what the human eye sees. One of the greatest modern photographers, Henri Cartier-Bresson, who described the camera as "an extension of my eye," almost always used a normal lens. The angle of view of most of his images is about the same as what the eye can see clearly from one position, and the relative size of near and far objects seems normal.

A lens that is a normal focal length for one camera can be a long focal length for another camera (see Figure 4.3). Film size determines what will be a "normal" focal length. The larger the size of the film format, the longer the focal length of a normal lens for that format. If the focal length of a lens is about the same as the diagonal measurement of the film (broken line), the lens is considered "normal." It collects light rays from an angle of view of about 50°, the same as the human eye.

FIGURE 4.3
A "normal" focal length of 150mm for a large format camera is extra long on a 35mm!

The difference between what is considered a normal focal-length lens for each type of camera is described in Table 4.1.

Table 4.1 Normal Focal Length Lenses for 35mm, Medium-Format, and Large-Format Cameras

For this type of camera...	A normal focal-length lens is...
35mm	50mm
2 1/4×2 1/4 (6×6cm)	75mm
4"×5"	150mm

Usage varies somewhat. For example, lenses from about 40mm to 58mm are also referred to as normal focal lengths for a 35mm camera.

A lens of normal focal length has certain advantages over lenses of longer or shorter focal length. Normal focal length lenses have the following characteristics:

- **Faster**. They open to a wider maximum aperture, so they can be used with faster shutter speeds or in dimmer light than lenses that do not open as wide.

- **Less expensive**. The lenses are the least expensive of all lenses because they are manufactured in such large quantities.

- **More compact**. Normal focal length lenses are often the smallest lenses available. If you're traveling with a 35mm camera, a 50mm is a must-have.

- **Lighter**. These lenses often weigh less than even wide-angle lenses!

What you choose for your lens suite is a matter of personal preference, however. Some photographers habitually use a shorter focal length because they want a wide angle of view most of the time; others prefer a longer focal length that narrows the angle of view to the central objects in a scene. If you have a 35mm camera, a 50mm lens is a good focal length to start.

Focal Length and Digital Cameras

Lenses for 35mm cameras have a different focal length on a digital camera. The CCDs used in these cameras are physically smaller than a 35mm frame. For this reason, lenses used on digital cameras (with removable lenses) have a longer focal length. In other words, a 50mm lens will actually be 80mm on some digital cameras.

If you already own lenses for a traditional film camera and are shopping for a digital camera that will work with them, find out what the focal magnifier is for each camera—it varies depending on the manufacturer and even the model line. CCD and CMOS sensors in these cameras vary greatly in size.

note

Conversion factors for lenses will cease to be an issue as fewer manufacturers produce 35mm cameras. In the future, you'll have to use a conversion factor for traditional film cameras because all lenses will be for digital!

Long Focal-Length Lenses

A long focal-length lens provides greater image magnification and a narrower angle of view than a normal lens. For a 35mm camera, a popular and useful long focal length is 105mm. For a camera using 2 1/4×2 1/4-inch film, the comparable focal length is 150mm. For a 4×5-inch view camera, it is about 300mm.

Long lenses are excellent when you cannot or do not want to get close to the subject. They are also preferred for portraits; most people become self-conscious when a camera is too close to them, so their expressions are often artificial. A long lens also avoids the kind of distortion that occurs when shorter lenses used close to a subject exaggerate the size of whatever is nearest the camera—in a portrait, usually the nose (see Figure 4.4).

FIGURE 4.4
A short focal length lens (left) distorts a subject's nose. Use a longer focal length lens (right).

Compare the size of the nose and chin in the two pictures of the same subject in Figure 4.4. Photographing a person at too close a lens-to-subject distance makes features nearest the camera appear too large and gives an unnatural-looking dimension to the head.

There are subtle qualities that can be exploited when you use a long lens. Because a long lens has less depth of field, objects in the foreground or background can be photographed out of focus so that the sharply focused subject stands out clearly. Also, a long lens can be used to create an unusual perspective in which objects seem to be closer together than they really are (see Figure 4.5).

FIGURE 4.5

Telephotos, especially large ones, make distant features seem close together (300mm lens).

Long lenses do have some disadvantages:

- Long telephotos are heavier, bulkier, and more expensive than normal focal-length lenses.
- Because they have relatively shallow depth of field, long lenses must be focused accurately.
- Long lenses are difficult to use for handheld shots because they magnify lens movements as well as subject size.

The shutter speed for a medium-long lens, such as a 105mm lens on a 35mm camera, should be at least 1/125 second if the camera is handheld. For a 200mm lens, you will need at least 1/250 second. Otherwise, camera movement might cause blurring. A tripod or other support is your best protection against blurry photos caused by camera movement.

A *tele-extender* or *teleconverter* contains an optical element that increases the effective focal length of a lens. It attaches between the lens and the camera body and magnifies the image from the lens onto the film. With these devices, the effective length of the lens increases, but less light reaches the film. A converter that doubles the lens, for example, loses two f-stops of light. Regardless, this tiny addition to your lens collection is welcome. A tele-extender can turn a normal telephoto into a super telephoto, which comes in handy if you're birding, or in a situation where you're extremely far away and can't get closer to the subject.

> **note**
>
> Photographers commonly call any long lens a telephoto, or *tele*, even though not all long lenses are actually of telephoto design. A true telephoto has an effective focal length that is greater than the distance from lens-to-film plane.

Short Focal-Length Lenses

A short focal-length lens increases the angle of view and shows more of a scene than a normal lens used from the same position. A short lens (commonly called a *wide-angle lens*) is useful when you are physically prevented (as by the walls of a room) from moving back as much as would be necessary with a normal lens.

For a 35mm camera, a commonly used short focal length is 28mm. A comparable lens for a camera using 2 1/4×2 1/4-inch film is 55mm. For a 4×5-inch view camera, it is 90mm.

Wide-angle lenses have considerable depth of field. A 24mm lens focused on an object seven feet away and stopped down to f/8 will show everything from four feet to infinity in sharp focus. Photographers who work in fast-moving situations often use a moderately wide lens, such as a 35mm lens on a 35mm camera, as their normal lens. They don't have to pause to refocus for every shot, because with this type of lens, so much of a scene is sharp. At the same time, it does not display too much distortion.

Pictures taken with a wide-angle lens can show both real and apparent distortions. Genuine aberrations of the lens itself such as curvilinear distortion are inherent in extremely curved or wide elements made of thick pieces of glass, which are often used in wide-angle lenses. Although most aberrations can be corrected in a lens of a moderate angle of view and speed, the wider or faster the lens, the more difficult and/or expensive that correction becomes.

A wide-angle lens can also show an apparent distortion of perspective, but this is actually caused by the photographer, not the lens. An object that is close to a lens (or your eye) appears larger than an object of the same size that is farther away.

Because a wide-angle lens can be focused close to an object, it is easy to get this kind of exaggerated size relationship. The cure is to learn to see what the camera sees and either minimize the distortion, or use it intentionally.

Special-Purpose Lenses

A number of lenses exist that do not fit into the traditional wide-angle, medium, and telephoto lens categories.

Fisheye Lens

For the widest of wide-angle views, consider the *fisheye lens*. Super wide-angle lenses allow the photographer to get very close.

A fisheye lens has a very wide angle of view—up to 180°—and exaggerates to an extreme degree differences in size between objects that are near to the camera and those that are farther away. Inherent in its design is *barrel distortion*, an optical aberration that bends straight lines into curves at the edges of an image. Two types of fisheye lenses exist:

- **True fisheye**. A circular image is taken and the rest of the frame is black. Literally, a circle is all you get.

- **Full-frame fisheye**. The fisheye lens fills the entire frame. Distortion still occurs, but the frame has no black, blank areas (see Figure 4.6).

FIGURE 4.6

A full-frame fisheye fills the frame.

Fisheye lenses also produce great depth of field. Objects within inches of the lens and those in the far distance will be sharp. It is not a lens for every situation, but it can produce startling and effective views.

Macro Lens

A *macro lens* is useful for extremely close shots. The lens allows you to focus at a very close range (see Figure 4.7) and is corrected for aberrations that occur at close focusing distances. The lens is occasionally called, somewhat inaccurately, a *micro lens*. Some zoom lenses come with a macro feature. They focus closer than normal, but not as close as a fixed focal-length macro lens.

FIGURE 4.7

An art piece created with a macro lens.

Copyright ©2004 Nicholas E. Papadakis

Soft-Focus Lens

Aberrations are deliberately introduced in a *soft-focus lens*, also called a *portrait lens*. The goal is to produce an image that will diffuse and soften details such as facial wrinkles.

Perspective-Control Lens

A *perspective-control lens* brings some view/camera adjustments to other types of cameras. The lens shifts up, down, or sideways to prevent the perspective distortion that

causes parallel lines to tilt towards each other if the camera is tilted. Before Photoshop, these lenses were the only way 35mm and medium-format architectural photographers fixed the distortion of buildings. These lenses are now essentially obsolete because you can fix the problem in Photoshop.

Catadioptric (Mirror) Lens

A *catadioptric lens* (also called a *mirror lens*) is similar in design to a telescope. It incorporates curved mirrors as well as glass elements within the lens. The result is a very long focal length that is smaller and lighter than a typical lens of equivalent focal length.

These mirrors come into vogue and then fall back out again every few years. These lenses are the smallest telephoto lenses you can buy, but they have some issues. The front mirror in the lens has the unusual effect of causing out-of-focus highlights to take on a donut shape, rather than the usual disk shape produced by an ordinary lens. Mirror lenses are also slow because of a fixed aperture. The aperture is usually f/8 or f/11.

Catadioptrics aren't as sharp as high-quality telephotos. Most professionals use a telephoto and a tele-extender when they need extreme telephoto capabilities.

Automatic Focus

Automatic focus (AF) does the focusing for you. In the simplest designs, you push the shutter-release button and the lens snaps the image into focus. The camera adjusts the lens to focus sharply on whatever object is at the center of the viewfinder within the focusing brackets. This type of autofocus works well in situations where the main subject is—and stays—in the middle of the picture. The camera will display a confirmation light when it has focused, but the light does not assure that the picture will be sharp overall.

If your subject is not within the focusing brackets, you can use autofocus lock to make it sharp:

1. Frame the subject within the focusing brackets.
2. To temporarily lock in the focus, press the shutter release button halfway down.
3. Keeping the shutter partially pressed, reframe the scene (move the subject out of the center), then press the shutter release button all the way down.

Wide-area focus systems provide more elaborate electronics. The viewfinder displays several focusing brackets. By rotating a dial or thumbwheel on the camera, you select

a bracket that covers the subject you want to be sharp. When you press the shutter, the camera focuses on the selected area. This feature allows you to maintain your framing without autofocus locking and reframing each picture. It also allows you to shoot fast-moving subjects that are not in the center of the frame (see Figure 4.8).

FIGURE 4.8

Begin panning before a fast-moving subject is in front of you. This is always preferable to playing catch-up.

Some wide-area autofocus systems use the light reflected off your eyeball to determine where you are looking in the viewfinder, and therefore what aspect of the picture to bring into sharp focus. Other systems automatically select the nearest subject in the picture and focus there.

Types of Autofocus

Your camera might let you select among *manual*, *single-shot*, and *continuous focus*. With single-shot autofocus, sometimes called *focus priority*, the camera will not let you take a picture until it has focused. After the lens locks in the focus, you must either expose the picture or let up on the shutter-release button. This assures you of a high percentage of sharp pictures, but can prevent you from capturing a critical moment.

With continuous focus, the camera constantly searches for the correct focus when you partially depress the shutter button. The camera revises its focus as the subject moves closer or farther away. Continuous focus allows you to make an exposure whenever you like. This approach works well for shooting action but does not guarantee a sharp picture every time.

After you lock onto a subject, some cameras predict where the subject is likely to be next, keeping the subject in focus even if it moves across the frame. These focus tracking systems can lock onto a subject, adjusting the focus as the subject moves closer to, or farther from, the camera. The system works especially well if the subject, like a race car, is traveling at a constant speed toward or away from the camera.

Some cameras have two autofocus systems. Active autofocus sends out a beam of red light that the camera uses to measure the distance to the subject. Passive autofocus uses the contrast in the scene to determine when the subject is sharp.

Autofocus systems are not infallible. Active autofocus is limited to subjects fairly close to the camera. Passive autofocus is limited by the brightness and contrast of the subject. A camera might fail to focus or miss the focus if a subject has very low contrast, is in very dim light, or consists of a repetitive pattern like window blinds or a complex pattern, like a plaid. Some cameras employ both systems for maximum sharpness under most conditions.

Read your camera's instructions to know how its autofocus mechanism operates and when you would be better off focusing manually.

caution

Continuous focus kills batteries. If you're out in the field, curb your use of this type of focusing to preserve battery levels.

note

Some autofocus systems can take a long time to adjust, as the lens "hunts" back and forth, unable to focus.

Center-Weighted Autofocus Lock

Autofocus cameras often focus on the center of a scene. This can make an off-center main subject out of focus if it is at a different distance from whatever is at the center (see Figure 4.9). To focus properly on the subject of your picture if he/she/it is not in the center of the image:

1. In autofocus mode, first focus by placing the autofocus brackets on the main subject. With many cameras, you partially press the shutter button down. Keep partial pressure on the release to lock focus (Figure 4.10).

2. Reframe your picture (see Figure 4.11) while keeping partial pressure on the shutter release.

3. Push the shutter button all the way down to make the exposure.

FIGURE 4.9
Most autofocus cameras by default focus on the center of the image.

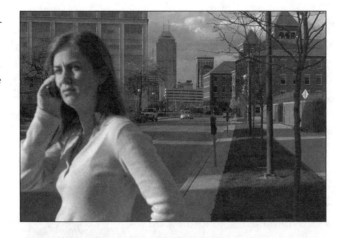

FIGURE 4.10
Place the subject in the center, press down halfway on the shutter to focus, and hold the shutter release down.

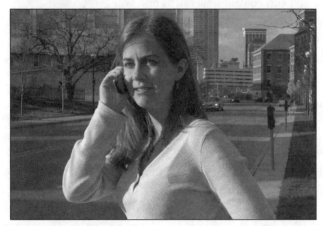

FIGURE 4.11
Reframe the image before pressing the shutter all the way down.

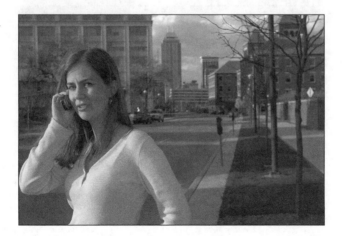

Focus and Depth of Field

What exactly is sharpness, and how much can it be controlled? In theory, a lens can only focus on a single distance at a time (the plane of critical focus) and objects at all other distances will be less sharp. However, in most cases, part of the scene will be acceptably sharp both in front of and behind the most sharply focused plane. Objects will gradually become more and more out of focus the farther they are from the most sharply focused area.

Depth of field is the part of a scene that appears acceptably sharp in a photograph. Depth of field can be shallow, with only a narrow band across the scene appearing to be sharp, or it can be deep, with everything sharp from nearest to farthest. To a large extent, you can control how much of it will be sharp. There are no definite endings to the depth of field; objects gradually change from sharp to soft the farther they are from the focused distance.

note

Physically small apertures such as f/22 produce greater depth of field. Large apertures such as f/2.8 produce shallow depth of field (see Figure 4.12).

Controlling Depth of Field

Evaluating and controlling depth of field is more important in some situations than in others:

- If you are relatively far from the subject, the depth of field (the distance between the nearest and farthest points in a scene that appear sharp in a photograph) will be greater than if you are up close.

FIGURE 4.12
Photo taken at f/2.8 with a 300mm lens.

■ If you are using a short focal-length lens, you will have more depth of field than with a long lens.

■ If the important parts of the scene are more or less on the same plane left to right, they are all likely to appear sharp as long as you have focused on one of them.

But when you photograph a scene up close, with a long lens, or with important parts of the subject both near and far, you might want to increase the depth of field so that parts of the scene in front of and behind the point on which you focused will also be sharp (see Figure 4.13).

FIGURE 4.13

Telephoto lenses require you to "stop down" the lens to f/22; otherwise, subjects not in focus will be blurred.

Sometimes, though, you will want to blur a distracting background that draws attention from the main subject. You can accomplish this by decreasing the depth of field.

You can use the aperture to control depth of field. To increase the depth of field so that more of a scene in front of and behind your subject is sharp, setting the lens to a small aperture is almost always the first choice. Select f/16 or f/22, for example, instead of f/2.8 or f/4. You might have to use a slower shutter speed to maintain the same exposure, however. A slow shutter speed can be a problem if you are photograph-ing moving objects or shooting in low light.

tip

Slow shutter speeds at small apertures usually require a tripod. Keep a tri-pod in the trunk of your car for just this purpose!

To decrease the depth of field and make less of the scene in front of and behind the subject sharp, use a wider aperture, such as f/2.8 or f/4.

There are other ways to control depth of field. You can increase the depth of field by changing to a shorter focal-length lens or stepping back from the subject, although both of those choices will change the picture in other ways as well.

To decrease the depth of field and make less of the scene in front of and behind your subject sharp, you can use a longer lens or move closer to the subject. These alternatives will also change the composition of the picture.

Lens Focal Length, Aperture, and Light

Why does a lens of longer focal length produce less depth of field than a shorter lens at the same f-stop (aperture)? The answer relates to the diameter of the aperture opening. The relative aperture (the same f-stop setting for lenses of different focal lengths) is a larger opening on a longer lens than it is on a shorter lens (see Figure 4.14).

FIGURE 4.14

f/4 on a 50mm lens and a 300mm lens. The smaller focal length has greater depth of field at the same aperture as a 300mm lens.

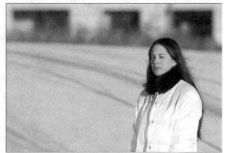

Both lenses were set at f/4, let in the same amount of light, even though the actual opening in the 50mm lens is physically smaller than the opening in the longer 300mm lens.

The longer the focal length, the less light that reaches the film (or CCD chip on a digital camera), therefore a long lens will form a dimmer image than a short lens unless more light is admitted by the aperture.

The sizes of the aperture openings are determined so that at a given f-stop number the same amount of light reaches the film, no matter what the focal length of the lens. The f-stop number, also called the *relative aperture*, equals the focal length of the lens divided by the aperture diameter.

$$\text{f-stop} = \frac{\text{lens focal length}}{\text{aperture diameter}}$$

If the focal length of the lens is 50mm, you need a lens opening of 12.5mm to produce an f/4 aperture.

$$\frac{50\text{mm lens}}{12.5\text{mm lens opening}} = \frac{50}{12.5} = \text{f/4}$$

If the focal length of the lens is 300mm, you need a lens opening of 75mm to produce an f/4 aperture.

$$\frac{300\text{mm lens}}{75\text{mm lens opening}} = \frac{300}{75} = \text{f/4}$$

THE ABSOLUTE MINIMUM

Lenses are the most important part of a camera system. The quality of your images depends entirely on the glass between the subject and the film or CCD. If you own a non-SLR digital or film camera, you're stuck with a specific lens. If you own an SLR, however, your choices are much greater. Keep these tips in mind when considering the cost or purpose of a lens:

- Buy the best lens or lenses you can afford. For SLR owners, used lenses are fine as long as they are high quality.
- A "normal" focal length lens, in the 35–85mm range, is by far the most valuable lens you can own.
- Digital camera sensors are physically smaller than a 35mm film frame. This causes regular lenses to have a longer focal length. A 35mm lens for example might actually be 50mm on a digital camera SLR.
- Fixed-focal length lenses on consumer-level digital cameras are often not that large. This results in slower shutter speeds or more noise in low-light situations.
- Telephoto lenses require you use a monopod or tripod. Invest in one and use it whenever you take pictures with a telephoto.
- Fisheye lenses are fun, but full-frame fisheye lenses are much more useful.

IN THIS CHAPTER

- Digital Cameras & Color Balance
- Film & Color Balance
- Exposure Latitude & Film Latitude
- Film Latitude

5

EXPOSURE AND FOCUS

Color balance and latitude are two important characteristics of film and digital media. *Color balance* is the film or CCD's response to colors in a scene. *Latitude* is the amount film or a CCD can be under- or overexposed and still deliver a decent picture. Digital cameras are capable of overexposure and underexposure but actually have no more latitude than print film! For this reason, your images must be technically accurate for both types of media.

By comparing film and film technologies to the capabilities of digital cameras, you will certainly learn new techniques to try in digital. This chapter explains color balance and then examines the capability of both mediums to handle extreme exposure situations.

Digital Cameras and Color Balance

Digital cameras are not immune to color balance issues, although white-balance features in most cameras help to reduce problems when used properly. White-balance enables photographers to set the "white point" for a camera before pictures are taken. This forces a camera to consider a specific color of lighting as purely white light.

The purpose of a white point (white balance) is to force the camera sensor to see the color you designate as pure white. To avoid off-color images taken indoors with fluorescent bulbs or zenon bulbs, you might need to point the camera at a white object (such as a piece of cardboard or a white wall), and then set the white balance on the camera. By setting a white point, the camera will not have color-cast issues later on. Television news crews, for example, avoid strange colors and skin tones by setting the white point of their video cameras prior to every shoot.

Most digital cameras can accurately compensate for lighting color and overcome unusual lighting conditions. However, occasionally their automatic adjustment systems get confused. This often happens indoors, where lighting systems can vary greatly. If you're shooting indoors under unusual lighting, set the white balance on the camera before taking pictures.

To set the white balance for your camera, follow these general steps:

1. Access the menu on your camera. Usually there is a dedicated Menu button somewhere on the back of the camera.

2. Scroll through the menus until you find a setting for WB, White Bal, or White Balance.

3. There might be a few more choices, such as Presets. Continue through the menus until you reach choices that resemble the following:

 - **Auto**. Automatically corrects white balance. This setting is often the only one you need, especially if you photograph outdoors.

 - **Daylight**. Set the white balance to daylight if you're shooting outside.

 - **Tungsten**. Set white balance to tungsten, if you're shooting indoors with incandescent bulbs (the screw-in type from GE). These bulbs emit a lot of yellow light. The tungsten setting will compensate by reducing yellow and increasing blue.

 - **Fluorescent**. Set to fluorescent to compensate for the excessive green output by these tubes.

4. Highlight one of these choices and then press OK. The camera is ready for unusual lighting.

The color temperature of "white light" is measured on the Kelvin scale (see Figure 5.1). Warm colors of light have low color temperatures; cool colors of light have high color temperatures.

FIGURE 5.1

The Kelvin scale measures color "temperature."

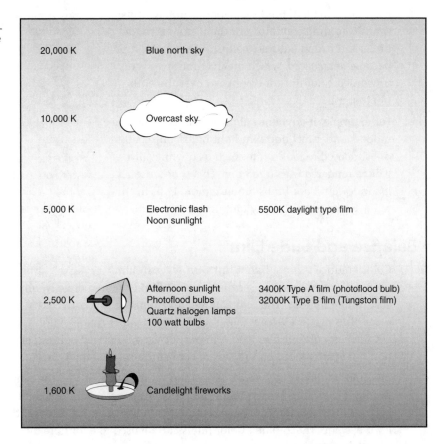

20,000 K	Blue north sky
10,000 K	Overcast sky
5,000 K	Electronic flash — 5500K daylight type film Noon sunlight
2,500 K	Afternoon sunlight — 3400K Type A film (photoflood bulb) Photoflood bulbs — 32000K Type B film (Tungston film) Quartz halogen lamps 100 watt bulbs
1,600 K	Candlelight fireworks

Different color films are manufactured for different color temperatures. Daylight film is balanced for 5,600° Kelvin (or K) light and gives accurate color with midday sunlight or electronic flash. Indoor film, called Type B or tungsten film, is balanced for 3,200°K light and gives excellent color with professional quartz-halogen lights (powerful lights up to 1,000 watts). It will give acceptable, slightly warm color with ordinary incandescent light bulbs, which are 2,500°K to 2,800°K.

Video cameras and some digital cameras have circuitry to automatically adjust the color balance to match the color of the light source. Digital cameras also provide settings that enable you to emulate the warm yellow cast of indoor lighting or the harsh green color common with fluorescent lights. These custom settings resemble different types of film such as tungsten and indoor film.

Color Balance and Film

Color film can record colors that your eye does not see when the picture is made. This is because film is manufactured to reproduce color accurately under specific lighting conditions. If the picture is made under the wrong lighting, colors in the photograph become *unbalanced*, which means that there is an unwanted color tint (or color cast) over the entire photograph.

For example, if daylight-balanced film is used indoors under incandescent light bulbs, objects that are supposed to look white, such as a white shirt, will be rendered with a red tint. This is because incandescent light bulbs produce more light in the red wavelengths than daylight does.

Color Balance and Slide Film

Color balance is more important with reversal film than with negative film. Because reversal film is viewed directly, any minor color cast will be noticed. The colors in negative films can be corrected in printing, so negative films produce acceptable results under a wider range of lighting. Even so, you get the best colors if film is shot under correctly balanced lighting or if color correction filters are placed on the lens to correct the color of the light.

The color of daylight changes depending on the weather and the time of day. Daylight color film is color balanced for average noon sunlight. An hour or two before sunset, the light becomes very red or yellow. On cloudy days, the color of daylight becomes much bluer. Color filters can be used to eliminate the bluish color if it is undesirable.

note

Fluorescent lamps do not produce a continuous color spectrum of light like an incandescent bulb. Instead, fluorescent bulbs generate spikes of light at certain wavelengths within the spectrum, especially green light. They are generally considered to be at a temperature of 4500°K.

Exposure Latitude

Color transparency film and most consumer digital cameras have little exposure latitude. Even slight overexposure or underexposure is readily visible, especially in contrasting lighting. Consumer-level digital cameras *blow out* highlights in overexposed prints (see Figure 5.2). A *blowout* is a dead giveaway the image was taken with a digital camera.

FIGURE 5.2
Digital cameras are not good at overexposure. Highlights overcome the sensor's ability to record useful information.

Some professional digital cameras capture 36 bits per pixel instead of 24, and are better able to deal with high-contrast scenes than less expensive, point-and-shoot digital cameras. Even though 24 bits per pixel means millions of color combinations are possible, 36 bits per pixel increases that capability to billions. As a result, 36-bit cameras capture what the human eye sees more accurately. This helps color balance by providing more colors that can be edited and adjusted.

Film Latitude

Accurate exposure is just as important with color reversal films as it is with digital. Reversal films also have little exposure latitude—that is, they do not tolerate over- or underexposure (see Figure 5.3). Colors in a transparency begin to look too dark with as little as one-half stop underexposure. Because there is little tolerance for overexposure, colors look pale and bleached out.

Color negative film has much more exposure latitude than reversal film. You will have a printable negative with as much as one stop underexposure or three stops of overexposure. However, the best results always come from correctly exposed film.

FIGURE 5.3

Slide films have very little latitude. The image in the middle was exposed properly; the one on the top is only one stop underexposed; the one on the bottom is only one stop overexposed.

In contrasting lighting, color reversal film and most digital cameras are not able to record the full range of brightness. In scenes with very bright highlights (such as snow or sand) and very dark shadows, the scene's brightness range (the overall contrast) is greater than the exposure range of the film or sensor.

If the shadows are correctly exposed the lightest areas will be blank white. If the light areas are well exposed, the shadows will be featureless black. You can compromise and expose for the most important part of the scene. You can also bracket (shoot additional pictures with different exposures). The best solution to greatly contrasting scenes is to use an electronic flash or a large reflector to add light to the shadow areas, thus reducing the scene's contrast (Figure 5.4).

FIGURE 5.4

Use a flash even in bright scenes to force details in the shadows. This is especially necessary for extremely bright scenes.

Low-contrast lighting has a smaller tonal range and thus allows film and digital cameras to easily capture details in both the bright and dark areas. In addition, such lighting is more forgiving of exposure errors than greatly contrasted lighting. Fill-in flash can also lighten contrasted shadows.

Even though negative film is more forgiving, remember that you will lose additional detail when you scan in an image. Scanning an overexposed or underexposed negative results in loss of detail in shadows and highlights. This situation is even worse when you scan in prints!

THE ABSOLUTE MINIMUM

Photoshop and Photoshop Elements can correct many color balance issues by setting the white point using the Image, Adjustment, Levels option. For the best images, however, you should always set the correct white balance on your digital camera, or use the correct type of film. Keep these important points in mind when you photograph with either medium:

- Daylight has a color temperature of 5600° Kelvin.

- Indoor incandescent light bulbs have a color temperature of 2850° Kelvin. Look for indoor film at this temperature if you plan to shoot under these lights.

- Fluorescent light bulbs come in many different "colors" of light. The most common fluorescent bulbs have a color temperature of 4000–4500° Kelvin. The color emitted is often called "cool white," but it actually shows up as green on daylight-balanced film.

- Filters are available that adjust indoor lighting to work with daylight-balanced film. Check out filters by such companies as Hoya (www.thkphoto.com/products/hoya/index.html) and black and white (www.schneiderkreuznach.com/).

- Slide film is much more sensitive to exposure and color "casts."

IN THIS CHAPTER

- Using a Scanner
- Making a Scan Step-by-Step
- Keeping Dust Out of the Picture
- Determining the Samples Per Inch of a Scan

6

GETTING YOUR PIX ONSCREEN

Scanning creates digital images from negatives, transparencies, or prints (see Figure 6.1). When images are scanned, their tones and colors are converted into numbers that the software can edit. A scanner captures samples of brightness and color in a regular grid pattern. The more samples the scanner takes, the more detailed the scanned image is.

Image quality depends on the quality of the scan. Just as you can't get a good darkroom print from a poor negative, you can't get a good image from a bad scan, or even a good scan from a bad negative or print. Scans made from poorly exposed or badly scratched film require extra time to edit and rarely produce acceptable results.

FIGURE 6.1

Scanners enable you to scan in negatives and prints for your digital dark-room.

The scanning process is much easier if you know beforehand how the image will be used. A proper scan is the best starting point for editing a print or negative, if you're still using film cameras. If the final result is to be realistic, the scan should produce an image as close to realism as possible. If the final result is to be a colorful departure from reality, the scan should be as close to the intended colors as possible.

Before you scan an image, you also need to know how it will be presented. Will the final image be viewed on a Web site or printed in a publication? Will it be exhibited as a fine print, and if so, how large will it be? A digital image has no real physical size until you print it or show it on a monitor. Potentially, it might be printed or displayed in many sizes, but if you select the wrong settings, you might end up with a sub-par image. Your scanning decisions must be based on both the physical size you want and the characteristics of the printer or display device.

tip

Scanners capable of scanning negatives are much more valuable to aspiring photographers. Scans of negatives and slides are much better for editing.

Working with Scan Software

Scanning software is simplified image-editing software (see Figure 6.2). To get a good scan, you might need to adjust the size, brightness, contrast, and overall color balance of a negative or print before you actually scan it. Fortunately, these basic adjustments are available in good scanning software.

FIGURE 6.2

Some scanner plug-ins are just as advanced as many image-editing programs.

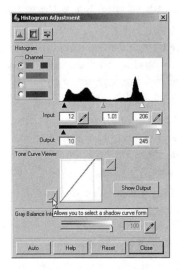

Two types of scanning software come with scanners:

- **Normal**. Like ordinary software, you open the scan software, wait for it to find the scanner, scan the image, and save the image as a file for editing.

- **Plug-in**. Many scanners include plug-in software that works in conjunction with another program. You must open your favorite image-editing software (Photoshop, Photoshop Elements, iPhoto, and so on), choose File, Import, and then select the scanner's plug-in software from a list. Once chosen, the scanner plug-in will hide the image-editing software and display its own interface and controls. When scanning is complete, the plug-in software will exit, return to your image-editing program, and display the new scan, ready for editing.

Scanning is not difficult. The best approach is to practice scanning different types of prints, different size prints, and negatives (if possible).

Making a Scan Step by Step

The following steps walk you through the scanning process. The most important thing to remember as you work through these steps is to treat lint and dust like the plague. In addition, rely on the scanning software that comes with your scanner. Perfect the image *before* you scan.

If you have a negative or print you're ready to scan, follow these steps to get the best image possible onscreen:

1. Prepare the scanner and the area around the scanner. Ideally you already have the scanner connected and working. Did you install the scanner driver, and have you successfully calibrated the scanner (using its built-in calibration software)?

2. Prepare the area by removing anything that can attract dust. If you're working with a flatbed scanner, make sure the glass plate is clean. Keep the top closed and prepare a cloth made for cleaning optical glass surfaces (you can pick one up at a camera store).

3. Dust the film or artwork. Wear antistatic gloves, and use an antistatic brush or compressed air to clean film. Scanners are very sensitive and will capture dust spots on the film as part of the image. You'll pull your hair out later "cloning" out dust and scratches—so clean beforehand.

4. Load the film or print according to the directions. Be sure to orient film so that the emulsion side is facing the correct direction. The scanner instructions should make this very clear. If not, check out the Internet support site for your scanner.

5. On the computer, open the scanner software. If you have plug-in software for Photoshop or Photoshop Elements, open the image-editing software and launch the scanner software from the File, Acquire (or File, Import) menu.

6. Preview the scan. A preview scan is a quick, low-resolution scan that shows you the image in miniature (see Figure 6.3). It lets you plan corrections to brightness, contrast, color balance, and cropping.

7. Crop the image if necessary by dragging the outlines (edges) of the scanned area until only the part of the image you want to record is within the rectangle (see Figure 6.4).

note

For information on bit depth and color space, see Chapter 12, "The Importance of Resolution."

FIGURE 6.3

Canon's
CanoScan print
driver software.

FIGURE 6.4

A preview scan
enables you to
crop an image
before scan-
ning. This saves
considerable
time with high-
resolution
scans.

8. In the scanner software, set the color space: Grayscale, RGB, or CMYK, the bit depth (if necessary), and the sampling rate. Set Sampling Rate to 72 or 96 for the Web, and 150–300 for prints. For film scans, indicate whether the image is a negative or positive (consult the scanner instructions).

9. Click Scan, then wait a few seconds. The wait depends on how many samples you chose. Higher sampling rates, such as 300–1200 samples per inch (ppi), take much longer than 72 samples per inch.

More advanced scanner software enables you to correct the preview image for brightness, contrast, and color balance. There could be several ways to make these adjustments:

- Slider bars for basic adjustments to brightness, contrast, and color.
- Histogram controls for precise adjustments to brightness, contrast, and color.
- Curve controls for complex adjustments to brightness, contrast, and color.

Most scanner software will show changes in the Preview window immediately.

Determining the Samples per Inch of a Scan

Unless you have a powerful computer, unlimited RAM, and unlimited disk storage for your files, you'll need to limit the size of your scans. The scans shouldn't have more resolution (number of pixels) than you need for the task at hand. The following steps show you how to produce scans that have just enough resolution.

1. Determine the size (in inches) of the largest print you intend to make from the image. For example, perhaps you intend to make a print measuring 10×15 inches.

2. Determine the cropped size (in inches) of the film or print to be scanned. For example, if you are scanning a 35mm negative with no cropping, the size of the scanned image is 1×1.5 inches. Some scanner software shows the dimensions of the scan. With other scanners, you'll need to measure the original print or film.

Table 6.1 shows some typical magnifications from uncropped 35mm film.

Table 6.1 Typical Magnifications from Uncropped 35mm Film

Final Output for Scanned Negative	Approximate Dimensions	Magnification Required
An image in a print	12 inches + 8 inches	8×
An image on a monitor	6 inches + 4 inches	4×
A poster size image	48 inches + 32 inches	32×

3. Calculate the magnification (enlargement) by dividing the size of the final print by the size of the scanned artwork. In this example, the 10×15 print matches the shape of a 1×1.5-inch 35mm color slide. Fifteen inches divided by 1.5 inches equals a magnification of 10.

4. This example "scales" properly: a 1×1.5-inch print easily scales to 10×15 inches. But what if the output doesn't match the aspect ratio of the negative or print? You will need to crop either the input or the output. For example, if the image to be scanned is 3×3, you could crop the dimensions of the scan to 2×3. This will crop some of the image, but later it will print properly.

Table 6.2 shows some typical requirements for scanner samples per inch.

Table 6.2 Typical Requirements for Scanner Samples Per Inch

Final Output	Final Output Pixels Per Inch	Scanner Sample Rate Required
An image in a print	8 magnifications × 250 pixels per inch	2,000 samples per inch
An image on a monitor	4 magnifications × 95 pixels per inch	384 samples per inch
A poster size image	48 magnifications × 50 pixels per inch	1280 samples per inch
Offset (magazine) printing at 120 screen lines per inch	8 magnifications × 300 pixels per inch	2400 samples per inch

5. If the image scales naturally or after cropping, determine what the output requires in ppi (pixels per inch). A photo printer can handle from 150–300 ppi. Most Web sites assume images are 72 ppi or 96 ppi. Assuming your goal is a print from a photo printer, 200 ppi is adequate.

6. Finally, multiply the magnification factor by the number of pixels per inch. For example, a magnification of 10 for a print with 200 pixels per inch requires a scan of 2,000 samples per inch. Set the scanner to 2000 samples per inch. Most scanners use the term *dpi* (dots per inch) instead of samples per inch. If your scanner does not allow custom settings such as 2000, set the scanner to the highest number around this amount, such as 2400 dpi.

The following sections explain further preparation for scanning for a specific type of output.

Scanning for Internet Output

If the image is for the Internet (or any multimedia presentation), it must look as sharp as possible. Computer monitors only display between 70 and 100 pixels per inch, so even a small amount of unintentional blurring is easily noticed and results in an unprofessional-looking image.

If you know the exact image resolution desired for your onscreen image (for example, 600 pixels wide × 400 pixels high), simply set the scanner software to scan exactly that many pixels from the film or print.

Scanning for Inkjet and Dye-Sublimation Output

For inkjet and dye-sublimation printers, a print looks reasonably sharp if it has 200 pixels per inch as a rule of thumb. Prints with more than 300 pixels per inch are rarely useful; most people can't see such fine detail. Between 200 and 270 pixels per inch on the print is a good target number for prints that must look sharp.

How sharp does an image need to be? It depends on how it will be viewed. If an image is smaller than 8×12 inches, it needs to look sharp, because people will view it up close. You'll not only need a scan that has enough samples per inch, but the film or print you are scanning must be very sharp to begin with—otherwise the final print will be unsharp, no matter how many samples per inch.

Some images don't need to be sharp. Poster-sized images can have fewer pixels per inch (25 to 100) because they are viewed from a distance (see Figure 6.5). The largest images seen daily—outdoor billboards—may be printed with only two pixels per inch. Images that are unsharp for deliberate aesthetic reasons do not need high-resolution scanning, but the pixels in the print must be small enough to avoid creating a jagged look.

FIGURE 6.5

As you scale up an image, the resolution (in pixels per inch) can go down. This 13×19 inch image was printed at 150 ppi.

Scanning for Laser and Offset Printing

If your goal is to print on a halftone device, such as a laser printer or an offset printing press, you will need to determine pixels per inch in a different way. For a laser printer, use 2× the manufacturer's published "screen lines per inch." To find this number, you will need to read the printer manual or find out from lab personnel. It is likely to be between 90 and 133, so your printed image will need between 180 and 266 pixels per inch.

If your image will be printed on coated paper (magazine-type paper) by an offset printer, use 2× the press's stated screen lines per inch (see Figure 6.6). Ask the printer or service bureau how many screen lines per inch they will print. It is likely to be 120 to 144 lines per inch, so your printed image will need 300 or 333 pixels per inch. Uncoated paper is printed with fewer screen lines per inch, usually 70–100.

FIGURE 6.6
Laser printers output images similar to an offset press. On the left, an enlargement from a magazine; on the right, an enlargement from a color laser printer.

Alternatives to Scanning

The Kodak Photo CD and Kodak Picture CD are good alternatives to scanning. Kodak will digitize your negatives and transparencies, put them on a CD, and return the CD to you for a reasonable fee. With Kodak plug-in software, you can open these images directly from the CD. A number of higher-end developers also create their own CDs for you with a faster turnaround time.

Another alternative is to use *service bureaus*, shops where professional photographers, advertising agencies, and artists have film developed, images scanned, and other high-end work. Service bureaus will scan 35mm film and store the images on a CD-ROM-type disc. Some companies that offer film developing and prints by mail also offer scans on CD-ROM. The images are not as high-resolution as Kodak Photo CDs, but might be satisfactory for small prints or for Internet use. You can find these mail-order service bureaus in the back of most photography magazines.

THE ABSOLUTE MINIMUM

Scanners enable traditional film photographers to become digital photographers. If you are a film photographer and would like to edit your images onscreen, keep these tips in mind:

- Scanners range in price from $40–$40,000. Research and then buy the best scanner you can afford. The difference in quality is significant.

- If you are serious about digital photography and will continue to use film, invest in a good negative scanner or flatbed scanner that can scan negatives.

- Dust is a serious pain when scanning. Keep your scanner clean and invest in gloves, an antistatic brush, and a can of compressed air.

- Scans of slides include the most tonal information, followed by negatives, and then prints.

- 48-bit depth scans are much larger in size than 24-bit scans, but they contain much more color and tonal information.

- It is always better to scan at the correct resolution than to resize the image afterward. Determine the output size before you scan.

- If you want to make copies of a print, scan at 300 samples per inch, then print at 300 ppi on your printer. This ensures that the print stays the same size.

IN THIS CHAPTER

- Photoshop Elements and Photoshop: File Format Compatibility

- JPEG File Format

- How JPEG Works

- The Replacement for JPEG: JPEG2000

- TIFF File Format

- Photoshop File Format

7

FILES AND FILE FORMATS

Most modern image editing software on the Mac and PC save images in a number of different formats. Photoshop and Photoshop Elements for either platform enable you to save images in 14 formats! Table 7.1 defines the purpose of each of these formats and when they should be used.

Table 7.1 File Formats Available in Photoshop and Photoshop Elements

File Format	Purpose
Photoshop	Photoshop and Photoshop Elements native format. This format enables you to retain the channels, layers, paths, and other settings you used editing an image. In Windows, this format uses the .psd extension.
CompuServe GIF	Graphics Interchange Format created by CompuServe (now AOL). GIF became a Web standard because of its lossless compression and capability to save images in specific 256-color palettes. Licensing and royalty issues with the GIF compression format (LZW) have forced some Web developers to choose the PNG format instead. In Windows, this format uses the .gif extension.
JPEG	Joint Photographic Experts Group format. By far the most popular format for images because of its continuous tone and compression capabilities. JPEG provides variable compression capabilities. In Windows, this format uses the .jpg extension.
Photoshop PDF	Portable Document Format. Saves images that Adobe Acrobat reader can open and display. This Photoshop format is mainly used for documents or drawings that need to be portable among page-layout applications, such as FrameMaker, QuarkXPress, and Adobe InDesign. Photoshop PDF format can include vector data, such as text and specific fonts. In Windows, this format uses the .pdf extension.
Pixar	A 3D format used with 3D Pixar workstations. Photoshop is capable of opening and saving images that will be used for 3D shapes and 3D animation. This format was created by Pixar Studios, the producers of *Toy Story* and *Finding Nemo*. In Windows, this format uses the .pxr extension.
RAW	A raw image format that includes no information about the image data. You must know the image information beforehand. This format is designed for scientific applications that do not yet have a standard. A warning: Images saved in this format might not be recoverable because you must know the correct settings before saving. In Windows, this format uses the .raw extension.
TARGA	A flexible image format that supports images of any dimensions with between 1 and 32 bits of color. This format was originally created to allow text to be laid over video. When saving an RGB image in this format, you can choose a pixel depth of 16, 24, or 32 bits per pixel. This format is more powerful and flexible than the TIFF format, but isn't used as often. In Windows, this format uses the .tga extension.

File Format	Purpose
BMP	Windows Bitmap format that originated with Windows Paint. This 24-bit format is still used as wallpaper within Windows. Images can be saved in Windows or OS/2 format, an older operating system format from IBM. In Windows, this format uses the `.bmp` extension.
Photoshop EPS	The Encapsulated PostScript (EPS) format is used to share images with page-layout software such as FrameMaker, QuarkXPress, and Adobe InDesign. EPS format can include "clipping paths," which are often used in page layout software to flow text around an image. EPS format images must be printed on PostScript-capable printers. In Windows, this format uses the `.eps` extension.
PCX	An older format created for the DOS program PC Paintbrush. Clip art is still found in this format, but the format is not current with today's printers and software and should not be used. In Windows, this format uses the `.pcx` extension.
PICT	An Apple Mac OS image format that bridges compatibility between graphics and page-layout applications. Enables color RGB images to be saved in 16-bit or 32-bit format. This format is not supported very well in Windows. In Windows, this format uses the `.pct` extension.
PNG	A royalty-free alternative to the GIF format that is lossless, supports 24 bits (instead of GIF's 256-color palette), and antialiased background transparency. PNG supports RGB, indexed color, and grayscale images. In Windows, this format uses the `.png` extension.
Scitex CT	Scitex Continuous Tone (CT) format is used by high-end Scitex (Kodak Versamark) color printers. In Windows, this format uses the `.sct` extension.
TIFF	The Tagged-Image File Format is a common format for photographers, and is common among many applications. This lossless format can be compressed using LZW or ZIP compression, and retains channels and layers in CMYK, RGB, and grayscale format (LAB mode loses channels). Most scanners generate TIFF images. In Windows, this format uses the `.tif` extension.

Photoshop for the Mac and PC also includes these formats:

- **Photoshop DCS 1.0.** Desktop Color Separations format created by QuarkXPress for separations. This format is commonly used when work must be imported into QuarkXPress, Adobe InDesign, PageMaker, and FrameMaker. In Windows, this format uses the `.eps` extension.

- **Photoshop DCS 2.0.** An updated Desktop Color Separation format that enables CMYK images to contain a single alpha channel and multiple spot-color channels. In Windows, this format uses the `.eps` extension.

RAW FORMAT AND DIGITAL CAMERAS

The RAW format available in Photoshop and Photoshop Elements is similar to the RAW format you will see advertised with digital cameras, but you must import (using File, Import) raw camera images with a special plug-in available from Adobe. This plug-in is available with Photoshop 7 and Photoshop CS, but does not work in Photoshop Elements. (Elements only supports RGB-based plug-ins.) Most high-end digital cameras that support the RAW format include their own import software that enables you to modify the raw image, output it as a TIFF file, then open it in Photoshop.

The raw file output available in high-end digital cameras is preferred by photographers because brightness values for each pixel are imported with no modification into the plug-in (or the camera software).

Photoshop Elements and Photoshop: File Format Compatibility

Photoshop Elements includes the same file formats as Photoshop, except for DCS 1 and DCS 2. The JPEG formats in these two programs are identical--An image saved in one program can be opened in the other. The Photoshop PSD and TIFF formats differ, however.

Photoshop Elements has no Channels or Paths palette and cannot create annotations or layer sets. No matter what format you save an image as in Photoshop, Elements will not display channels or paths. Annotations appear and can be moved and closed, but not edited. Aside from these differences, the following list explains compatibility regarding the PSD and TIFF file formats:

- **Layers**. Interchangeable between programs. Save an image with layers in PSD or TIFF format in either program; the other program will provide access.

- **Adjustment layers**. Partial compatibility in PSD and TIFF formats. Photoshop Elements displays adjustment layers created in Photoshop, but they are locked. You can turn them off, move them, and paint on the layer's mask, but you cannot double-click on the layer to edit it. Adjustment layers created in Elements can be edited in Photoshop however.

- **Layer sets.** Partial compatibility in PSD and TIFF formats. A layer set created in Photoshop is locked in Elements. You can turn it off, but you cannot modify it.

- **Text and text layers**. Interchangeable. Text is fully editable between Elements and Photoshop for TIFF and PSD images. Text can be created and manipulated in either program. In addition, if text falls within a layer set, you will not be able to access the text layer, but you can edit the text! Advanced text options are not available in Elements of course, but every other text-related feature is available.

- **Channels and saved selections.** Elements does not have a Channels palette, but selections saved in Photoshop in TIFF and PSD are accessible by clicking Select, Load Selection in Elements (see Figure 7.1). You can create a selection in Elements, save the image as a TIFF or PSD, and open it in Photoshop, as well.

- **Paths**. No compatibility. Elements has no Paths palette. An image created with paths in Photoshop and saved as a TIFF or PSD file will open in Elements, but there is no way to access paths. A workaround is to create a selection from the path, save it as a selection in Photoshop, and then send the file to Elements.

FIGURE 7.1

A channel created in Photoshop (left) and accessible in Elements (right).

©2004 Nicholas E. Papadakis

The majority of Photoshop features are compatible with Photoshop Elements as long as you use the PSD format (.psd). JPEG and TIFF features aren't as big an issue between the two programs. The following sections explain the science behind each popular format--JPEG, TIFF, and Photoshop--and explore when one format should be used rather than another.

JPEG File Format

JPEG (Joint Photographic Experts Group) is the favored format for compressing color photographs and other multicolor images, and has become a standard format on the Internet. JPEG can compress images to as little as two to five percent of their original file size, but as the degree of compression increases, there is a corresponding loss of image quality.

JPEG is called a *lossy* compression process because visual information is lost (discarded) in the compression process. The compression algorithm extracts essential information from an image and discards unnecessary information (see Figure 7.2). Because of the lost information, highly compressed images show visible distortions, called *compression artifacts*.

FIGURE 7.2

JPEGs saved with 12 quality (670KB) and 0 quality (39KB) in Photoshop. The original TIFF file was 1.3MB.

Images that include large areas of single colors or slight gradients, such as the sky, display these image artifacts prominently (see Figure 7.3).

JPEG compression is primarily designed for photographs. The reason is that JPEG sacrifices colors for brightness. The human eye is very sensitive to brightness changes, but not color changes. For this reason, the JPEG compression algorithm can remove or average color information in an image without affecting brightness information.

The JPEG format has specific advantages among file formats:

FIGURE 7.3

High compression in JPEG files creates visible banding and image artifacts in areas with no tonal variation.

- **Excellent image fidelity.** The JPEG format was designed to be fast and provide high fidelity in compressed images. This format was also designed to be adjustable so that users could "dial in" the desired level of compression.

- **Platform independent**. The format is simple enough to be included among many different operating systems and software programs.

- **Flexible.** Almost any continuous-tone still image can be compressed in JPEG regardless of color, color space, or size. JPEG also supports grayscale. JPEG also is not limited by a specific range of colors, such as GIF, with its 256-color palette.

- **Compression or no compression**. JPEG provides several compression methods, including a user-defined, scalable compression method.

- **Sequential or progressive load**. Aside from traditional sequential opening, images can be saved in Progressive mode. This popular format for the Web loads the image in a series of steps, with each step adding detail.

> **caution**
>
> Do not use the JPEG format for computer-generated images, such as those used for 3D computer graphics. The compression algorithm will introduce artifacts and noise in the image. JPEG should only be used for true continuous tone images.

The JPEG image compression scheme includes two compression methods: lossy and lossless. The lossy method uses a method called DCT (Discrete Cosine Transform) to compress specific size blocks of an image (explained later). The lossless portion of JPEG uses a predictive method for lossless compression, but is rarely implemented.

The lossy portion of JPEG includes several compression methods:

- **Baseline sequential**. The standard JPEG compression method and the fastest. This method is supported by all applications, but the optimized method is recommended for your images.

- **Baseline optimized.** This encoding uses an improved compression algorithm that results in better compression with the same quality as baseline sequential. File sizes should be around five percent smaller.

The following section explains how the JPEG compression algorithm works. You will quickly learn some new terms, such as luminance, chrominance, and YUV color.

How JPEG Works

An RGB image is comprised of three channels. The JPEG compression algorithm performs the following steps on the image to reduce file size without affecting quality:

1. Converts the RGB image to $Y'C_BC_R$, a different color space that defines each pixel based on brightness (Y) and chrominance (C_BC_R). This color space is also known as the *YUV color space* and was created for video processing. The Y' value represents the brightness of the pixel, C_B represents one component of the chrominance (blue), and C_R represents another component of chrominance (red). The C_BC_R values represent the hue or color information in the file.

2. Immediately reduces the file size by up to 50 percent by sampling the entire image and cutting the chrominance information in half. The luminance component is left alone. (Remember—our eyes are sensitive to changes in brightness.) The chroma information will be reduced 2:1 horizontally, and either 2:1 or 1:1 (no change) vertically (see Figure 7.4). This process is called *4:2:2 sampling*, and is a standard in the television industry. This step reduces the data volume by one-half or more. It seems lossy, but actually it has little or no visual impact.

3. Scans the image starting at the top left and creates blocks of pixels (see Figure 7.5) 8×8 pixels in size (64 pixels total).

4. Converts brightness values in each block from 0–255 to -128 to +127. Processes each block through the DCT (Discrete Cosine Transform) function to create a frequency map of values.

FIGURE 7.4

During JPEG compression chroma (color) information is sampled intermittently. Luminance (brightness) sampling occurs at regular intervals.

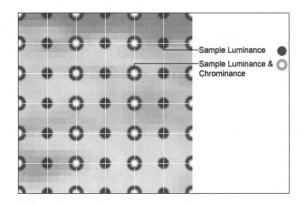

Sample Luminance ●
Sample Luminance & ○
Chrominance

FIGURE 7.5

Blocks of pixels 8×8 are created during JPEG compression.

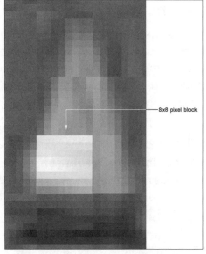

8x8 pixel block

5. In each block, divides each of the 64 frequency components by a separate quantization coefficient and rounds the results to integers. This is when information is lost. The larger the quantization coefficients, the more data is discarded. Even the minimum possible quantization coefficient, –1, loses some information because the DCT function does not normally output integers. The higher frequencies in the block are quantized less accurately (given larger coefficients) than lower, because they are less visible to the eye. The precious luminance data is

note

Downsampling is not applicable to grayscale data. As a result, color images are more compressible than grayscale images.

quantized more accurately than the chroma data by using separate 64-element quantization tables. These tables were provided by the Joint Photographic Experts Group and provide a scaling multiplier that the user (you!) can adjust—the Quality slider bar in Photoshop.

6. Encodes the reduced coefficients using the Huffman method, which is a lossless mathematical model for compression.

7. Outputs the file with the appropriate header information, including the compression information.

When the JPEG file is opened, it is decompressed based on the header information of the file.

The Replacement for JPEG: JPEG2000

New developments in the JPEG file format--specifically the JPEG2000 format--promise improved quality and greater compression. This format has been approved by the JPEG group, but is not supported yet by many applications. Photoshop CS includes a JPEG2000 plug-in and many high-end digital cameras support this format, but you need to install a plug-in for most browsers. The company Lura produces these plug-ins, which can be found at www.luratech.com.

Key advantages of JPEG2000 over JPEG include the following:

- **Scalable by resolution, color channel, or quality**. By organizing the codestream in different ways, the compression can generate multiple levels of compression.

- **38-bit depth.** Up to 38-bit depth is available in addition to the standard 24-bit depth. This standard also allows for big images (up to 2^{32} rows and columns), 16,384 components, and different bit depths for each channel.

- **Wavelet-based compression.** JPEG2000 uses the CWT (Cosine Wavelet Transform) algorithm to compress images. Unlike the existing JPEG format, the wavelet algorithm does not divide image into blocks. Instead, it analyzes the entire image by treating it as three separate continuous waves (R, G, B), centered along a zero axis. JPEG2000 images can be compressed more tightly, preserve detail, and avoid the blockiness common in highly compressed JPEG images.

 An unusual benefit to wavelet compression is decomposition. *Decomposition* creates a number of less detailed or smaller images. When you open this file, the image is reconstructed and grows in pixel size and detail.

- **Lossless encoding.** Lossless encoding is available in this format. The JPEG format allowed for it as well, but few developers integrated it into their JPEG format.

- **Area-specific encoding**. You can select which regions should receive a higher-quality compression. The process is taken care of during compression; no requirements are placed on the decoder.

- **Error resilience.** JPEG2000 uses a packet-type codestream, resync markers, table of content markers, and start-of-packet and end-of-packet markers that add more error resilience.

The JPEG2000 format hasn't really taken off yet, and many wonder whether it will. As of this writing, Internet Explorer, Mozilla, Opera, and Apple's Safari browser do not include the capability to open JPEG2000 images (QuickTime does, however). ActiveX plug-ins are available for both Internet Explorer and Mozilla that enable you to view these files.

When the browser manufacturers finally put this standard in their browsers, the outlook for JPEG2000 may improve. However, this was predicted for the Portable Network Graphics (PNG) format, and it still hasn't caught the attention of most professional Web developers.

TIFF File Format

TIFF (Tagged Image File Format) comes closest to a universal file format for photographers--most imaging software can read it. TIFF stores images in a variety of bit depths in both RGB and CMYK. It includes lossless compression, and is designed into most imaging hardware, such as digital cameras and scanners.

The TIFF format supports the Grayscale, Indexed Color, RGB, YcbCr, CMYK, and CIELab (LAB) color spaces.

One minor drawback to TIFF is that it cannot store vector graphics, such as Photoshop text or paths. Also, there is no progressive load option, as with GIF and JPEG images.

When you click File, Save As and choose the TIFF format, the somewhat intimidating TIFF Options dialog box appears. Read through these options to overcome any fears:

- **Image Compression: None**. Save the file with no compression. TIFF files have a four-gigabyte file size limit. Ideally none of your images will be that large!

> **note**
>
> Photoshop TIFF files can store annotations. Photoshop Elements can open and display these annotations, but they cannot be edited (see Figure 7.6). Other software programs, including older versions of Photoshop, do not display these annotations, however.

FIGURE 7.6
Annotations are viewable but not editable in Elements.

Hockey Game -- Penguins vs. Red Wings December 2000

clem clements

- **Image Compression: LZW**. Save the file with Lemple-Zif-Welch compression. LZW is a lossless compression format that is best for large areas of a single color, such as a sky, wall, or a screenshot. File sizes can be reduced by up to two-thirds with no loss of data.

- **Image Compression: ZIP**. A lossless compression format similar to LZW. This format is best used for images with large areas of a single color.

- **Image Compression: JPEG**. JPEG (Joint Photographic Experts Group) compression that uses the same DCT function as the JPEG standard. Use the slider bar to control the amount of compression (see Figure 7.7). Note that most programs other than Photoshop and Photoshop Elements will not be able to open TIFF files saved with this compression technique.

caution

If you are going to give a friend, customer, or service bureau a TIFF file, ask about compression options before you save it. To ensure compatibility with others, never use compression on TIFF files.

FIGURE 7.7

JPEG compression in the TIFF Options dialog box can lead to the same pixilated mess if you choose too much compression.

- **Byte Order: IBM PC**. Determines how the TIFF file is saved. This setting and the Macintosh setting are no longer an issue unless you are working with older software. Most new image-editing software can accommodate both file formats. For example, you can save an image as a TIFF file in iPhoto and open it in Photoshop Elements on a PC with no problems. Older versions of Photoshop would ask for the correct byte order before opening.

- **Byte Order: Macintosh**. Determines how the TIFF file is saved. This setting isn't necessary any longer; most modern image-editing software can accommodate TIFF files saved in Macintosh or PC format. Leave the setting as PC for images.

- **Save Image Pyramid**. Creates or preserves multiresolution versions of the file. This option is designed for page-layout software such as FrameMaker, InDesign, and QuarkXPress. Page layout designers often want to place a low-resolution version of an image so that page updates do not slow to a crawl every time you change layout or text. Photoshop, Photoshop Elements, and most image-editing software always open the largest version of a TIFF file saved with an image pyramid.

- **Save Transparency**. Preserves transparency as an additional alpha channel when the file is opened in another application. (Transparency is always preserved when the file is reopened in Photoshop Elements or ImageReady.)

Photoshop and Photoshop Elements 2 included new Layer capabilities in TIFF files. If your image contains layers, the following options will be available in the TIFF Options dialog box:

- **Layer Compression: RLE**. Run-Length Encoding. A lossless compression method. This format, like ZIP compression, is most effective on large areas of a single color.

- **Layer Compression: ZIP**. A lossless compression format similar to LZW. Use this compression format for layers that contain large areas of a single color.

- **Discard Layers and Save a Copy**. Flattens the layers in the image and then saves the file as one layer. Annotations remain separate, however.

Photoshop and Elements are capable of opening layer-embedded TIFF files, but other programs might not. In addition, older versions of Photoshop prior to Version 7 cannot open multilayered TIFF files.

RUN-LENGTH ENCODING EXPLAINED

Run Length Encoding (RLE) is a simple compression format that searches for strings of data (called a run) and encodes the string in two bytes. The first byte (the run count) represents the number of characters in the run. An encoded run can contain from 1 to 128 or 256 characters. The amount is usually the number minus 1 (0–127 or 255). The second byte (the run value) is the value of the character in the run, which is in the range of 0 to 255.

For example, assume a string of 20 Xs appears in a document. This would normally require 20 bytes to store:

XXXXXXXXXXXXXXXXXXXX

After run-length encoding the file, the string would be represented by two bytes:

20X

The first byte is 20, which represents the number of Xs it found in the file. The second byte represents the actual character that appeared in the run.

One confusing setting in the TIFF Options dialog box is Byte Order. In the 1990s, the Mac and Windows platforms were compatible in disk formats, but software still had to know how and on which platform TIFF files were saved. TIFF files saved on the Mac used the Mac byte order (obviously). If you opened a TIFF file saved on the Mac or PC, you had to tell Photoshop where or how the file was saved (IBM PC or Mac).

Newer versions of Photoshop (since version 6) and most other programs no longer require this hand-holding.

One interesting feature of TIFF is its capability to save files in any bits-per-pixel depth. If your scanner supports 48-bit depth, you can scan at this bit depth and then save the resulting (huge) file as a TIFF file that is completely portable.

Photoshop File Format

The Photoshop PSD format is the native file format for Adobe Photoshop and Photoshop Elements. This format is also available in most high-end Adobe products as an export option. The PSD format can store layers, layer sets, paths, channels, masks, and annotations seamlessly. This often results in large files, but provides the tools you need during a large, complicated project.

File size for the PSD format has always been an issue; PSD files are large.

File sizes for the Photoshop format are similar to TIFF files with LZW compression. Table 7.2 compares the file sizes of a single image saved in a variety of TIFF and PSD formats.

Table 7.2 File-Size Reduction Using Compression File Formats

Photoshop format (48-bit depth)	45.6MB
Photoshop format (24-bit depth)	22.8MB
TIFF with no compression (48-bit)	70.1MB
TIFF with LZW compression (48-bit)	55.1MB
TIFF with no compression (24-bit)	22.8MB
TIFF with LZW compression (24-bit)	17.9MB
TIFF with ZIP compression (24-bit)	15.2MB
TIFF with JPEG compression (quality: 0)	565KB
TIFF with JPEG compression (quality: 6)	1.4MB
TIFF with JPEG compression (quality: 12)	11.6MB

As you can see, the Photoshop format isn't that much better than TIFF with LZW compression. Nevertheless, when you're halfway through a major project and need to keep layers, channels, paths, and masks in perfect registration, the PSD format is the only choice.

THE ABSOLUTE MINIMUM

Most image editors provide numerous choices when saving files. The most popular file formats are GIF, JPEG, and TIFF. The TIFF format is the photographer's format; use it to save and transport files between applications. Here are some other tips related to file formats:

- Photoshop Elements can open files created in Photoshop and vice versa.
- Web browsers can only open and display GIF, JPEG, and PNG files, and nothing else.
- The GIF file format is used for the Web almost exclusively because it has a limited color palette of 256 colors.
- JPEG compresses images using a "lossy" compression technique. Each time the file is saved, data disappears.
- Open and then save the best images taken with your digital camera as TIFF files after importing them from your camera.
- If you are doing substantial work on an image and use a Photoshop product, save it in the Photoshop format. You can later convert it to TIFF format if necessary.
- JPEG2000 is a superior file format that hasn't yet taken off.

In this Chapter

- File Recovery: Finding "Lost" Images
- Using PC Inspector File Recovery
- Recovering Lost Images from Flash Media
- Partially Corrupt Files
- Filesystems at Work: The File Allocation Table (FAT)
- What Happens to Lost Data
- Preventative Maintenance: Defragmenting Flash Media
- Formatting Flash Media
- Another Disaster Point: USB

8

File Recovery: Finding "Lost" Images

If you haven't run out of batteries during your trip to Belize, then you've probably dropped, frozen, dunked, or deleted the media that goes in your camera. Usually this happens after the best photos are taken, but a few hours before they were backed up on your laptop. The result: lost images! Don't panic yet—you can still save these "lost" files.

Today's digital photographers face potential disaster that could result in lost images or corrupt flash media cards:

- **Nature's elements**. Including dirt, wind, dust, or oily potato chips.

- **Electrostatic energy**. Nothing like static to ruin a perfectly formatted disk.

- **Fahrenheit/Celsius**. Flash media is designed to operate between 5°C and 55°C. Industrial flash media is designed to operate between –40°C and 85°C.

- **H₂O**. Water is a hazard to media. Liquids in general, including Jolt Cola and every other sugary-sweet soda, are even worse.

- **Extraction**. Pulling out the media from the camera while it's writing to disk, or pulling out media from the USB flash reader while it's writing.

- **Read failure**. Media readers that are incompatible with the operating system or the drivers on the operating system.

- **Old age**. Even though flash media are solid-state, the contact surfaces do wear off. In addition, they become covered in fingerprint oil. This won't kill a card, however.

If you've been fortunate to this point and haven't had any media failures, you might be in the minority. The author had his Smartmedia give up the ghost with 120 images, thanks to a USB card reader with a firmware issue. Ninety images were recovered successfully—the rest went down with the Titanic.

Physical damage to a flash media card, such as that from water, soda, or exposure, is difficult or impossible to recover from; however, formatting or deletion errors, electrostatics, or a corrupt (or virus-riddled) computer can be reversed. Software is available for every operating system to help you recover from these seemingly irreversible errors.

Recovering files from flash media does not require any technical skills thanks to today's easy-to-use software. You will need to know a little about file structure and the way files are stored on a disk drive; aside from that, you are steps away from recovering lost files.

This chapter focuses on using a file recovery tool for Windows. Mac users should investigate Image Rescue from Lexar Media, PhotoRescue by DataRescue, or Recovery PRO by CompuApps.

The most powerful software programs for digital photographers aside from Photoshop are, surprisingly, freeware applications: PC Inspector's File Recovery and the more advanced WinHex. This chapter shows you how to use the File Recovery application to restore files. WinHex is very powerful, but also confusing for those who do not understand hexadecimal and binary storage.

If you're desperate and need to recover files now, the next section will help. If you aren't exactly in panic mode, you might want to skip to the end of the chapter to learn first how a filesystem stores files. This little tutorial will help tremendously when you later experience a disaster.

Using PC Inspector File Recovery

PC Inspector File Recovery is a must-have application for Windows PC users. This program is freeware and is available from a German company called CONVAR Deutschland GmbH. You can find it here:

www.pcinspector.de/file_recovery/uk/welcome.htm

Download and install this software (see Figure 8.1). PC Inspector File Recovery enables you to do the following:

- Reconstruct damaged files.
- Restore drives corrupted by a power outage or other abnormal system event.
- Recover from some computer viruses.
- Undelete files that were mistakenly deleted.
- Find forgotten or lost files after a disk is formatted.

If the flash media for your camera was physically damaged, PC Inspector File Recovery will not be able to recover data from it. This software is only capable of recovering from bad file operations, not physical damage.

FIGURE 8.1

The PC Inspector File Recovery user interface.

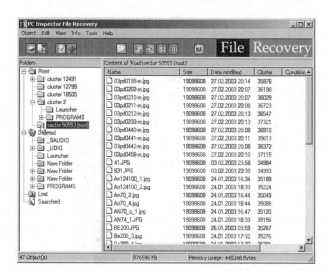

Recovering Lost Images from Flash Media

PC Inspector File Recovery provides a number of settings for accessing files on damaged drives. The following steps will scan flash media and display files on the media that can be recovered.

1. If you have a flash card reader, connect it to your computer and insert the damaged flash media card. Windows should at the very least recognize the flash card reader. Windows should also "see" the damaged card, but it might not know what to do with it. If you do not have a flash card reader, you might also be able to connect your camera to your PC. If Windows recognizes your camera as another drive, you may proceed.

note

If the settings suggested here do not work, experiment. The software cannot corrupt the damaged media any further.

2. Open the PC Inspector File Recovery software. You will first see an introductory screen that explains what the software does. Click Close to move past this intro window. The main screen will appear with nothing in it.

3. Click the Open Drive icon or choose Object, Drive. The system will scan your computer, looking for all possible physical and logical drives, and then it will display the Select Drive dialog box.

4. When the Select Drive dialog box appears, make sure the Logical Drive tab is selected. Select the drive letter that represents your flash media. Make sure it is highlighted.

 Any external flash media will usually appear near the bottom of this list. The flash media drive might be listed as drive F: or G:, for example, and say 117MB if the flash media is a 128MB card. You can also select a specific directory. This will be explained later.

tip

If you formatted the card by mistake, select the Use FAT drop-down box on the Select Drive window and choose No before continuing.

5. Click on the Preview button to review the contents of this logical drive (see Figure 8.2). If the contents or file structure looks familiar (you see either a DCIM folder or .jpg images), choose the correct drive letter.

FIGURE 8.2

If you have
selected the
correct drive,
Preview should
show the files
you're trying to
recover.

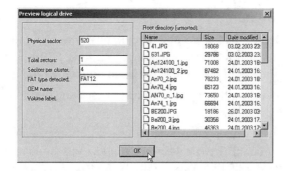

6. Click OK to close Preview and then click the OK button on the Select Drive window.

7. The Select Sector Range dialog box will appear with two slider bars. Slide the End Sector (the bottom) slider bar all the way to the right.

 These slider bars are preset to half the capacity of the flash media unless the media is small (smaller than 32MB). Sliding the bottom slider to the right will force the software to scan the entire flash media card.

8. Click OK to begin scanning the media. Be patient while the software scans the drive—this could take a few minutes.

 You're halfway through recovery. When the main File Recovery window appears, you will see a File Manager (Windows Explorer) representation of the medium (see Figure 8.3). The software was able to find the files listed in this window. In the following section, you will see how you can recover specific images or entire directories.

FIGURE 8.3

The recovered
drive shown in
a Windows
Explorer-type
window.

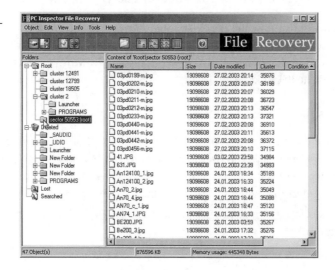

Recovering Specific Images

After PC Inspector File Recovery scans bad media, it lists the files it found in a File Recovery window. You can select a specific image and have PC Inspector File Recovery copy the image from the corrupt media to a healthy hard drive or disk.

The following steps walk you through the process of selecting and recovering files from the File Recovery window:

1. The File Recovery window should be onscreen. If it isn't, follow the steps in the preceding section. The File Recovery window will display three main folders: Root, Deleted, and Lost. Expand all the folders. You should see a DCIM directory under Root or Deleted. Continue expanding until files appear. If the drive is especially corrupt, you might see garbage filenames. These files are probably history, although something might be salvageable.

2. Select a file and right-click on it. Only select one file—do not select multiple files just yet. The right-click menu will appear. Click Save To.

 Do not select multiple files in the right window until you ensure that you can recover one file. If you select multiple files and the software can't recover one of them, the software will hang and it will be difficult to close it. A hang is often worse than a crash because your system slows down so much you can't close an application.

3. In the Select Directory dialog box, select where you want to save the file.

4. If the drive was formatted, make sure you select No Fat (Consecutive) in the drop-down list. Otherwise, it should say FAT 1. If you experience problems, try FAT 2.

5. Click OK. The file will appear in the directory.

If no files appear, it's possible the flash media drive was formatted or a logical drive wasn't detected. Return to step 3 and change settings in the Select Drive dialog box, such as Use FAT and Skip Bad Clusters. If a logical drive wasn't detected, highlight the drive and click Find Logical Drives.

Partially Corrupt Files

Images recovered from badly corrupted flash media will occasionally be partially missing. This happens when newer files have overwritten the image's data, or because the recovery software doesn't know how large the file is. The latter can be remedied. To determine whether the entire image can be restored, try the following:

1. Choose Object, Options, Files. Make sure the Find Lost Files check box is checked.

2. Change the Default file size to a number somewhat larger than the typical file size generated by your digital camera. Table 8.1 shows typical files sizes for digital cameras. Choose the megapixel size of your camera and read across to find a suggested setting for default file size.

Table 8.1 Average JPEG Default File Sizes for Digital Cameras

Image Sensor Size	Average Resolution	Approx. File Size (normal JPEG compression, not RAW or TIFF)	Enter in *Default File Size...*
1.3 megapixels	1152×864	540KB	1474560
2 megapixels	1600×1200	600KB	1474560
3.2 megapixels	2048×1536	1,100KB	2097152
4 megapixels	2272×1704	1,000KB	2097152
5 megapixels	2560×1920	1,100KB	4194304
6 megapixels	3072×2048	3.1MB	6291456
8 megapixels (Sony)	3264×2448	2.4MB	4194304

3. Repeat the steps in the preceding section to determine whether a partially restored file is recovered in total. If these steps don't work, chances are good that the file was overwritten by more recent data.

Filesystems at Work: The File Allocation Table (FAT)

A little knowledge can be a good thing, especially when it comes to file recovery. This section explains how Windows stores files.

Every disk or hard disk on a Windows PC uses a variant of the File Allocation Table (or FAT) to store files on the hard disk and flash media. A FAT-based filesystem is built as shown in Figure 8.4.

note

Please note that this table lists approximate file sizes. Each camera uses different compression schemes for JPEG files. Most cameras also enable you to save files as TIFF files and RAW files, which creates significantly larger file sizes.

FIGURE 8.4

The write process for a FAT-based system.

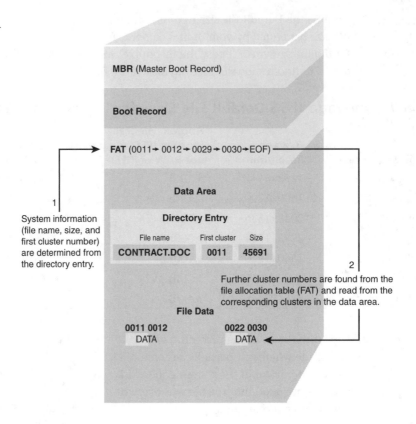

When a disk is formatted, a number of special areas of the disk are set aside for organization:

- Master boot record
- Partition table
- Boot record
- File Allocation Table (from which the FAT system takes its name)
- Root directory

At a low level, disks are organized into 512-byte groups called *sectors*. The FAT system allocates space for files using a unit called a *cluster*, made up of an integral (side-by-side) number of sectors.

A *boot record* is a sector that contains code executed by the computer. A boot record contains important information about the FAT filesystem, such as the cluster size and the positions of the file allocation table, data area, and the root directory. The *master boot record* is the first boot record that the computer executes when it accesses the hard disk.

The file allocation table, located next to the boot record, is a database that associates clusters of disk space with files. For each cluster the FAT stores an entry of 12, 16, or 32 bits. Because the first two entries are reserved for the filesystem, the third entry and those following are assigned to clusters of disk space, which catalog the entire data area.

This complex system is designed to know where files are located that are not stored successively; in other words, some files are often split into pieces and stored in separate, noncontiguous clusters in the data area. The operating system must know where a file's pieces are located in the data area. This is the task of the File Allocation Table (FAT).

For any cluster used by a file that is not the file's last cluster, the FAT entry will contain the number (that is, the location) of the next cluster used by the file. When a program asks the operating system (OS) to provide the content of a file, the OS reads the first cluster of a file. It then looks at the corresponding first cluster entry in the FAT and finds where the file continues (the file's next cluster number). Now the OS reads the associated cluster in the data area. After this cluster is read, the OS repeats the entry check until the whole file is read. This process is called "reading the FAT chain."

FAT entries may contain special values called *flags*, which indicate whether the cluster is occupied, free, or some other condition. Here are some examples of flags for a FAT16 system:

- **0000H**. The cluster contains one or more sectors that are physically damaged and should not be used.
- **FFF7H**. This cluster is the final cluster in the file.
- **FFF8-FFFFH**. End of File (EOF).

But how does the OS know what files are on the disk and where to find the first cluster of a file? This is the reason for the directory entries, which are also stored in the data area. Each directory entry has a size of 32 bytes and includes information about the file or directory name, size, first cluster number, and its attributes.

At a higher level, operating systems such as DOS and Windows allow for two types of drives: physical drives and logical drives. *Physical drives* are the actual physical disk drives installed on your computer. *Logical drives* are sections on the physical drive. A physical drive can have multiple logical drives. For example, you can install a physical drive on your machine, then partition it into three logical drives, if necessary.

Flash media rarely requires partitions or logical drives. It is basically used for one thing, so multiple logical drives aren't required. You will usually see only one drive letter listed as a drive.

What Happens to Lost Data

Deleted data from flash media cards is not really lost, but simply ignored by the operating system. If you delete a file, the first letter of a directory entry is replaced with a special character. In addition, information about the order of the clusters is removed.

If the directory entries or the FAT or both are incorrect or deleted, the operating system cannot read anything. This is the reason why end-users think data is gone. The data is still in the data area, however. Finding this data can be difficult because the entire drive must be examined.

If the file was not fragmented (that is, every cluster for the file was stored successively), this loss of sector information doesn't really matter. If the file was fragmented by frequent writing and erasing, the chances for recovery are relatively slim. Fortunately, file fragmentation on a flash media card rarely occurs unless you have been using a card for months and selectively remove images while retaining others.

> **tip**
>
> If you're up to it, defragment your flash media. Read the section "Preventative Maintenance: Defragmenting Flash Media" in this chapter for tips.

If missing files are visible under the Deleted folder in PC Inspector File Recovery, you can try to recover them, but you might be out of luck. File Recovery will assume the files are not fragmented and try to recover them based on the maximum file size set in Object, Options, Files. The end result is the recovery file might contain a lot of garbage, especially if the drive was fragmented (the file's information was spread all over the disk).

Data is completely lost whenever content is damaged or overwritten. In this situation, the file was not lost because of incorrect information in the FAT or the directory entries, but rather from one of the following causes:

- The flash media is physically damaged.
- Viruses or something else have destroyed the data.
- Files have overwritten the disk.

If files are to blame, only a portion of the image is recoverable. Believe it or not, half an image can be recovered!

Preventative Maintenance: Defragmenting Flash Media

A defragmented hard disk drive can speed up disk writes and reads because files will be stored contiguously (next to each other). As flash media increases in size, defragmentation will become more of an issue. Currently, flash media is not large enough to warrant defragmentation.

If you would like to experiment with defragging a large flash media device (anything over 512MB), you will need a Windows PC. All flash media uses the FAT 16 or FAT 32 filesystem, a byproduct of DOS and Windows. If you are a Mac user, bother a friend with a PC and ask to defrag your camera's flash media. The read and write process on flash media is much slower than on a hard disk, so be prepared to wait while this operation takes place.

The following steps are Windows-specific because only Windows is capable of defragging a flash media device (FAT 16 or FAT 32 filesystem). If you are a Mac user, use the digital camera to reformat the flash drive, which will erase images and clean up the flash drive in one operation. Follow these simple steps to defragment a flash media card:

1. Plug the flash media into your PC. You can do this using a flash media reader that plugs into a USB port or FireWire port.

2. In Windows, double-click on My Computer.

3. Find the flash media drive and right-click on it, then select Properties.

4. When the Properties menu appears, click the Tools tab, then choose Defragment Now.

5. When the Disk Defragmenter appears, click Analyze to determine whether the disk needs to be defragmented. If a pop-up with the message "You do not need to defragment this volume" appears, you can either close the application or defragment anyway.

6. If you analyzed the media and still need to defragment, click Defragment. Depending on the size of the media card, you should be finished in a minute or two.

7. When the defragmentation finishes, you can view a report of the defragment operation, or click Close and then choose File, Exit to exit the application.

8. Remove the flash media card from your PC. For Windows 2000 users, remember to detach it properly by clicking the Remove Hardware icon in the system tray in the lower-right corner of the Start bar (next to the clock).

Formatting Flash Media

Every version of Windows since Windows 98 uses the FAT32 filesystem. This is a 32-bit filesystem in which the File Allocation Table stores cluster addresses as 32 bits, resulting in smaller cluster sizes (4KB versus FAT16's 16–32KB).

Here are a few different versions of the FAT family:

- **FAT12 File System**—The oldest type of FAT uses a 12-bit binary number to hold the cluster number. This filesystem can hold a maximum of 4,086 clusters, which is common on flash media smaller than about 16MB and floppy disks. This filesystem isn't too common anymore because even flash media are larger than 16MB.

- **FAT16**—The filesystem used for almost all flash media relies on a 16-bit binary number to hold cluster numbers. A flash media card using FAT16 can hold a maximum of 65,526 clusters, which is 16MB–2,048MB. Today's CF cards are already over 2GB—therefore the need for FAT32.

- **FAT32**—Today's flash media larger than 2GB require formatting using the FAT32 filesystem. FAT32-formatted media can theoretically handle 268 million clusters, and will support drives up to two terabytes in size!

Almost no flash media is formatted with the FAT32 filesystem, even with these advantages (smaller file size, greater capacity, and so on). The reason is that access times are long with 32-bit addresses. FAT32 tables must be accessed much more often because they contain so many more clusters. This matters when you are a professional photographer and have to shoot dozens of rolls in an hour. The time it takes to write each image to a FAT32 card is much longer than with FAT16.

Rather, most digital cameras rely on FAT16, or even FAT12. Flash media up to 16MB use FAT12; media between 16MB and 2GB use FAT16, and some media above 2GB use FAT32.

Formatting in the Camera

You usually should *not* format a flash media card in a Windows XP machine. Use the camera to format the card instead. Most cameras and portable devices will not accept media that has been formatted with the FAT32 filesystem, which is the default format for Windows XP. If a flash media card is formatted in Windows XP as FAT32 and you place it in a camera, you might see the following error messages:

- Error message asking to reformat the flash card.
- Error message that the flash card is not formatted.
- Error message indicating that the card is anomalous.

You *can* change the formatting utility in Windows XP to FAT16 using a drop-down list under Windows Explorer, but even this is dicey. Some cameras will not accept cards that have been formatted with this setting, either.

If you inherit a flash card that won't work and you suspect it was formatted in Windows, reformat the card in the camera. Ensure that the camera is not connected to the PC when you perform this operation. Every camera has a slightly different operating system, so check your user manual for formatting steps.

An interesting irony of FAT32 versus FAT16 is that you can now purchase high-speed flash media that stores pictures much more quickly than older media. These media usually are high-capacity and expensive. Today's high-speed flash media soon will surpass 2GB. Because the media must be formatted using FAT32, the flash media will actually be slower than flash media formatted as FAT16.

> **note**
>
> If you cannot format a flash card in a camera, either the card is physically locked (look for a lock), the card is corrupted and essentially useless, or your camera does not have enough battery power.

Another Disaster Point: USB

USB is the universal way to connect Flash Media readers to your PC. Two standards now exist that apparently are backward-/forward-compatible: USB 1.1 and USB 2.0. Some USB 2.0 multitype flash card readers do not function properly in USB 1.1 ports, however. As such, this is a potential trouble spot in Windows. The author recently lost data on an MMC card thanks to a faulty USB 2.0 card reader.

If you have a computer manufactured before 2002, it most likely has USB 1.1 ports; newer machines sport USB 2.0 ports. Check the manufacturer's Web site to ensure that USB 2.0 readers will work in USB 1.1 drivers, and that you don't need any firmware or operating system upgrades.

Another USB pitfall is in pulling a USB flash media reader out of its USB port while the operating system is trying to write data to it. Windows XP can safely recover from this surprise, but the media might not. In other words, improper removal of flash media will destroy the file structure on a disk!

The correct and safe way to remove flash media from Windows 98 2nd Edition, Me, 2000, and XP is to use the Remove Hardware button located in the system tray. Follow these steps to protect data on a flash media device:

1. Double-click the Remove Hardware icon.

2. In the Safely Remove Hardware dialog box, click on the flash media reader to highlight it. It might be listed simply as USB Mass Storage Device.

3. Click Stop. The Stop a Hardware Device dialog box will appear. Click on the USB device to highlight it and then click OK.

If a message appears saying it is safe to remove the hardware, you're finished. If a message appears stating the media is in use and to try again later, you might want to close all applications you think might be accessing the media, or shut down/reboot and remove the media.

THE ABSOLUTE MINIMUM

In January 2004, the Mars robot *Spirit* stopped operating because of corrupted flash memory. Engineers at NASA spent 10 days diagnosing and recovering the robot's flash memory before science operations could begin. At some point you might find yourself in the same situation, courtesy of your digital camera's flash memory. Fortunately, a number of tools exist for the Mac and PC to recover images that you might have written off as corrupted or lost. Keep in mind these points when recovering or working with files on flash media:

- Consumer-level digital cameras use the FAT16 filesystem, and high-end SLR digital cameras now use FAT16 and FAT32 filesystems.

- Filesystems use sectors to store file information. Sectors are grouped together to form clusters.

- Clusters in a FAT16 filesystem are 16KB in size, regardless of the data stored therein. A 1KB file, for example, will occupy one cluster and take up 16KB.

- Disk defragmentation is healthy maintenance you should perform on your computer every few months. It isn't necessary for flash media, however.

- Windows users have a built-in disk defragmenter; Mac users should check out DiskWarrior.

PART III

IMAGE EDITING

Basic Editing with Photoshop Elements
 and iPhoto .113

Editing with Selection Tools133

Advanced Selection Tools151

The Importance of Selections173

The Importance of Filters191

The Importance of Brightness/Contrast205

The Importance of Levels and Curves219

The Importance of Layers and Masks235

The Importance of Channels255

In This Chapter

- Finding an Image on Your Computer
- Editing with Photoshop Elements
- Resizing an Image in Photoshop Elements
- Editing with iPhoto
- Working with the Print Dialog Box in iPhoto
- Resizing an Image in iPhoto

9

Basic Editing with Photoshop Elements and iPhoto

This chapter introduces two common, easy-to-learn image editing applications for today's new digital photographers: Adobe's Photoshop Elements 2 and Apple's iPhoto. Elements is much more powerful than iPhoto, but the latter is much better at organizing images on your computer. Both are excellent programs for importing, storyboarding, organizing, and printing your images.

You don't need Photoshop to manage your images unless you plan to make a career as a photographer, writer, Web developer, or graphic artist. As the industry standard, Photoshop includes numerous features that you will never need, such as offset printing and registration tools, Web development and animated GIF tools, and color profiles and modes such as CMYK.

Finding an Image on Your Computer

Elements and iPhoto include file browsers, which provide a directory tree of your computer's innards. These browsers provide a fast, easy way to find images on your computer.

Not sure where a picture is located? Open the file browser and start poking around. In Photoshop Elements, choose Window, File Browser (see Figure 9.1). The browser provides thumbnails of your images and includes file information.

FIGURE 9.1

The file browser in Elements enables you to find an image quickly.

The file browser in Elements isn't really meant for top-to-bottom image management. Rather, it provides a quick thumbnail image before opening and enables you to rotate images.

For more thorough file management, you need something like Adobe Album, which is a chronological view of all the images on your computer (see Figure 9.2). Album provides a much more manageable interface. For Macintosh users, one application—iPhoto—provides features of Elements and Album.

Unlike Photoshop Elements' browser, iPhoto's image browser dominates the desktop. This browser is more of an in-your-face file location tool (see Figure 9.3). iPhoto's browser is so powerful that professional photographers use it to organize their clients' photo shoots.

FIGURE 9.2
Adobe Album, an optional image manager, might come in handy if you have problems finding files on your computer.

FIGURE 9.3
iPhoto's browser can be used to organize your entire photo collection.

First let's explore Photoshop Elements, which is available for the Mac and Windows.

Editing with Photoshop Elements

Photoshop Elements is available for Mac and PC computers and includes features designed specifically for amateur photographers. Table 9.1 highlights several features found only in Photoshop Elements by comparing it with the industry-standard Photoshop, the most powerful image editor available for non-Unix systems.

Table 9.1 Features Present in Photoshop CS Versus Photoshop Elements 2

In Photoshop CS, But Not in Photoshop Elements 2	In Photoshop Elements 2, But Not in Photoshop CS
Paths	Auto import of digital camera images
Actions Palette and Recordable Actions	Auto conversion of photos for the Web and email distribution
CYMK Support	Quick Fix window, Adjust Lighting, and Auto Color Correction
Channels, Curves, and Guides	Better menu bar and simplified toolbar
Masking	Palette Well & PhotoMerge, a panoramic stitching program
Editable Vector Shapes	Visual representation of filters and effects
Photoshop CS retail price: $649	Photoshop Elements retail Price: $99

Many of these features might sound like marketing-speak at the moment, but stick with this chapter and you'll learn the purpose of each. The bottom line is that for the price, Photoshop Elements is pretty powerful!

Printing Resolution

One of the most confusing parts of digital photography to a beginner is printing resolution. The act of scanning in a picture or taking a picture with a digital camera at one resolution and printing at another causes endless headaches for most amateurs. Fortunately, today's entry-level digital imaging software—Elements and iPhoto—makes this process easier than ever.

Resizing an Image Step by Step

If you use an image more than once, you'll probably need to change its size. In digital imaging, changing the dimensions of an image is called *resizing*. In Adobe Photoshop Elements 2.0, resizing is performed via the Image, Resize, Image Size command.

The Image Size dialog box offers two very different ways to resize the image, depending on whether the Resample Image check box is checked. This check box causes the image to change dramatically through a process called interpolation. *Interpolation* is a mathematical method that increases image resolution artificially.

If the Resample Image check box is *not* checked, changing the Width, Height, or Resolution fields does not really change the file onscreen. Changes will influence how the image prints, but the file will not actually change. Any modification to these Image Size fields merely tells the printer to print the image larger or smaller.

If you only want to change the print size, uncheck the Resample Image check box. If Resample Image *is* checked and then you change the Width, Height, or Resolution, the file will change in size, resolution, and quality.

When Resample Image is checked (see Figure 9.4), Elements changes the number of pixels in the image. Resample Image fundamentally and permanently changes the image; the computer increases or decreases the number of pixels in the image, data is usually lost, and the file size is changed.

FIGURE 9.4

Resample Image permanently alters the image information. Only use this when you are forced to resize an image.

The following steps explain how to use the Image Size dialog box to convert digital photos and scans to a resolution that will produce the best photos. If you need to resample an image, make sure you modify a copy of the original to keep any mistakes from ruining your original image:

1. Open an image in Elements through the file browser (Window, File Browser) or through the File menu (File, Open).

2. Before you do anything, choose File, Save As and save the file with a new name.

3. With the image onscreen, choose Image, Resize, Image Size.

4. When the Image Size dialog box appears, uncheck the Resample Image check box (see Figure 9.5).

5. Change the printing size of the image by typing a number in the Width, Height, or Resolution (pixels per inch) field. A change to any one of these fields will update the values in the other fields. For example, if the current print width is 15 inches and you want a 10-inch-wide print, type **10** in the Width field.

The Resolution value is helpful, as it tells you how many pixels per inch will appear in the print, so you can estimate how sharp it will look. Most color inkjet printers are very happy printing images at 150–300 pixels per inch (ppi). If you enter a number in this range in the Resolution box, the image will print well on the printer.

The following section continues with this exercise after explaining the purpose of resampling.

Resampling an Image

Sometimes you must change the number of pixels in an image by resampling. This often happens when you need to reduce (*downsample*) a large image for a Web site, or enlarge (*upsample*) a low-res image for a large-format printer. For these situations, you must resample the image.

An image that begins its life as a print 2,400×1,600 pixels in resolution must be made much smaller to be viewed on the Web, anywhere from 90×60 to 800×600. Resampling *down* is usually not a problem if there is more information than you need (see Figure 9.6). Let Elements use fancy math to remove this data properly.

FIGURE 9.6
Downsampling is usually fine. Use Resample Image to downsample when necessary.

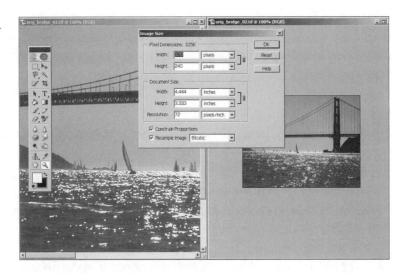

Rescan or Resample a Photo

For photos that weren't scanned in at the correct resolution, should you resample or scan again? If you need the image to be larger that what you currently have, consider scanning the image again at a higher resolution instead of resizing it (see Figure 9.7). A rescanned image will have better quality than one you make larger by resampling.

FIGURE 9.7
Rescan rather than resample if you need a larger size.

It's usually best to scan photos and negatives at the highest resolution possible, then downsample later. There is a limit to this, however: Scans of photos at resolutions above 2400 samples per inch usually bring out the photo grain, which begins to degrade the scan.

Resampling 101

Resampling an image permanently alters it. Some of its data is discarded when you downsample, resulting in an image that is usually not as good as the original. That being said, if you really have to resample, follow these steps:

1. Open the problem image and save it with a new name.

2. With the image open in Photoshop Elements, choose Image, Resize, Image Size.

3. Check the Resample Image box if it is not already selected. With this box checked, you can change the number of pixels in the image.

4. Check the Constrain Proportions box. When this box has a check, it keeps the shape of the image constant. Whenever you make a change to the width or height, Elements automatically adjusts the other dimension.

5. Choose Bicubic from the Resample Image pop-up menu if it is not already selected (see Figure 9.8). The Bicubic algorithm resizes the image with the greatest amount of image quality possible. Use the faster but lower-quality methods—Nearest Neighbor and Bilinear—only if Bicubic resampling takes too long with your computer.

FIGURE 9.8

Bicubic is the highest-quality algorithm for resizing an image.

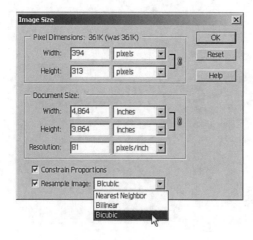

6. Change the number of pixels. There are three ways to do this:

 ■ Type the number of pixels you want in the Pixel Dimensions Width or Height fields. The print size will also change.

- Type values for the Document Size Width or Height. The number of pixels will automatically change to match the new document (print) size. This is recommended if your goal is to print the image on a specific size piece of paper, such as 8 1/2×11 or 11×17.

- Type a value in the Resolution (pixels per inch) field. The number of pixels will automatically change to match the new resolution. The print size will not change.

7. When you finish, click OK and print the image.

Modifying an Image in Elements

Many images need to be rotated. Film and prints can easily be misaligned in a scanner, and often cameras are not held level. As a result, architectural elements or the horizon might appear tilted. To correct this, you can rotate the entire image.

Perspective Correction in Elements

You can change the shape of images to correct errors in perspective or for creative purposes. Ordinary 35mm camera lenses cannot correct for perspective. When a camera is pointed up at a tall building, the picture it takes will show the building's sides converging toward the top of the image. Perspective controls in software can correct this; the sides of the building will appear parallel after editing.

Figure 9.9 was taken with an ordinary wide-angle lens pointed upward. The vertical lines of the building should appear parallel, but they converge because of distortion.

FIGURE 9.9

Correcting perspective on a building photographed from ground level. Doesn't look right, does it?

To correct perspective problems:

1. Open your image and save it with a new name.

2. Choose Select, All or press Ctrl+A (⌘A for Mac users) to select the entire image.

3. Choose Edit, Transform, Perspective. A border will appear around the image and the options toolbar will change.

4. Move the cursor to the top-left or top-right corner anchor point. Press down and hold the Shift key and then click and drag horizontally with the mouse (see Figure 9.10).

FIGURE 9.10

The Perspective command in Photoshop and Photoshop Elements replaces the need for a perspective-control lens.

5. Click the check mark in the options toolbar to submit the change. If you don't like the change and aren't sure how to undo it manually, simply click the cancel icon at the top of the toolbox.

This perspective correction fixes the perspective issue by making the sides of the building look parallel.

Rotating an Image in Elements

A large percentage of photographs taken by amateurs and even pros are not level (see Figure 9.11). Often this is intended, but more often it's an accident. Fortunately, you can fix a tilted horizon via the Rotate commands available in Photoshop and Elements.

Follow these steps to fix an image that you received or took a little off the horizontal:

1. Open the off-kilter image and save it with a new name.

2. Choose Image, Transform, Free Transform. A "bounding box" appears around the entire image. Elements might ask you to place the edit on a layer. Click OK twice to continue.

FIGURE 9.11
Almost art. This
image needs to
be level.

3. Move the mouse cursor outside the image. Click and drag down on one of the corners of the bounding box (see Figure 9.12). When the image looks level, click the check box to commit the change.

FIGURE 9.12
Straightening
the horizon.

You probably will need to crop the image a little to remove the empty, blank areas in the corners.

4. Click the Crop tool (see Figure 9.13). Click and drag from one corner to the other to select the entire image. A bounding box will appear around the image.

FIGURE 9.13

The Crop tool as it appears in Photoshop Elements.

5. Press down and hold the Shift key, then click a corner of the bounding box and drag with your mouse (see Figure 9.14). Adjust each edge until the empty, blank areas aren't visible.

6. Commit to the change by clicking the check mark icon in the toolbar.

FIGURE 9.14

Using the Crop tool to remove blank, empty areas caused by the Rotate command.

Unlimited Transformations in Elements

Photoshop and Photoshop Elements include the Free Transform tool, which enables you to scale, add or remove perspective, rotate, and distort an image. You can access the Free Transform command by choosing Edit, Free Transform or Image, Transform, Free Transform.

The Free Transform tool is capable of all these actions, but it's often more difficult to work with than a dedicated command. For this reason, Photoshop and Elements include each command separately.

■ **Scale.** Enlarge or shrink a selection by dragging its corner horizontally and vertically. Press and hold down Alt+Shift to adjust the entire image symmetrically (see Figure 9.15). Press and hold down Shift to retain the aspect ratio as you scale one corner. Now choose Image, Resize, Scale.

FIGURE 9.15

The Scale tool is often used in conjunction with the Info palette.

■ **Skew**. Transform a rectangular selection into a parallelogram by dragging one corner horizontally or vertically. Choose Edit, Transform, Skew.

■ **Distort.** Freehand distort an image with this command by dragging a corner (see Figure 9.16). This command is often used to place images on other objects as textures. Choose Image, Transform, Distort.

The options bar provides more precise changes to images by enabling you to enter specific degrees for rotation, pixels for scaling, or measurements that Distort should use. Also, if you need to nudge an image one way or another, enter a small value in the options toolbar instead of trying to perform the function freehand.

FIGURE 9.16

The Distort command creates perspective.

Editing with iPhoto

iPhoto is not as capable as Photoshop Elements in terms of editing, but it is much more seamless. The strengths of iPhoto are its file-management capabilities and its integration with the hardware.

iPhoto provides a large, organized view of all the images on your Mac. This view can be scaled up or down using a simple slider.

You can connect your digital camera and iPhoto will open automatically. You can create galleries of photos and create picture CDs directly from iPhoto. You can also archive images onto CD-R, CD-RW, or DVD (with the SuperDrive) directly from iPhoto. Not even Photoshop can perform these somewhat advanced functions.

iPhoto includes basic retouching tools, but not much else in the main program (see Figure 9.17). You cannot edit areas or color-correct selections manually (most editing functions are automatic).

However, an unusual workaround exists to mitigate this lack of editing features. If you have a photo printer connected to your Mac, complex editing tools may be available in the Advanced Options part of the Print dialog box!

FIGURE 9.17
iPhoto's basic
editing com-
mands in the
Edit menu.

Working with the Print Dialog Box in iPhoto

This section assumes you are using a photo printer with your Mac, such as an Epson, Canon, Lexmark, or HP photo printer. These printers have powerful print drivers that often provide exceptional editing capabilities.

NOW YOU KNOW WHY PRINT DRIVERS MATTER...

About to buy a new printer for your Mac? Read as many reviews as you can stand before you buy a photo printer. Find out whether its printer driver provides editing capabilities. That way, if you're too lazy or too busy to open Photoshop or Photoshop Elements, you can still perform editing within iPhoto.

The following steps examine the options available for one photo printer: a Canon S9000.

1. Choose File, Print to access the Print dialog box. The standard Print dialog box appears (see Figure 9.18).

FIGURE 9.18
The standard
Print dialog box
in iPhoto.

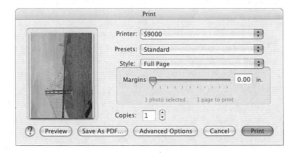

This dialog box is common among all printers. You can create a white border around a printed image by moving the margins slider bar.

2. Click the Style drop-down arrow and change the print layout (see Figure 9.19). Options include Contact Sheet, Full Page, Greeting Card, N-up (the same image printing however many times you need it), Sampler, and Standard Prints (two 4"×6" images per page).

FIGURE 9.19

iPhoto's Style menu in the Print dialog box.

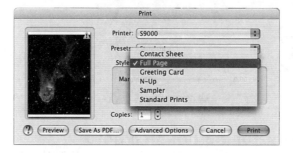

3. Click the down arrow next to Presets to force the printer to print on photo paper at a higher resolution (see Figure 9.20).

FIGURE 9.20

The Photo paper selection in Presets will force the printer driver to print at its highest resolution.

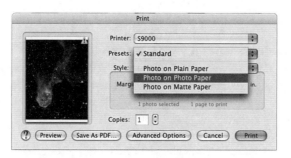

4. To access more powerful features available on your printer, click Advanced Options at the bottom of the Print dialog box.

The advanced options available for higher-end photo printers such as the Canon S9000 include numerous features, such as color balance, sepia tone, greeting card, black-and-white conversion, and even print scheduling (see Figure 9.21).

FIGURE 9.21

Edit an image through your printer driver! Just be sure you have plenty of paper.

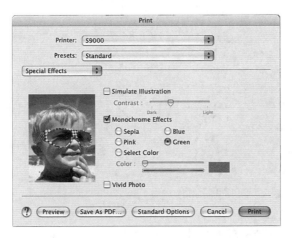

The Canon printer driver includes a number of options that may be available on your photo printer as well (see Figure 9.22):

- **Copies & Pages**. Standard print options available in the standard iPhoto Print dialog box.

- **Layout**. Change printout to horizontal and change contact sheet or N-up printouts from left-to-right to right-to-left.

FIGURE 9.22

A photo printer might have a more advanced printer driver than its host application (iPhoto).

- **Output Options**. Export the image as a PDF file.
- **Scheduler**. Schedule when an image prints.
- **Paper Handling**. Specify which paper tray will be used.
- **ColorSync**. Reduce or increase brightness and contrast. You can also print a sepia-tone image.
- **Quality & Media**. Specify what type of paper will be used. Similar to the Presets drop-down in the Print dialog box.
- **Color Options**. Set color balance and saturation. Essentially, editing (see Figure 9.23)!

FIGURE 9.23

Edit color balance and saturation in a printer driver—Canon's photo printer driver for the Mac.

- **Special Effects**. Special filters such as "illustration look," monochrome effects, and color replacement.
- **Borderless Printing**. Select the width of the margin of the image. Similar to the Margins feature in the standard Print dialog box.
- **iPhoto**. Print multiple copies of the same image on one piece of photo paper by selecting N-Up in this dialog box.
- **Summary**. Information about your image.

Always preview your image by clicking on Preview in the Print dialog box (see Figure 9.24). You will save precious photo paper and can easily cancel and return to your image.

Resizing an Image Step by Step

The title of this section is somewhat of a joke. Resizing in iPhoto is about as simple as missing that "Kodak moment" by half a second. iPhoto includes a one-click solution to changing the resolution of images. This feature, called Constrain, includes the most popular sizes that amateurs like to print, such as 8×10, 4×6, and 5×7 (see Figure 9.25). This is a simple resizing choice for quick crops.

FIGURE 9.24

Print Preview
ensures your
image will print
properly.

FIGURE 9.25

iPhoto's
Constrain func-
tion works in
conjunction
with the Crop
tool.

Resizing using Constrain is not too difficult:

1. Open an image, click the Edit button, and then click Constrain.
2. Choose the desired size for your image. iPhoto will resample it to the new size.

Keep in mind that images with barely any resolution are not going to scale up very well. Scaling down from a large file (in pixels) is what Constrain does best. Scaling up isn't going to be pretty with small (pixel-wise) images.

THE ABSOLUTE MINIMUM

Comparing Photoshop Elements and iPhoto is somewhat like comparing apples to oranges. Both applications enable you to adjust photos, but Photoshop Elements is a much more advanced tool. Elements includes resizing tools and transformation tools that enable you to scale, rotate, and adjust perspective for distorted images. iPhoto is essentially an image manager with basic retouching tools.

Regardless of which tool you use, keep these ideas in mind:

- Image management is a necessary evil in digital photography. Images are now *easier* to lose than they were when we used shoeboxes and three-ring binders.

- Photoshop Elements includes the same transformation tools as Photoshop, which are Scale, Rotate, Skew, Distort, and Perspective.

- All cameras import at 72 ppi. Images should be printed at 150–300 ppi. You must resize the image after importing it.

- Resampling an image should always be a last resort, especially if you need to increase the image's size. Rescan or reshoot if possible.

IN THIS CHAPTER

- Introduction to Selection Tools
- The Photoshop Toolbox
- Introduction to Image Editing
- Color Balance 101

10

EDITING WITH SELECTION TOOLS

Have you ever cut out parts of several pictures and pasted them together into one image? Or have you ever had a portrait in which you wished you could somehow eliminate the background? Ever receive or take a photo and wish you could lighten a shadow on the face of a friend?

The first step to making changes like these is to tell the imaging software what parts of the image you want to work with. This process is called selecting an area of the image, or simply making a selection (see Figure 10.1). This chapter explains in depth all the selection tools available in Photoshop to budding digital photographers.

After you select part of an image, you can change it or its background in many ways.

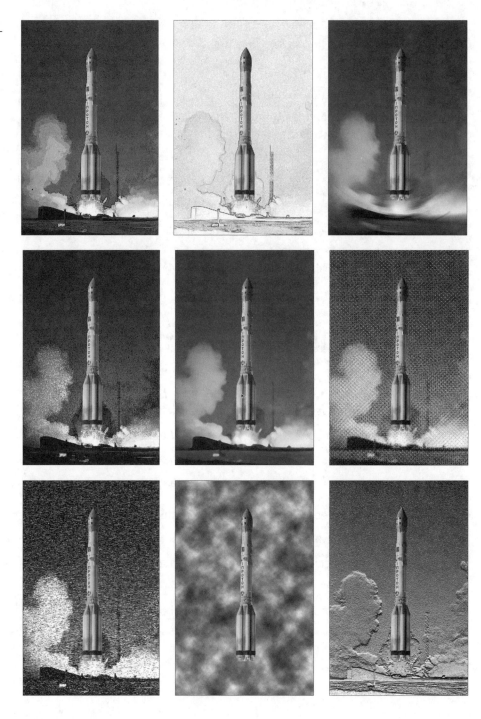

This chapter walks you through the most important selection tools:

- **Magic Wand.** A fast way to select similar color pixels.

- **Rectangular and Elliptical marquee**. The number one tool for cropping photos.

- **Lasso tool**. The most popular tool for quick, freehand selections.

Later you will see how easy it is to apply different filters to a selected area with commands such as Blur and Sharpen. Photoshop and Photoshop Elements' palettes, which include Layers, History, and Navigator, will also be introduced (see Figure 10.2).

note

You will find some tools such as Curves do not appear in Photoshop Elements. If a tool is not available in Elements, a workaround is explained later in this chapter.

FIGURE 10.2

Photoshop's palettes.

While you're experimenting in Photoshop, keep in mind the most important command: Undo. Choose Edit, Undo to cancel your last action, returning the image to its previous state. This lets you try an effect, then undo it to see how it looked before. You can choose Edit, Redo to reinstate the command.

tip

In Photoshop and other image editors, press Ctrl+Z to undo, and Ctrl+Z again to redo the command. Since version 6 of Photoshop, you can perform multiple Undos by pressing Ctrl+Alt+Z.

As a reminder, the best Undo of all is to save a copy of any image before you work on it. This is especially important when working with compressed images such as JPEG files. The first time you open a JPEG file, for example, you should save it with a new name as a TIFF or PSD file to save the original and prevent further compression of the image.

Introduction to Selection Tools

The following examples use the full version of Photoshop to prepare a digital file that is large enough (in resolution and pixel size) to print on an 8"×10" sheet of photo paper. The examples were edited with Photoshop on a Windows computer; the use of Photoshop on an Apple Macintosh computer is very similar. These tools are similar in Photoshop Elements on either platform. Follow these steps to change the image size:

note

Every image you open in Photoshop should be saved with a new name to preserve the original. Form a habit of saving images with a new name immediately after opening. You will thank yourself later when your machine crashes, the power goes out, or your image file becomes corrupted.

1. Open Photoshop or Elements. Open an existing image file by choosing File, Open. This exercise uses an image pulled from NASA's Planetary Photojournal Web site (see Figure 10.3) at

 `http://photojournal.jpl.nasa.gov/index.html.`

FIGURE 10.3

A test image downloaded from NASA's Planetary Photojournal.

2. Make a duplicate of the file so that the original file remains intact by choosing File, Save As (give the new file its own name).

3. Check the size and resolution of your final image by choosing Image, Image Size. The image should be at least 1600×1200 and at least 150 pixels per inch. Adjust these settings if necessary.

4. Choose File, Save to save the file.

Try some of the procedures shown on the following pages or experiment on your own.

Toolbox Options

Every tool has options that enable you to refine the tool's effects on your image. Click on a tool on the toolbar (see Figure 10.4). You can adjust the effects of many of these tools in the Tool options bar that appears at the top of the screen. Click on a different tool and a different set of options will appear in the options bar.

FIGURE 10.4

Tool options for the Magic Wand appear after clicking on the tool.

After you select a tool, you can refine it by adjusting its options in the Options bar.

Fly-Out Menus

The toolbox contains more tools than those that appear. Wherever you see a small arrow in the right-hand corner of an icon, a fly-out menu is available (see Figure 10.5). Related tools are accessible by clicking on the icon and holding down the mouse button until the fly-out menu appears.

FIGURE 10.5

The Toolbox
and several of
its expanded
choices.

The Most Popular Selection Tools

Selection tools let you extend photographic techniques such as burning and dodging that are used to change a specific area in a photograph. By using a host of different selection tools, you can define and refine an area, and then change it a little or a lot.

Photoshop and Elements include the following basic selection tools:

- **Marquee tools.** Click and drag a rectangle or ellipse to select rectangular or rounded areas (see Figure 10.6).

FIGURE 10.6

Rectangular
Marquee tool.

- **Magic Wand.** Click the Magic Wand (see Figure 10.7) on an image to select areas of similar color. When the Magic Wand is selected, you can customize the color range to which it is sensitive (Tool options bar). This allows you to select more or fewer similar areas.

FIGURE 10.7
Magic Wand
tool.

- **Lasso tools.** Click and drag Lasso tools to outline items and draw shapes freehand (see Figure 10.8). The regular Lasso enables you to select areas freehand. The Polygonal Lasso enables you to click on multiple points before returning to the start. The Magnetic Lasso snaps to the edges of an area being outlined.

FIGURE 10.8
Lasso tools.

These selection tools isolate areas of any size, down to a selection size of one pixel (see Figure 10.9). Once an area is selected, you can alter its color, sharpen it, blur it, duplicate it, relocate it, remove it, and more.

FIGURE 10.9
One of the most
difficult selec-
tions possible:
hair.

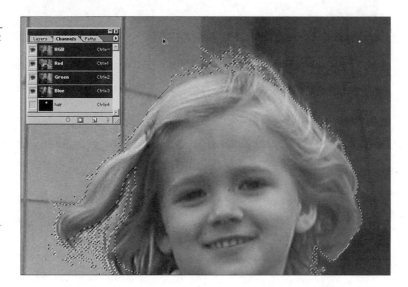

The following steps demonstrate a few ways to select an item, and then modify it without affecting the rest of the image. You can read more about selection tools in the next chapter.

1. If your test image is still open, choose the Lasso tool and select a specific item or area. Then choose Image, Adjust, Levels or Image, Adjust, Curves to lighten or darken the selection, the equivalent of dodging or burning (see Figure 10.10).

FIGURE 10.10
Adjusting levels on a selected area.

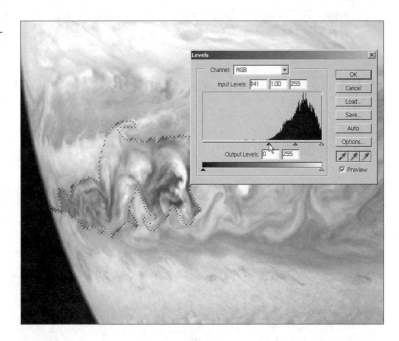

2. Press Ctrl+Alt+I to invert the selection.

3. Choose Image, Adjust, Hue/Saturation, then move the saturation slider bars all the way to the left to eliminate any color.

4. Click OK and then choose Edit, Undo or press Ctrl+Z (⌘Z for Mac). The change will revert.

5. Press Select, Deselect or Ctrl+D (⌘D for Mac) to remove the selection.

Using the Magic Wand Tool

The Magic Wand is useful when selecting areas of similar colors (see Figure 10.11). Set options for the Magic Wand in the Tool options bar. Experiment with the amount of Tolerance, which defines the color range the Magic Wand will select.

FIGURE 10.11

Magic Wand
at work.

Selecting Anti-Aliased in the options bar smoothes the jagged edges of a selection
and is useful when cutting, copying, and pasting selections to create composites.

The Tolerance setting determines which pixels will be selected. A low Tolerance set-
ting (10, for example) will select only pixels that are almost exactly the same in
brightness and color to the pixel you click on; a high Tolerance setting (120) will
allow more pixels in the selection (see Figure 10.12).

FIGURE 10.12

The results of
increasing
Tolerance. A
Tolerance of 25
is seen on top; a
Tolerance of 75
is on the bot-
tom.

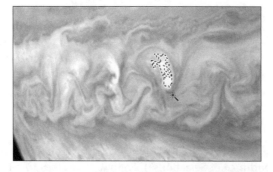

The Contiguous setting selects only adjacent pixels within the tolerance range. Otherwise, all pixels within the range, even on the object, would be selected. Follow these steps to use the contiguous settings option:

1. With your test image open, select the Magic Wand tool.

2. Click on an area of the picture to select it, then release the mouse.

3. To select an unconnected area of similar color and brightness, highlight the icon for Add To an Existing Selection in the Tool options bar and click the Magic Wand again.

4. To select an item in a picture with a plain background (if your image has one), use Magic Wand to select the background areas of common color, and then choose Select, Inverse, which will select the item. This is easier than trying to draw around the item with other tools.

5. Press Ctrl+D or choose Select, Deselect to remove the selection marquee.

note

When Anti-Aliased is checked, the selection will be surrounded by a border of partly selected pixels.

tip

Holding down the Shift key while making a new selection adds the new selection to the old one. Conversely, holding the Option (or Alt) key while clicking subtracts the newly selected pixels from the original selection.

Using the Lasso Tool

The Lasso tool enables you to select an area of any size or shape by drawing around it freehand (see Figure 10.13).

Try your hand at the Lasso tool. This tool is great for small irregular selections. Anything larger, though, and you really should use the Pen tool (described in Chapter 11, "The Importance of Selections"). Follow these steps to select an area using the Lasso tool:

1. Click on the Lasso and drag the mouse to outline the area to select.

2. Press and hold down the Alt key while drawing with the lasso and watch what happens. Press Delete (or Ctrl+Z; ⌘Z for Mac) if you need to undo the last polygon added to your selection.

3. Complete the loop to select the item and then release the mouse.

4. To add more, click on the Add symbol in the Tool options bar and outline the additional area. You can also press and hold down the Shift key to add to an existing selection.

5. After the areas have been selected, release the mouse.

6. Choose Select, Inverse if you want to deselect the object and alter the background.

7. Make whatever changes you want to the selected area.

8. Choose Select, Deselect or press Ctrl+D to remove the selection marquee.

Using the Rectangular Marquee Tool

The Rectangular Marquee tool is pretty straightforward. The important part to know about this tool is that keyboard shortcuts are available. Follow these steps to use the Rectangular Marquee tool:

1. Click on the Rectangular Marquee tool.

2. Before you draw a selection, press down and hold the Alt key. Now draw a selection. The marquee tool will draw from the center of the rectangle instead of the edge.

3. Press down and hold the Alt and the Shift keys and draw another selection (see Figure 10.14). Now the marquee is restricted to a square.

FIGURE 10.14

Keeping the great red spot in the center by pressing Alt+Shift with the Square Marquee tool.

4. You can click on the center of a subject and press down and hold the Alt key, then drag the cursor out to create a rectangle around the subject.

Using the Elliptical Marquee Tool

The shortcut keys that are available to the Rectangle Marquee tool are also available when you need to create ellipses and circles.

1. Press down and hold the cursor on the Rectangular Marquee tool until the fly-out menu appears. Select the Elliptical Marquee tool.

2. Before you draw a selection, press down and hold the Alt key. Now draw a selection. The marquee tool will draw from the center of an ellipse instead of the edge (see Figure 10.15).

3. Press down and hold the Alt and the Shift keys and draw another selection. Now the marquee is restricted to a perfect circle. You can click on the center of a subject and press down and hold Alt, then drag the cursor out to create an ellipse or circle around the subject.

4. Press Ctrl+D (⌘D on Mac) to deselect.

FIGURE 10.15

The Elliptical
Marquee tool.

Introduction to Image Editing

Now that you have some idea how to select specific
items in an image, why not edit something? The
rest of this chapter throws you into the most impor-
tant elements of editing: Levels, Curves, and HSB
(Hue, Saturation, and Brightness). Later chapters
will explore each editing feature in depth.

If you have an image you can experiment with,
open it in the image editor of your choice and fol-
low these steps:

1. Evaluate the image's brightness and con-
 trast. Is the image too light or too dark? Is
 the contrast too high or too low? Our sam-
 ple image here is too dark (see Figure 10.16).
 Other defects may be revealed once the
 image is made lighter.

note

The editing functions
discussed on the next few
pages are available in Photoshop
and advanced editors such as
Corel Photopaint and Paintshop
Pro. Photoshop Elements lacks
Curves, but does include Levels,
which is used more often by pho-
tographers.

FIGURE 10.16
This Soyuz
seems too dark.
Let's fix it.

2. Evaluate the image with Levels. Choose Image, Adjust, Levels to view a histogram of the image, which enables you to evaluate highlights and shadow pixels.

 The Level's histogram shows that the image has few white tones, or even light gray tones (see Figure 10.17). This means that it is too dark and has low contrast.

FIGURE 10.17
A histogram of
the dark image
shows that most
data is confined
to the dark side
of histogram.
This results in
little or no
contrast.

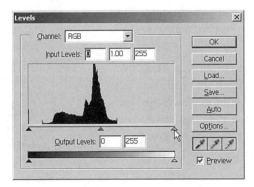

If the image is clipped (if data was never scanned because of a scanner error), scan it again or reshoot the image. Remember that an image that intentionally has large areas of pure black or white should not be diagnosed as clipped.

3. Adjust the contrast and brightness with Levels sliders. Adjust the white and/or black sliders to improve the contrast and brightness, using both your aesthetic judgment of the image and a technical evaluation of the histogram (see Figure 10.18). You can read more about Levels in Chapter 15, "The Importance of Levels and Curves."

FIGURE 10.18

Slider bars at bottom of Histogram control amount of contrast in image.

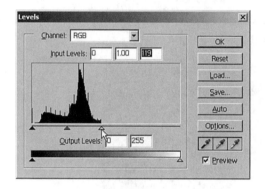

4. Move the white slider to the left until the onscreen appearance of the light tones is correct. The dark tones need very little adjustment. You only need to move the black slider a tiny bit to the right.

5. Adjust the gray tones with the gray slider until the mid-tones of the image look correct. In this image, the gray tones are a little dark, even after correcting with the white point. As a result, the image feels "heavy." Moving the gray slider to the left gives the midtones a lighter appearance.

caution

Be careful not to unintentionally clip an image when you increase its contrast. When you move a white slider to the left, all the pixels to the slider's right will be clipped (made white). Unless this effect is desirable, be careful to avoid it. The farther you move the slider to the left, the more the data disappears. The black slider will also clip all pixels to the left of it (all pixels will become black).

Color Balance 101

Color images often need color correction. For example, someone's shirt might be too bright, or even the wrong color because of incorrect lighting (tungsten when it should have been strobe, fluorescent when you should have used sodium, and so forth). To fix these problems, try the following techniques.

Open your test image if you closed it. Evaluate the color balance. Three basic commands are used to improve color balance:

- **Histograms**. Use the histograms of the individual color channels (Image, Adjust, Levels) to balance colors.

- **Color Balance**. Choose Image, Adjust, Color Balance to balance serious color casts (see Figure 10.19).

FIGURE 10.19

Adjusting color using Color Balance.

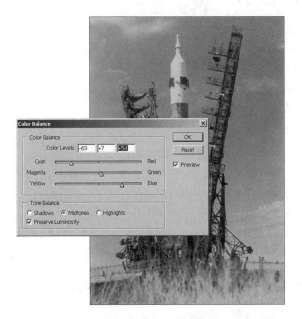

- **Hue/Saturation**. Choose Image, Adjust, Hue/Saturation to balance severe color casts.

Too much red appears in the midtones, so the Color Balance tool is used to shift red to cyan (red's opposite on the color wheel), as follows:

1. Evaluate the color saturation (see Figure 10.20). Use Image, Adjust, Hue/Saturation if the saturation is excessive or insufficient.

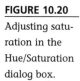

FIGURE 10.20

Adjusting saturation in the Hue/Saturation dialog box.

2. In this test image, the colors are too saturated. Move the Master Saturation slider to -30 to decrease the saturation of all colors equally.

In many cases, you only need to adjust the saturation of individual colors. In some images, the saturation will be so high or low that you need to adjust saturation first before any color balance.

When contrast was increased, it increased saturation. Saturation and contrast are linked in principle: Saturation always increases when the image's contrast increases, and saturation always decreases when the image's contrast decreases.

ENHANCEMENTS TO THE BASIC PROCESS

In Photoshop you can use the Variations command (Image, Adjust, Variations) to preview the effects of adjustments to Brightness, Color Balance, and Saturation.

Some tools are more powerful than others. For example, the Curves control is superior to Levels for adjusting brightness, contrast, and individual colors. You will also learn that adjustment layers are the best way to manage editing and corrections. Adjustment layers shield the original image from Levels, Color Balance, Hue/Saturation, and Curves changes.

THE ABSOLUTE MINIMUM

The full version of Photoshop includes valuable tools for selecting parts of an image, such as the Path/Pen and Lasso tools. Photoshop Elements includes the Magnetic Lasso, which performs a similar function depending on the sensitivity you set in the options toolbar. The bottom line is this:

- Photoshop's most powerful selection tool is the Pen tool. Learn how to use it by following the exercises in this book.

- Photoshop Elements' most powerful selection tool is the Magnetic Lasso. Adjust Frequency and Edge Contrast to control its sensitivity.

- If an image looks faint or washed out, try increasing its saturation.

- Enter a value between 0–25 in the Magic Wand's Tolerance box if the wand is selecting too many pixels.

- When using the marquee tools, press and hold down Alt+Shift (⌘Shift) to create perfect square or circular selections.

- Selecting hair is difficult. See Chapter 17, "The Importance of Channels," for tips.

IN THIS CHAPTER

- Quick Mask in Photoshop and Photoshop Elements
- The Amazingly Versatile Pen Tools
- When Your Software Tools Quit Working
- The Power of the Color Range Command
- Feathering and Antialiased Selections
- Photoshop Elements Workarounds for Pen and Quick Mask

11

ADVANCED SELECTION TOOLS

In the last chapter, you were introduced to the most common selection tools in Photoshop through a short exercise. This chapter expands on that walkthrough by drilling down into all the selection tools available.

A number of these selection tools will remain a mystery or be forgotten unless you experiment heavily with them. Eventually you will develop your own method for selecting complex areas. Photoshop and Elements are so flexible that you can choose from a host of powerful selection tools besides the traditional Rectangle and Lasso:

- **Advanced Lasso tools**. Polygonal Lasso and Magnetic Lasso.

- **Specialized Marquee tools**. Single Row and Single Column.

- **Pen Path tools**. The Pen, Freeform Pen, Add Anchor, Delete Anchor, and Convert Point tools.
- **Powerful Quick Mask**. Paint a mask that will become a selection area.
- **Color Range**. Sampled Colors, Highlights, Midtones, and Shadows selections.

The fastest way to learn these tools is to experiment with each. If you are continuing from the last chapter, use the test image from earlier exercises or choose a new one (see Figure 11.1).

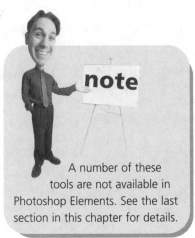

note

A number of these tools are not available in Photoshop Elements. See the last section in this chapter for details.

FIGURE 11.1

The Audi Cabriolet we'll be using in this chapter.

The following sections introduce the more obscure Photoshop selection commands by experimentation.

The Polygonal Lasso Tool

The Lasso tool is a powerful selection tool in the Photoshop arsenal. The Polygonal Lasso provides even more power by creating straight lines. See for yourself:

1. Open a sample image you can use as you walk through this chapter and save with a new name.

2. Click and hold the mouse button on the Lasso tool until the fly-out menu appears. Select the Polygonal Lasso tool.

3. Click along an edge of an area you'd like to select and then move the mouse and click again. The Polygonal Lasso will create a marquee line between the two points (see Figure 11.2).

note

Adobe's entry-level product—Photoshop Elements—lacks some of the tools described in this chapter. There are numerous workarounds, however.

FIGURE 11.2

The Polygonal Lasso tool at work.

4. If you make a mistake, press Delete. The last line will be removed. Press Delete again and the line before that will be removed.

5. Continue clicking until you return to the starting point and then click a final time. You will enclose the selection.

6. Press Ctrl+D or choose Select, Deselect to remove the selection.

Magnetic Lasso

The Magnetic Lasso helps when you need to select a complex subject such as a wave or flower and don't have time to use the Pen tools:

1. Click and hold the mouse button on the Lasso tool until the fly-out menu appears. Select the Magnetic Lasso tool.

2. Click on the edge of something in your sample image (an area with a difference in contrast) and then drag the mouse along the edge (see Figure 11.3).

The Magnetic Lasso notices the edges of objects and tries its best to stick to the edge as you move the cursor. The options available let you fine-tune this tool's stickiness:

■ **Width.** Enter a number (in pixels) to tell Photoshop how far from the edge the tool will still work.

tip

Press the Alt key to switch to the traditional Lasso tool while you have the Polygonal Lasso selected.

tip

When one of the lasso tools is selected, press Shift+L to toggle among the three lasso tools.

FIGURE 11.3

The Magnetic Lasso tool.

■ **Edge Contrast**. If the tool isn't "sticky" enough, enter a higher Edge Contrast value. Edge contrast tells the Magnetic Lasso tool how much contrast must exist between the subject and the background.

■ **Frequency.** If the Magnetic Lasso is setting too many points, enter a smaller number in this field. Frequency tells Photoshop how often to set points.

3. Press Ctrl+D or Select, Deselect to remove the selection.

Single Row and Single Column Marquees

The row and column marquees enable you to create dramatic borders and dividers within images. These tools benefit from Photoshop's powerful options toolbar, which includes icons for creating a new selection, adding to an existing selection, subtracting from an existing selection, and intersecting a selection. The following steps demonstrate how these marquee tools are used. Photoshop Elements does not include these tools, but the Rectangular Marquee tool can be used as a last resort:

1. Press and hold down the cursor on the Rectangle Marquee tool until the fly-out menu appears.

2. Select the Single Row Marquee Tool.

3. In the options toolbar for the Single Row Marquee tool, click the Add to Selection icon (see Figure 11.4).

FIGURE 11.4

The Add to Selection icon.

4. Click anywhere in the image several times. Notice the rows that appear.

5. Press and hold down the cursor on the Single Row Marquee tool in the toolbar and select the Single Column Marquee Tool.

6. Click anywhere in the image several times. Notice that several columns of marching ants also appear.

7. With several rows onscreen, choose Edit, Fill and fill with either all white or all black.

8. Press Ctrl+H (⌘H for Mac users) to hide the marching ants. Notice what you've created—black bars (see Figure 11.5).

The Single Column and Single Row Marquee tools are primarily used to create black horizontal and vertical lines.

Quick Mask Mode

Quick Mask mode enables you to paint or draw a mask that will protect part of an image while you make changes to other areas. Quick Mask mode is not available in Photoshop Elements; you must use the standard Marquee tools to create a selection in this program.

To become better acquainted with Quick Mask mode, keep your test image open and follow these steps:

1. Choose the Lasso tool and create a selection around some object in the image (see Figure 11.6).

2. Click Quick Mask on, and select the Brush (or other painting tool) from the Toolbox.

3. Select white as the foreground color by clicking the arrow above the black-and-white swatches.

4. In the Tool Options Bar, set the Brush to **100** percent opacity and **Normal** mode.

5. Paint over the area you want to turn into a selection. The white appears as a transparent overlay. If you paint beyond the area you want to select, switch the foreground color to black by clicking on the inverse arrows. Paint white on the parts you want to remove from the selection.

caution

If you change the feather amount for row or column, you might see a warning and then not be able to see the selected area. The selection is still there. Zoom out, then choose Edit, Fill and you'll see that the selection is still real. Choose Edit, Undo to revert back.

FIGURE 11.6
Using Quick
Mask mode.

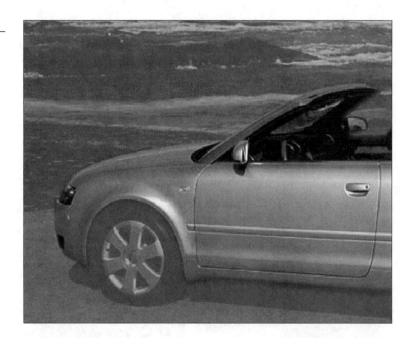

6. Click back to standard view to change the quick mask into a selection. You can now make changes to the selected area.

The Amazingly Versatile Pen Tools

tip

Press Ctrl+I to invert the mask, then continue painting an area to remove any mistakes. This is the fastest way to perfect a selection area.

The Pen tool creates paths, which are vector lines that you can save with an image. Choose Window, Paths to access the Paths palette (see Figure 11.7).

Paths are extremely important selection tools. If you've been confused about their purpose, fear not. They are *not* confusing. If you've ever worked with Illustrator, the Pen/Path tool is very similar. If you're new to the Pen tool, just keep these things in mind:

■ A path has special properties. It looks like a line, but it can be turned into a number of different items such as a selection, a line, or even an erased area (what's called a *stroked path* in Adobe-speak). See Figure 11.8.

FIGURE 11.7

The Pen tools and the Path palette. The Pen tools create "paths" which appear in the Paths palette.

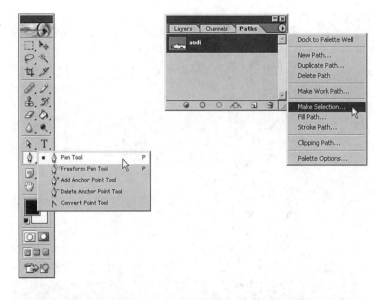

FIGURE 11.8

A stroked path.

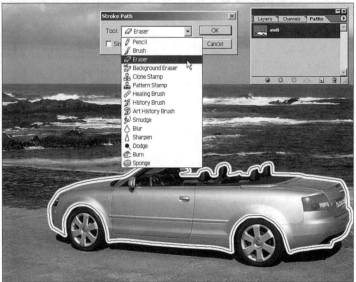

■ A *path* is a line that you can save with your image, just as you can save layers and channels. You can close the image, open it again, and the path you created earlier will still be listed in the Paths palette.

■ Paths take up much less storage space than any other type of selection, such as channels or layers.

■ Every time you click, you create an "anchor" along the path that can be turned into a curve or remain an angle.

Follow these steps to acquaint yourself with the Pen tool:

1. Click on the Pen tool, and then click along an edge of a simple object in your drawing (see Figure 11.9). Move the mouse and click again. A line is created.

2. Continue tracing an object with the Pen tool (don't worry about precision at this point), and then return to the starting point.

3. Click again and the selection will be enclosed.

Move to a new object that has some curves and try your hand at curved paths.

1. Click to set the first anchor.

2. Move the mouse to the next location where you'd like to create an anchor point. Click and hold down the mouse button, then drag the mouse (see Figure 11.10). You just created a second anchor point, but are modifying it so that it has a curve to it.

3. Click and drag again at the next anchor point. Notice that the direction in which you drag the handles will "lead" the path for the next anchor point.

4. You can influence the "lead" of the forward anchor handle by pressing down and holding the Alt (⌘ for Mac users) key. With the Alt key pressed, click on the forward handle and move it in the direction of the next anchor point, then release the mouse button and the Alt key. Continue with your anchor points (see Figure 11.11).

5. Return to the starting point of your path and click. Choose Window, Paths to access the Path palette.

FIGURE 11.10
Creating anchor points.

FIGURE 11.11
Press down and hold the Alt key to access the Pen's Convert Point tool.

6. Turn the path into a selection by clicking on the Paths palette (Window, Paths), and then Ctrl+click (⌘-click) on the path entry listed in this palette. This will turn it into a selection. You can also click the palette's menu bar, then select Make Selection.

7. Press Ctrl+D to remove the selection. Load the path by clicking on it in the Paths palette.

Click and hold down the cursor on the Pen tool until the Pen fly-out menu appears. Experiment with each command in the fly-out toolbar:

- **Freeform Pen tool**. Click and drag much as you would with the Lasso tool (freehand). The cursor can be used to create any shape. When you release the mouse, the path turns into straight polygonal lines that mimic the freehand path you just drew (see Figure 11.12).

FIGURE 11.12

The Freeform
pen tool
enables you
to create pen
paths freehand
that "stiffen"
when you
double-click
the mouse.

- **Add Anchor Point tool**. Add anchor points along an existing path to trace more precisely along an object. Some professional Photoshop users create paths quickly with few anchor points. Afterward, they add anchor points to refine the rough paths created with few lines (see Figure 11.13). This method minimizes the use of anchor points and speeds selection work.

- **Delete Anchor Point tool**. Delete existing anchor points. Often you will create a path and have excessive anchor points. To refine the path, use the Delete Anchor Point tool and remove excess anchors and then edit the remaining anchors by selecting the Direct Selection tool.

■ **Convert Point tool.** After you create a path, click the Convert Point tool on an existing anchor to convert it from a right-angle to a curve and back again (see Figure 11.14). This tool creates softer, smoother anchor points in curvy areas.

FIGURE 11.13
Adding anchor
points.

FIGURE 11.14
Converting
paths.

Paths are used for much more than simply creating selections. You can read more about how paths create clipping paths, stroked paths, and masks in more advanced books on Photoshop.

Saving Selections

Selections disappear if you try to select something else. You can fortunately save a selection by choosing Selection, Save Selection. Selections are saved as alpha channels in the Channels palette (Window, Channels).

The capability to save selections can save you immense amounts of time. Some selections take hours to create, such as selecting a person in a crowd.

You can read more about selections and working with channels in Chapter 17, "The Importance of Channels."

When Your Software Tools Quit Working

When you begin working with selections, you may experience moments when the software suddenly stops functioning. For example, you might try to use a Brush tool to paint on the image, but the brush refuses to paint. The software might be ignoring the Brush tool because you are painting outside a selection—a selection you created by accident, or one you forgot about. The brush will only work inside the selection.

Another cause is a hidden selection. First look carefully at the image to see whether a selection is visible (look for the moving marquee). If you don't see one, pull down the View menu. Is the command View, Show, Selection Edges check marked? When there is no check mark beside the command Selection Edges (a minus sign appears instead), it means that there is a hidden selection in the image. Choose View, Show, Selection Edges to make the selection visible.

To deselect a selection, use the command Select, Deselect or just press Ctrl+D (⌘D for Mac). Your brush will now work anywhere in the image.

The Power of the Color Range Command

The Color Range command can be accessed by choosing Select, Color Range. This feature selects all pixels in the image that resemble the sample pixel(s) you chose.

Unlike the Magic Wand, Color Range partially selects pixels based on how closely they match the clicked-on pixel. If, for example, fuzziness is set to 40 and you clicked on silver (see the following figure):

- All silver will be selected.
- All white pixels will be 100% selected.
- Grays will be 30%–70% selected.
- Dark gray might be only 10% selected.

Later in this chapter you will learn more about partially selected pixels (see the section "Feathering and Antialiased Selections"). The Color Range preview window will show the current selection. The Fuzziness setting, a slider in the Color Range dialog box, allows you to numerically define the range of partially selected pixels (see Figure 11.15).

FIGURE 11.15

Color Range partially selects pixels.

The key here is partial pixel selection. Partial selection extends the capabilities of other commands, such as Color Balance, Hue, and Saturation. Because these commands can be applied to partially selected pixels, their power is given an additional dimension.

For example, if the lightest pixels in an image are selected by Color Range and then you choose Adjust, Hue/Saturation, the saturation of the highlights will be changed a lot, the saturation of the midtones a little, and the shadow saturation will be unchanged (see Figure 11.16).

FIGURE 11.16

Correcting a bad scan with Color Range.

Another advantage of Color Range is selecting pixels within an existing selection. Ordinarily, Color Range selects similar pixels everywhere in the image. However, if a selection already exists, Color Range will select only within that selection. This is useful if you want to edit only one part of the image. If you want to add a Color Range selection outside an existing selection, hold down the Shift key while choosing the Color Range command.

To see the selection in more detail, you can apply a colored overlay (a mask) to the unselected areas of the image itself by choosing a mask from the Selection Preview pull-down menu. A white mask is shown (see Figure 11.17).

After completing the selection, a complex curve is created to bring out the shadow detail (if any) without blowing out the midtones.

Modifying Selections

You can increase or decrease the size of a selection. The changes do not have to be made with the original selection tool; you can lasso a selection, add areas to it with a color selection tool, and then shrink it with the Contract command. The following commands are available in Adobe Photoshop 6 and higher:

FIGURE 11.17
The White
Matte Selection
Preview high-
lights areas that
will be selected.

1. Choose Select, Modify, Expand or Select, Modify, Contract to make the selec-
 tion grow or shrink in every direction by the number of pixels you specify in
 a dialog box (see Figure 11.18).

FIGURE 11.18
The Expand
command
expands by the
specified num-
ber of pixels.

2. Expand with the options in the Select menu:

 ■ Select, Grow operates like a magic wand. It selects neighboring pixels in
 the image that resemble those in the existing selection. Tolerances are
 taken from the Magic Wand options bar.

■ Select, Similar selects pixels in the image that resemble those in the existing selection, but (unlike the Grow command) the pixels do not need to be physically connected by similar pixels. Tolerances are taken from the Magic Wand options bar.

■ Select, Modify, Border changes the selection, which is a solid area, into a hollow ring or donut shape (see Figure 11.19). The thickness of the ring is specified in a dialog box.

FIGURE 11.19
Modifying the border of your selection.

■ Select, Feather gives the selection soft edges, so that pixels at the edge are partly selected, whereas pixels at the center are completely selected.

You will use Select, Feather a *lot,* often with a setting of two or three pixels. Feather softens selection areas by blending the specified number of pixels with the area outside the selection. This softens whatever edits you make to a selection.

■ Select, Inverse reverses the selection status of every pixel in the image. Selected pixels become deselected and unselected pixels become selected.

■ View, Show, Selection Edges. This command hides the "marching ants" selection marquee; the selection is still there but hidden. This is useful when you need to compare the selection to the surrounding area while making changes. Remember to restore the marquee by choosing View, Show, Selection Edges again or you might forget that there is a hidden selection.

tip

Press Ctrl+Shift+I to invert the selection. This shortcut will come in handy as you gain more experience.

HIDING THE CRAWLING ANTS

At times the selection marquee can be a distraction, and you might prefer to work without it. You can temporarily hide the selection marquee by choosing View, Show, Selection Edges, or just press Ctrl+H (⌘H for Mac). You can make the marquee reappear by choosing View, Show, Selection Edges again.

Feathering and Antialiased Selections

Ordinarily, pixels are either completely selected or completely unselected. A few selection tools, however, create partially selected pixels. Partially selected pixels are extremely useful in editing. For example, a narrow zone of partially selected pixels at the edge of selection will create soft gradations between the edited and unedited areas. Soft gradations make your edits appear to be a natural part of the picture. The following exercise will show you how feathering blends edited areas into an image. Figure 11.20 is the subject.

Feathering and antialiasing are available options. In the Feather box, you enter a number; the width of the feathered zone will be several times this number. Other selection tools offer similar options. You can also feather any selection after it is created.

Images with no antialiasing and no feathering stand out immediately after any changes are made (see Figure 11.21). Antialiased selections are surrounded by a one-pixel-wide ring of partially selected pixels. Feathered selections have a border from one pixel to whatever value you enter for the partially selected pixels (see Figure 11.22). The width of the border can even be big enough to let you create such features as vignettes.

FIGURE 11.20
A harmless looking taillight will be our subject.

FIGURE 11.21
The taillight selected with lasso, no feather, and no antialiasing. Notice the sharp edge after filling.

FIGURE 11.22
The taillight selected with lasso, four-pixel feather, and aliasing. Notice the soft gradation between image and black fill.

Don't Forget the Crop Tool

Selections can be used to crop an image, or you can use the Crop tool found near the top-left on the toolbar; cropping can also be done by drawing a rectangular selection and choosing Image, Crop (see Figure 11.23).

FIGURE 11.23

Crop tool at work.

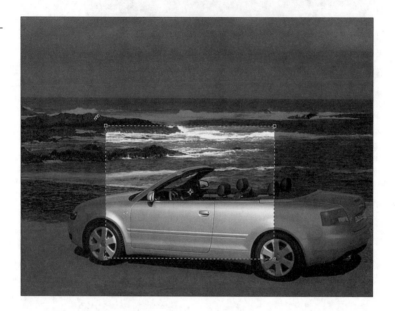

Photoshop Elements Workarounds for Pen and Quick Mask

Elements does not include the Quick Mask feature, nor does it include the Pen tool. Fortunately, workarounds are available in the form of Elements' Magnetic Lasso, its Selection Brush, and the Save Selection command.

To select objects in Elements with the same precision as Photoshop, just follow these steps:

1. Open an image in Photoshop Elements and zoom in on an object you'd like to select or trace.

2. Click and hold down the cursor over the Lasso tool until the fly-out menu appears. Select the Magnetic Lasso tool.

3. Begin tracing your image with the magnetic lasso. You do not need to click and drag. Just move the mouse. As you trace, the Magnetic Lasso will set anchor points (see Figure 11.24). You can set your own as you trace by clicking the mouse at corners.

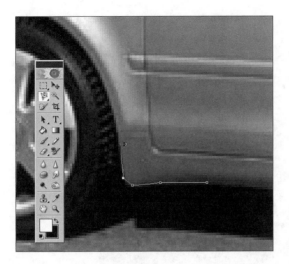

To move the image while you trace, press and hold down the spacebar on your keyboard. Move the mouse and then release the spacebar. The Magnetic Lasso tool reappears.

If you have problems keeping the Magnetic Lasso from jumping all over the image, increase the Edge Contrast in the toolbar.

If an unwanted anchor appears, or if you jerk the mouse by mistake, simply press the Delete key on the keyboard. The anchor will be deleted. Press Delete again to delete the preceding anchor. Continue pressing Delete as far back as necessary and then continue tracing.

4. Return to the starting point and the selection will be enclosed.

5. Click the Selection Brush tool. The image changes to a quick mask! Now you can see how well you did and even correct mistakes.

6. Zoom in and examine the selection. Press and hold down the spacebar and move the mouse to see how the selection went. Select a small brush size in the toolbar, such as five pixels, and fix mistakes (see Figure 11.25). You can reverse the quick mask by pressing Ctrl+Alt+I (Ctrl-I in Photoshop).

 If you need to come back to the image later and aren't finished, you can save the selection.

7. Click Select, Save Selection and then give the selection a name.

8. When you return to the image, choose Select, Load Selection and then continue working with the image. If you need to use the Magnetic Lasso to add to the existing selection, click the Add to Selection icon in the Lasso's toolbar.

FIGURE 11.25
Correcting mistakes in a quick mask.

THE ABSOLUTE MINIMUM

This chapter introduced Photoshop's incredibly powerful selections tools, such as the Pen tool. Professional photographers and graphic artists use the Pen tool in their work every day to isolate parts of an image.

Mastering this tool requires practice and patience. Start with an image that needs correction in a specific area, create a path with the Pen tools and turn it into a selection by Ctrl+clicking on the Path name. Later, switch to Quick Mask mode to review. Photoshop Elements users have almost as powerful a combination in the Magnetic Lasso and Selection Brush, and with practice can isolate areas of an image.

Regardless of the version of Photoshop you use, follow these tips when working with advanced selection tools:

- In Photoshop's Quick Mask mode, press Ctrl+I to invert the mask.
- The Selection Brush in Photoshop Elements is a hidden quick mask! Select it to see a quick mask of a selection. Press Ctrl+Shift+I (⌘Shift-I for Mac users) to invert the selection.
- In Photoshop, remove a poorly placed anchor point by pressing Delete once.
- Press Ctrl+H (⌘H on Mac) to hide the crawling ants selection border in either program.
- The powerful Color Range command partially selects pixels. Use the fuzziness slider to increase the amount of partially selected pixels.
- The Single Column and Single Row Marquee tools create filled-in lines. Multiple lines can be created.

IN THIS CHAPTER

- Understanding Different Terms for Resolution
- Digital Cameras and Resolution
- Resolution of Film: How Many Pixels?
- Scanner Software and Resolution
- Understanding Bit Depth

12

THE IMPORTANCE OF RESOLUTION

In a few pages, you will encounter a table that you should photocopy and stick on your wall. It contains the final solution for resolution confusion. The one subject in digital photography that is most difficult for beginners will be explained as clearly as possible.

The Sunday paper usually includes a 16-page color ad from your local electronics store filled with gadgets. The descriptions use terms few of us really understand. Surely you've encountered the terms dpi, ppi, lpi, cpi, 24-bit, megapixel, Mb, MB, Kb, and KB. How comfortable are you with them?

Individually, these terms might make sense (on an alert day), but when these terms and their associated technologies are used together to edit or output a digital image, only experienced graphic artists and photographers really understand what is going on.

Here is an example:

Sarah, an ambitious beginning photographer, is asked to photograph her best friend Cynthia's graduation party. She arrives at the party with her 4-megapixel digital camera and fills up her memory card with dozens of images. At home, Sarah copies the images to her computer. Cynthia calls and asks Sarah to put the best images on Sarah's Web site for review. Sarah picks the 10 best images and begins to upload.

Even with her fast DSL connection, the upload takes 20 minutes, far longer than Sarah expected. Cynthia gets online, sees the images, calls, and says the images are so big she can't really see them on her screen. So, Cynthia asks Sarah to simply print out the images and bring them to her house. Frustrated, Sarah opens each image in Photoshop, reduces its size, and then uses the File, Print Command.

The images print out, but are pixelated and a mess. She takes them to Cynthia, who promptly decides none of them were good enough to keep. Distraught, Sarah throws up her arms, runs out the door, and munches on cupcakes for the rest of the week.

The images were fine, but Sarah used the wrong resolution twice: online and in print. She took perfectly acceptable photos, but her presentation failed because she didn't understand when to use the appropriate resolution.

Understanding Different Terms for Resolution

The term *resolution* is formally defined as follows: The process or capability of making distinguishable the individual parts of an object, closely adjacent optical images, or sources of light.

In simpler terms, resolution is a measure of elements or pixels in an image. The number of pixels in a digital image or dots in an inkjet printout, for example. Cameras currently use the term *megapixel* to define their resolution; printers use *dpi*, and scanners use *ppi*. Let's sort out the terms used by digital photographers that refer to resolution.

Photographers and printers use the following terms when discussing resolution:

- **ppi**. *Pixels per inch* measures how many pixels that are lined up side by side that fit within a one-inch square. A computer screen varies between 72 ppi and 96 ppi. Scanners will scan anywhere from 300 ppi to 2400 ppi or more. In other words, the number of pixels it creates within an inch as it scans an image.

- **dpi**. *Dots per inch* is used by inkjet printers, dye-sublimation printers, and laser printers to define their output resolution. For example, some printers have 600 dpi output resolution; photo inkjet printers will have anywhere from 1440 dpi to 5760 dpi. This is *not* the same as ppi. The two do not go hand-in-hand.

- **lpi**. *Lines per inch* is used by printers who print magazines and newspapers. Their printing equipment prints a specific number of halftone dots per inch (called *line screen*, or *lines per inch*). A newspaper is 85 lpi and a glossy magazine is 130 lpi.

- **Samples per inch**. This term is used with scanners to represent the number of bits of information that are created per inch when scanning. The scanner "samples" an image as it runs along it with a bright light. The sampling rate, such as 72, 100, 300, or 600, is the number of samples the scanner grabs per inch and then converts into pixels. Scanner sampling turns into ppi after the image is scanned into image-editing software. As such, "samples per inch" and ppi are interchangeable.

- **Megapixels**. Digital cameras currently define resolution using the term *megapixels*. A digital camera that takes pictures at VGA resolution (640×480 pixels) is called a 0.3-megapixel camera. Cell phones use this resolution. A high-end camera, such as a Nikon 6-megapixel camera, will generate an image that contains 3000×2000 pixels. Quite a difference!

note

Some scanners use the term *dpi* to represent resolution. Scanners "sample" an image, so either term is essentially correct. A sample turns into a pixel; a sample can also be called a *dot*.

These terms are all used to describe resolution. Resolution is what you need to determine when working with images on a computer. The digital camera will record the image at a set resolution. When you import it into an image editor, you can change this resolution. What you decide to change it to depends on the output. For printing on fine photo paper, you need one resolution; for a quick thumbnail on a Web site or even an email, a smaller resolution is needed.

Here is a simple rule that will help you understand resolution:

ppi is used for **input**, and dpi is used for **output**.

Images taken with digital cameras and photographs or negatives scanned into the computer use the term *pixels per inch (ppi)* to represent resolution; printed images that are output from printers use the term *dots per inch (dpi)* to represent resolution. You can only control one: ppi. The output—dpi—is fixed by your printer. We'll explore these terms in the next section.

Input Resolution

Scans from a scanner and images from a digital camera come into your computer at different resolutions. Cameras import images at 72 ppi and scanners import images at whatever resolution you specify in the scanner software.

The resolution you use to *input* images into your computer might not be the best resolution for *output* to a printer or the Web. The next few sections discuss input resolution and how you can change it in your favorite image editor.

Digital Cameras and Resolution

Resolution for digital cameras is simple because only two numbers apply—sensor resolution and output resolution.

Sensor resolution is the size in pixels of the sensor (for example, 2-megapixel, 4-megapixel, 5-megapixel, 6-megapixel, 8-megapixel, and so on). This is the big number you see advertised in the paper. The larger the sensor, the higher the resolution of the image when it's taken. Table 12.1 contains the approximate resolution of some digital cameras.

Table 12.1 **Digital Camera Sensor Resolutions**

Sensor Size	Approximate Image Size
22-megapixel (for medium-format cameras)	4056×5356
13.7-megapixel	4536×3024
11-megapixel	4064×2704
8-megapixel	3264×2448
6-megapixel	3072×2048
5-megapixel	2608×1952
4-megapixel	2272×1704
3.3-megapixel	2048×1536
2.1-megapixel	1600×1200
1.3-megapixel	1280×960
0.3-megapixel	640×480

One term that cannot be used with digital cameras is *pixels per inch.* The reason is that CCD sensors come in different sizes. A 2.1-megapixel sensor might be twice the size of a 4-megapixel sensor, for example. This why you only hear about cameras in terms of total pixels (megapixels) or output resolution (1600×1200 pixels, for example).

Every type of digital camera—from a low-end phone camera to the latest Nikon or Canon—outputs at 72 pixels per inch.

When you import an image from a digital camera to your computer, it is *not* ready to print. Why? It comes in at a screen resolution (72 ppi) that would generate an enormous print. To print it, you need to change its resolution from 72 ppi to something useful on your printer—300 ppi, for example. If you try to print a photo immediately after importing it, either your image editor will state that the image is larger than the paper size, or you will print only a portion of the image on paper.

The difference in size of CCD sensors versus film actually leads to other annoyances, such as the "focal length multiplier." On digital SLRs (single-lens reflex cameras), the focal length of a lens must be multiplied by a number to determine the actual focal length. On a Fuji S3 SLR, for example, the focal length multiplier is 1.5x. A 50mm lens actually is working at 75mm, for example.

Today's newer technologies, such as EXIF printing and print scaling in software, enable digital pictures to be printed correctly without changes. (You can read about EXIF printing in Chapter 2, "Advantages and Disadvantages of Digital Cameras.") For example, you can connect an HP camera directly to an HP photo printer and print a picture at the highest resolution possible.

If you are more interested in editing images, however, you will need to change the resolution of your images after you've imported them. This is pretty simple:

1. Connect your digital camera to your computer and import the images.

2. Once they are on the hard drive, open Photoshop or your favorite image editor and open the first image.

3. Change the resolution. In Photoshop for example, choose Image, Image Size and then change Resolution to 200, 300, or 600 depending on the quality of your printer. Click OK when finished. Photo printers with high-quality glossy photo paper can accommodate 300–600 ppi. Traditional color inkjet printers can accommodate 200–300 ppi.

4. Put glossy or matte photo paper in your printer, make sure you have the correct physical size of the image (use Image, Image Size again if necessary), and print your photo.

Resolution of Film: How Many Pixels?

The first high-end consumer cameras in 1998 were 1-megapixel or less, and could create digital images up to 1280×960 resolution. Since 1998, the digital camera industry has continually released better cameras. Cameras producing images of 3000×2000 pixels are now under the $1,000 mark. To the untrained eye, images from these advanced third-generation cameras are the same as a regular film image.

If today's cameras are *that* good, have they finally caught up with traditional film in terms of resolution? Essentially, no. The resolution of film—negative and positive (slide) film—is much, much higher. Film has a resolution of between 20 and 27 million pixels!

Film is an analog medium and is affected greatly by the lens, film speed, type of film, lighting conditions, handheld stability of the photographer, and scanner. A compromise in quality in any of these areas will lower this resolution dramatically to that of a 6-megapixel camera or less.

The most significant disadvantage to film is that it must be scanned. Digital images are made up of ones and zeros that can be imported into your image editor with no loss. Film must be scanned, and scanner quality varies dramatically, with drum scanners being the best at capturing detail. As you increase the resolution of the scanner however, you reach a threshold where further detail becomes noise. The scanner then becomes the limiting factor in this film/digital comparison.

The scanner forces film to about a 20-million pixel limit. This means that a digital camera that can produce images at 5000×4000 pixels will equal the quality of a scanned negative. Today's 11-megapixel cameras, which feature 4064×2704-pixel resolution, are closing in. Digital film "backs" (extensions that fit onto the back of the camera) for medium-format cameras already surpass this resolution, but are incredibly expensive ($10,000 and up, minus the camera) and slow (shutter speeds of one second or longer).

The pictures produced from disposable cameras equal the resolution of a 2- to 4-megapixel camera because of their plastic lenses, fixed shutter speed, fast film, and amateur hands (see Figure 12.1).

So, if anyone asks whether digital cameras are available that equal the quality of film, the answer is yes...and no. The "yes" part means that cameras and lenses are available that equal film-camera quality. The "no" part is that these tools rely on the photographer.

FIGURE 12.1

Closeup of a scan from a disposable camera negative and a 4-megapixel image—the digital camera wins.

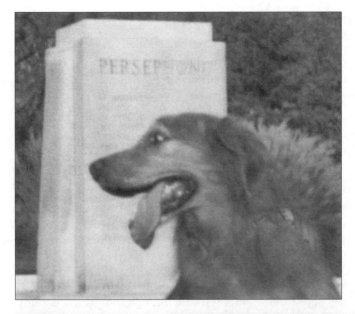

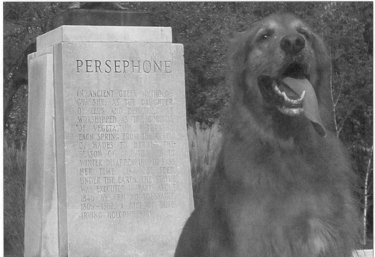

A professional photographer with a disposable camera will be able to take pictures that are indistinguishable from a top-of-the-line 6-megapixel camera. An amateur with a 14-megapixel camera will make the same mistakes as he would with a disposable camera.

Scanner Software and Resolution

If you have a scanner, you probably will be scanning negatives or photos. The resolution you would like to use when scanning is measured in pixels per inch (or samples per inch).

Today's scanner software includes numerous settings that can help you get the best scan resolution onto your hard drive. Follow these steps to scan an image at the appropriate resolution:

note

See Chapter 6, "Getting Your Pix Onscreen" for a detailed description of scanners.

1. Install the scanner software before you connect the scanner, if you haven't done so already. Reboot your computer if this is your first time using it.

2. Connect the scanner.

3. Open Photoshop and choose File, Import, *name_of_scanner_software*. You can also access the scanner software through the Start, Programs menu, but the software may differ and not be as robust. The driver that interfaces with Photoshop (or your favorite image editor) usually is best.

4. When the scanner software appears, you might see a beginning interface with few settings, or a more advanced interface (see Figure 12.2). Try to access the Advanced settings.

5. Dust off the scanner glass and your print or negative and place it on the scanner flatbed.

6. Click Preview to preview the image.

When the print or negative appears in the preview window, the scanner software might detect its borders automatically. If not, click and drag with the mouse to select the area to be scanned. You might have to click on a Marquee tool before selecting this area (depends on your scanner software). By setting the area to be scanned, you also tell the scanner what area to adjust automatically for color and sharpness.

Choose the appropriate settings in the scanner software. You might see settings like those in Table 12.2.

FIGURE 12.2

Beginner and advanced interface for Canon scanner software.

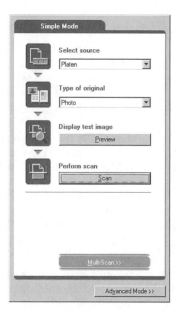
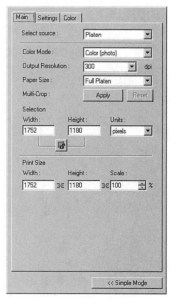

Table 12.2 Common Scanner Settings

Scanner Software Option	Common Settings	Purpose
Color Mode	Black-and-White Print, Grayscale Print, Color Photo, Color Document, Text Document, Negative Transparency, Positive Transparency	Tells the scanner what type of image it is about to scan.
Output Resolution	72, 75, 96, 100, 200, 300, 400, 600, 1200, and higher	Selects the number of samples the scanner will use as it passes under your image. The higher the number of samples, the larger (in pixels and file size) your image will be.
Filter Processing	Unsharp Mask, Descreen	Ensures the sharpen filter is active or turns it off. Unsharp Mask, which is also available in almost all image editors, is often used with scanners. This feature should be used during scanning to sharpen the image. Most scanners also include a descreen option to remove any line screen that appears on magazine photos. Select this filter only when scanning a magazine or newspaper image.

Table 12.2 Continued

Scanner Software Option	Common Settings	Purpose
Bit Depth	12, 24, 36, 48	Specifies the bit depth you would like to use during the scan. Twenty-four-bit depth is the default, and is what Photoshop expects. The higher the bit depth, the more tonal values that will be available in the image. You will not be able to take advantage of all the editing functions in Photoshop at anything higher than 24-bit depth. Most image editors can import high bit depth scans, but usually require the image to be downsampled to 24-bit after minor corrections.
Color Settings	Levels, Curves, Color Balance	Settings to automatically color-correct or adjust the color in an image. These features do not affect resolution, but do affect the color values in the image.
Print Size	4×6, 5×7, 8×10, 11x17, 13×19, 640×480, 1024×768, 1280×1024, and Letter	Preset sizes for scanning. This is a convenience feature mainly used by Web developers who need to scan items at an exact resolution for the Web. Photographers do not use this feature much because these dimensions can be adjusted in Photoshop.

1. After you set the options covered in Table 12.2, scan the image, which will appear in your image editor. Close the scanner software to return to your image-editor software.

2. Save this scan with a new name as a TIFF file. You can save it as a JPEG image, but you should avoid a lossy compression like JPEG in case you need to edit it later.

3. Check the resolution by choosing Image, Image Size (in Photoshop and Photoshop Elements). Notice that it is the same resolution you set in the scanning software (see Figure 12.3).

4. Change the resolution to match your output. If you plan to print, the resolution should be 150–400 ppi. If you plan to email or place the image on a Web site, the resolution should be 72–150 ppi. You might have to resample the image (explained in the section "Digital Methods for Increasing Resolution").

FIGURE 12.3

The scan resolution will show up in Photoshop as the Image Size.

5. Exit the scanning software and save the image with a new name. You can now edit it and print it, depending on the resolution.

Understanding Bit Depth

A bit is the foundation for all computing: it's the smallest unit of data—a one or a zero. Bit depth is directly related to the amount of data (bits) a scanner or camera captures per pixel. Most scanner software provides several scanning bit depths, such as 24-, 36-, and 48-bit depth.

Eight bits make up a byte. A byte is a handy way to group bits (1 or 0). Two to the eighth power equals 256. Therefore, 8 bits of data (a byte) can have 256 different values (0–255) (see Table 12.3). For simplicity, let's call each value a brightness.

Table 12.3 Bit Depth and Corresponding RGB Colors

Bit Depth	Number of Values Available	Values Available in an RGB Image
1	2	Not applicable
2	4	2×2×2 = 8 color values. Only applicable to a GIF image (indexed color in Photoshop)
4	16	4×4×4 = 16 color values. Only applicable to a GIF image (indexed color in Photoshop)
8	256	8(R)×8(G)×8(B) = 24 bits = 16,777,216 values
12	4096	12(R)×12(G)×12(B) = 36 bits = 68,719,476,736 values
16	16,384	16(R)×16(G)×16(B) = 48 bits = 281,474,976,710,656 values

Most everything you work with relies on 8-bit images. Your monitor, your digital camera, and so on usually rely on 8-bit values for each color. In other words, 256 brightness levels per color per pixel. Eight bits of data are used for each color that makes up an image. In an RGB image, that means a byte for each color, or 256 brightness values for each color.

Three times eight is 24, which is the origin of the term *24-bit color*. By default, most cameras and scanners capture in 24-bit RGB, but this can be changed in your printer options during scanning. This means that more than 16 million possible brightness and color combinations are possible for each pixel. Although this is impressive, your eye can actually take advantage of even more color.

EIGHT-BIT AND 24-BIT USED INTERCHANGEABLY
Often you will read about a 24-bit capture, and then the same image referred to as 8-bit. The terms are related. Remember, a 24-bit image consists of three colors (RGB) at an 8-bit depth (3×8 = 24). So, a 24-bit image or scan comprises three 8-bit channels of color.

12- and 16-bit Scan Rates

Every scanner and digital camera is capable of producing 24-bit images. Higher-end scanners are capable of 36-bit and 48-bit scans. This works out to 12-bits or 16-bits per color (R, G, and B). This increase in bit depth enables more brightness and color levels to be captured for each sample in a scanned image. A 16-bit scan can sense up to 65,536 discrete levels of brightness. This is considerably higher than the 256 levels of an 8-bit image.

This dramatic increase in sensitivity enables the scanner to capture subtle shadow detail in the darker areas of an image. A 16-bit scan creates a 48-bit image. This of course means 16 bits of data for the R, G, and B channels in an RGB scanner. The result is tremendous clarity, but unfortunately a dramatically larger file size.

How Can a 48-Bit Scan Help Me?

If you are scanning negatives and need the highest quality possible, scan at 16-bit depth. The resulting 48-bit scan will provide much more brightness values to work with in your image editor. When you apply a Levels or Curves adjustment to the resulting image, you have much more data to work with than with a traditional 24-bit image. Convert to 8-bit after you make your tonal corrections by choosing Image, Mode, 8 Bits/Channel (see Figure 12.4).

FIGURE 12.4

16-bit scans must be converted.

A low-bit scan, which has less information than a 48-bit scan, is compressed further by any changes in Levels or Curves. The result is gaps that appear as brush bristles in the image's resulting histogram (see Figure 12.5). The edited image has dramatic jumps in brightness levels, which result in posterization.

FIGURE 12.5

Two histograms of the same image: a 24-bit histogram after tonal correction versus a 48-bit histogram after correction.

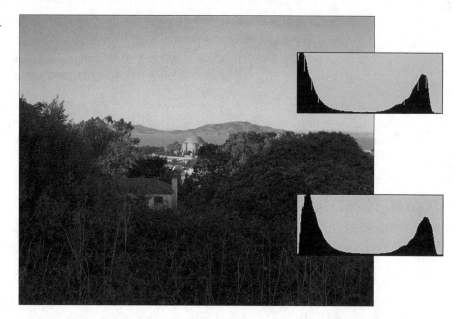

Drawbacks to 48-Bit Images

A negative that is only 24×36 millimeters scanned at 2400 samples per inch at a 48-bit depth approaches 36 megabytes (MB) in file size. A medium-format negative (6×7cm) can be upwards of 300MB! Modern G5 Macs and Pentium 4 PCs won't have too much trouble opening these large files, but edits can bog down even a high-end system. Not only that, but some functions just plain aren't available.

You cannot use adjustment layers on 48-bit images because Adobe wants you to make your tonal corrections with Curves or Levels and then convert the image to 24-bit. For this reason, you should use Levels or Curves (or both) to adjust and then convert the file to 8-bits per channel using Image, Mode, 8 Bits/Channel. Later, you can edit the file with Photoshop's tools. Follow these steps to convert from 48-bit to 24-bit:

1. Scan your negative, slide, or photo at 48-bit depth. Use a realistic scan resolution: 1200 samples per inch on a 8"×10" print will not even open in Photoshop. Stick to 300 samples on prints, and 1200 samples on medium-format negatives, and a maximum of 3200 samples per inch for 35mm negatives.

2. When the image appears in Photoshop, save it to your computer's hard disk before you make any changes as a TIFF file. Make sure the filename includes wording like _48bit or _16bit.

3. Make your adjustments in Image, Adjust, Levels or Image, Adjust, Curves.

4. When you're satisfied with the look of the image, convert to 24-bit using Image, Mode, 8 Bits/Channel.

5. Save the new 24-bit image on the hard drive with a new name and then delete the massive 48-bit file, or burn it onto a CD/DVD-RW as a backup.

You really do *not* need to work with every image at 48-bit depth; only with the most important images in your collection. For casual photography, 24-bit depth is fine. After sitting through (actually, sleeping through) a 48-bit scan, you will see why this feature is only worthwhile on your most important images.

Output Resolution

Images that output (print) on a printer use dpi for their resolution. This includes laser printers, inkjet printers, dye-sublimation printers, and even offset printers. The latter are used to print magazines, newspapers, and books.

You can read more about printer resolution and dots in Chapter 18, "Printers and Printer Resolution." The next section will explain how you can upsize an image that might not be at a resolution you can use. This process of interpolation is not foolproof, and is often a last-resort method for salvaging an image.

Digital Methods for Increasing Resolution

Photoshop and other image editors are capable of increasing the resolution of an image using interpolation. *Interpolation* is a software technique that uses mathematical algorithms to increase the number of pixels in an image (see Figure 12.6). This

technique is essentially JPEG technology in reverse. JPEG compression performs a series of steps to compress an image: initial input, discrete cosine transform, quantization, and encoding.

FIGURE 12.6

Interpolation options in Photoshop.

Cameras, scanners, and image editors provide interpolation technology to increase the resolution of an image. For example, Photoshop includes several algorithms that enable you to increase the resolution or physical size of an image. To access these options (listed here), choose Image, Image Size:

- **Nearest neighbor**. Nearest neighbor interpolation is a simple interpolation method. Each interpolated pixel is assigned the value of the nearest pixel of the input image. If more than one pixel has the same distance to the pixel to be interpolated, one of these is chosen. The drawback to this method is the poor quality of the interpolated image.

- **Bilinear**. Uses four adjacent pixels to calculate the interpolated pixel value. Bilinear interpolation is a relatively simple interpolation method. However, image quality is better than if you use nearest neighbor interpolation.

- **Cubic**. Cubic convolution uses adjacent pixels to determine the value of the interpolated pixel. The number of adjacent pixels the cubic algorithm uses is not fixed. Instead, the algorithm approximates and optimizes the sine/cosine function.

Cubic convolution provides the highest-quality interpolated image, but requires the most processing power (and time). For image processing, the bilinear interpolation is a fine compromise between quality and time. Avoid the nearest neighbor interpolation method unless you're in a hurry.

These techniques should only be used if you're in a bind. For example, if you've scanned or downloaded a small image and need to increase its resolution so that you can print it at a much larger size.

Printing Press Output and Resolution

At some point, your images might end up in the printing press. Printing presses use a plate containing a special screen to print images. This system relies on dots as well, but the term used for printing presses is line screen, or lines per inch (lpi).

Lines per inch is the number of dots that appear on a halftone screen (see Figure 12.7). A halftone screen is a plate containing a uniform pattern of transparent holes in an opaque background. The plate is usually metal, and is etched by a laser and chemicals. The plate is put on a massive roller and coated with ink on every revolution. The paper travels through at high speed and receives the ink. This line screen enables printing presses, which use solid colors of ink, to produce continuous tone images.

FIGURE 12.7

A photo from a magazine showing the line screen used by the printer.

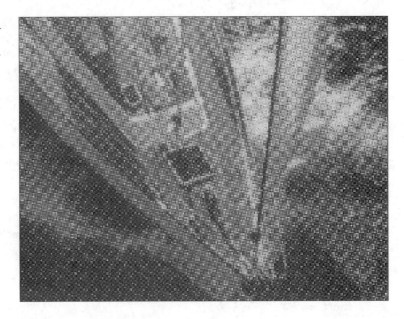

Converting pixels in a digital image to dots that make up the screen requires a device known as a RIP (Raster Image Processor). You might have seen one of these devices next to a color laser printer at your office, or even at Kinko's.

Imagesetters, which are used to make the plates that go in printing presses, can only create one size of dot. However, if you combine the dots to make larger ones, you can create these continuous tones.

A halftone dot is created from a grid of laser spots known as a *halftone cell*. The greater the number of cells filled with spots, the larger the halftone dot will appear, and the darker the dot will seem.

The human eye cannot distinguish dots from a distance if the dots are small enough. Because printing presses cannot create continuous tones (like a dye-sublimation printer), trickery must be employed to create the perception of a continuous tone. If you vary the size of dots across a grid of dots, and if the dots are small enough, the eye will see only a gradation, not separate dots.

THE ABSOLUTE MINIMUM

An accurate understanding of resolution is difficult even for experienced photographers. Wade through the terms and differences among hardware devices and you might find yourself thoroughly confused. Experiment with scanning, printing, and onscreen editing to understand how images flow through the chain of resolution. The following tips might help, as well:

- Digital cameras capture images at 72 pixels per inch. You need to change this resolution prior to printing.
- Disposable cameras have about the same resolution as a 3-megapixel camera.
- Because of scanner limitations, 35mm slides taken with the highest quality optics contain as much resolution as an equivalent 20-megapixel sensor.
- The common accepted term for input resolution is pixels-per-inch (ppi).
- The common, accepted term for printer resolution is dots per inch (dpi).
- Most digital cameras capture at 8 bits per color (24-bit) resolution. High-end SLRs can capture at higher 12-bit and 14-bit resolution in RAW mode.
- Editing in Photoshop and Photoshop Elements is done at 8-bits per pixel resolution. Only a few editing options are available at 16-bits per pixel.
- Most professionals scan negatives and slides at 48-bit resolution (16 bits per pixel), which must be converted to 8 bits per pixel after importing into Photoshop and Photoshop Elements.

IN THIS CHAPTER

- Sharpening Prints with Unsharp Mask
- Taking Advantage of Blur
- Getting Rid of Noise

13

THE IMPORTANCE OF FILTERS

Photoshop and Photoshop Elements include a number of filters that range from functional to artistic. The most commonly used filters by photographers are in these categories:

■ **Sharpen**. The Unsharp Mask filter is commonly used to increase the apparent sharpness of images.

■ **Blur**. Gaussian Blur is often used to blur corrections made to an image.

■ **Noise**. Despeckle is used to fix grainy scans.

This chapter will explain the use of these filters. Keep in mind while reading that filters only work on layers that contain pixels. In other words, make sure the correct layer is selected or the filter won't do anything. In particular, filters do not work on adjustment layers, so make sure the actual image is selected rather than an adjustment layer.

note

Adjustment layers are explained in Chapter 16, "The Importance of Layers and Masks."

Sharpening Prints

Digital sharpening accentuates the existing details in an image. It increases the perception of sharpness in a print, but it cannot create detail where there is none. Most scanned images need some sharpening because the scanning process can blur fine details. The most helpful sharpening technique is called *unsharp masking* (see Figure 13.1).

FIGURE 13.1

Controlling an unsharp mask.

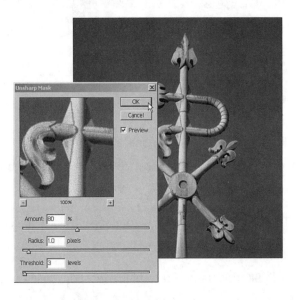

Unsharp Mask is a filter that works by comparing neighboring pixels and increasing the contrast between them. It makes light pixels lighter and dark pixels darker, so that the contrast of fine details is enhanced. In areas of smooth, flat tone where there is no difference between neighboring pixels, the filter doesn't change the pixels.

Unsharp masking gets its paradoxical name from a rarely used darkroom procedure that creates an illusion of sharpness in prints. An out-of-focus ("unsharp"), low-contrast, positive image ("mask") is made by contact printing from a negative. The two films are sandwiched together and printed with higher contrast.

To sharpen your own images, open an image in Photoshop or Photoshop Elements and choose Filter, Sharpen, Unsharp Mask. In the Unsharp Mask dialog box, you need to adjust three settings:

- **Amount**. This slider controls the strength of the sharpness mask. Amount also controls how much the contrast between pixels is increased.
- **Radius**. This slider controls distance. Radius controls how far from each pixel the effect extends. Ugly effects are often caused when too large a radius is chosen. For most printed images, a radius of .5 to 2 is sufficient.
- **Threshold**. This slider controls sensitivity. Threshold sets a requirement on the amount of contrast between neighboring pixels. If the contrast between neighboring pixels is below the threshold, no sharpening will occur. The range is 0–255. In images with skin tones, a higher threshold number is recommended to prevent unwanted skin texture.

Experimentation is an essential part of learning to use Unsharp Mask. You can always undo your changes by choosing Edit, Undo Unsharp Mask afterward or File, Revert to return to the original image.

Degrees of Unsharp Masking

You can easily ruin an image by abusing this powerful filter. Take the following image, for instance (see Figure 13.2). The image was printed at 300 ppi without the Unsharp Mask filter. The original image is basically acceptable.

FIGURE 13.2
Image before using Unsharp Mask.

In the second image (see Figure 13.3), an unsharp mask was applied with these settings:

- Amount: 20 percent
- Radius: 2 pixels
- Threshold: 6 levels

FIGURE 13.3
Image with
Unsharp Mask
applied.

These settings bring out more detail and look presentable. In the third image (see Figure 13.4), the following unsharp mask was applied:

- Amount: 400 percent
- Radius: 4 pixels
- Threshold: 6 levels

This excessive sharpness brings out all the water droplets and makes the image look spastic. Some professionals prefer the maximum amount of sharpness, however, so this excessive application of the Unsharp Mask filter cannot be discouraged completely.

An Exercise with Unsharp Mask

Before you sharpen an image, determine how it will be used. Will you make a print, or put the image on the Internet? If you print it, you must know how many pixels per inch there will be in your print. (You can read more about pixels per inch in Chapter 18, "Printers and Printer Resolution.")

Follow these steps to perfect your approach to the Unsharp Mask command:

1. Open an image in Photoshop or Photoshop Elements and save it with a name. In this example, we will use Figure 13.5.

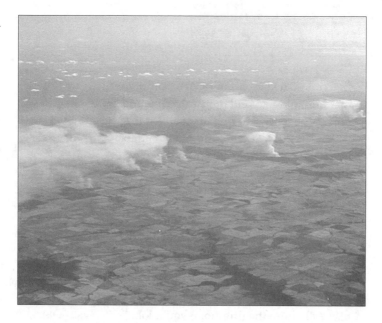

2. Choose Filter, Sharpen, Unsharp Mask. Check the Preview check box. A check in this box lets you preview the sharpening effect across the monitor screen. Set the image magnification at 100%. Clicking Preview on and off repeatedly lets you compare the sharpened and unsharpened images.

3. Determine the radius first. For a printed image, divide the pixels per inch in the print by 200. For example, for 180 pixels per inch, divide 180 by 200. The radius is therefore .9. If you are printing at 300 pixels per inch, divide 300 by 200; your radius will be 1.5 (see Figure 13.6). If you are preparing an image for display on the Internet or in multimedia, simply use a radius of .5.

FIGURE 13.6

Determining the radius in the Unsharp Mask filter.

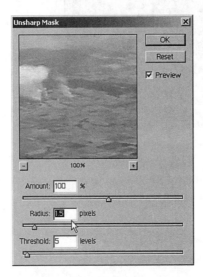

4. Determine the best amount. Temporarily set the threshold to 5 and adjust the amount. Try amounts between 50 and 300 percent to see what works best. There is no magic number here—each image benefits from different amounts, depending on the image's sharpness, the subject matter, and the scan's graininess.

5. Finally, experiment with the threshold. If the image is grainy or if skin tones are prominent, you will need to use a higher value for the threshold. Raising the threshold decreases the sharpening effect, so if you significantly raise the threshold, you might need to compensate by increasing the amount.

note

Pixels per inch is not the same as the printer's dots per inch. These two terms measure different things. Ignore the printer's dots per inch and calculate the radius using pixels per inch.

For portraits or images with people, make sure you zoom in on the individual's face and experiment with threshold. Sharpening will create a texture in the skin, which should be subdued or avoided if possible.

Taking Advantage of Blur

More often than not, images are blurry. Rarely are they too sharp. So why are the blur filters used just as often? The reason is blur filters are the only way to remove moiré patterns and halftone dots that occur when you scan printed material. You also might want to blur selections to make them blend with the image.

Removing Moiré Patterns and Halftone Dots

Suppose you need to scan an image from an old brochure or magazine. If you scan the image, there are three possible results: the actual halftone screen used by the printer will appear, a moiré pattern will appear, or both will appear in the scanned file.

A moiré pattern is an interference pattern produced by overlaying similar but slightly offset templates (see Figure 13.7). The printer uses a *screen*—a metal plate with a pattern of holes—to produce the printed material. Your scanner has its own pattern that it uses to scan. The two screens usually interfere with each other, creating a moiré pattern.

FIGURE 13.7

Examples of moiré patterns.

The easiest way to reduce or remove a halftone screen pattern or moiré pattern when scanning is to turn off auto-sharpening. Most scanner software will automatically sharpen a scan to compensate for the imperfections of the scanner hardware. Turn off this feature if possible to reduce these patterns.

To reduce or remove the effects of moiré and halftone screens in Photoshop, use the Gaussian Blur filter. Gaussian Blur smoothes differences in an image by averaging pixels next to the hard edges of defined lines and shaded areas.

By applying the correct amount of blur, you can remove these unwanted patterns and still retain some sharpness in the image. Follow these steps to apply the Gaussian Blur filter to a scanned image with moiré or halftone screen patterns:

1. After scanning an image, save it with a new name as a TIFF file.

2. Make sure you are viewing the image at 50% or 100%. Zoom in (View, Zoom In) if you aren't viewing it at one of these resolutions. Moiré patterns can develop when viewing at other resolutions.

3. Choose Filter, Blur, Gaussian Blur (see Figure 13.8). Click the Preview check box in the dialog box if it isn't already checked.

FIGURE 13.8

Gaussian Blur.

4. Drag the slider bar or enter a number to see the effect on the image. Try 1.0, then 2.0, and 3.0 to start and see what value removes the halftone dot pattern but retains some sharpness in the image.

5. Click OK to close the dialog box and view the blur. You can always undo the change by choosing Edit, Undo or pressing Ctrl+Z (⌘Z for Mac users).

Using Blur to Add an Artistic Touch

Some images weren't meant to be "tack sharp." Artistic images for example, might look better out of focus or with a small amount of blur added, such as in Figure 13.9, for example.

This image looks more appropriate for its use as a Christmas card after some Gaussian Blur has been added (see Figure 13.10). In this case, a value of 1.0 was applied, then green and blue highlights were reduced using Image, Adjustments, Color Balance.

FIGURE 13.9
A Christmas card image with a little too much detail (before Gaussian Blur).

FIGURE 13.10
The addition of a small amount of Gaussian blur to convey the mood of the holiday.

Noise Filters: Despeckle and Dust & Scratches

The two most important Noise filters are Despeckle and Dust & Scratches. Despeckle blends dots of color; Dust & Scratches is an amazing tool that blurs dust that might have come through on a negative scan, but retains the sharpness of the actual image.

Using Despeckle

If you scan a print at a high resolution, the actual paper grain will appear (see Figure 13.11). One way around this is to scan the negative, but if you don't have it or can't find it, you might have to remove this grain. The Despeckle Noise filter can help.

FIGURE 13.11
An old department store photo scanned at 600 samples per inch. The somewhat 70s-ish "textured" photo pattern is prominent.

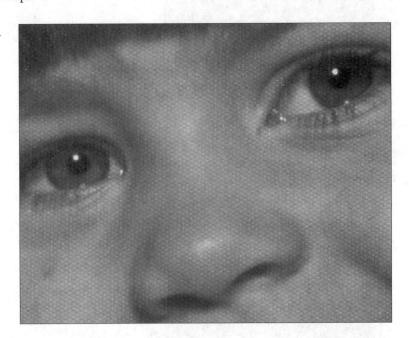

The first thing to try is a filter called Despeckle. The Despeckle filter detects the edges in an image (parts of the image with significant color changes such as the edge of a roof against a sky) and blurs everything but the edges. By blurring, Despeckle removes noise, yet is capable of preserving detail.

Too much Despeckle can blur the image. The goal is to remove film grain and retain detail. The following steps walk you through the process:

1. After scanning an image, save the file with a new name.

2. Choose Filter, Noise, Despeckle. This filter has no dialog box, so the effects are immediate.

3. Click Filter, Despeckle again or press Ctrl+F (⌘F for Macs) to run the filter again.

The film or paper grain pattern will slowly fade into the image. You also will see the moiré disappear. In some cases, you might have to repeat the process. The following images show the scanned photo before and after the Despeckle filter was applied four times (see Figure 13.12).

FIGURE 13.12
Image before and after using Despeckle.

Using Dust & Scratches

The Dust & Scratches filter provides several slider bars for removing dust and scratches from image scans. This filter works best on areas with little detail, such as skies and solid-colored walls that have excessive dust. This filter includes two slider bars:

- **Radius**. The radius in pixels that Photoshop searches for differences among pixels. Always adjust this number first.

 Larger numbers blur the image, so use the smallest number possible. This blurring effect is one reason why Dust & Scratches should only be used on large areas with little detail, such as the sky.

- **Threshold.** This slider sets the degree of difference among pixels that will be affected by the filter.

 Adjust this slider after finding the appropriate radius value. Start at zero and then move the slider to the right until detail emerges, but dust does not. The higher the better, but not too much or the dust will reappear.

The best way to remove dust is not to scan it. Use an antistatic brush and a pair of antistatic gloves, and never touch the negatives with your hands. You can find antistatic brushes at your local camera store.

To use the Dust & Scratches filter, follow these steps. Figure 13.13 is an extreme case of dust and really should be rescanned, but it shows how helpful Dust & Scratches is:

1. Open an image or scan an image into Photoshop or Photoshop Elements. Save it with a new name if you need to preserve the original.

2. Click the Lasso tool and select the area with dust or scratches. Use the Lasso tool and select a broad, random area. Avoid the Square or Circle marquee tool because selected areas in the shape of a square or circle are easier to see.

tip

If you're planning on scanning a lot of negatives, rent or buy a scanner with a feature called Digital ICE. This hardware solution detects and removes scratches and dust as the scan is made.

FIGURE 13.13
An extremely dusty scan that needs serious dust removal.

3. With the dusty area selected, choose Filters, Noise, Dust & Scratches.

4. Move both sliders to the far left: 1 for Radius and 0 for Threshold.

5. Radius needs to be adjusted first. Move the slider to the right until a majority of the dust disappears. The goal is to remove most of the dust. Large areas will be removed later with the Clone Stamp tool.

6. Threshold is adjusted after you find the best Radius for the dust. When you find the correct Radius value, move the Threshold slider to the right as far as possible until the dust begins to emerge. Back down a little. Click OK to accept the settings.

If dust and scratches remain in the image, use the Clone Stamp tool. Follow these steps to use the Clone Stamp tool to remove any remaining dust and scratches:

1. Find some spots that still have dust and zoom in (Window, Zoom In).

2. Click the Clone Stamp tool and then select a brush size appropriate for the dust. The smaller the better, because you have more control and the changes aren't as easy to spot.

3. Before you can use Clone Stamp, you need to tell the tool what area to use as a guide. Move the cursor somewhere acceptable (an area with no dust), press down and hold the Alt (⌘ for Mac users) key. The cursor will change to a target. Now click the mouse once. You've set the clone point.

4. Move the mouse over any remaining dust and then click and drag. The Clone Stamp tool will copy the area you selected earlier over the dust.

The area you selected should be free of dust. The bottom line is that even the worst scans can be saved. Removing dust and scratches from areas with people and other subjects is more difficult, and requires more than the Dust & Scratches filter.

tip

For an advanced treatment of dust and scratch removal on complex subjects such as people, pick up Katrin Eismann's *Photoshop Restoration & Retouching* from Que Publishing.

THE ABSOLUTE MINIMUM

Photoshop and Photoshop Elements provide the same filters. The most common filters you will use are Blur, Dust & Scratches, and Unsharp Mask. Keep these tips in mind while working with images that require the use of these tools:

- The best sharpening tool is Unsharp Mask. Use it instead of the other Sharpen commands.

- In Unsharp Mask, Threshold is adjusted last. Set it to zero until you are finished adjusting Amount and Radius.

- The Dust & Scratches tool can work wonders, but isn't foolproof. Try to keep dust off your images using a brush and antistatic gloves.

- With the Dust & Scratches filter, Threshold is adjusted last. Set it to zero until you've adjusted Radius.

- Use the Clone Stamp tool to remove a few scratches or pieces of dust. Use the Dust & Scratches filter to remove a large amount of dust from a selected area.

- Gaussian Blur is often used to soften skin, especially close-ups. Use it sparingly.

IN THIS CHAPTER

- Introduction to Histograms
- Correcting Brightness and Contrast
- Setting and Using Black Points and White Points

14

THE IMPORTANCE OF BRIGHTNESS/CONTRAST

When you print a photograph in a darkroom, you make decisions about changing brightness and contrast after looking at test prints.

For example, you'd evaluate brightness by making several exposures on a test strip, then develop and examine the results. You'd change contrast by using a different grade of printing paper or by changing a polycontrast filter after examining the developed test print.

With digital imaging, you make changes using various commands as you look at the image on a computer's monitor screen. Your changes are immediately visible. You of course don't need to make a print until you are satisfied with the onscreen image.

Photoshop, Photoshop Elements, and other image editors include several ways to adjust the brightness and contrast of an image digitally (see Figure 14.1). In Photoshop, the Brightness/Contrast command (Image, Adjust, Brightness/Contrast) has the advantage of being easy to use, but is limited in its capacity to change the image.

FIGURE 14.1

The Brightness & Contrast dialog box in Photoshop and Photoshop Elements.

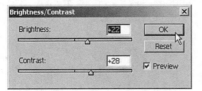

The Levels and Curves commands (Image, Adjust, Levels and Image, Adjust, Curves) are more complicated, but their effects are much more powerful and useful. Using Levels, you make separate adjustments in three tonal areas: highlights, shadows, and midtones. Curves enable you to make nearly unlimited adjustments to tonal areas. You can read more about the Levels and Curves commands in Chapter 15, "The Importance of Levels and Curves."

Some photographers feel that the first tool you should use when editing washed-out photos is Brightness/Contrast. The importance of this dialog box is substantial, although many professional photographers feel the same results can be achieved using Levels or Curves.

To see whether the Brightness/Contrast dialog box will fix any problems you encounter with an image, follow these steps:

1. Open an image in Photoshop and save a copy of it with a new name.
2. Select the Image menu and choose Adjustments, Brightness/Contrast.
3. Click on the Preview box to see your changes as you make them.
4. Make the image lighter or darker by moving the Brightness slider bar or typing a number from -100 (darker) to +100 (lighter).
5. Change the contrast by taking the same actions with the Contrast slider bar. The image will show the changes you make.
6. Click OK to make the changes or Cancel to leave the image unchanged. To reset, press down and hold the Alt (⌘ on the Mac) key to change the Cancel button to a Reset button.

Introduction to Histograms

A histogram is a bar graph that shows the number of pixels at each brightness level in an image, with the darkest pixels to the left and the lightest pixels to the right (see Figure 14.2). The quantity (amount) of pixels in the image that uses a specific brightness value is shown by the height of the vertical bars. The higher the bar, the more pixels there are at that brightness level.

FIGURE 14.2

A histogram
of an image.

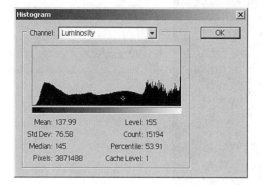

In addition to giving you information about an entire image, a histogram can show information about the pixels in a selected part of an image. To view a histogram for an image, choose Image, Histogram or Image, Adjustments, Levels. The Levels dialog box also includes a histogram.

You can only modify the histogram in the Levels dialog box by moving the black, 50% gray, and white triangular sliders with the mouse, or by typing in numbers in the Input Levels and Output Levels boxes. The three sliders beneath the histogram are used to lighten and darken the image, increase contrast, and to lighten and darken its midtones. The two sliders on the Output Levels bar are used to decrease contrast.

You can change a single color's brightness and contrast by selecting the color from the Channel pull-down menu at the top of the dialog box. This lets you make changes to the color balance. You will rarely change levels for a specific color channel, however. This technique is mainly used when there is some type of color cast—for example, when the image is predominantly one color because of lighting.

Correcting Brightness and Contrast for Dark Images

The histogram in Figure 14.3 graphically shows that the image is too dark by displaying a large number of pixels bunched at the left side of the graph. The histogram also reveals another problem: no pixels on the right end of the graph. This

means that there are no white pixels in the image. (An image that is too light would have a histogram with pixels on the right side of the graph.)

 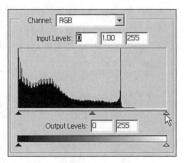

You can correct an overly dark image by dragging the white slider (the one on the right side of the histogram) to the left, which makes pixels that had been light tones of gray in the original image become pure white (see Figure 14.4).

 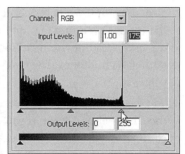

To correct an overly light image, do the opposite: Drag the black slider to the right (not shown).

Correcting Brightness and Contrast for Low-Contrast Images

In the following image, there is practically no contrast (a common problem with aerial photography because of smog and haze). The histogram shows no pixels at either the black (left) end or white (right) end of the graph (see Figure 14.5). An image with contrast too high would have peaks of pixels at the extreme black and/or white ends of the graph.

FIGURE 14.5
The histogram shows that this image has no contrast.

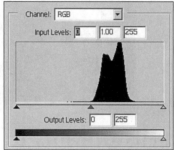

To increase contrast, drag the black-and-white sliders toward the middle of the graph (see Figure 14.6). To create a very highly contrasted image, try moving these two sliders very close together.

Note that this picture is still too dark overall. Move the gray slider triangle to correct the image without changing the overall contrast. The gray slider transforms whatever pixel it is placed beneath into middle gray, a brightness value of 127, midway between 0 (black) and 255 (white).

FIGURE 14.6

Move the sliders closer together to increase contrast.

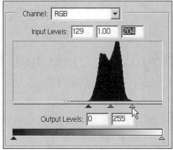

Using Histograms to Diagnose Exposure Problems

There are some exposure problems that Levels can't fix. Some scans (or digital camera images) have important tonal detail missing. Shadow detail might be missing (the shadows are pure black), highlight detail might be missing (the bright areas are pure white), or both. Just as film can be underexposed and overexposed, digital camera images or scans can suffer from the same problems.

Often you can tell whether an image is badly exposed by simply looking at the monitor, but its histogram will help you make a more confident diagnosis (see Figure 14.7). Digital images that are over- or underexposed are said to show *clipped histograms*. The term *clipped* suggests that the pixels necessary for a correct exposure have been clipped off the ends of the histogram by bad exposure.

The highlighted (bright) areas are clipped in the histogram. Notice that there are no pixels at the left side of the graph. This often indicates overexposure. Adjusting the sliders will not help because no image detail was captured in the highlights.

In most well-exposed and well-scanned images, some pixels are found at both ends of the graph. In a clipped scan, there will be a spike of pixels. If a scan is clipped, there is no way for editing software to fix it without hand-painting details on the image or copying them from another image. Be careful not to confuse a clipped image with one that intentionally contains large areas of pure black or pure white. The histograms of both types of image will look the same.

FIGURE 14.7

An overexposed
digital camera
image and its
histogram.

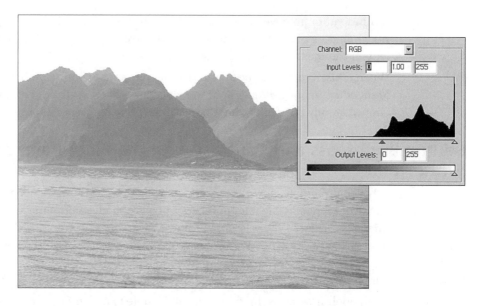

There is now enough shadow detail in the image in Figure 14.8. The pixels at the
left of the histogram represent shadow detail that was overexposed in the original
exposure.

FIGURE 14.8

The same scene
photographed
with less expo-
sure.

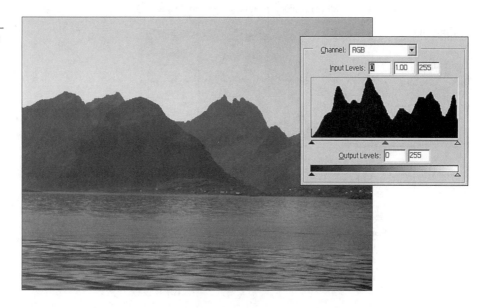

If a histogram from well-exposed film is clipped, you might be able to correct it by rescanning—consult the scanner's manual. Most scanning software has controls that let you change the exposure of the scan.

When a histogram is clipped because of bad camera exposure, reshoot the picture. Reshoot the image using fill light to reduce the scene's contrast. If an image is clipped at only one end, reshoot the picture with either more or less exposure.

Setting Brightness and Contrast with the Black Point and the White Point

A histogram graph shows the brightness values of pixels in an image. The height of each bar represents the total number of pixels of a given brightness in the whole image (see Figure 14.9). The spread shows the frequency of each of the 255 tones available for the picture. Pure black is 0; middle gray is 128, and paper white is 255.

The three images in Figures 14.10–14.12 have different histograms. The histograms tell you whether the image has high contrast, no contrast, or a broad representation of all brightness levels. In time, you will be able to determine what an image looks like just by examining its histogram.

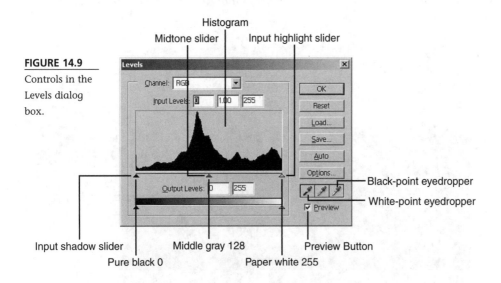

FIGURE 14.9
Controls in the Levels dialog box.

FIGURE 14.10
Normal con-
trast: The image
has a range of
blacks, whites,
and grays.

FIGURE 14.11
High contrast:
The whites and
blacks are clus-
tered at either
end, with very
little gray in
between.

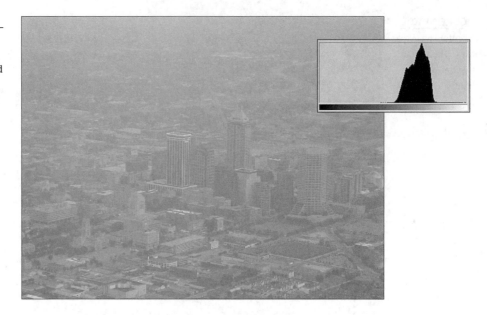

Low-contrast images can be saved by setting a new black point and a new white point. When printing a conventional photograph, you start by trying to ensure that the print will have bright whites and deep blacks, both with some detail. You might make test prints before making a final print.

Black-Point and White-Point Setup

Photoshop lets you define black points and white points to improve the brightness and contrast of an image simultaneously. Brighter images with sufficient contrast are much more interesting than washed out, bland images. When you set black points and white points, you first set the highlights, then the shadows, and finally you tweak the midtones.

The following exercise shows you how to set up the Levels dialog box to improve brightness and contrast for images that will eventually be printed. These steps apply mostly to inkjet printers. The settings will differ for other kinds of printers, such as dye-sublimation or laser printers.

1. Open a low-contrast image in Photoshop and save it with a new name. Keep the original safe in case you need to return to it.

2. Open the Levels dialog box by choosing Image, Adjust, Levels.

3. Click twice on the black-point eyedropper to open the Color Picker box.

4. Set the Red, Green, and Blue values to 2 to define the darkest black with some detail. (A zero in each color would produce a black with no detail at all.) Click OK.

5. Click twice on the white-point eyedropper to open the Color Picker box again.

6. Set the Red, Green, and Blue values at 244 to define the brightest white with detail in a photograph. (The number 255 in each color would produce paper white with no detail.) Click OK.

7. When the Levels box appears, click OK and then click Yes when the default dialog box question appears.

Brightness and Contrast Exercise

In the last exercise, you'll set up the Color Pickers for printing. Now Photoshop (or Photoshop Elements) is ready to save underexposed, washed-out, backlit, or just plain lifeless images.

> **tip**
>
> The Info palette might help you find the white and black points if you're having trouble. Choose Window, Info to see the brightness values.

1. Open a poorly exposed image and save it with a new name, such as a TIFF file or a PSD file.

2. Choose Image, Adjustments, Levels. The bell shape of the histogram confirms that this photo has very low contrast, without much black or white (see Figure 14.13).

3. Use Threshold to find the extremes. Threshold is great to use immediately before Levels. Choose Image, Adjustments, Threshold to find the blackest and whitest part of the image (see Figure 14.14). Open the Threshold window and then move the slider all the way to the left. Slowly move it to the right until you see black appear in areas you recognize. Those areas are the darkest part of the image. Move the slider to the right and then slowly move it left to see where the brightest areas are in the image. Remember these locations in the image and then select them with the black and white eyedroppers in the Levels dialog box later.

4. Click on the black-point eyedropper and find the darkest part of the image that should have detail. In this image, it is the eye (unfortunately). Click to set the black point.

FIGURE 14.13
White underexposes, especially on a bright sunny July afternoon.

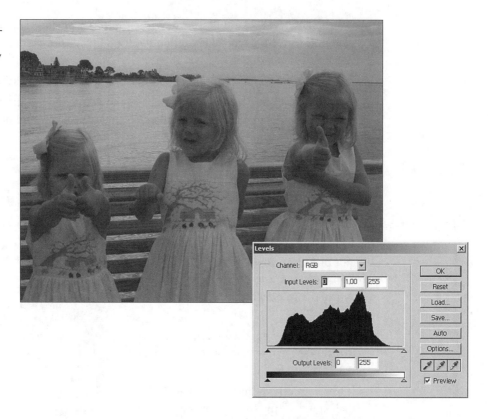

FIGURE 14.14
Threshold shows you the darkest and lightest parts of an image.

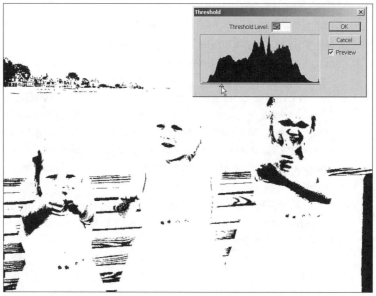

5. Click on the white-point eyedropper in the dialog box. Move the cursor over the image to the whitest area that should have detail. In this image, it is the side of the dress closest to the sun. Click there to set the white point (see Figure 14.15). Setting the white point for this very low-contrast photo shifts the center (midtone) slider and the right (highlight) slider to the left.

FIGURE 14.15
Setting the white point.

At this point, most images have been improved so much you'll be satisfied. Most will benefit from adjusting the midtones, however. Here, even with a crisp white and deep black, the photo is too dark in the faces.

1. Move the middle (gray) slider under the histogram to the left or right. A slight move to the left improves the image (see Figure 14.16).

2. Continue slight adjustments until you are satisfied with the balance of dark and light in the midtones. Save the image when you have finished.

In the next chapter, you will explore more tricks with Levels and also with Curves, which are even more powerful at correcting images.

FIGURE 14.16
Adjust the midtones as the finishing touch, and now the underexposed image is corrected.

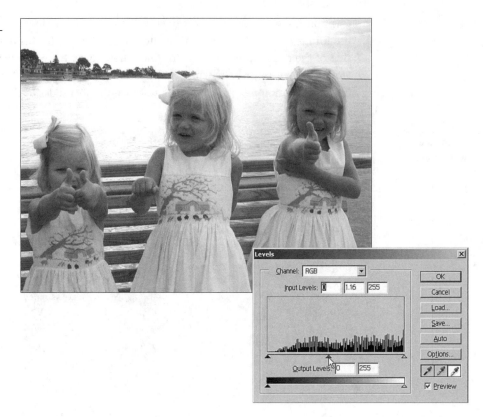

THE ABSOLUTE MINIMUM

A few point regarding histograms and adjusting brightness and contrast in images:

- Histograms show the distribution of pixels in an image across 256 brightness values. Pure black is on the left; pure white is on the right.

- Use histograms to see whether your image is lacking brightness and contrast. Empty, blank areas in the histogram indicate missing values.

- Use the black and white sliders in the Levels dialog box to adjust brightness and contrast.

- Double-click on the black-point and white-point eyedroppers in the Levels dialog box to set baseline black and white values.

IN THIS CHAPTER

- Using Levels to Fix Your Images
- Using a Curve to Correct Dark Tones
- Using a Curve to Correct Light Tones

15

THE IMPORTANCE OF LEVELS AND CURVES

Digital photographers use image editors primarily for one task: correcting images that weren't exposed properly. This capability is the biggest advantage to "going digital." You can recover images that normally would be thrown in the trash, or make great images even better. With the Levels and Curves tool, you no longer have to endure bland, gray, underexposed images or washed-out bright images!

Two correction tools common to image-editing applications are Curves and Levels. In Photoshop, you can access these tools by choosing Image, Adjustments, Levels or Image, Adjustment, Curves (see Figure 15.1). In Photoshop Elements, which only includes Levels, choose Enhance, Brightness/Contrast, Levels. Use Curves or Levels to give your image more "snap," or to fix an exposure error.

FIGURE 15.1

Photoshop's Levels and Curves tools for a black-and-white image.

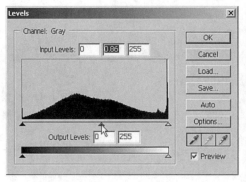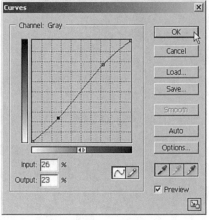

This chapter will show you how to use Levels and Curves. The Levels tool is a little easier to understand and is powerful enough for most photographers. Curves provide tremendous editing capabilities for specific luminance values, but can be learned quickly, so anyone can use it. This chapter explains the use of each tool in detail and also provides tips on how to leverage these tools when you're in a hurry.

Using Levels to Fix Your Images

Most image editors include a fast fix for bland images. In Photoshop for example, you can take the following steps:

1. Open your image.
2. Select Image, Adjustments, Auto Levels.
3. The image will adjust to improve contrast and correct the distribution of tones in the image.
4. Save your image as a JPEG, GIF, or TIFF file.

The Auto Levels feature is for those in a hurry. You can fix an image in seconds and then email or print it. This automated feature comes in handy when you are in a hurry, but often it doesn't fix an image properly. For example, look at Figure 15.2.

The goal in Figure 15.2—to convey the calm stage set before the big show—doesn't fall in line with Photoshop's goal: adjusting tones to take advantage of all the tonal values. Auto Levels simply pulls out all the brightness it can muster and ruins the image. For this reason, you should learn more about the Levels dialog box.

FIGURE 15.2

The result of Auto Levels occasionally doesn't produce the desired effect.

Before Auto Levels After Auto Levels

Levels Dialog Box

The Levels dialog box in Photoshop and Photoshop Elements is a subset of Curves. It isn't as powerful as Curves, but it is actually easier to use. The reason is that the Levels feature includes a visual representation of your image called a histogram. A *histogram* is a visual graph that shows the amount of pixels in an image that use specific brightness values.

If you have an image open, examine its histogram by choosing Image, Adjustments, Levels. In Photoshop Elements, choose Enhance, Brightness/Contrast, Levels.

tip

You can also view a histogram of your image in Photoshop by clicking Image, Histogram. This view provides significantly more information on the tonal values in an image, but the information isn't really valuable unless you plan to use Curves.

In 8-bit mode, an image can have 256 luminance values (or different brightness values) for each color. In other words, 256 shades of gray between pure black and pure white are available for each pixel in each channel in a color image. A histogram (see Figure 15.3) shows whether all 256 tones are being used (the x-axis of this graph), and how many pixels in the image use a specific value (the y-axis).

FIGURE 15.3

A histogram. The x-axis shows 256 gray (brightness) values; the y-axis shows the amount of pixels with each gray value.

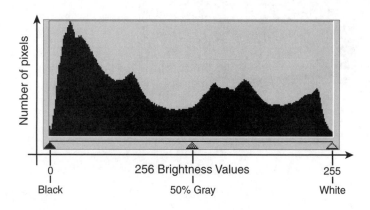

How Can Color Images Use Gray Values?

This talk of gray tones might seem foreign if you only work with color images. But gray tones play a major role in color images, too. Remember that all color images are made up of channels—plates that store information about a specific color. These channels resemble the dye layers that make up color negative film: a layer of dye for each color.

Most digital cameras use the RGB color space, which means there is a Red channel, a Blue channel, and a Green channel. These channels by themselves are actually black-and-white images that contain gray brightness values. As such, each channel (R, G, and B) contains a combination of the 256 tonal values for brightness.

Working with Histograms and Levels

Not all images share the same histogram. Here are some histograms of different image types (see Figures 15.4–15.6) as they appear in the Levels dialog box:

FIGURE 15.4

This histogram shows a balanced distribution of tones in the image. Chances are good this image is bright, contrasty, and needs little, if any, correction.

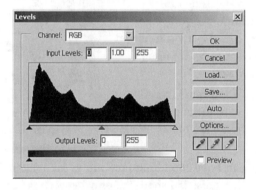

FIGURE 15.5

This histogram, with most of its pixels at the lower end of the tonal range (in other words, dark pixels), either needs correction or is a night shot that conveys a dark mood.

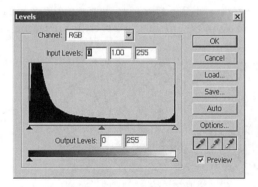

FIGURE 15.6

This histogram, with most of its pixels closer to white, is either an outdoor shot on a brightly lit, overcast day, or a mistake courtesy of excessive flash.

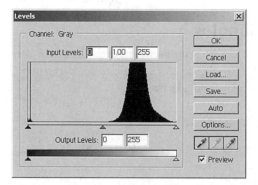

The bottom line is that each image you open has a different distribution of tonal values. The graph shows how many pixels contain a specific brightness value. Dark images will always have most of their pixels on the left side of the histogram. Bright or light images will have the majority of their pixels at the far right end. Images with excessive gray values will have a pixel distribution in the center of the histogram. The goal is to have pixels represented at each point on the x-axis of the histogram.

Fixing an Image

To fix images with awkward histograms, use the slider triangles under the histogram to change the distribution of tonal values in the image. Follow these steps to fix a sample image:

1. Open an image that needs correction and save it with a new name.

2. Select Image, Adjustments, Levels. The Levels dialog box will appear.

3. Look at the histogram for your image. If the graph looks balanced with pixels at every tonal value, you might not need to do anything. If the black triangle is to the far left of the graph, slide it to the right until it is under the start of the histogram. If the white triangle is to the far right of the graph, slide it to the left until it is under the start of the histogram.

4. Click Preview to view the change to your image. The image should appear brighter, with more contrast, and generally more appealing.

5. If the change is not what you wanted, click Cancel or press and hold down the Alt key and click Reset (the Cancel button changes to Reset when you press and hold down Alt). On the Mac, press ⌘ to see the Reset button.

The Purpose of Levels Triangles

The sliders under the Levels histogram represent absolute black, 50% black (middle gray), and absolute white (see Figure 15.7). These colors correspond with values of 0 for black, 128 for middle gray, and 255 for white.

Histogram of Image

FIGURE 15.7

Levels histogram.

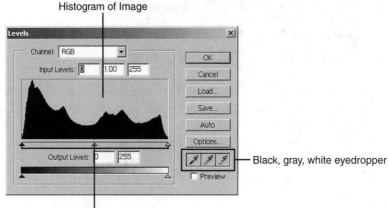

Black, gray, white eyedropper

Black, gray, white slider triangles

Here is a breakdown of the sliders. Examine Figures 15.8 and 15.9 for a visual aid in understanding how these sliders work:

FIGURE 15.8

Some images seem to have a gray haze over them. This often occurs when a picture is taken underexposed at high noon.

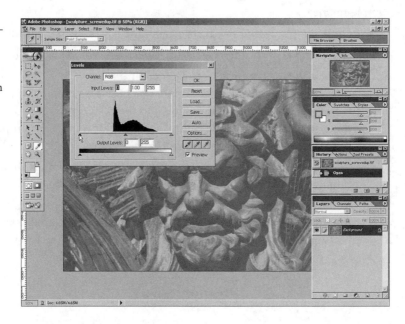

FIGURE 15.9

Move the sliders under the histogram to force tones to pure black and pure white.

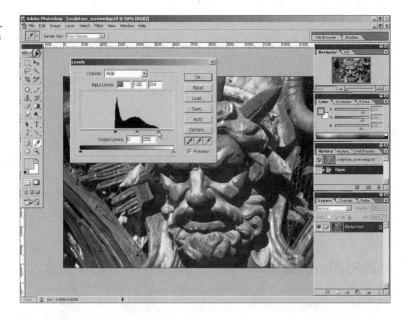

- **Black slider triangle.** Move this control to the right to force grays to black. All tones to the left of the slider will become black.

- **Gray slider triangle.** Use this slider to re-adjust the average gray value (50% black). If you slide this triangle to the right, the image will become darker because lighter tones will be forced to 50% black. Shift the gray slider to the left to force darker tones to 50% black. This will lighten the image.

 Most images suffer from lack of contrast, which involves the white and black triangle sliders, not the gray slider. For images that do not need much adjustment, use the gray slider to give the image a little more punch. For example, slide the gray triangle to the right to force lighter values to middle gray, which will make the image a little darker.

- **White slider triangle.** Move this control to the left to force grays to white. All tones to the right of this slider will be turned white in the image.

The Output Levels Section

The Levels dialog box includes two sections: Input Levels and Output Levels. This chapter focuses only on the Input Levels section in the Levels dialog box. The Output Levels section at the bottom of the dialog box is mainly used for offset (magazine/book/newspaper) printing. Output Levels includes a gradient through which you can force tones to a specific brightness.

Printing press work usually requires that true black and true white have some tone (or color) to them. This is because of the need for some type of ink to appear on the paper, or to avoid random coloration if a pure black were to be present. The sliders on the Output Levels gradient are pulled in a little to a value of usually 97% black and 3% white.

Correcting Images with Curves

Curves enables you to control the tonal variation in an image. The graph that appears when you access curves performs a function similar to Levels, but uses a visual cue—a line on a graph—as the interface between the image's tones and the user. In Photoshop you can access the Curves dialog box by choosing Images, Adjust, Curves.

Curves for People in a Hurry

When you move the line and change its shape (by clicking and dragging), the image's tones change interactively. If you are in a hurry, one quick solution is to use the classic "S" curve, which boosts contrast by increasing brightness levels and making dark tones blacker. Just follow these steps:

Photoshop Elements includes a Levels dialog box but no Curves feature. iPhoto includes only brightness and contrast adjustments.

1. Open an image and save it with a new name so that you do not alter the original.

2. Choose Image, Adjustments, Curves. In the Curves dialog box, make sure the Preview box is checked. Time to create the classic S curve.

3. In the Curves dialog box, move the diagonal line in two places: Click and drag near the top right of the curve and move the curve to the left. Afterward, click and drag near the bottom left of the curve and drag to the right. The goal is to create the S curve (see Figure 15.10).

4. Click OK and review the image. If you make a mistake, press and hold down Alt. The Cancel button will change to a Reset button. Click Reset and then start again, if necessary.

FIGURE 15.10

The classic S curve that is often used as a gauge to increasing brightness and contrast in an image.

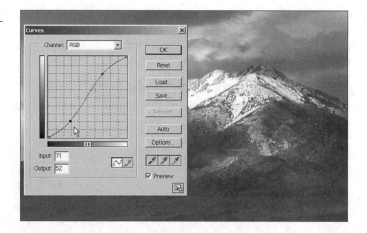

Understanding the Curves Dialog Box

The Curves command changes brightness, contrast, and color balance more power-fully than the Levels and Color Balance commands. Levels enable you to adjust only three points on the tonal scale: black, middle-gray, and white; Curves lets you adjust as many as 16 gray points, more than most images need. In addition to a curve for the combined colors, there is a curve for each primary color. Thus Curves will do what the Color Balance command does, and do it with more power and control.

The straight line from the bottom-left corner of the graph to the top-right corner is what will become a "curve." When you click and drag on the line, it becomes elastic and forms a curve (see Figure 15.11). Moving this line changes the tones of the image.

FIGURE 15.11

The curve becomes an elastic curve when you click on it and drag with the mouse.

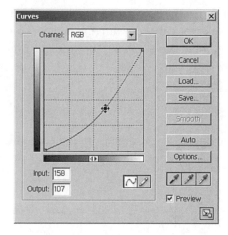

Understanding input versus output is the key to using Curves. When the curve is moved, the brightness of the pixels changes. If the curve moves down, the image's pixels become darker. If the curve moves up, the image becomes lighter.

Using a Curve to Correct Excessively Dark Tones

The image in Figure 15.12 has good white tones and black tones, but the midtones are too dark.

FIGURE 15.12

The image before editing.

Correcting this image with Curves is easy. Because the problem is that the midtones are too dark, simply drag the middle of the curve upward (the midtones are in the middle). The tones become lighter wherever the curve is moved upward (see Figure 15.13).

FIGURE 15.13

Correction with Curves.

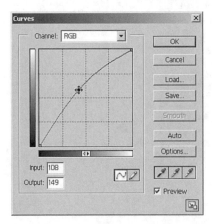

Fortunately with Preview checked, you can see the effects on the image as the curve is dragged upward. The middle tones are now clear and visible in Figure 15.14.

FIGURE 15.14

After editing.

Using a Curve to Correct Excessively Light Tones

Curves fix problems with light tones as well, such as when you overexpose an image. This occurs commonly at night with a flash. The image in Figure 15.15 has a problem: The camera flash has overexposed it after a valiant attempt to capture the natural look of the bar with a slow-sync flash setting.

FIGURE 15.15

A slow-sync shot overexposed by too much flash.

With slow sync, the flash fires but the shutter remains open to capture any natural light in the image. When the camera meter mistakenly meters a scene, a slow-sync shot turns into a washed-out, blurry image.

To fix this problem, simply open the Curves menu by choosing Image, Adjustments, Curves. Then pull down the elastic line to lower the brightness of the midtones in the image. The image should now look correct: plenty of contrast and brightness with no glare.

Getting Information About the Image

With the image onscreen and the Curves dialog box open, you can move the cursor over the image and see brightness information appear interactively in the Curves dialog box. As you move your cursor over the image, the eyedropper icon displays:

- A circle on the curve, showing the brightness of the pixel under the cursor.
- A numerical brightness value for the pixel below the curves graph. The Input box shows the brightness value (0–255) of the pixel before the curve was edited, and the Output box shows the pixel's brightness value after editing (the current value).

Moving the cursor with the mouse button held down enables you to sample pixels from many places in the image (see Figure 15.16). As the cursor glides around, the circle on the graph moves and the corresponding numbers change. The information you gain can help you decide how to place new points on the curve and which way to drag them to change their brightness.

FIGURE 15.16

Use the cursor to sample brightness values in the image.

The steepness of the curve controls the contrast of the image. A steep curve results an image with considerable contrast. A flat curve gives the image low contrast.

Color Corrections with Curves

The Curves dialog has a curve for the combined colors, plus individual curves for each color.

You can adjust specific color channels. In an RGB image, for example, select the Green channel to correct a color problem (see Figure 15.17). You can see in the curve shown in Figure 15.17 that green is emphasized when a picture is taken through a tempered car windshield, causing magenta shadows and greenish highlights.

FIGURE 15.17

Adjusting the green channel curve.

The green curve is raised in the shadows (which adds green) and lowered in the highlights (which subtracts green).

Accessing Levels and Curves Adjustment Layers

Now that you know how to use Curves and Levels, you need to learn the best way to access them. There are two ways to open the Levels and Curves dialog boxes. Clicking Image, Adjustments, Curves or Image, Adjustments, Levels opens the ordinary controls. Layer, New Adjustment Layer, Curves or Layer, New Adjustment Layer, Levels opens these tools in an adjustment layer. Either method produces the same interface and changes the image's appearance in the same way.

Professional photographers always use adjustment layers to keep changes away from the original image. This improves clarity in the image and enables you to turn on/off each change you make to an image.

Follow these steps to edit an image with a Curves adjustment layer:

1. Use an adjustment layer to make your changes. Select Layer, New Adjustment Layer, Curves from the Layer menu or click the Adjustment layer icon at the bottom of the Layers window.

2. Be sure the Preview box is on (an × is in it) so that the entire image will change as you edit the curve. Before you begin changing the curve, click on different tones of the image. This makes a marker appear on the curve corresponding to the brightness of the pixel you clicked. Use this marker to learn about the relationship of the curve to the image.

3. Click on the curve to create points and drag them until you have created a good curve for the image. The image should appear sharp and with good contrast.

4. Experiment with changing the curve of each color, leaving the others unchanged. Then try giving each color a different curve. See how these changes affect the image.

5. Click OK when you are satisfied with the change, or press and hold down the Alt key and click Reset to try again.

The beauty of adjustment layers is that:

■ You can turn them off and see the original image.

■ You can drag them to the trash if they're unnecessary.

■ The original bits of the image are not changed until the layers are flattened and saved.

■ By adding a layer mask, you can "paint out" the change using a brush/airbrush.

note

The use of layer masks is a little more advanced than the scope of this book. If you are interested in learning more about adjustment layers coupled with layer masks, check out some of the more advanced Photoshop books by New Riders Press and Que Publishing.

THE ABSOLUTE MINIMUM

Even the most washed-out images contain valuable information. Photoshop and Elements are capable of pulling this information out of an image using Levels and Curves. By using Threshold and histograms, you can see where information lies and adjust brightness values appropriately. Keep these tips in mind when experimenting:

- Histograms of an image are available in three places: Image, Histogram, Image, Adjustments, Threshold, and Image, Adjustments, Levels.

- Choose Image, Histogram and then move your mouse over the histogram to see the number of pixels that use a specific brightness value.

- Choose Image, Adjustments, Threshold in Photoshop or Photoshop Elements to view a histogram of an image. Move the slider to the left to see the darkest parts of the image; move to the right to see the lightest parts of the image.

- The x-axis of the histogram maps the 256 brightness values available for each pixel; the y-axis maps the total number of pixels in the image at a specific brightness value.

- A common repair technique using Curves is to use the "S" shape. Choose Image, Adjustments, Curves and create an S shape to increase brightness and contrast in the image.

IN THIS CHAPTER

- Creating Image Layers
- Adjustment Layers: Preventing Color Banding and Data Loss
- Advanced Selection Techniques: The Pen Tool
- Layers Masks: Attaching a Mask to a Layer

16

THE IMPORTANCE OF LAYERS AND MASKS

Using layers is the most reliable and quickest way to combine images. Layers are images within the image. They appear stacked on top of each other, like layers in a cake or cards in a deck. Unlike cards, images in layers do not have to be the same size. Photoshop and Photoshop Elements provide the same layer tools and layer palette.

An image composed of layers is like a stack of glass plates with a photograph glued to each plate. The transparent areas outside each photograph let you view photographs on the layers below. You can move the pictures from side to side, or change the order of pictures in the stack.

Layers enable image editors to perform the following tasks:

■ Reposition the image in each layer vertically and horizontally. The image in a layer can be moved within the layer.

■ Change the stacking order of layers. A layer can be shuffled up or down.

■ Apply editing commands to just one layer. Each layer behaves like an independent image. Color balance, hue, saturation, levels, selections, and brush effects can be applied to a layer without affecting the other layers.

■ Make a layer semitransparent so you can see through it. In addition, a layer mask can be applied to a layer, letting you control the transparency more precisely. For example, a mask can make an image in a layer transparent or semitransparent in its center, but opaque around its edges.

Adjustment Layers Are a Different Kind of Layer

Adjustment layers do not contain images. Instead, they contain editing commands, such as Levels or Color Balance, that are applied to some or all of the image layers below them (see Figure 16.1).

FIGURE 16.1
Adjustment layers protect an image while you edit it.

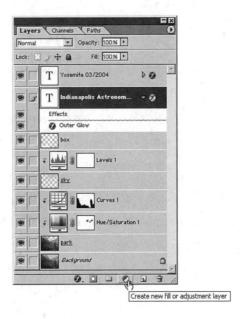

Type layers are a third kind of layer. Type layers contain numbers and letters that appear in the image (see Figure 16.2). Type layers can be reopened for editing.

FIGURE 16.2
Type layers enable you to edit type without sacrificing the image or the text.

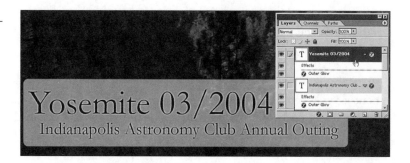

In Adobe Photoshop, layers are stored in the Layers palette. To see the Layers palette, choose Window, Show Layers. The order of the layers in the palette matches the top-to-bottom order of the layers in the image. The eye icon is present when a layer is visible. Making layers temporarily invisible is helpful when editing other layers.

Many types of editing can be done to only one layer at a time. You must click to select the layer you want to edit; the selected layer is called the *active layer*. When a layer is active its name is in boldface, and its bar is highlighted. When a layer that contains an image is active, it will also display a paintbrush icon next to its name bar. Adjustment layers and type layers don't contain images.

Creating Image Layers

How are image layers created in Photoshop and Photoshop Elements? Follow these steps:

1. Open an image in Photoshop.
2. Choose Layer, New Layer. You can also select the New Layer icon in the Layers palette (see Figure 16.3). Choose Window, Layers to view the palette.

FIGURE 16.3
Select the New Layer icon in the Layers palette to create a new layer.

3. Click on the Type tool and then click the cursor somewhere in the window. When you use the type tool to place text in the image, each text entry creates its own layer.

If you copy another image and paste it into this image, a new layer will also be created.

Whenever you create a layer from a menu or palette, you'll be asked to name it. However, if you paste a picture into an image the layer will be named automatically. It's easier to keep track of layers when they have descriptive names ("Red Toyota"). You can rename a layer by double-clicking on its current name in the Layers palette (Photoshop) or by right-clicking on the layer and choosing Layer Properties.

Semitransparent layers can create strong visual effects. When you set the opacity of a layer to less than 100 percent, it becomes semitransparent and the layers beneath it can be seen.

Blending and Opacity Experiment

Try your hand at blending. If you have two images, blend them together using these steps:

1. Open two images in Photoshop.

2. Click on one of the images to select it. Choose Select, All, and then Edit, Copy to select the entire image.

3. Paste the image into the new image by choosing Edit, Paste. Photoshop automatically places it on a new layer.

4. In Photoshop, double-click the new layer thumbnail icon to access the Layer Style dialog box (see Figure 16.4). Photoshop Elements does not include this powerful dialog box, but for this exercise the Opacity slider on the Layers palette provides the same effect.

FIGURE 16.4

Layer Style dialog box in Photoshop.

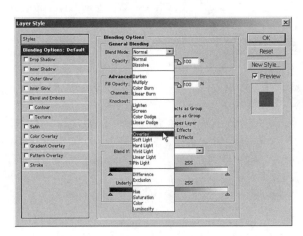

The Layer Style dialog box in Photoshop includes many effects. The General Blending mode is often the most important effect; it enables you to make the image in the layer opaque or semitransparent. The Opacity slider in Elements provides the same effect.

5. Slide the Opacity slider down to 50% and then click OK. Notice the Opacity value changed in the palette. You can access Opacity in either place.

6. Re-open the Layer Style dialog box and experiment with the Blend If section under Advanced Blending. This feature is only available in Photoshop, but similar capabilities are possible in Elements by changing Normal in the Layers palette to Darken, Lighten, Color Dodge, or Color Burn. This depends entirely on the colors in the background image, so your results may vary.

The Blend If section enables you to make parts of the layer transparent while leaving the remainder opaque. For example, Blend If lets you make only the lightest pixels of the layer opaque. Wherever its pixels are dark, they are made transparent and the underlying image shows through. Blend If also permits separate opacity effects for each primary color.

Harmonizing the Elements of a Collage

When images are pasted into other images, they often clash with their new surroundings (see Figure 16.5). Something about them looks wrong. If realism is your goal, an image blended into a background must match the background in several ways.

FIGURE 16.5
Two layers clash with their background.

Matching color balance and saturation is important to making realistic collages. In the preceding image, one layer has a cyan-blue color cast, which can be corrected with the Image, Adjust, Color Balance command or with Levels or Curves.

The other layer is balanced, but it has too much color saturation. The Saturation command via Image, Adjust, Hue/Saturation could remedy this.

Scale and Resolution in a Collage

An object's size must harmonize with its background. If an object is placed anywhere that gives clues as to its spatial relationship with the background, it is easy to see whether it looks too large or too small. It's also easy to see a clash between an object and the background if they differ in sharpness or graininess.

A conflict of perspective can occur when two images taken by lenses of different focal length are combined. For example, imagine two people shown talking face to face. The result will look peculiar if one person was photographed with a wide-angle lens and the other was photographed with a telephoto lens.

The quality of the light on an object can make that object look like it doesn't belong in the picture. Sunlight casts shadows and creates sharp boundaries between the sunlit and shadowed parts of an object, whereas light from a cloudy sky is smooth and without shadows. Make sure your subjects are all lit from the same angle before blending.

The direction of light is important, too. If the background light appears to come from the right, it will be distracting when the light on a foreground object comes from the left. Contrast often needs to be adjusted if an object is to blend into the background; it's distracting when several shadows don't look equally dark. Note that indoor light often comes from several directions—each light source may have a different color tint.

Managing Layers

An image with many layers can use up all the memory (RAM) on your computer. This will slow your computer down and make it difficult for you to work productively. Images with fewer layers also print more quickly; in some cases, an image with too many layers might fail to print or cause the computer to freeze.

Speed up your computer by reducing the number of layers. You can merge layers together. In Photoshop and Elements you can merge layers using several options:

- **Layer, Merge Down** merges the active layer into the layer shown below it in the Layers palette.

- **Layer, Merge Visible** merges all the visible layers (those with their eye icons visible in the Layers palette). The active layer must be visible or this command will not work.

- **Layer, Flatten Image** merges all the layers into one layer.

If you work with TIFF or PSD files, you might see the error message "Layers will increase file size" when saving, even though you only have one layer in your image. Usually this means you haven't flattened the image. Cancel out of the save, and then choose Layer, Flatten Image.

Layers are saved only when the file is saved in Photoshop (PSD) format or TIFF format. Layers are not saved in JPEG or GIF formats. Save an archival copy of your image in Photoshop format if you believe you might work on it again in the future.

Creating an Extended Family

Follow these steps to add people to an image using layers:

1. Find several digitized images of your family or friends. Your artistic goal is to combine people from the separate images so they seem to belong together, or to make the image obviously artificial but acceptably plausible.

2. Use the selection tools (Lasso, Rectangle Marquee, and Pen) to copy images of people (with or without their surroundings) from two or more sources and paste them into a third image. Consider whether you want realism or an artificial look. Realism requires much more work. You'll be combining images from several sources, so you'll need to plan ahead to ensure that the people's images are the right size relative to each other.

3. Choose one image as the "master." Choose Image, Image Size in Photoshop or Image, Resize, Image Size in Elements. Note the Resolution in the Image Size dialog box. All the other images should have a similar resolution.

4. Check the resolution in the other images to be copied and ensure they have the same resolution. If they do not, you can change their resolution in the Image Size dialog box.

5. Copy and paste each image into the master by selecting the image (or a portion of it) using Select, All and then Edit, Copy and Edit, Paste. Each pasted image will appear on a new layer. Use the Lasso tool or the Pen tool if you want to select only a portion of an image.

6. Apply color and tonal corrections to each layer to make it match the master image. Layers enable you to make tonal corrections without affecting the other images (layers). You can also move the layer's image until you have a satisfactory composition.

7. Keep file size in mind while you work. If you are pasting a large number of images, you might need to "merge down" some layers to keep the computer/RAM happy. The only indication that things are out of control (RAM-wise) is that Photoshop will slow to a crawl. Use the Layer, Merge Down command to keep layers organized.

8. Adjust the tones and colors of each individual layer using adjustment layers. If your composition works, you will create an artificial but interesting group portrait, or a complete joke!

This general exercise is just a guide to help you consider the issues common to photographers and artists who merge images together.

note

If you paste in an image and it is dramatically larger or smaller than the other images, the file resolution might need to be changed. Delete the new layer or choose Edit, Undo and then return to the image and change its resolution by choosing Image, Image Size (Photoshop) or Image, Resize, Image Size (Elements).

Preventing Color Banding and Data Loss in Adjustment Layers

Normally, as you edit an image, its data is altered forever. For example, if you change gray pixels into pure white pixels, the changed pixels are given new values of red 255, green 255, and blue 255. If you cannot Undo the change, all records of the original values are lost forever. Often, after a series of edits, the original data is so altered that only a few thousand of the original 16 million colors remain. The result is that banding is visible (see Figure 16.6).

The image on the right in Figure 16.6 has gaps that look like the teeth of a comb. These gaps represent brightness levels where data was lost during editing. At the left is the histogram box for an image that has had the same editing done with adjustment layers. The image has smooth gradations, and all of its original tones are present in the histogram.

Without adjustment layers, colors can show bands. A histogram can be used to diagnose banding. This image was previously edited with Curves, Color Balance, Hue, and Saturation commands. Banding is visible; the tonal gradation has an abrupt staircase appearance instead of a smooth, normal transition.

FIGURE 16.6

Banding occurs when you edit colors without adjustment layers.

Adjustment layers solve banding problems. Adjustment layers (Layer, New, Adjustment Layer) enable you to edit many aspects of the image without ever changing the original pixels. An adjustment layer contains no image, just commands that alter tones and colors in the layer(s) beneath it. The adjustments never alter the original pixels. An adjustment layer's effects are permanently "undoable," even if you reopen the image years later.

Adjustment layers do have limits, however. Not all image editing can be done in adjustment layers, but many important ones can: Levels, Curves, Color Balance, and Hue/Saturation. Certain special effects, such as drop shadows and type effects, can also be applied in adjustment layers. Unfortunately, at this time adjustment layers cannot be used to change image resolution or to apply filters like Unsharp Mask.

note

The History palette in Photoshop 5 (and later) and the Undo History palette in Elements enable you to step backward a number of steps. These Undo steps are erased each time you close the image, however. You cannot undo anything when you reopen the image.

Adjustment layers appear in the Layers palette. Instead of displaying a paintbrush icon to the left of its name, an adjustment layer displays an icon that indicates a "mask."

An adjustment layer normally affects all of the layers beneath it. However, if you want to limit its effects, you can group it with one layer (or with several layers) using the command Layer, Group with Previous (see Figure 16.7). Layers beneath the grouped layers are not affected by the adjustment layer. After you create an adjustment layer, group it with a specific layer to prevent the adjustment from affecting the entire image.

FIGURE 16.7

An adjustment layer can be grouped with a specific layer.

Group with Previous arrow. Layer modifies layer below it.

Making a Composite Image Step by Step

Web developers and artists often must combine images into a composite image much like the collage you read about earlier in the chapter. If you need to combine several images for a Web graphic or just for fun, this section will walk you through the important steps.

Visualize the Image

Before starting, visualize your final image and decide which component images you will use. Don't plan an image that's too big for your computer or its memory. Remember that by opening several images at the same time and having many layers in an image, you will increase the demands on your computer. Sketch what you have visualized. Draw a picture of your background image (the master image) and place paper cutouts of each component layer over it. Will the image components work together visually? Will they create an interesting image? Make changes in size and placement until you have a good design. Sketching on paper is faster than using a computer to sketch a design.

Inspect Each Component

Examine the component images together at the same magnification (see Figure 16.8). Do the components and the background have compatible contrast, color balance, and saturation? If you plan a realistic image, do the components have similar lighting qualities (hard-edged light or soft light), and is the direction of the light the same? If the light is incompatible, you might need to choose other components or play with the Render filters in Photoshop.

Examine each component to see how difficult it will be to remove it from its background. If the selection process will take too much time, you might want to use another component image.

Adjust All the Components

Compare your sketch with the components on the screen. Will you need to resample any of the components so that they all have the right size? Components that are too large can be scaled down, but components that are too small might need to be rescanned at a higher resolution. If you need to make scans for any missing components, be sure their pixel resolutions are compatible.

When reducing the size, use the Image, Image Size command (see Figure 16.9). Check the Resample Image box and select Bicubic from its drop-down menu. Bicubic resampling retains the highest image quality, although it takes more time than other options.

Adjust the contrast, color balance, and saturation of all the components. You will get a chance to fine-tune them later, so this adjustment can be approximate.

tip

You can also scale the image after pasting it onto the background. Click Edit, Transform, Scale and hold down the Shift key while scaling.

FIGURE 16.9

Changing your image size using the Image Size dialog box.

Select a Component and Copy It

The proper selection process will make component images blend into the background image more easily. Almost all selection procedures are easier and more precise if you zoom the monitor image to 200 to 400 percent magnification.

Keep these tips in mind when selecting complex objects in an image:

- If the colors of the background image and the component image are identical, select the area you want to copy with the Lasso tool. Feather the selection and draw the selection far enough away from the subject so that it isn't in the feathered area.

- If the background must be removed around the edges of the subject, try selecting the background with the Magic Wand or the Color Range command. Then use Select, Inverse command to deselect the background and select the subject.

- If the background must be removed, but the edges of the subject are out of focus or difficult to work with (such as hair), make selections with a Pen tool because pens are precise and allow selection boundaries to be changed later if they are not perfect. Many experienced users prefer to use masking, another process for creating editable selections. You can read more about masks in Chapter 17, "The Importance of Channels."

- Dedicated masking software such as Extensis Mask Pro works in conjunction with Adobe Photoshop. These tools and plug-ins offer sophisticated features that simplify creating selections.

After making the selection, save the selection by choosing Select, Save Selection in case you need to redo it.

Copy the Selection and Paste It into the Background Image

Use the Move tool (in the main Tool palette) to position the new image over the background. Determine how well the new image blends in. If too much of the old background remains around its fringes, you might try erasing the unwanted fringe with a tiny brush. If this doesn't work, you'll need to redo the selection process.

Evaluate the layer's overall quality. Is the image on the new layer the right size? If it is too large, you can scale it with Edit, Transform, Scale, but if it's too small, you'll need a larger original. Are the contrast, color balance, and saturation settings correct? You can use a grouped adjustment layer to correct the contrast and color imperfections of any one of your component images.

Flatten the Image When Finished

Before you flatten the final image by choosing Layer, Flatten Image, save a copy of the original with all of its layers in case you need to edit it again. You can always burn the large file to CD if it's taking up too much room on your hard drive.

Advanced Selection Techniques: The Pen Tool

Occasionally you will need to select large areas precisely. Outlining tools, such as the Lasso, are effective and extremely precise, but they are cumbersome for drawing large selections. The Pen tool combines the advantages of the outlining tools with greater speed and flexibility (see Figure 16.10).

FIGURE 16.10
The Pen tool at work.

A Pen tool lets you draw editable selection boundaries. The Pen tool creates a series of automatically connected lines (*a path*) that can be edited after they are drawn. A path can be moved, stretched, and curved. The lines of a path are so flexible that they can be made to curve around and enclose complex shapes. If the path's two ends are joined together to form a complete enclosure, the entire path can later be turned into an ordinary selection, which can be further edited with any of the regular selection-modifying commands. Creating a path does not automatically create a selection; you must convert the path into a selection with a command.

Drawing a Straight Line

Follow these steps to draw straight lines with the Pen tool (see Figure 16.11). You will eventually turn these lines into a selection.

FIGURE 16.11

Creating a selection with the Pen tool and straight lines.

1. Select the Pen tool and create an anchor point by clicking on the image wherever you would like to create a selection (outline).

2. Move the pen and then click the mouse to "set" the next anchor point. A path will appear between the two points.

3. Click repeatedly to place additional anchor points as you trace an object in the image. This creates anchor points with straight lines between them.

4. When you return to the starting point, the cursor will display a small circle. This means you can click at that point to close the path.

5. If the path is indeed closed, right-click on the path with the Pen tool and choose Make Selection. A small dialog box will appear asking for some settings (see Figure 16.12). The default is Anti-aliased and a 1-pixel Feather Radius.

 You now have an accurate path that is much easier to manipulate. In addition, if you need to use this selection again, you can access it in the Paths palette. Choose Window, Paths, right-click on the path you created, and select Make Selection.

6. To save the path permanently, choose the item Save Path from the Paths palette's pop-up menu.

FIGURE 16.12

Making a selection using the Pen tool.

Other Uses for Paths

Paths have other uses. Although making selections is the most useful task photographers can do with paths, paths can be filled directly with a color from the palette. Paths can also be turned into a colored line of variable width.

Paths are so versatile because they are not based on pixels—they are vector objects. Vector objects are a class of computer graphics unrelated to pixels. Pixels are arranged in rows and columns, whereas *vector objects* are mathematical descriptions of the location of points and the lines connecting them. Of course, you don't see the mathematical equations; only the lines created by the equations are visible on the monitor. These equations create curved lines, which are called *Bezier curves*.

Because a Bezier curve is only a set of numbers, it takes less memory and disk storage than a memory-hungry bitmap. This means that an image file composed of a picture plus a set of paths will be smaller than the same picture plus saved bitmapped selections. (Selections are saved as alpha channels.)

If you'd like to experiment with Bezier curves and the power of paths, follow these steps for creating a path around an image.

tip

If you need to outline a number of items in an image, use paths instead of selections. Paths take much less disk space than alpha channels, which is where selections are stored.

1. Open an image, preferably one with a sharp, distinct object that you can trace with the Pen tool. This exercise will trace a round object so that you can see how Bezier curves are formed with the Pen tool.

2. Click to create the first anchor point and hold down the mouse button while dragging the cursor in the direction you want the curve to go. Two odd-looking direction lines will appear (see Figure 16.13).

FIGURE 16.13
Creating your
first anchor
point.

3. To create a curved line that follows the curved shape in the image, direction lines with handles at their ends will grow out of the first anchor point. One of them will follow the dragged cursor. Ignore them for the moment.

4. After dragging the cursor for a short distance, release the mouse button and move the cursor to the location of the second anchor point (see Figure 16.14). It is important not to place the second anchor on the same spot where you released the mouse button. Click again and hold down the mouse button.

FIGURE 16.14
Creating your
second anchor
point.

5. Without releasing the mouse button, continue dragging. Notice that a curve is drawn between the first two anchor points as you drag the cursor away from the second anchor point. Drag the cursor so that the curve being drawn between the first and second anchor points is placed where you want it. Release when the curved line between the anchor points is the shape you desire.

6. Click in a third location to create the third anchor point, and drag to create the desired curve between the second anchor point and the third, new point (see Figure 16.15).

tip

Press down and hold the Ctrl (⌘ for Mac) key to move the anchor point you just created.

FIGURE 16.15
Creating your third anchor point.

7. Repeat this procedure until you have drawn the entire curve. When you return to the starting point, the cursor will display a small circle. If you click the path while this circle appears, the path will close.

The key to curves is that by dragging the cursor away from the last anchor point you created, you create the curved line between that anchor point and the previous one.

The Purpose of Clipping Paths

Another valuable use for paths is as a clipping path (see Figure 16.16). A *clipping path* is a mask. When an image that contains a clipping path is exported to another software program such as Adobe Illustrator, the portion of the image outside the clipping path is cropped; it is invisible (transparent) in the other program. For example, if you create a clipping path around one person in a group photograph and then export the image to Adobe Illustrator, only the clipped person is visible.

FIGURE 16.16
Clipping paths are used to create unusual shaped graphics. You are not limited to rectangles or squares.

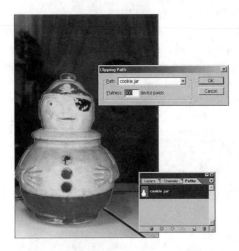

Layer Masks: Attaching a Mask to a Layer

A layer mask is a mask attached to a layer. Layer masks are useful because each mask only affects what is on the layer; the rest of the image is untouched. Two types of layer masks are useful to photographers:

- **Image layer masks**. A layer mask can make part of an image on its layer invisible: Wherever the layer mask has full density (black), the image is hidden; and wherever the layer mask is transparent, the image is visible. A partially erased mask makes the layer's image partially visible. Outlining an object is a common use for an image layer mask. By painting the mask black around the object, you'll make the layer around the object disappear.

 To create a layer mask, choose Layer, Add Layer Mask, Reveal All. As a result of choosing Reveal All, a transparent mask is created. When you paint black onto the mask, that part of the image becomes invisible. This is a forgiving procedure; if you make an error while painting, you can erase and repaint.

- **Adjustment layer masks**. Creating an adjustment layer creates a transparent mask in the Channels palette. Whenever the adjustment layer is active in

the Layers palette, its mask becomes visible in the Channels palette. When you paint on the mask, the paint masks the adjustment layer; the effects of the adjustment layer are eliminated.

Painting directly on an adjustment layer mask is the best way to force a change on only certain objects. Adjustment layers affect the entire image unless they're grouped with a particular layer. By grouping with a layer and then painting on the adjustment layer mask, you can selectively "edit" an image. The changes will only appear wherever the mask is transparent or partially transparent.

Masking an Adjustment Layer

A mask attached to an adjustment layer controls the intensity of the layer's effects. In Figure 16.17, an adjustment layer was used to decrease contrast until the image was almost a featureless gray. However, the mask protected the central area of the image and preserved its normal contrast. This creates a vignette-type of photo.

FIGURE 16.17

Using a mask on an adjustment layer.

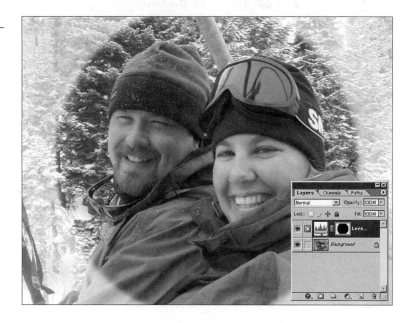

THE ABSOLUTE MINIMUM

Layers enable you to protect parts of an image that do not require changes. Keep elements in an image on separate layers so that you can easily move or resize objects.

- Photoshop Elements does not include the Curves command or Curves adjustment layer.

- JPEG images cannot store layers. You must flatten an image before saving as a JPEG. Choose Layer, Flatten Image prior to saving as a JPEG file.

- Give each layer a distinct name when working on an image. Don't settle for the default names or you will get confused.

- Adjustment layers include a mask when they are created. Click on the layer mask and then paint with the Paintbrush tool to isolate portions of the image.

- Paint white on an adjustment layer mask to reveal the effects of the mask; paint black on a mask to hide the mask's effects.

IN THIS CHAPTER

- Understanding Channels
- Keeping Track of Layers, Channels, and Masks
- Using Masks to Create Selections
- Alpha Channels: Where Masks Are Stored

17

THE IMPORTANCE OF CHANNELS

Information about colors in an image is stored in channels. An RGB image has four color channels: red, green, blue, and a composite channel of every color. A CMYK image has five color channels: cyan, magenta, yellow, black, and a composite channel of every color. Each channel is a grayscale image of brightness values for that color.

Like the dye layers in slide film, these channels blend together when the image is viewed normally and the appropriate colors are applied. The power of Photoshop and Photoshop Elements lies in the capability to view and manipulate these channels separately or in combination with more than one channel.

With Photoshop, you have the capability to view and edit channels; however, in Photoshop Elements, you can save only selections; iPhoto does not allow you to save channels or selections. Because color channels are more advanced and more complex than layers, it's important to know the difference between a layer and a color channel:

- A layer is an individual, full-color image. Layers can be stacked to create a composite image.

- Color channels are the color components of a layer. Each RGB layer has three color channels.

- When you edit color channels, you edit the color channels of one layer at a time. The active layer (the one selected in the Layers palette) is the only layer on which the color channel editing is happening.

note

Photoshop Elements does not include channels or the Channels palette. Any version of Photoshop more recent than Photoshop 3 includes channels, however.

Sometimes it can help to edit only one color channel. On occasion, one channel may be less sharp than the others, or it may appear too grainy (see Figure 17.1). To fix this, you might remove grain in one color channel by blurring it with a filter, while you sharpen another color channel with a different filter. If you'd like to try this yourself and have a copy of Photoshop, just follow these steps:

FIGURE 17.1

Removing grain using the Despeckle filter in one color channel.

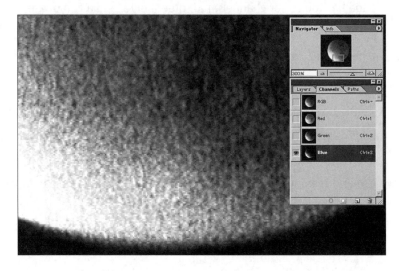

1. Open Photoshop (any version) and open a color image. Save the image with a new name to preserve the original.

2. If the image is not in RGB mode, convert it to RGB by clicking Image, Mode, RGB Color.

3. Open the Channels palette, if it isn't already open, by clicking Window, Channels.

4. Click one of the color channels in the Channels palette. The other channels will turn off and only the selected channel will display.

Again, an RGB image has three color channels plus the composite channel. Individual color channels are displayed in Photoshop as thumbnail images in the Channels palette. The composite channel is labeled RGB and represents all three channels together. When the eye icon is present next to the composite RGB channel's thumbnail, the image is displayed in full color in the main image window. When working with channels, it's always easier to see your edits when the composite RGB channel is unchecked. It's best to view the individual color channel's thumbnail images in black-and-white (instead of color) because they are easier to compare with each other.

Color channels can be viewed individually in the main image window by making the other channels invisible. Channels are turned on or off by clicking their eye icons. In Figure 17.1, only the blue channel can be seen (as a black-and-white image) in the main image window. The composite channel and other single color channels have been turned off (their eye icons are not visible).

Using Masks to Create Selections

Channels store masks. Masks are the most advanced way to create selections. Think of a mask as a sheet of plastic that lies on top of an image. Masks restrict the editing performed to the image beneath the mask.

In some ways, a mask is like a stencil. You can edit the colors and tones of the image beneath wherever you cut holes in the plastic, but nothing can change wherever the plastic is solid because the image is masked (see Figure 17.2).

One advantage of masks is their variable density. Whereas ordinary selections have feathered or antialiased edges, a mask lets you make any part of a selection opaque, transparent, or in-between. Where a mask is transparent you can edit the image normally. Where a mask has partial density,

Before a mask can be used to edit an image, it must be converted into a selection.

the editing effects are partial. For example, if you increase contrast, the image under the transparent areas of the mask shows high contrast but the image under the semitransparent areas of the mask shows only a smaller increase in contrast.

FIGURE 17.2

Masks cover an image except for those areas that are cut out.

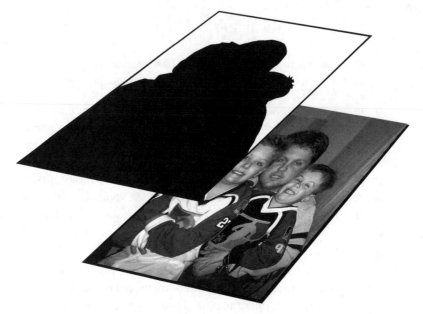

Masks are not selections; additional commands are used to create selections from masks. For example, in the Channels palette, clicking the "Load channel as selection" icon turns the currently highlighted channel into a selection (see Figure 17.3). You can also Ctrl+click on the channel where the mask is stored, or choose Selection, Load Selection.

FIGURE 17.3

Loading a mask in the Channels palette.

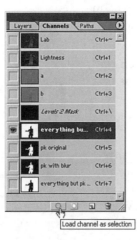

Seeing Through a Mask

A mask can be easier to use than an ordinary selection because of its visibility. Ordinary selections are visible because their edges are marked by a moving marquee (the marching ants). But if it's a feathered selection, the marquee doesn't show exactly where its edges are. A mask is better; you can see all of it.

A mask appears on the monitor as a blanket of color over the image. The colored blanket is most dense where the mask is fully opaque and is transparent where the mask is transparent. You choose both the color of the mask and how opaque you want it to appear on the monitor. (Usually you don't want a mask to be so opaque that you can't see the image beneath it.) You can also temporarily make the mask invisible if it blocks your view of what you're doing.

note

A feathered selection blends into the area outside the selection. In Photoshop make a selection, then click Select, Feather.

Adobe Photoshop treats masks as grayscale (8-bit) images. This has significant consequences. Because the software treats masks like images, you can edit them like images. This means you can use a brush to paint on a mask, making the mask either more opaque (blacker) or more transparent (whiter).

Because masks are treated as images, you can also paste shapes and other images into masks. For example, you can put type into a mask; the shapes of the letters can then be transformed into colors or effects (see Figure 17.4). You can paste images into masks (but only 8-bit grayscale images).

Selections also can be turned into masks. Clicking the Save Selection As Channel icon in the Channels palette turns the selection into a mask. Why do this? Most complex selections start with a simple selection, as you might make with the Lasso tool or the Magic Wand; by turning them into masks, you can edit them more precisely. Finally they are turned back into selections. This might sound roundabout, but it is a powerful technique. For example, it is helpful when creating extremely complex selections, such as around someone's hair.

FIGURE 17.4
FIGURE 17.4
Adding type to
a Layer mask.

Removing an Object from an Image and Pasting into Another Image

How would you remove an object from one image and paste it into another image?
The following steps will show you how to move a person from one image to another.

1. Use the Quick Mask tool to create a selection. First switch to Quick Mask
 mode by clicking the Quick Mask icon on the toolbar (see Figure 17.5).

FIGURE 17.5
The Quick Mask
icon.

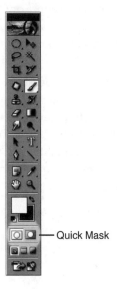

Quick Mask

2. Use the paintbrush at varying sizes to mask over the subject to be inserted. Press Ctrl+I (⌘I for Mac) to invert the mask. Occasionally you will need to invert the entire selection to remove mistakes.

 Hair is always a problem and is only roughly selected in the image (see Figure 17.6). More work must be done on the hair. This is especially difficult in images where it's difficult to see the hair against the background.

FIGURE 17.6

Selecting a person's hair with in Quick Mask mode.

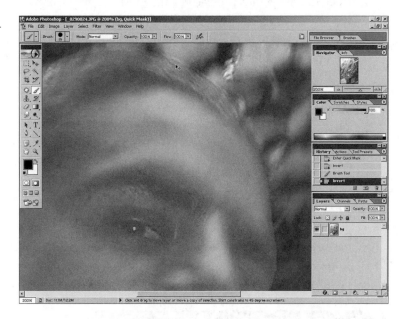

3. To turn the mask into a selection, simply switch out of Quick Mask mode by clicking the icon to its left and then click Select, Save Selection. The mask is shown as light red where is it opaque and is transparent over the former selection.

4. Now load the selection by clicking Select, Load Selection.

5. Copy the selection by clicking Edit, Copy or pressing Ctrl+C (⌘C). If you have inverted the selection, click Select, Inverse or press Ctrl+Shift+I (⌘-Shift-I).

6. Move to the new image and paste it by clicking Edit, Paste or Ctrl+V (⌘V). The selected area was then copied and pasted into another image, which appears behind the figure's hair.

tip

To improve hair selections, edit the quick mask you've created by painting. Delicate detail can be preserved with semitransparent brushstrokes.

Using a Mask Created from an Image to Create Special Effects in Another Image

Follow these steps to merge two images and create art:

1. Open any image that you want to become the background. In this example, a landscape from Greenland will become the background.

2. Open an image that will become the mask. In this example, a Mosquito reconnaissance plane from WWII will be the mask.

3. Create a channel in the landscape by clicking on the New Channel icon in the Channels palette (see Figure 17.7) or by choosing Window, Channels. Name it "ghost image."

FIGURE 17.7

Create a new channel.

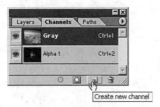

4. Outline the image using the Lasso tools or the Pen tool and then paste it into the new channel. In this example, the airplane image is pasted into the landscape's new channel (see Figure 17.8). This creates a mask containing an image of the aircraft.

FIGURE 17.8

Paste the object into a new channel.

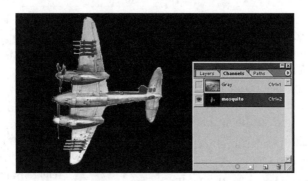

5. Return to the landscape by clicking the top channel. Load the "ghost image" mask as a selection in the landscape.

6. Now create two adjustment layers: Hue/Saturation and Curves. They affect only the selection (the ghost plane). The adjustments create the ghostly image in the sky (see Figure 17.9). In this example, the plane has been copied several times and reduced using Edit, Free Transform.

FIGURE 17.9

A ghostly
armada over
the Greenland
landscape.

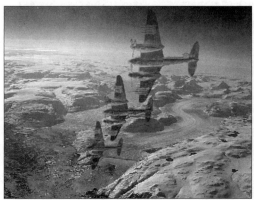 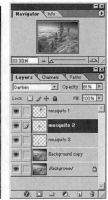

Alpha Channels: Where Masks Are Stored

Masks are stored in the Channels palette and are
called *alpha channels*. Photoshop and other
advanced image software (Freehand or Corel
Photopaint) enable you to work with alpha
channels. Because color channels are also found
in the Channels palette, it is important to know
that the two have little in common.

Color channels contain the color information
about an image. The information in color chan-
nels is part of the image. Color channels are visible in the image. However, masks
stored in alpha channels are not part of the image; they are never seen in the
image. Alpha channels are merely storage areas for masks—nothing more—and
masks are just editing tools that help create selections (see Figure 17.10). You never
see the mask itself in the completed image.

Here are the different types of channels:

> **tip**
>
> When you create an effect,
> make sure you move the
> adjustment layers slightly
> away from each other so
> their effects are not exactly
> superimposed.

■ **Color channels**. The Red, Green, and Blue channels and the RGB (compos-
ite) channel are part of every RGB image. CMYK images have five channels,
and LAB images have four channels. These types of channels are all related
to color information.

■ **Adjustment layer masks**. The channels appear when corresponding
adjustment layers are selected in the Layers palette. Only one adjustment
layer mask is displayed at any time, no matter how many adjustment layers
the image contains.

FIGURE 17.10

Different types of alpha channels: color, adjustment layer, alpha, quick mask.

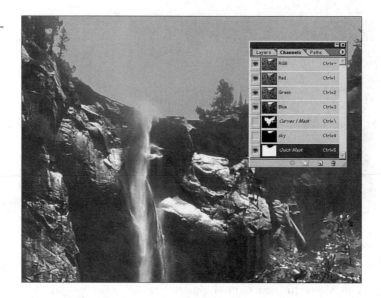

- **Alpha channels**. The channel named "sky" in the preceding image is a mask that was created to lighten the dark tones in the clouds.

- **Quick Mask**. There is a second type of alpha channel on this palette, a Quick Mask. Quick Masks are convenient, temporary alpha channels in Adobe Photoshop. They are created by clicking the Quick Mask Mode icon on the tool bar (not shown). You can convert a Quick Mask into an alpha channel by loading and saving it, but you can have only one Quick Mask at a time.

 The Quick Mask is the red-tinted area covering the image. It is visible in the image window because its eye icon is switched on. Note that the eye icons of the adjustment layer mask and the alpha channel are switched off. Masks whose eye icons are not visible cannot be seen in the image window.

Alpha channels are a part of the image's file; they may remain when the image is saved. One disadvantage is that they increase the file's size. For example, an RGB image file that is three megabytes can expand to four megabytes with one alpha channel.

When your image editing is complete, you may have no reason to keep extra channels, so you can

note

When you discard alpha channels, be careful not to unintentionally discard masks attached to layers. Masks with names that appear in italics in the Channels palette are not alpha channels. These masks are used by adjustment layers.

drag the alpha channels to the trash can in the Channels palette. Don't discard them if you expect to rework the image later. If you want to keep channels, save your files in Adobe Photoshop format. Some formats, such as JPEG, cannot save alpha channels.

Troubleshooting: Keeping Track of Layers, Channels, and Masks

Selections, layers, channels, and masks make image-editing software the tool of choice for thousands of artists, but such power also brings complexity and the potential for confusion. You might be stumped when the software does not do what you expect it to do. In such an event, the following troubleshooting tips might help.

The Image-Editing Software Stops Working

Try closing a palette to see whether the computer is frozen.

- If a palette won't close, try switching from the image-editing software to Microsoft Windows or the Macintosh Finder. If you can do this, the computer is okay, and your problem is with the image-editing software.

- Is your image so large that the computer is still working on your last command? If not, you might need to exit and restart the image-editing software.

- If the computer is frozen, restart the computer or get help from a support technician or a geeky friend.

The Last Command Did Not Work the Way It Should Have Worked

Stop. Do not issue new commands, as you could accidentally edit the image. As a precaution, use the software's Undo command to undo your last known successful command.

- Does Undo work the way you expect? If it does, cancel the Undo command.

- If Undo does not work, something you weren't aware of occurred after your last successful command. Don't cancel the Undo command, as it might undo an action you do not want to undo.

I'm Still Not Getting the Results I Want

So you've tried the suggestions and still no luck. You have no idea what's going on. Back up and ask yourself a few questions:

- Are you are trying to perform an edit outside of the selection? If more than one image is open, are you confused about which image is active?

- Is an invisible layer selected, such as a text layer? Are you trying to edit the wrong layer? Only the active layer can be edited, but it is possible for the active layer to be invisible, so your edits are happening but you can't see them! Be sure that you have the desired layer active and that it is visible.

- Are you trying to edit a channel or mask that isn't visible or isn't active? It is possible for the active channel to be invisible, so your edits are happening but you can't see them happening. Be sure that the channel you want to edit is active and visible. Also, you might have the right channel, but you might be working in the wrong layer.

A Command Is Grayed Out or Is Missing from the Menu

Some commands are not available at certain times. For example, when an adjustment layer is active, many menu options are grayed out or dimmed. They become available only when an image layer is active. Problems like this are best solved by reading the software manual.

I Can't Save My File

Are you trying to save a file but can't?

- You might be trying to save the file in a format that won't accept the features in your image. For example, you can't save a layered image in JPEG format.

- You might be trying to save the file to a disk that can't accept new files, such as a locked disk or a CD-ROM.

THE ABSOLUTE MINIMUM

Channels are a more advanced selection and editing tool than layers. Most beginners do not need to use channels for simple editing and adjustment to images.

- Alpha channels are merely storage areas for masks.

- To turn a mask into a selection, Ctrl+click on the channel name or select Selection, Load Selection.

- Channel names in *italics* are adjustment layer masks, not alpha channels. Do not delete them.

- If something doesn't work, make sure a selection isn't hidden. Press Ctrl+H to unhide the selection marquee.

- Still stumped as to why a command won't work? Make sure you don't have the wrong layer selected, such as a text layer.

PART IV

DIGITAL OUTPUT

Printers and Printer Resolution269

Preserving Your Images285

Color Theory .293

Lighting .307

IN THIS CHAPTER

- The Correct Settings for Printing Images
- What Resolution are My Images?
- Ink and Resolution: Tips for Quality and Saving on Cost
- ICC Profiles
- Paper and Resolution: Tips for Quality and Saving on Cost

18

PRINTERS AND PRINTER RESOLUTION

Understanding what a printer is really capable of in terms of resolution has become something of a science. Today's printer brochures say 1200 dpi for one thing and 4800 dpi for another (see Figure 18.1). In truth, all inkjet printers are pretty much capable of the same output resolution because of limitations with inkjet printer technology.

Some color laser printers and all dye-sublimation printers print higher resolution images than today's top-of-the-line inkjet printers. However, these printers still are beyond the reach of most consumers.

This chapter will sort out the terms used by inkjet printer manufacturers and provide a realistic, reasonable assessment of today's printer capabilities. More important, we'll examine the least expensive way to get the best prints and highest resolution possible.

FIGURE 18.1

Thanks for the confusing marketing-speak! A printer's advertised resolution.

print quality / technology	
print technology	HP Thermal Inkjet
print quality, black	Up to 1200-rendered dpi black when printing from a computer
print quality, color	Up to 4800 optimized dpi (up to 4800 x 1200-optimized dpi color when printing from a computer and 1200-input dpi)
resolution technology	PhotoREt Pro

Printer Technology

Today's color printers make instant photos possible. Several types of printers exist, but the most common and affordable technology is inkjet printers. Today's inkjet printers are capable of printing what many consider to be photographs because of new technologies. The inkjet printer industry changes almost as frequently as digital cameras, but a few basic rules persist regarding how to print great photos.

The advertised dpi of inkjet printers does not equal the resolution it can produce on paper. Printer manufacturers will say their printers can print 1200×4800 dpi or 1440×720 dpi (dots per inch). These numbers are the number of dots the printer can squirt into a square inch of glossy paper as it prints an image.

note

This chapter focuses on inkjet printers. Dye-sublimation printers and laser printers should also be researched by budding photographers to see whether they can match the cost-per-page of inkjet printers.

Suppose your printer is advertised as having 1200×1200 dpi resolution. This means it can squirt 1200 dots per inch onto the paper. This is *not* the same as 1200 ppi. The printer must create a rainbow of colors using only four to seven inks. Inkjet printers are only capable of printing specific colors because they have a specific number of inks.

WHAT ABOUT DYE-SUBLIMATION PRINTERS?

Dye-sublimation printers use a thermal process to transfer colored dyes from a roll of thin polymer film onto special print media. The process uses layers of dye (cyan, magenta, and yellow) that are deposited on the paper in three passes. Continuous tones are possible with this technology because the inks can blend together. In addition, there is no noticeable grain with dye-sub printers. Today's inkjet printers, which are much more versatile, have recently been able to match the quality of dye-sublimation printers.

Most printers are CMYK printers; in other words, they only have cyan, magenta, yellow, and black (K) inks. To print all the colors of the rainbow, they must combine dots and simulate colors. This technique of halftoning (similar to the printing press) tricks the eye into seeing a specific color. Its this combination of inks that generates the dpi numbers you see in advertisements.

To create a specific color such as green, for example, a CMYK printer must combine several colors and drop them onto the same tiny spot. The printer will lay down a little cyan and a little yellow in a specific area (see Figure 18.2). It will then lay down some black if the color was the least bit dark. All of these spots are printed near each other to fool the eye into seeing the color green for this specific pixel.

FIGURE 18.2

Close-up of an inkjet print. Notice the small dots, which are laid up to create specific colors.

Pixels per inch is the number of pixels that will be printed per inch. Select View, Image Size in Photoshop or Image, Resize, Image Size and check the ppi rating for your image. Inkjet printers are good for around 150–300 pixels per inch; high-end photo inkjets can handle 400 pixels per inch.

For example, a 3:1, 5:1, or even 7:1 relationship is necessary to create the color green depending on the number of separate inks in a printer. It takes multiple spots (dots) per pixel location on a printer to create the color intended for that pixel. For this reason, the dpi rating you see in printer advertisements should be divided by the number of inks to obtain a rough estimate of printed ppi (pixels per inch). Today's modern photo printers can accept high ppi ratings, but the human eye cannot perceive much beyond 16 pixels per millimeter. For this reason, the maximum ppi rating for an image should be around 360 or some number divisible by your printer's advertised dpi resolution.

Software Dithering and Error Diffusion

Printers include software features that further trick the eye into seeing pure continuous tones.

Inkjet printers employ *dithering* techniques, which print random colored dots to smooth harsh lines and blend colors that cannot be printed accurately using the fixed set of inks. Wherever lines on the image create harsh differences, such as between the corner of a building and the sky, the printer will print lighter (or darker) shades in a somewhat random pattern to fool the eye into seeing smooth edges or smooth continuous tones.

You can see the dithering created by the printer to help simulate a continuous tone along the edge of the structure (see Figure 18.3).

FIGURE 18.3

Another software trick is dithering, as shown in the scan of an inkjet print.

Error diffusion is another software technique used by inkjet printers. Dots of the opposite color near a specific pixel are printed to create the illusion of the correct color. For example, if a green pixel is printed and the dots cannot match that green color, the printer software will print much greener dots near the pixel location that overcompensate for the error. This process continues across the image. The eye is fooled into seeing the same color as on the original digital image or negative/print.

The Correct Settings for Printing Images

Cast aside every confusing term and definition regarding printing digital images. Believe it or not, the correct settings for printing photos are not difficult. Here is all you need to know:

Print at 150 to 300 ppi using photo paper.

That's all there is to know, no matter what printer you are using. Save your images at a ppi from between 150–300 ppi and they will print beautifully on glossy paper. For printing on normal paper use 150 ppi or less. Choose Image, Resize, Image Size in Photoshop Elements or Image, Size in Photoshop and change the value in the Pixels Per Inch text field. Make sure Resample Image is turned off before you click OK.

Photo printers and normal inkjet printers that use four or more inks are capable of printing at photo-quality if you set the pixels per inch between 150–300 ppi. Dye-sublimation printers can handle 400 ppi if you're fortunate enough to have one.

Almost all inkjet printers can only handle this ppi range. Even today's most precise inkjet printers, which can shoot a miniscule 2-picoliter drop of ink (two millionths of a millionth of a liter!) will not be able to print at a density much higher than 400 ppi. If you need to print a physically larger image, simply lower the ppi setting and experiment. Make sure Resample Image is turned off in the Image Size dialog box, however. Failure to do so will physically alter your image and degrade its quality.

Every image editing program includes settings that enable you to adjust for ppi. In Photoshop, for example, set the ppi of your image by choosing Image, Image Size and then changing Resolution.

tip

The larger the image, the lower the ppi number necessary. For images larger than 11×17 inches, the ppi rating can be under 200 pixels per inch.

What Resolution Are My Images?

Most digital cameras save images at 72 ppi. When you import the image, it will be displayed on screen at 72 ppi or 96 ppi, which are the most common resolutions of computer monitors. If you have a decent inkjet printer (any printer that uses four or more inks), follow these steps immediately after importing an image to print it properly:

1. Open the image in an image editor such as Photoshop or Photoshop Elements.

2. Change the ppi of the image from 72 to between 150–300 ppi (see Figure 18.4).

FIGURE 18.4

Change ppi from 72 to between 150–300 ppi before printing.

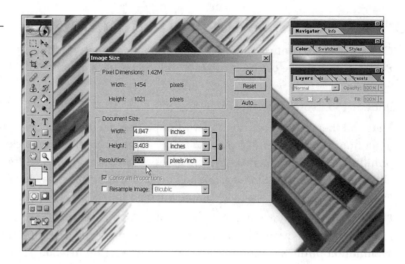

3. Save the image with a new name as a TIFF file.

4. Load up the printer with glossy or matte photo paper and print!

Most cameras create JPEG images that lose detail every time you save them. You really need to keep the original image safe and secure in case you want to come back later and modify it. For this reason, create a copy of the image and save it as a TIFF file after you import it. You can mess around with this image to your heart's content and still have the original as a backup.

When you import a photo from a digital camera, change its ppi rating first, and then save it as a TIFF file. Choose Image, Image Size in Photoshop or Image, Resize, Image Size and change the Pixels Per Inch text field to 200–300 ppi. Afterward, save the image as a TIFF file with a new name. Make these steps a habit so that your original digital camera images do not accidentally become overwritten the next time you import photos.

caution

Always save your image as a TIFF file after you import it from the camera. Most images come in as JPEG files, which lose detail every time you save them. For this reason, keep your originals safe and pristine. Always save a copy as a TIFF after importing.

LINE ART AND TRUE RESOLUTION

Print line art at the highest resolution your printer will accept, such as 600 ppi. The only time an inkjet prints its true resolution is for line art, which requires no dithering. The color is either black or white, so multiple dots are not required per "pixel."

Ink and Resolution: Tips for Quality and Saving on Cost

Almost everyone except budding photographers uses the ink manufactured by the printer manufacturer. Unfortunately, this is expensive after a few dozen prints. When the ink runs out, it's time for a trip back to the store for another $25 to $35 cartridge. That's for one cartridge! Multiply that by four (CMYK) and printing starts to get expensive.

Want to know just how ridiculously expensive (and profitable) ink is? Take a look at Table 18.1. Keep in mind that one fluid ounce (in the United States) is equal to 29.57 milliliters. A gallon contains 128 fluid (U.S.) ounces.

Table 18.1 Printer Ink by the Gallon—A Comparison

Ink Cartridge	Store Price	Amount in Cartridge	Amount Used When Refill Light Blinks (~85% used)	Cost per Gallon
HP 27 black inkjet print cartridge (C8727AN)	$17.99	10ml	8.5ml	**$7,990.00**
HP 28 tri-color inkjet print cartridge (C8728AN)	$21.99	8ml × 3	6.8ml	**$12,210.91**
HP Business Inkjet 10 Black C4844A*	$33.99	69ml	58.65ml	**$2,325.76**
HP Business Inkjet 11 Cyan C4836AN	$33.99	28ml	23.8ml	**$5,405.50**
Canon BCI-6M Magenta	$11.75	13ml	11.05ml	**$4,024.32**
Lexmark No. 82 Black 18L0032	$32.65	14ml	11.9ml	**$9,405.15**
Lexmark No. 83 Tri-color inkjet 18L0042	$37.75	7ml × 3	5.95ml	**$24,013.82(!!)**

HP's largest and most economical ink cartridge for their large-capacity consumer inkjets. In other words, their least expensive consumer-level ink!

The store prices shown here were the actual prices advertised by a number of office supply stores at the time this book was written. The tri-color ink cartridges are much more expensive because if you run out of one, you have to buy all three! The lesson here is avoid tri-color ink cartridges. Stick with printers that have separate ink cartridges.

HOW MUCH IS TOO MUCH?

In the first fiscal quarter of 2001, HP reportedly had an operating loss of U.S. $1 billion in its hardware business, which included printers and PCs. However, its net income in ink cartridge sales was U.S. $5 billion—that's in three months!

Some printers are less than $80 retail. However, if you were to print only five pages a day for a year, your cost in supplies would be $360.45. Most people will hold onto a printer for three years, so the total cost to operate the printer comes to $1,081.35. The first two ink purchases would exceed the cost of the printer!

Just for comparison...

- Milk—$1.99 per gallon
- High-end interior acrylic high-gloss enamel paint—$22.97 per gallon
- Gourmet ice cream—$35 per gallon
- Dom Perignon Champagne Brut '92 (1.5 liter)—$681.15 per gallon

Printer ink costs four to seven times as much as Dom Perignon! Highway robbery? Well, yes. For this reason, you might want to consider refills and third-party ink. However, does it affect resolution?

Third-Party Ink and Printer Resolution

If you have a printer and love it, save your empties! Don't ever throw away an empty cartridge. You might want to reuse it some day soon. Even Epson users may be able to benefit from old cartridges (read the section "Epson Printers and Big Brother" for details).

Companies on the Internet and local companies now sell their own ink, ink refill kits, and paper. Here are some examples:

- **Economy ink**. Web companies now contract with third-party ink companies and manufacture ink cartridges that fit into your printer. These cartridges cost half to three-quarters the cost of OEM cartridges. One line of cartridges uses high-end ink that runs IRIS printers, which are used at prepress facilities.
- **Store brand ink cartridges**. Office supply stores now sell cartridges for the most popular (or oldest, most popular) printers. This is similar to generic cereal in the cereal aisle at your local supermarket. Generics are usually less expensive, but often do not use the same quality ink.

- **Ink refill kits** for empty cartridges.
- **Remanufactured ink cartridges**. Old, spent cartridges are cleaned and refilled with third-party ink—nothing fancy here, just recycling at work.
- **Continuous-ink systems**. A few companies sell simple external ink supply systems that snake PVC tubing to the printheads in the printer. Instead of installing a small 15ml cartridge, you attach a hose with a four-ounce or more bottle of ink. The savings are tremendous if you are a frequent printer.

tip

Save your empties! When an ink cartridge runs out of ink, do not throw it away. You might need it later if you decide to refill the cartridge with third-party ink. Trust me, ink is so expensive that all digital photographers eventually consider this cost-savings technique.

How do these third-party ink cartridges and refill inks affect printer resolution? They don't, but they can affect color. For this reason, small software plug-ins—called ICC profiles—have been invented that overcome a number of color issues.

ICC Profiles

ICC profiles are plug-ins to image-editing programs that describe the exact color profile of an output device, such as a printer or monitor. If you are serious about printing photographs, make sure the printer or software you use can support ICC profiling. Photoshop Elements has a much simpler color space system (see Figure 18.5).

If you have Photoshop, follow these steps for a tour of color profiles. Let's create an image, save it without color profile information, and then open it to see what happens.

1. Open Photoshop, choose File, New, and create a new image. Don't worry about the settings. Just click OK in the New dialog box.

2. Now save this blank image. Choose File, Save As. In the Save As dialog box, uncheck the ICC Profile check box (see Figure 18.6) and then save this temporary file somewhere.

note

You can read more about ICC profiles at the International Color Consortium home page at www.color.org.

FIGURE 18.5

Photoshop
Elements does
not provide
much color pro-
filing options.
Photoshop pro-
vides extensive
color profiling
tools.

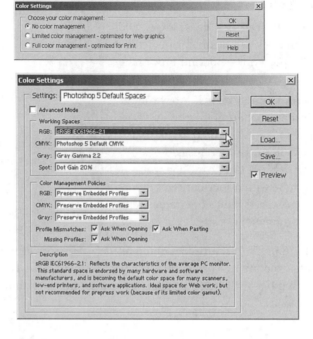

FIGURE 18.6

Uncheck ICC
Profile to save
an image with
its existing color
profile.

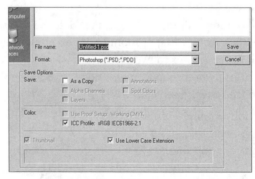

3. Now find the image on the network and open your image in Photoshop.
Before the image opens, a dialog box appears (see Figure 18.7).

The image has no color profile information. As a result, Photoshop doesn't know
what color space created it, nor what ICC color profile should be used with it.
Consumer digital cameras tag images with either the sRGB or uncalibrated RGB
color profiles. More advanced digital SLRs include the RAW mode, which contains no
color profile information. For this reason, the user must import the RAW information
into a special program or plug-in and then attach a working color profile.

FIGURE 18.7

Photoshop asks
for a color pro-
file if one is not
embedded in
the image.

FIGURE 18.7

Photoshop asks
for a color pro-
file if one is not
embedded in
the image.

Let's open the image you created earlier and see what color space Photoshop is cur-
rently using:

1. In the Missing Profile dialog box, assign a color space to the image by click-
 ing Assign Profile. Assign the sRGB color space to the image and then click
 OK. The image will open for editing.

2. Now let's see what color settings your version of Photoshop is using. In
 Photoshop, choose Edit, Color Settings. The Color Settings dialog box will
 appear (see Figure 18.8).

FIGURE 18.8

The Color
Settings dialog
box in
Photoshop. This
is where you set
up your work-
ing color
spaces.

Two sections comprise this small dialog box: Working Spaces and Color Manage-
ment Policies. The Working Spaces settings determine what color space is used by
Photoshop. The bottom section determines how Photoshop handles ICC color profiles
for images that are opened for editing.

Epson Printers and Big Brother

Epson currently makes the best inkjet printers for digital photographers. Epson inks, which are archival, and Epson paper are by far the best media for budding digital photographers. However, the dark side is that Epson printer ink cartridges include Big Brother technology that forces you to spend more on printing.

Epson includes hardware and software in its printers that monitors exactly how much ink has been used and then issues a warning before the ink cartridge runs out. This sounds helpful, but actually it is a clever way to force users to buy more ink. The print cartridge does not issue a warning when the ink is completely empty; instead it warns you that the ink will run out soon. This leaves a sizeable amount of ink in the cartridge, which will go to waste if you follow the rules.

In addition, when a warning is issued for a specific cartridge, the Epson software flips a switch in the ink cartridge and renders the cartridge useless. In other words, when the warning goes off, the ink cartridge no longer squirts ink!

These "chipped" ink cartridges are unusable if you would like to refill them with third-party printer ink. Small companies, however, have found ways to fool these chipped cartridges into thinking ink remains. These technologies include the following:

- **Hardware chips**. A chip resetter is a small punch that pulls the old Epson chip and replaces it with one that fools the printer into thinking the cartridge is full.

- **Software**. A small program is available in Europe that fools Epson printers into thinking a new ink cartridge has been placed in the printer. This small software program bypasses the chip in the inkjet cartridges with a FULL notice.

- **Continuous-ink supplies**. As mentioned in the last section, a few companies sell simple external ink supply systems that snake PVC tubing to the printheads in the printer. Instead of installing a small 15ml cartridge, you attach a hose with a four-ounce or more bottle of ink. The savings are tremendous if you are a frequent printer.

Ink refill kits are almost mandatory for digital photographers. Fortunately these kits are available over the Internet from a number of companies, through eBay, and at your favorite warehouse club. Warehouse clubs also have finally started selling ink refill kits.

Paper and Resolution: Tips for Quality and Saving on Cost

Often the paper is more important than the printer. If your color printer already produces halfway decent images on plain paper, photo-grade paper, such as that from Ilford, Legion, and Epson, can create amazing images.

The most vivid photo papers contain no paper in them at all. They are simply plastic and are called photo film. They usually provide the most "pop" and will make images look much more professional. Here are your choices of papers for printing images:

- **Film**. Pure plastic with no actual paper in it. Film is often used when rear projection is required. Prints look great on this "paper."
- **Glossy or Super glossy**. The most common photo paper and what works best when printing photos on an inkjet.
- **Pearl**. A smooth, medium-glossy paper that is often used for presentation. It has the softness of matte paper but still shines. A common paper among fine-art photographers.
- **Matte**. The best archival paper. If longevity is an issue, try matte paper. This paper is also used for business graphics and scientific/engineering work, where gloss is not necessary.
- **Plain**. Common printer/copier paper. Even this paper has become high-end, with different brightness formulations. Usually this paper is only used for everyday work.

Most of these papers are available at your local photography store and online at major photography sites. Compare your printer manufacturer's paper to generic brands, or third-party brands such as Kodak. Experiment with a number of papers and figure out the cost per page.

Use Table 18.2 as a starting point for determining resolution for printing your images. All photo papers are engineered to prevent color bleed, so the resolution of the image doesn't matter much as long as the paper you're using is termed "photo paper." The only paper that might bleed is matte paper. Perform some tests on this type of paper at a low resolution (150 ppi, for example) before trying higher ppi settings.

Table 18.2 Printing Resolution for Specific Papers

Type of Paper	Recommended Maximum ppi Setting
Film	300–400 ppi
Glossy or Ultra Glossy Paper	300–400 ppi
Pearl Paper (semi-gloss)	300 ppi
Matte-Finish Photo Paper	150–300 ppi
Plain Paper	100–150 ppi

The best photo papers for longevity are made of 100% cotton and are acid-free. Cotton papers can last decades, but don't have the "pop" plastic papers contain.

The two most important factors that affect the quality of paper are the presence of impurities and an acidic pH. Finished papers may contain natural impurities, such as lignins (glues that hold plant cells together) that have not been removed during processing, and unnatural impurities such as residual chemicals like sulfites, which are not washed out during final processing.

Why Do Images Look So Good on the Monitor?

The monitor has the lowest resolution of any device in your computer system. An older monitor is only 72 ppi (pixels per inch); Sony monitors and other more modern monitors use a shadow mask of 96 ppi. Even LCD screens are up to 100 ppi. So why do images look so good on a monitor? Two reasons:

- **Backlit illumination**. Have you ever seen an illuminated billboard on the highway? Notice how much better it looks than a front-lit billboard?

- **Phosphor intensity**. Every phosphor onscreen can produce the intensity of every pixel in an image. This differs from an inkjet printer, which can only produce a dot or leave the area blank. Basically, the monitor can generate 255 intensity values (0–255), whereas a printer can only generate two (a blank or a dot).

Printing Big Pictures

A good scanner will enable you to scan in an image and print it much larger than its original size, but only a few times larger. If you really need to print large images, a film scanner is required.

Film scanners can scan at a much higher resolution. A Nikon scanner, for example, can scan at 4000 samples per inch. Granted, a 35mm negative is much smaller than a print, but even this size will enable you to print images up to 16×20 inches with no noticeable grain. The big problem is the cost.

Some scanner manufacturers have created more advanced flatbed scanners that include negative and slide "sleeves." You place the negative in the sleeve and place it on the flatbed scanner (see

tip

Film scanners have a much higher "dynamic range," which is the capability to pick up details in the shadows. When you scan a print, detail is lost considerably in shadow areas. Scan film negatives and slides for maximum quality and dynamic range.

Figure 18.9). This way you can scan at up to 2400 dpi or higher. These lower-cost flatbeds are a great way to scan negatives inexpensively.

FIGURE 18.9

Flatbed scanners now enable you to scan your negatives.

This type of hybrid technology will enable you to print much larger prints. Regular scanners, which can only scan images, usually scan from 600 samples to 1200 samples per inch. Considering that your printer can only print at a realistic 300 ppi, you can double or triple the size of a print by scanning negatives and slides. You can read more about samples per inch and its relationship to ppi in Chapter 6, "Getting Your Pix Onscreen."

Assuming your printer's maximum print resolution is 300 ppi, here is a simple enlargement formula:

> Max scanner resolution/300 ppi = Max print enlargement

In other words, your printer can print at 300 ppi, your scanner's maximum scan resolution is 1200 samples, and the image you want to enlarge is 4"×6". In this example, you would follow the following rules to achieve specific enlargement sizes:

- **100%.** Image scanned at 300 samples and printed at 300 ppi
- **200%.** Image scanned at 600 samples and printed at 300 ppi

tip

Need to increase the printed size of a scanned image and only have the print? Scan the image at 300 samples per inch and then print it at 150 ppi. This will double the size. Or, scan at 600 samples and print at 300 ppi or 150 ppi. If your scanner software allows you to scan at percentage values (100%, 200%, and so on) you can also choose this method. It's that simple!

- **400%.** Image scanned at 1200 samples and printed at 300 ppi
- **800%.** Image scanned at 1200 samples and printed at 150 ppi

If you scan a 4"×6" image at 300 samples and then print at 300 ppi on your printer, the image should print at 100%. If you scan the image at 600 samples and print at 300 ppi, the print will be doubled at 8"×12". If you scan at 1200 samples and print at 300 ppi, the print will be four times the size.

Keep in mind that most prints cannot be scanned very well beyond 600 samples per inch—there just isn't enough information in the print. For this reason, the effective maximum enlargement is around 4×. To do this, you would scan at 600 samples and print at 150 ppi.

note

The effective maximum you can enlarge a print is 4× for most scanners. Scan at 600 samples and print at 150 ppi. Film (negatives and slides) can be scanned at much higher resolutions using film scanners.

THE ABSOLUTE MINIMUM

High-resolution color printers are available for under $100, and advanced color printing papers are available for much less. Experiment with printing to see what quality you can produce. The goal should be to print an image that a friend or relative won't recognize as a computer printout. Keep these tips in mind as well:

- Inkjet printers print dots of color that fool the eye into seeing continuous colors, just as a magazine uses dots of color.
- Ink is extremely expensive per gallon, but not per cartridge. To avoid the insane costs of ink, buy a printer with the largest inkjet cartridges you can justify for printing photos. The larger the cartridge, the less expensive the ink.
- Inkjet cartridges now have "intelligent" chips that shut off the cartridge before ink runs out. Unfortunately, they shut off the cartridge when there is still usable ink in it. This waste of resources adds up when you must return again and again for new ink cartridges.
- The most vivid photographic "paper" for printing images is called *film*—it is pure plastic.
- If you plan to print a considerable number of prints, look into a bulk ink delivery system. Search the Internet for the phrase "bulk ink."

IN THIS CHAPTER

- The Importance of Paper
- Archival Paper
- Advantages of CD-ROMs
- Archiving Your Own Photo Gallery

19

PRESERVING YOUR IMAGES

Today's inkjet printers rival machine prints from your local drugstore or photo lab. However, these printers will only print to the quality of the media you put in them. In other words, don't skimp on paper! Use the best paper you can afford when printing images on your printer.

The amazing thing about today's inkjet printers is that the technology powering the $25,000 machines is exactly the same as the little inkjet printhead in a $100 printer (see Figure 19.1). The only difference is the amount of ink each can hold and the printing width. The quality you see on billboards is available on a consumer-level Epson or HP printer.

This chapter will outline the different types of papers available for inkjet printers. A mini-renaissance in paper science, technology, and manufacturing has occurred in the past 10 years thanks to inkjet printers. Companies such as HP, Kodak, Epson, Ilford, Agfa, and Fuji have research-and-development dollars and salaries working on brighter, faster-drying, and better priced papers.

FIGURE 19.1

Large-format photo printers can be had for less than $400.

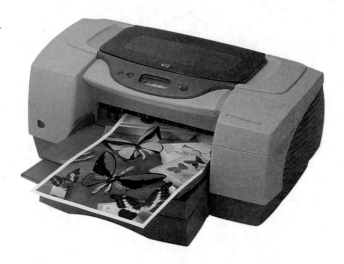

MADE IN ?

Visit your local office supply store and check out some of the new photo papers for inkjet printers. Notice where they're being made: the United Kingdom, Switzerland, and Japan. The profit margins in high-quality paper are tremendous, as is the technology race to stay competitive. Can anyone actually afford to manufacture anything in Switzerland, where the average annual income is one-third greater than the United States? Only if the technology cannot be duplicated elsewhere affordably. Paper technology has become a science that rivals military manufacturing.

As you learned in Chapter 18, "Printers and Printer Resolution," print papers are available in film, glossy, pearl, matte, and various shades of plain.

Photo Papers

Photo papers are divided by size, gloss, and thickness. The size, of course, depends on the printer. Most printers can print a maximum 8×11-inch size paper. Large-for-mat printers are available that can print 11×17-inch and 13×19-inch cut sheets, and larger printers (sometimes referred to as "plotters," their outdated predecessor) can print up to widths of 108 inches! The larger printers use rolls of paper instead of cut sheets.

High-gloss paper is available for all sizes of printers. High-gloss papers with a thick-ness greater than 8 mil (8 thousandths of a meter) are more expensive than thinner,

less glossy papers. Usually the thicker the paper, the better it is for presentation. Thinner papers are good for snapshots and review work.

HP manufactures a "Premium Photo Gloss" paper that currently is available in 11 mil thickness. Their older version was 10 mil. Most paper manufacturers prefer to increase the thickness as their printers become better at printing on thick papers.

Some papers are cut to a specific standard, called an ISO size. You may have seen A4 paper, which is the standard letter size for European papers. The A standard starts at A0, which is 1 square meter, and continues up to A6, which is smaller. All the A-sized papers use a ratio of 1:1.1414. If you cut an A0 piece of paper in half, you will end up with two A1 sizes of paper. Table 19.1 presents a breakdown.

Table 19.1 ISO Paper Sizes

Sheet Size	Width × Height (in centimeters)
A0	84.1 × 111.9
A1	59.4 × 84.1
A2	42 × 59.4
A3	29.7 × 42
A4	21 × 29.7
A5	14.8 × 21
A6	10.5 × 14.8
A7	7.4 × 10.5
A8	5.2 × 7.4

Plain Papers

Brightness ratings exist for plain papers—the brighter, the better. Most copier paper (that generic paper you use for just about everything at work) is around a brightness of 82.

Higher-end plain papers by Kodak and HP have a brightness of 94–102. The science behind these numbers is rather subjective, but the bottom line is these papers are whiter and brighter and more expensive. Often these papers are fine for invitations, pamphlets, and even working photos during heavy editing.

Archival Issues with Paper

How long will your print last? This is a question that paper manufacturers asked the leading paper archival specialist in the U.S., Wilhelm Imaging Research. You can read more about paper permanence and download the Wilhelm book on permanence free at www.wilhelm-research.com/. This lab in Iowa tests papers for longevity using different lighting and torture tests.

DEEP UNDERGROUND

Corbis Imagery, a stock photography startup founded by Bill Gates back in the early 1990s, now owns millions of photographs from the nineteenth and twentieth century's great master photographers. These images are preserved inside a giant cave carved out of a mountain in Pennsylvania. This underground warehouse is kept at a constant 28° Fahrenheit to slow the aging process.

Archival paper with a matte or semi-gloss finish is designed for pigment-based inks, which are common on high-end photo printers. Images printed on these types of printer are displayed behind non-glare archival glass for many decades or more without any noticeable fading.

What About Dye-Sublimation Printers?

Keep in mind the benefits of dye-sublimation printers. If you need to print dozens or hundreds of prints at exactly the same size—4"×6", for example—a dye-sublimation printer might be for you. Visit your local camera store or copier house (for example, Kinko's), where you'll be able to use their dye-sublimation printer. You can also purchase your own dye-sublimation printer. When you buy ink for these printers, the exact number of prints that can be produced is also included.

Saving Your Images on CD-ROM

Photographs printed on paper, even archival paper, will not last forever. Printed images are vulnerable: They can be lost to fire or theft, they can be damaged by spills or tears, or they can simply fade. Storing your images electronically can prevent these risks and allow you to keep your images for posterity. The best way to store your images electronically is to save them on a CD-ROM.

Granted, with technology changing at the speed of light, CD-ROMs will be obsolete before a protected inkjet print starts to fade, but at the very least you'll have your images in a format that can be moved digitally to the next storage medium.

Whether this medium is dual-layer DVD, blue-laser DVD, or kryptonite doesn't matter. Just keep your eye on new storage technologies and you'll be in a position to save these images forever.

In addition to music, CDs can hold information such as photographs, graphics, text, audio, and video (see Figure 19.2). CD-ROMs are used for encyclopedias, language programs, software, training tutorials, books, games, and in many other ways.

FIGURE 19.2
CD-ROMs hold more than just music.

The Advantages of a CD-ROM

One advantage to a CD-ROM is the large amount of information the disk can hold. One CD-ROM can hold over 650 megabytes, enough for 12,000 images. By comparison, only 25 pictures of that size could fit on a floppy disk.

Other advantages are the low cost of reproducing CD-ROMs (compared to printing on paper) and the ease and minimal cost of shipping a small, lightweight product (see Figure 19.3). The disk is read by a laser beam, so unlike a floppy it won't wear out. Because the disk can only be read, not written on, data can't be altered accidentally or infected by a virus. CD-RW (compact disc, rewritable) is an alternate form of CD that allows you to save additional information to the disc at a later time.

CD-ROMs are popular because they can be multimedia and interactive. A basic definition of multimedia is a combination of two or more media such as text, illustrations, photographs, sounds, narration, animation, and video. Computers blend media with a new ingredient—interactivity.

Interactivity can range from simple to complex. A simple multimedia CD can include onscreen buttons that the viewer uses to move forward or back through a series of pictures, or to activate events such as audio narration or video. With more complex programming, a CD can be personalized, with the content presented in different ways, as the viewer chooses.

Make Your Own Photo Gallery on CD-ROM

You can create your own CD-ROM title. All you need are basic computer skills and the time to learn the techniques. How you want people to view your disk will determine how many software programs you must learn.

If this is your first project, start with the basics. Suppose you have 30 photographs that you would like in CD-ROM form so you can send the disk to an editor or gallery. A relatively simple project could also include text (your resumé) and video narration about your work.

1. Begin with a storyboard. First decide what you want people to see, hear, and be able to do. List or sketch each component of the CD, and how you plan to present it. If you want the user to be able to skip around the material, you need to map out the different routes the user will be able to take.

2. Decide whether you want your CD to play on either Macintosh or IBM (Windows) computers, or both. This affects your choice of authoring software and the way the material is assembled by the software. Fortunately, Macs can read Windows CDs with no problem.

3. Prepare your photographs. You will need an image-editing program such as Adobe Photoshop or Photoshop Elements to crop and resize your

photographs, and to adjust the contrast, color balance, or other characteristics. You can also use art software to create backgrounds or navigation buttons that take the viewer from one place to another on the CD.

4. Open your images in Photoshop or Photoshop Elements and crop your photographs (if necessary).

5. Create navigation buttons in Photoshop (see Figure 19.4) or find free buttons on the Internet. Visit Google.com and enter the search phrase "Web site buttons" and visit some sites. Usually the free buttons aren't as valuable as the tutorials for making buttons in Photoshop or Illustrator.

FIGURE 19.4

Building buttons in Photoshop Elements for your custom CD.

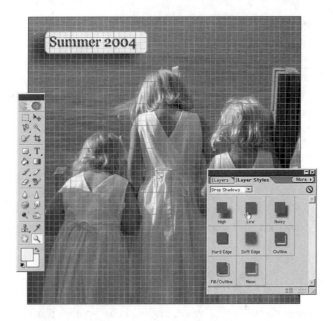

6. Prepare the text. Text such as titles and captions can be created either in Photoshop or Macromedia Director, or imported from a word processing program such as Microsoft Word. Text can be embedded in pictures using Photoshop.

7. Write and lay out the text portion of your CD. This is probably the easiest part of the assignment, as long as you have something to say. Place the subject matter, the time the images were taken, and any other story behind the pictures in your document.

8. Add video if you have it. You will need to learn how to import video into your project (see Figure 19.5). Prepare video clips (optional). Videos can be converted to digital QuickTime movies using an editing program like Adobe Premiere, iMovie, or Microsoft Movie Maker.

FIGURE 19.5

Importing a video clip into Windows XP's Movie Maker.

9. Put all the elements together. Authoring software such as Apple's iDVD enables you to author CDs and DVDs. Similar programs on the PC include Sonic MyDVD, Pinnacle Studio, and Nero 6.

Use one of these tools to build your CD. You can import all the media you've created and organize it into an interactive CD. For making test disks or small editions, a CD-R (CD-recordable) drive will record the material onto a blank CD. For larger editions, the obvious choice is DVD. Current DVD-Rs and DVD-RWs store up to 4.7GB. New dual layer technology will double that number, enabling you to store four hours of uncompressed video. After that, any number of disks can be produced at a low cost per copy.

THE ABSOLUTE MINIMUM

This chapter focuses on preserving your images in places other than your computer's hard drive. The best method for backing up images is DVD-ROM or CD-ROM. The price of CD-ROMs is so small now (lower than five cents each) that they are excellent, portable storage media. Photographic prints are fine but fade unless you purchase special dye inks or pigment-based inks. Follow these tips to preserve your images on media:

- Typical photographic prints do not last forever, nor do the inks that print the photo. If you are looking for longevity, consider higher-end pigment-based inks and cotton-fiber papers.

- The average cost for CD-ROMs is four cents when you buy them in a promotion or in a spindle of 100.

- CD-ROMs are an excellent backup medium for images. Just be sure to keep the CDs in a padded binder in a remote location.

- Photographic prints last longest when printed on matte paper.

In this Chapter

- Color Processes
- Color Image Layers
- Making Your Prints Match the Monitor

20

Color Theory

Color images can be created by adding primary colors together or by subtracting primary colors from white light. The first color photographic processes made use of additive color, but for the past 60 years subtractive processes have been the choice of photographers and printers.

The additive color process mixes the light of the primary colors red, green, and blue (known as the RGB colors) to create all possible colors. When equal amounts of red, green, and blue light are mixed, the result appears white. Television tubes and computer monitors are the most common examples of additive color systems.

The subtractive color process uses the inks or dyes of the primary colors cyan (blue-green), magenta (a purplish pink), and yellow (known as the CMY colors). The three CMY colors are *complementary* to, or opposite, the RGB colors used on the color wheel shown in Figure 20.1.

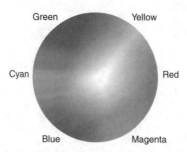

When white light (which contains all colors) shines on paper (or passes through film), the CMY inks or dyes absorb their opposite colors. Cyan ink absorbs red light, thus subtracting red from the image. Magenta absorbs green, and yellow absorbs blue.

The color wheel is used in photography, printing, and computer monitors. Red, green, and blue (RGB) are primaries in additive systems like television. Cyan, magenta, and yellow (CMY) are the subtractive primaries in photography and printing processes.

In the additive process, three beams of colored light combine to produce all other colors (see Figure 20.2). Green plus blue produces cyan, blue plus red produces magenta, and red plus green produces yellow. White is produced when all three colors mix in equal amounts.

FIGURE 20.2

Additive
process.

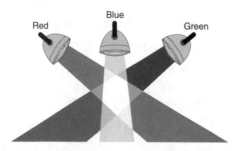

In the subtractive process, colors are produced when dyes or inks absorb color (see Figure 20.3). Inks of the three subtractive primaries—cyan, magenta, and yellow— here overlap on a white sheet of paper. White light, the illumination, is a mixture of all wavelengths of light. Where the cyan and magenta inks overlap, they absorb red and green; only blue is reflected from the paper. Where magenta and yellow overlap, only red is reflected. A mixture of yellow and cyan inks reflects only green. If inks of all three colors are mixed, all the light is absorbed and the paper appears black. Color film uses the same principle; layers of dye absorb light as it passes through the film.

FIGURE 20.3
Subtractive
process.

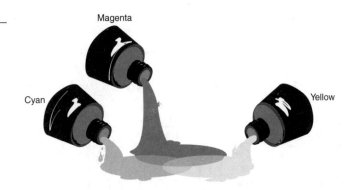

Magenta

Cyan

Yellow

Three Image Layers Create Color Images

A color photograph begins as three superimposed layers of light-sensitive silver halide emulsion capturing the image. The layers are like the emulsions in black-and-white film, except that each layer responds only to one primary color: red, green, or blue. Additional layers are added to improve the color response of the three basic layers.

Film Development Process

The two most popular forms of film are slide film and color negative film. Both forms of film rely on the subtractive process to create a reproduction of an image. This subtractive process comes into play during development, which occurs in several steps. Slide film and color negative film are sensitive to red, green, and blue, but the end product is their complementary colors cyan, magenta, and yellow. The following steps walk through this transformation process during the development of color negative film:

note

Color films are either positive (reversal) or negative. Reversal films create images that can be viewed directly, such as color slides. The images in negative films (color and black-and-white) must be printed to be viewed. Almost all reversal films are developed with Kodak's E-6 process. Color negative films are developed with Kodak's C-41 process.

1. Color negative film contains three layers of emulsion. Each layer is sensitive to one color: red, green, or blue. During exposure, an invisible latent image forms in each layer where light strikes the film.

2. When a color negative is developed, the exposed light-sensitive silver halides in each layer are converted into a metallic silver negative. At the same time, the developer oxidizes and combines with the dye-forming chemicals built

into the layer. Thus a color dye image appears in proportion to the amount of developed silver in each layer. The silver is then bleached out, leaving only a negative dye image. Cyan dye forms wherever the film was exposed to red light, magenta dye forms wherever the film was exposed to green light, and yellow dye forms wherever there was blue light (see Figure 20.4).

FIGURE 20.4

Color negative layers.

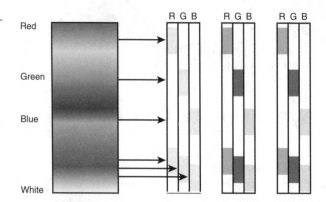

3. After development, bleach and fixer baths dissolve the silver in the layers. Only colored dyes remain in the film, forming the "negative" image, which is actually the image in cyan, magenta, and yellow.

The process of developing slide film, also called *color reversal* film, is more complex. This type of film is developed to make a silver negative first, but no color dyes are produced. A second developer chemically exposes and develops the remaining unexposed silver halide, thus producing a silver positive. The second developer also creates dyes that form a positive color image, dark in the shadows and transparent in the highlights. Next, the silver is bleached out, leaving only the dyes of the positive image.

Printing Process

Color negative printing paper employs the same principles as color negative film.

1. During printing, light from the enlarger passes through the color negative. Wherever dyes are present, only light that is the same color as the dye can pass through the film to expose the paper (see Figure 20.5). A latent image forms in the paper.

2. During development, a negative dye image forms in each layer along with a silver negative. This is identical to the way color film develops.

3. After bleaching and fixing, only dye remains in each layer. As the film image was a negative, the negative dyes in the photographic paper create a positive image.

FIGURE 20.5

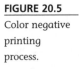

Color negative
printing
process.

Making Your Prints Match the Monitor—Gamuts and Color Management

Prints don't look exactly like the image on the monitor. And just as in darkroom printing, a great deal of time and money is wasted by photographers who make print after print until the image is perfect. Software like Adobe Gamma is very helpful, but it only begins to solve some parts of the problem of getting prints to match the monitor. Adobe Gamma is available with Photoshop and Photoshop Elements.

Adobe Gamma software is monitor calibration software that significantly improves the color balance and contrast of a monitor.

The real problem is that a computer does not "know" two important pieces of information: How accurately does your monitor reproduce colors, and how accurately does your printer reproduce colors. All a computer does is send instructions to the monitor and to the printer about what color each pixel should be. A computer has no way of receiving feedback about how each device actually illuminates screen phosphors or mixes inks. As a result, when the monitor and the printer have different "ideas" about what the color "red 220, green 164, blue 139" looks like, the print will not look like the image on the screen. Even when the monitor is calibrated with Adobe Gamma software, the inks and dyes used by printers rarely form colors identical to the colors of a monitor (see the sidebar "Human Vision and Color Gamuts").

HUMAN VISION AND COLOR GAMUTS

The human eye sees more colors than machines can reproduce. The term *gamut* is used to describe all the colors that a particular machine (a monitor or an inkjet printer, for example) can reproduce. The entire shaded area represents the human "color space" (gamut), all the colors the eye can see (see Figure 20.6). The area inside the line represents the colors that a computer monitor can reproduce.

FIGURE 20.6

Entire color space/gamut.

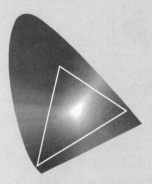

Here, the area inside the line shows the gamut that an inkjet printer can reproduce with CMYK inks (see Figure 20.7).

FIGURE 20.7

Gamut with CMYK inks.

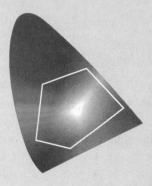

Here, the area inside the line shows the gamut that the CMYK inks used in offset printing can reproduce (see Figure 20.8).

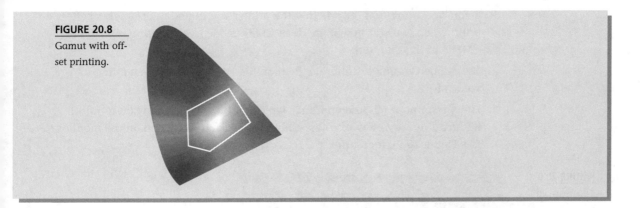

FIGURE 20.8
Gamut with off-set printing.

Color management, a new technology, seeks to perfect color matching. Color management synchronizes the monitor and the printer by giving the computer feedback about what colors each device produces. Apple Computer's ColorSynch software, for example, requires that color synchronization databases be made available to the computer's operating system.

Color management software works by comparing the color gamuts of your monitor and your printer, which it can do if it has a device profile for each of them. A *device profile* is a software database that describes the colors that the device (monitor or printer) can create. After comparing the two profiles, the color management software adjusts the monitor so it only shows colors that the printer can create. This means that your first print will more closely match the appearance of the monitor image.

Even with color management, you will probably need to make more than one print to perfect your image. In this respect, digital printing is like darkroom printing: You make test prints to come closer to a final print that expresses your idea. However, with color management, you begin the process much closer to the end result.

Printing Without Color Management

Some photo labs do not use color management yet. If your lab doesn't use it, you will need shortcuts so you can create finished prints with fewer test prints. The following procedure creates such a shortcut, a reusable software file that adjusts your monitor to match your printer. Photoshop Elements users do not have access to the CMYK color space. It is still possible to calibrate a monitor and a printer with Elements, so follow along:

1. Before you print, find out whether the printer you intend to use makes better prints when you edit in RGB mode or CMYK mode (see "Printing in RGB and CMYK" in this chapter).

2. Use Adobe Gamma to calibrate the monitor. For prints, set the gamma to a value of 1.8.

3. Edit a test image (choose an image typical of the photos you want to print). Be sure it has a variety of colors and tones. Make it look good on the monitor (see Figure 20.9), then print it.

FIGURE 20.9

The onscreen image.

4. Compare the print (Figure 20.10) and the monitor image. Does the print have a color bias and if so, which colors? Are any print colors over- or under-saturated? Are the print's midtones and shadows too dark or too light?

FIGURE 20.10

The printed image without color management.

5. Create one or more adjustment layers (refer to Chapter 16, "The Importance of Layers and Masks") to fix the print's problems (see Figure 20.10). The most useful layer tools are Layer, New Adjustment Layer, Hue/Saturation and Layer, New Adjustment Layer, Levels (see Figure 20.11). Use the adjustment layer(s) to modify the monitor image in the direction opposite from that of the print. For example, if the print is too green, use the adjustment layer to make the monitor less green (more magenta). If the print's midtones are too dark, make the monitor's midtones lighter. Make another print.

FIGURE 20.11

Layers palette with a Levels adjustment layer.

6. Compare the new print to the image on the monitor with the adjustment layer temporarily turned off. The secret of this shortcut is to print with the adjustment layer turned on and compare the print to the monitor with the monitor's adjustment layer(s) temporarily turned off.

7. Keep modifying the adjustment layer(s) until you have a print (see Figure 20.12) that is close to the monitor's image (with the adjustment layer turned off). Save each adjustment layer as a settings file: Click the Save button in the layers dialog box, name your settings file (put the name of the printer in the file's name), and save it on a personal diskette for later reuse.

Whenever you print a new image on the same printer, edit the image until it looks correct on the monitor. Then create an adjustment layer (or layers) and load your saved settings from your diskette into the adjustment layer. When you print, the settings in the adjustment layer(s) will approximately compensate for the difference between your printer and your monitor and make the print approximately match the monitor with the layer(s) turned off. You'll probably need to do another print to get perfect colors and tones.

This shortcut has limitations. It's not as convenient as a real color management system. If you do not use the same monitor each time it will be less effective. Also, different types of paper produce different colors, so you might need to create and save different settings for different papers.

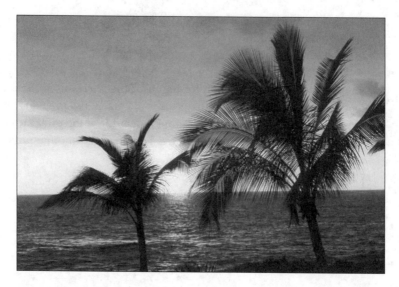

Printing in RGB and CMYK

RGB and CMYK are the two modes commonly used to edit color images. Some printers, especially inexpensive inkjet printers, work better if your image is edited and printed in RGB mode. These printers' built-in automatic RGB-to-CMYK conversion software produces better looking prints than you will get if you edit in CMYK mode. Other printers produce better quality output from CMYK mode images. If your printer makes better prints in one particular mode, always use that mode.

When you edit an image in RGB mode without color management, you can use Gamut Warning to locate and adjust colors that the printer cannot reproduce. Unfortunately Photoshop Elements does not have this feature. If you use Photoshop, follow these steps:

1. Open an image in Photoshop. Select an image with a rich range of colors (see Figure 20.13).

2. Before you can check your image for gamut problems, ensure that you have the correct printer profile installed. To see whether the profile for your printer is installed, choose Edit, Color Settings, Working Spaces, CMYK in Photoshop. Without the correct profile, Gamut Warning is not accurate.

3. Edit the image as you normally would, and then prior to printing choose View, Gamut Warning. When the Gamut Warning is turned on, any colors that your printer cannot properly reproduce will be concealed behind a mask of flat color (see Figure 20.14). The underlying colors are not altered—they are simply hidden from view. The hidden colors are those that cannot be accurately reproduced by CMYK printing devices such as your inkjet printer (your printer actually prints in CMYK, not RGB).

FIGURE 20.13
Monitor image
with out-of-
gamut colors.

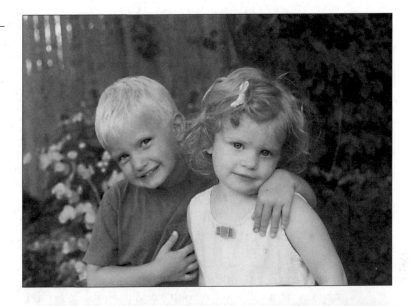

FIGURE 20.14
Gamut
warning-colored
mask.

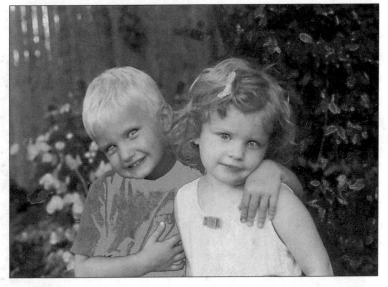

4. The best way to correct the out-of–gamut colors issue is to desaturate those colors. Use a selection tool like the Magic Wand, or even better, the Color Range command to select the problem colors; after they are selected, use the Saturation command to decrease saturation in those colors (see Figure 20.15).

FIGURE 20.15
Desaturating
out-of-gamut
colors.

6. When the colors are within the gamut, the Gamut Warning will disappear. In some cases, you will need to lighten or darken the colors to make them fall within the printer's gamut. Figure 20.16 shows the results of desaturating the out-of-gamut colors.

FIGURE 20.16
The adjusted
image.

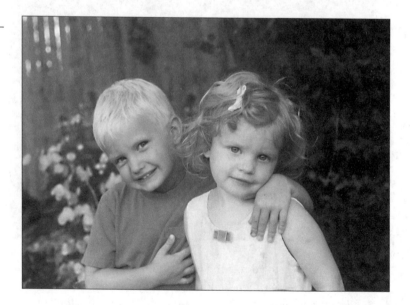

Multiple Printers: About Paper

There may be more than one printer connected to a computer. Because the color gamut database (profile) for each printer is different, your image-editing software must be told which printer's profile to use. In Adobe Photoshop, a list of available profiles can be viewed by choosing Edit, Color Settings, Working Spaces, CMYK.

Choose File, Color Settings, CMYK Setup, CMYK Model, ICC to select the printer profile (see Figure 20.17). Select the name of your printer and the type of paper that the printer is using (glossy or matte, for example).

Paper makes a difference in how your prints look. Different brands of paper react differently to ink or dyes. Inkjet papers produce the greatest amount of variation because ink seeps into the paper in different degrees. In general, papers that absorb less ink produce more brilliantly saturated colors and deeper tones. This is why all photo-quality inkjet papers are coated with a moisture-resistant white substance. Glossy paper gives rich dark tones, just as glossy darkroom paper gives tones with greater depth. Ordinary copier paper produces muted colors and dull tones because the ink soaks in freely; it may even bleed through to the other side.

note

To work in CMYK mode select Image, Mode, CMYK Color. Editing in CMYK has certain advantages. Even if your computer doesn't have a complete color management system, no out-of-gamut colors are shown on the monitor in CMYK mode. CMYK mode prohibits the monitor from displaying any color that the printer cannot reproduce.

FIGURE 20.17
CMYK Setup.

Choosing the wrong paper can reduce the effectiveness of color management systems. At this time, most printer manufacturers supply color management data (profiles) only for the papers they sell. If you print on another brand of paper the color management software may not have the data profile it needs to match the monitor and the printer.

THE ABSOLUTE MINIMUM

Digital cameras and computer monitors use the additive color process. Color film and inkjet printers use the subtractive color process, which relies on variations of cyan, magenta, and yellow inks. Follow these steps when working with color onscreen and in print:

- Color negative film and slide film are sensitive to red, green, and blue light, but form their complement (cyan, magenta, yellow) during development.

- You can save an adjustment layer as a settings file that can be loaded into other images when you are ready to print. This is a poor man's color calibration method.

- Select View, Gamut Warning in Photoshop to see which colors in the image won't print on your printer. You must have the correct printer profile installed to use this command successfully.

- You can adjust gamut issues by desaturating areas that are out of the gamut. Choose Select, Color Range and then select the out-of-gamut colors.

IN THIS CHAPTER

- Direct Versus Diffused Light
- Using Available Light
- Using Artificial Light

21

LIGHTING

Lighting is the most important part of photography. Without light, you would not have an image. Variations of light create brightness and contrast, and both create good images. Distinct combinations of light create the most interesting pictures.

An important characteristic of lighting is its degree of diffusion, which can range from contrasty and hard-edged to soft and evenly diffused. When people refer to the "quality" of light, they usually mean its degree of diffusion.

Direct light creates hard-edged, dark shadows (see Figure 21.1). It is *specular*: its rays are parallel (or nearly so), striking the subject from one direction. The smaller the light (relative to the size of the subject) or the farther the light is from the subject, the sharper and darker the shadows will be. The sharpest shadows are created by a point source, a light small enough or far enough away that its actual size is irrelevant.

FIGURE 21.1
Direct light has
hard-edged
shadows.

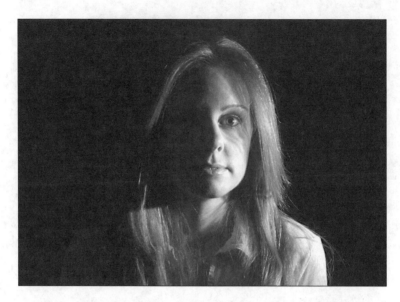

A spotlight is one source of direct light. Its diameter is small, and it often has a built-in lens to focus the light even more directly. If you think of a performer on stage in a single spotlight, you can imagine an extreme case of direct light: the lit areas are very light, and the shadows are hard-edged and black unless there are reflective areas near the subject to bounce some light into the shadows.

The sun on a clear day is another source of direct light. Although the sun is large in actual size, it is so far away that it occupies only a small area of the sky and casts sharp, dark shadows. It does not cast direct light when its rays are scattered in many directions by clouds or other atmospheric matter—its light is then directional-diffused, or even fully diffused.

Degree of Diffusion: From Hard to Soft Light

Diffused light scatters onto the subject from many directions. It shows little or no directionality. Shadows, if they are present at all, are relatively light. Shadow edges are indistinct, and subjects seem surrounded by light.

Sources of diffused light are broad compared to the size of the subject—a heavily overcast sky, for example, where the sun's rays are completely scattered and the entire sky becomes the source of light. Fully diffused light indoors would require a very large, diffused light source close to the subject, plus reflectors or fill lights to further open the shadows. Tenting is one way of fully diffusing light.

Directional-diffused light is partially direct with some diffused or scattered rays (see Figure 21.2). It appears to come from a definite direction and creates distinct shadows, but with edges that are softer than those of direct light. The shadow edges change smoothly from light to dark, and the shadows tend to have visible detail.

FIGURE 21.2

Directional-diffused light combines the qualities of direct and diffused light. Shadows are visible, but not as prominent as in direct light.

Sources of directional-diffused light are relatively broad. Indoors, windows or doorways are sources when sunlight bounces in from outdoors rather than shining directly into the room. Floodlights used relatively close to the subject are also sources; their light is even more diffused if directed first at a reflector and bounced onto the subject or if partially scattered by a diffusion screen placed in front of the light. Outdoors, the usually direct light from the sun is broadened on a slightly hazy day, when the sun's rays are partially scattered and the surrounding sky becomes a more important part of the light source. Bright sunlight can also produce directional-diffused light when it shines on a reflective surface such as concrete, and then bounces onto a subject shaded from direct rays by a tree or nearby building.

Fully diffused light provides an even, soft illumination (see Figure 21.3). Here, the light is coming from above, as can be seen from the somewhat brighter cheeks, but light is also bouncing in from both sides and, to some extent, from below. An overcast day or a shaded area commonly has diffused light.

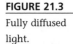

FIGURE 21.3
Fully diffused
light.

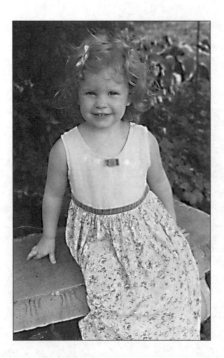

Available Light: Outdoors

What kind of light will you find when you photograph in available light (the light that already exists in a scene)? It may be any of the lighting situations discussed in this chapter. Stop for a moment before you begin to photograph to see how the light affects the subject and to decide whether you want to change your position, your subject's position, or the light itself.

A clear, sunny day creates bright highlights and dark, hard-edged shadows (see Figure 21.4). On a sunny day, take a look at the direction from which the light is coming. You might want to move the subject or move around it yourself so the light better reveals the subject's shape or texture as seen by the camera. If you are relatively close to your subject (for example, when making a portrait), you might want to lighten the shadows by adding fill light or by taking the person out of the sun and into the shade, where the light is not so contrasty. You can't change light outdoors, but you can at least observe it and work with it.

On an overcast day (at dusk, or in the shade), the light will be diffused and soft (see Figure 21.5). This is a revealing light that illuminates all parts of the scene. It can be a beautiful light for portraits, gently modeling the planes of the face.

FIGURE 21.4
Direct light out-
doors can pro-
duce prominent
shadows, so it is
important to
notice how such
light is striking
a subject.

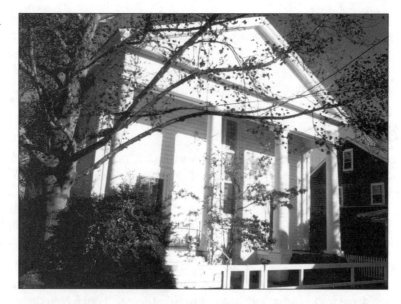

FIGURE 21.5
Diffused light
outdoors, such
as in the shade
of a building, is
soft and reveal-
ing.

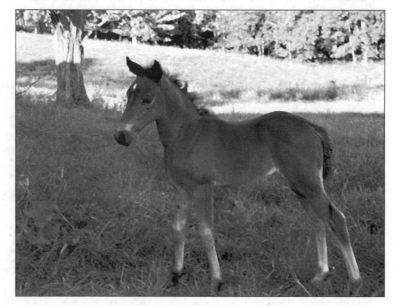

The light changes as the time of day changes. The sun gets higher and then lower in the sky, affecting the direction in which shadows fall. If the day is sunny, many photographers prefer to work in the early morning or late afternoon, because when the sun is close to the horizon, it casts long shadows and rakes across the surface of objects, increasing the sense of texture and volume.

Available Light: Indoors

Available light indoors can be contrasty or flat, depending on the source of light. Near a lamp or window, especially if there are not many in the room, the light is directional, with bright areas fading off quickly into shadow (see Figure 21.6). The contrast between light and dark is often so great that you can keep details in highlights or shadows, but not in both. If, however, there are many light fixtures, the light can be softly diffused, illuminating all parts of the scene (see Figure 21.7).

When shooting indoors, expose for the most important parts of the picture. The eye adapts easily to variations in light; you can glance at a light area and then quickly see detail in a nearby dark area. However, there will often be a greater range of contrast indoors than film can record. Rather than make an overall meter reading, you need to select the part of the scene that you want to see clearly and meter for that.

FIGURE 21.6

Shooting toward a bright window or lamp indoors creates contrasty light. The side facing the light source is much brighter than the side facing the camera.

FIGURE 21.7
Diffused light indoors occurs when light comes from several different directions, such as from windows on more than one side of a room.

Light indoors is often relatively dim. If you want to use the existing light and not add flash or other light to a scene, you might have to use a slow shutter speed and/or a wide aperture. Use a tripod at slow shutter speeds or brace your camera against a table or other object so that camera motion during the exposure does not blur the picture. Focus carefully, because there is very little depth of field if your lens is set to a wide aperture. A fast film speed (ISO 400 or higher) will help.

Qualities of Artificial Light

The same properties are present in artificial light as in available natural light. The direction of light and the amount of its diffusion can create a hard-edged light or a soft and diffused light. Because you set up and arrange artificial lights, you need to understand how to adjust and control them to produce the effect you want.

The bigger the light source relative to the subject, the softer the quality of the light. The sun, although large, produces hard-edged, dark shadows because it is so far away that it appears as a very small circle in the sky. Similarly, the farther back you move a light, the smaller it will be relative to the subject and the harder the shadows will appear. The closer you move the same light, the broader the light source will be, the more its rays will strike the subject from different angles, and the softer and more diffused its lighting will appear.

The more diffused the source, the softer the light. A spotlight focuses its light very sharply on a subject producing bright highlights and very dark, hard-edged shadows. A floodlight is a slightly wider source, but still one with relatively hard-edged

shadows, especially when used at a distance. A softbox or umbrella reflector is much more diffused and soft.

Use the type of light and its distance to control the light on your subject. If you want sharp, dark shadows, use a directional source, such as a photoflood or direct flash, relatively far from the subject. If you want soft or no shadows, use a broad light source, such as a softbox or umbrella reflector, close to the subject.

A softbox provides a very soft and diffused illumination. The light scatters over the subject from many directions providing almost shadowless lighting. Photographers often use a softbox or an umbrella reflector to produce the natural look of a broad, diffused window light (see Figure 21.8).

FIGURE 21.8

Diffused illumination created from diffused light coming from the right of the object.

A floodlight or direct flash produces directional lighting (see Figure 21.9). Notice how dark and hard edged the shadows are compared to the photo above.

FIGURE 21.9

Direct illumination from the right, creating prominent shadows.

The Main Light: The Dominant Source

Where do you start when making a photograph with artificial light? Using lights like photofloods or electronic flash that you bring to a scene and arrange yourself requires a bit more thought than making a photograph by available light where you begin with the light that is already there and observe what it is doing to the subject.

The most natural-looking light imitates that from the sun (see Figure 21.10): One main light source casting one dominant set of shadows—so usually the place to begin is by positioning the main light. This light, also called the key light, should create the only visible shadows, or at least the most important ones, if a natural effect is desired. Two or three equally bright lights producing multiple shadows create a feeling of artificiality and confusion. The position of the main light affects the appearance of texture and volume, as seen in Figures 21.10–15. Flat frontal lighting (see Figure 21.11) decreases both texture and volume, while lighting that rakes across surface features (as seen from camera position) increases it.

FIGURE 21.10
A high-side lighting portrait with a main light at about 45° to one side and 45° above the subject.

FIGURE 21.11
A portrait with frontal lighting.

Natural light usually comes from a height above that of the subject (see Figure 21.12), so this is the most common position for the main source of artificial light.

Lighting from a very low angle can suggest mystery, drama, or even menace just because it seems unnatural. Monsters in horror movies are often lit from below (see Figure 21.13).

FIGURE 21.12
Top lighting.

FIGURE 21.13
Under lighting.

Some types of lighting have been traditionally associated with certain subjects. Side lighting has long been considered appropriate for masculine portraits because it emphasizes rugged facial features (see Figure 21.14). Butterfly lighting was often used in the past for idealized portraits of Hollywood movie stars. The lighting is named for the symmetrical shadow underneath the nose. The main light is placed high and in front of the subject, which smoothes the shadows of skin texture, while producing sculptured facial contours.

FIGURE 21.14
Side lighting.

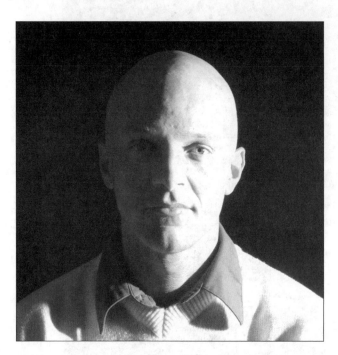

Lighting can influence the emotional character of an image. Figures 21.10–15 show how the mood of a photograph can be influenced merely by changing the position of one light. If photographs never lie, some of these images at least bend the truth about the subject's personality.

Most photographs made with artificial light employ more than one light source. A fill light or reflector is almost always used to lighten shadows. Sometimes, an accent light is used to produce bright highlights, and a background light is added to create tonal separation between the subject and background. Any one of these lights alone will not create the image necessary (see Figure 21.15). They must work together.

Here is more information on the lighting arrangements demonstrated in the previous figures. These concepts are applicable to portrait lighting, and all photography using artificial light.

FIGURE 21.15
Back lighting.

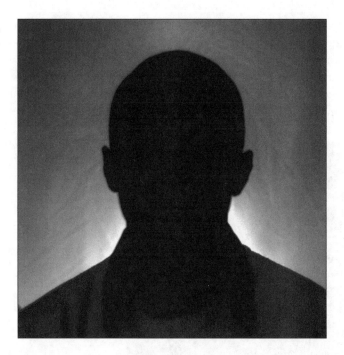

The Fill Light: To Lighten Shadows

Fill light adds light to shadows. When you look at a contrasty scene, your eye automatically adjusts for differences in brightness. As you glance from a bright to a shadowed area, the eye's pupil opens up to admit more light. Film, however, cannot make such adjustments—it can record detail and texture in brightly lit areas or in deeply shadowed ones, but generally not in both at the same time. If important shadow areas are much darker than lit areas—for example, the shaded side of a person's face in a portrait—consider whether adding fill light will improve your picture.

Fill light is most useful with color transparencies. As little as two stops difference between lit and shaded areas can make shadows very dark, even black.

Fill light can also be useful with black-and-white materials. In a black-and-white portrait of a partly shaded subject, shadows that are two stops darker than the lit side of the face will be dark but still show full texture and detail. But when shadows become three or more stops darker than lit areas, fill light becomes useful. You can fix these problems by adding fill light, rather than try to lighten a too-dark shadow prior to printing.

Artificial lighting often requires fill light. Light from a single photoflood or flash often produces a very contrasty light in which the shaded side of the face will be very dark if the lit side is exposed and printed normally. Notice how dark the shaded areas are in the single-light portraits shown in Figures 21.10–15. You might want such contrasty lighting for certain photographs, but ordinarily fill light would be added to make the shadows lighter (see Figure 21.16).

FIGURE 21.16

A softer photoflood/ studio light fills in shadows and creates detail.

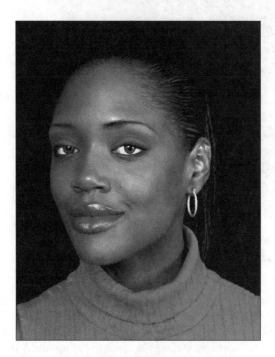

Some daylight scenes benefit from fill light. It is easier to get a pleasant expression on a person's face in a sunlit outdoor portrait if the subject is lit from the side or from behind and is not squinting directly into the sun. These positions, however, can make the shadowed side of the face too dark. In such cases, you can add fill light to decrease the contrast between the lit and shadowed side of the face. You can also use fill light outdoors for close-ups of flowers or other relatively small objects in which the shadows would otherwise be too dark.

A reflector is a simple, effective, and inexpensive way to add fill light. A reflector placed on the opposite side of the subject from the main light bounces the main light into shadow areas. A simple reflector, or *flat*, can be made from a piece of stiff cardboard, 16×20 inches or larger, with a soft matte white finish on one side. The other side can be covered with aluminum foil that has first been crumpled and then partially smoothed flat. The white side will give a soft, diffused, even light suitable

for lightening shadows in portraits, still lifes, and other subjects. The foil side reflects a more brilliant, harder light.

A floodlight or flash can also be used for fill lighting. A light source used as a fill is generally placed close to the lens so that any secondary shadows will not be visible. The fill is usually not intended to eliminate the shadow altogether, so it is normally of less intensity than the main light. It can have lower output than the main light, it can be placed farther away from the subject, or have a translucent diffusing screen placed in front of it.

A black "reflector" is useful at times. It is a sort of anti-fill that absorbs light and prevents it from reaching the subject. If you want to darken a shadow, a black cloth or card placed on the opposite side of the subject from the main light will remove fill light by absorbing light from the main light.

The Absolute Minimum

- Proper lighting is an acquired skill that can only be learned by trial and error. Rent strobes and experiment, or just go to the hardware store and buy two halogen lamps. Whatever you do, keep these tips in mind:

- When two strobes are used to illuminate a subject, they need to be different strengths or different distances from the subject. Different intensities create shadows and depth, avoiding the washed-out, flat look common with on-camera flash.

- Side lighting is preferable for photographing men or masculine-looking shots. Butterfly lighting is preferable for women's portraits.

- Experiment with unusual forms of lighting. Combine colored gels, a balance of strobes with ambient light, and under-lighting or side-lighting to differentiate your images.

- Always bring a large reflector with you on photo shoots. It can be something as simple as a car windshield blind or a large piece of crumpled aluminum foil. Reflectors often are the best form of fill light, and fortunately are inexpensive.

PART V

Using Your Digital Pictures

The Portrait .336

Digital Photography and the Web346

IN THIS CHAPTER

- Simple Portrait Lighting
- Converting from Color to Black and White
- Several Ways to Fix Red Eye

THE PORTRAIT

You don't need a complicated lighting arrangement for portraits or many other subjects. Often, the simpler the lighting, the better. Many photographers prefer to keep portrait setups as simple as possible so the subject is relaxed. Lights, tripods, and other paraphernalia can make some subjects overly conscious of the fact that they are being photographed, resulting in a stiff, awkward expression.

When shooting outdoors, open shade or an overcast sky provides a soft, even light. The person is not lit by direct sunlight, but by light reflected from the ground, from clouds, or from nearby surfaces such as a wall. Open shade or overcast light is relatively bluish, so if you are shooting color film, a 1A (skylight) or 81A (light yellow) filter on the camera lens will warm the color of the light by removing excess blue.

When shooting indoors, window light is a convenient source of light during the day. Contrast between lit and shaded areas will be very high if direct sunlight falls on the subject, so generally it is best to have the subject lit only by indirect light bouncing into the room. Even so, a single window can be a contrasty source of light, causing those parts of the subject facing away from the window to appear dark.

A main light plus reflector fill is the simplest setup if you want to arrange the lighting yourself (see Figure 22.1). Bouncing the light into an umbrella reflector (rather than lighting the subject directly) softens the light, makes it easier to control, and may even eliminate the need for fill.

FIGURE 22.1

The best way to experiment with portrait photography is with one strobe and a reflector.

Window light can be quite contrasty, so keep an eye on the amount of contrast between lit and shaded areas. A reflector opposite the window can bounce fill light onto the side of the subject away from the window (see Figure 22.2). Sometimes a nearby light-colored wall can do the same.

Follow these steps to try a simple lighting scenario that will look good in black and white:

1. On an overcast day, plan a portrait by sitting your subject next to a window. The light from an overcast day is bright, but not harsh.

2. Use a large white board (such as foam-core or cardboard) and have your assistant hold it on the other side of the subject. The light from the window will reflect and illuminate the other side of the subject's face.

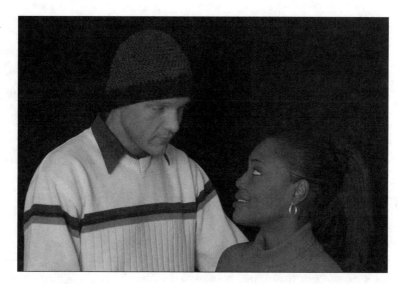

3. Take a series of pictures at different exposures. If your camera has a light meter, take a photo using its value, then take another picture that is overexposed. Open up the aperture or decrease the shutter speed and then snap a pic. Afterward, underexpose by closing down the aperture or giving the camera less light and then snapping another picture. This is called *bracketing.*

If your camera's meter says 1/60 of a second at f8, take a picture at that exposure and then overexpose by taking another picture at 1/60 of a second at f5.6 (opening up the lens one "stop"). Afterward, expose at 1/125 of a second at f8 (increasing shutter speed one "stop"). Keep in mind that camera meters are not very good at metering correctly, especially if the subject is bright (white) or dark (black). Take a series of pictures at different exposures to compensate.

Overexposure and underexposure are tough to keep straight, so remember the acronym WUBO—White Underexposes and Black Overexposes (see Figure 22.3). The reason is that all camera meters think you are metering a subject that is a neutral (called 18%) gray color. The camera meter cannot tell whether it is metering a subject that is any other color, such as black or white.

If the subject is close to white or is very bright, check the camera meter reading and then add a few stops by lengthening the shutter speed (from 1/250 to 1/60, for example) or "opening up" the lens (from f11 to f5.6 equals two stops). If the subject is very dark, check the camera meter and then shorten the shutter speed (from 1/125 to 1/500, two stops), or make the aperture smaller (from f5.6 to f8, one stop).

FIGURE 22.3

Just remember WUBO—white-color subjects lead to under-exposed images, and black-color subjects lead to overexposed images.

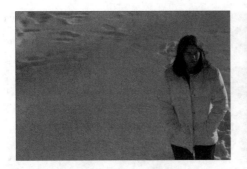 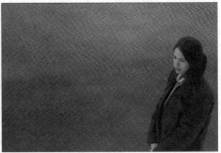

Converting Color to Black and White

Among the many processes the computer has simplified is the conversion of color images to black-and-white images. Making a black-and-white print from a color negative or transparency used to require either special printing paper or the production of a black-and-white internegative. Now, one digital color file can produce either a color print or a black-and-white print.

Digital imaging lets you easily confirm whether a color negative might yield a more dramatic black-and-white print than it does a color image. The ease of conversion also lets you use just one film type and camera body when you want to make both color and black-and-white photographs during the same shooting session. Many publications continue to print only in black and white, and most photographers prefer the control of converting their own color images into black-and-white prints rather than having someone else do so.

note

Black-and-white film is by no means obsolete—it has rich density and can capture much more tonal variations than most color negative films. For this reason, many professional photographers still swear by it.

Color to Black and White: Using Grayscale or Desaturate

The simplest way to convert a color photograph to black and white is to choose Image, Mode, Grayscale. This one-step conversion permanently strips all the color information from the photograph and leaves a black-and-white image with a small file size. This isn't necessarily the best way to create a black-and-white image from a color image, however.

Image, Adjust, Desaturate in Photoshop and Enhance, Adjust Color, Hue/Saturation in Photoshop Elements is another one-step conversion that keeps the color

information while resulting in a black-and-white image. The file will be larger, but you can then colorize the image in different channels—a more advanced technique to try on your own.

Another option for Photoshop and more advanced image-editing software users is to convert the image from RGB to LAB mode and then remove the A and B channels, leaving only the Luminance channel. This often produces superior results to the bland Image, Mode, Grayscale method. In LAB mode, brightness information is separated completely from color information. If your imaging-editing application has LAB mode capabilities, follow these simple steps to create a great-looking black-and-white image from color:

1. Open a color image and choose File, Save As. Save the image with a new name to preserve the original.

2. Choose Image, Mode, LAB.

3. Open the Channels window by choosing Window, Channels or by clicking on the Channels tab.

4. Click on the A channel and then drag it into the Trash (delete it). Click Yes when Photoshop asks whether you would like to flatten layers.

5. Delete the second channel (called Alpha 2) that results. You should be left with only one channel called Alpha 1.

6. Convert the image to grayscale by choosing Image, Mode, Grayscale (see Figure 22.4). You now can save the image as a JPEG or TIFF file.

FIGURE 22.4

On the left, image was converted using Image, Mode, Grayscale; the right image was converted using LAB mode. Notice the clarity and contrast in the right image.

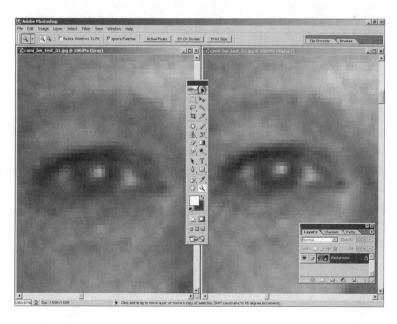

Color to Black and White: Using Channels Plus Grayscale

Another way to convert images to black and white in Photoshop is to use channels. Like a color film image, a digital color image in RGB mode is composed of three primary colors: red, green, and blue. Each of those colors can have different contrast levels and may convert to black and white differently as a result.

To see how each of the three colors converts to black and white, choose Window, Show Channels. By looking at the image in each channel—red, green, and blue—you may find a black-and-white version that already looks close to what you want in your final print.

Converting to black and white using this method involves deleting two channels. Converting to Grayscale while in the remaining channel strips its color but retains its contrast information. This often translates to fewer contrast adjustments following the conversion.

Photoshop Elements does not include channels, so this technique is not possible.

When you open the Channels Palette, three black-and-white thumbnails appear below the color composite channel. An eye icon shows which image is selected.

Click on each thumbnail to see its effect on the image. Usually the green channel is best because it contains the most brightness information (closest to black and white). With your final choice highlighted in the palette, choose Image, Mode, Grayscale to discard the other channels and convert the image to black and white, and then choose Save.

Fixing Red Eye

Another common fix for portraits is the dreaded red eye (see Figure 22.5). This isn't really an issue in black-and-white photography, but is so common in snapshot photography that everyone needs to know how to resolve this issue—beginners and professionals! Photoshop and Photoshop Elements provide a number of ways to fix red eye. Today's automated red-eye reduction features in cameras are usually annoying and don't work that well—the manual method is usually best.

This section shows you a few ways to reduce or eliminate red eye. There are probably 10 or 12 different ways to fix red eye, so don't despair. If you experiment with the steps in this section, you might find an even better way.

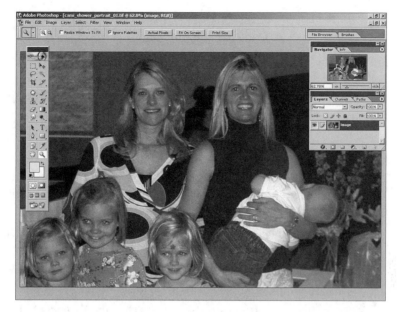

Before you begin your red-eye retouching journey, keep in mind this important suggestion: Keep the highlights! A person's eyes only look real if the highlight remains. You can fill in their eyes with black, but they won't look real.

Using Layers to Remove Red Eye

The following steps show you how to use layers and layer blend modes to reduce red eye in Photoshop and Photoshop Elements. This section assumes some of the person's accurate eye color is still available in the image. You might be able to see a slight border of the person's original eye color around the red iris. If not, use another method in this chapter to remove red eye.

1. Open an image and choose File, Save As to save a copy.

2. Make sure the Layer tab is visible (by choosing Window, Layers if you don't see it onscreen). Create a new layer by clicking the new layer icon in the lower-right corner of the Layers window. Make sure the new layer is active (highlighted in the Layer window).

3. Zoom in on the red eye as much as possible. Use the Eyedropper tool to click a color closer to the person's actual eye color. The color will most likely appear as a gray tint in the image.

4. Choose a brush or airbrush and paint over the red part of the eye on the new layer. Avoid any other part of the eye, including the eyelids.

5. Blur the paint job by choosing File, Blur, Gaussian Blur. A blur value of 1.00 should be okay.

6. In the Layer tab, click the down arrow next to Normal and change the Layer Blend mode to Darken or Saturation.

7. If the color is too weak and too much red eye still exists, create a duplicate layer and set it to darken.

8. If this method yields acceptable results, choose Layer, Flatten Image to merge all the layers.

Eliminating Red Eye Using Hue/Saturation

You can completely eliminate the color red from red eye by desaturating the color. This method relies on the Hue/Saturation tool available in Photoshop and Photoshop Elements. Most image editors include the same tool.

1. Open the image and choose File, Save As. Save the file with a new name (to preserve the original in case you mess up).

2. Choose Window, Layers to access the Layers palette. Create a new layer by clicking on the new layer icon in the lower right of the Layer's window.

3. Zoom in on a person with red eye and click the Elliptical Marquee tool.

4. Place the cursor in the center of the person's iris (the red-eye area). Press and hold down the Alt key (in Windows) or the ⌘ key on the Mac and then click and drag a circle or ellipse that encompasses the red iris.

5. Choose Image, Adjustments, Hue/Saturation in Photoshop or Enhance, Adjust Color, Hue/Saturation in Elements. The Hue/Saturation dialog box appears. Select Reds from the drop-down box.

6. Slide the Saturation slider to the left into negative territory until the red color is gone (see Figure 22.6).

FIGURE 22.6

Slide Saturation all the way to the left to eliminate red eye.

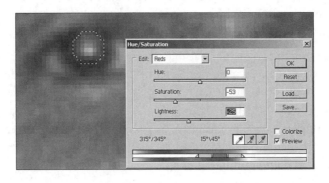

7. Slide the Lightness slider to the left to reduce the highlight and brightness.

8. If the iris is too gray, change the colors from Reds to Master in the drop-down and shift the Hue and Saturation sliders to add a little color.

This method is preferred by most photographers. The problem is that selecting the red portion of the eye with the elliptical marquee isn't always easy. Be sure you press down and hold the Alt key so that the marquee expands outward. Another aid is to choose Select, Modify, Expand and expand the selection by a few pixels.

Channels aren't available in Photoshop Elements. Use the layer method described in the section "Using Layers to Reduce Red Eye" instead.

Using Channels to Reduce Red Eye

A fast, quick, and dirty way to reduce red eye in Photoshop is to use channels. This method is so simple that even beginners can get acceptable results in minutes and keep family members happy.

Follow these steps in any version of Photoshop to reduce red eye using channels:

1. Open an image and choose File, Save As to save the original from any mistakes you might make. Name the new image.

2. Make sure the image is in RGB mode by choosing Image, Mode. If the file is in CMYK or LAB, change it to RGB mode by choosing Image, Mode, RGB.

3. Zoom in as much as possible on any red eye.

4. The easiest way to select only the red eye is to use the red channel of the image. Click the Channels tab to access the image's red, green, and blue channels (choose Window, Channels if Channels isn't onscreen).

5. Click on the red channel (see Figure 22.7). The other channels should be deselected and only the red channel should be highlighted/checked. The color image will become black and white.

The red channel provides the most tonal separation from the eyes and the face, making it easier to select the entire eyeball. If you cannot access the Channels tab or aren't sure what a channel is, you can still select the red eye using the ellipse selection tool.

You now need to select the offensive eyes in the image:

1. Click the Magic Wand tool on one of the eyes. The Magic Wand should select most of the eyeball.

2. Press and hold down the Shift key and select the other eyeball. At this point you should have both eyes selected (see Figure 22.8).

FIGURE 22.7

The red channel provides the most contrast, enabling you to select the red eyes more easily.

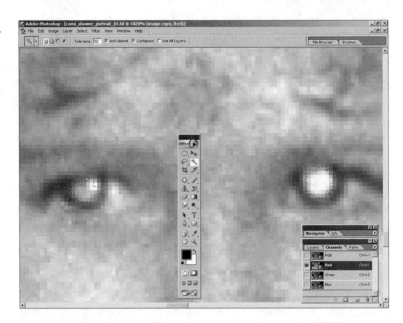

FIGURE 22.8

Both eyes selected in the red channel.

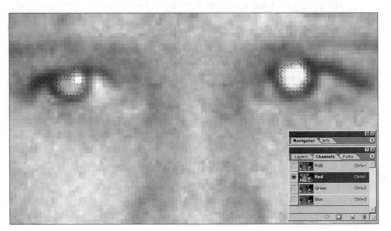

3. Expand the selection if necessary by choosing Tools, Modify, Expand and clicking two pixels. The selection will expand a little.

4. Choose Tools, Feather, and then feather the selection by two pixels.

5. Click the RGB channel again to return to the color image. The image should switch from black and white to color. Your eyes should be highlighted.

6. Turn off the crawling ants around the eyes by pressing Ctrl+H (in Windows) or ⌘H (on a Mac).

7. Time to fill the eyes with something darker. Choose Edit, Fill. The Fill dialog box appears (see Figure 22.9). Select the color black and an opacity of 60% or higher.

note

You might want to add some noise to your changes. Choose Filter, Noise, Add Noise. Use Uniform (not Gaussian) and experiment with the amount by starting at 6%. Less is more in this situation, so be careful.

FIGURE 22.9

Fill the red eye with a darker color.

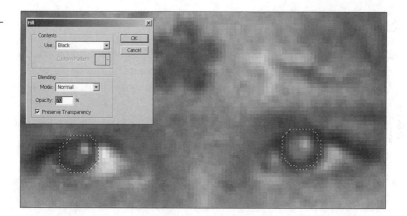

8. Click OK in the Fill dialog box and then zoom out to see the results. Click Undo and try again if 60% opacity isn't enough.

That's it (see Figure 22.10). This simple method retains a lot of the highlights in a person's eyes, but isn't very good at actually eliminating the red color. The other methods, which are possible in Photoshop Elements as well, are recommended.

FIGURE 22.10
Fixed using the different methods in this chapter!

THE ABSOLUTE MINIMUM

Portraiture is a great way to move from amateur to advanced or even professional photographer. If you can capture your subject's personality or make them look flattering, your services will be in demand. Keep these tips in mind when experimenting with portraits:

- Professional photographers use handheld light meters to take light readings. In-camera meters can only measure light reflected off the subject. Studio photographers use flash meters.

- In-camera light meters can only meter light off the subject. This leads to the underexposing or overexposing of images based on the reflectivity of the subject.

- When taking a light reading with the camera's meter, remember WUBO—White Underexposes and Black Overexposes.

- Bracket your images to ensure you expose a subject properly. Expose at the suggested meter reading and then take two more pictures: one at a stop over the meter's suggested setting (more light) and one under the meter reading (less light).

king Images for the Internet

Developing a Web site requires work, especially designing and building the site. Afterward, updating the site requires minimal work unless you need to keep it fresh every day (as most commercial sites must do). You may want to redesign the site periodically to keep up with new technology and trends, but this might only be necessary every 12 months. If you don't know how to program, you'll have to learn how or get someone to do it for you. However, there are software tools that you can learn to use, such as Microsoft FrontPage, Dreamweaver, and Macromedia Flash that make Web development easier (see Figure 23.1).

Many photographers who don't want the commitment of learning these programs and maintaining the site or want a much more high-tech site than they can develop on their own will join other photographers on a group Web site. This distributes the cost, enabling them to hire a professional Web programmer to build, maintain, and update the site. If you plan to build your own site, keep these tips in mind:

- Most images need to be resized before uploading to a Web site. Most scanned images have more pixels than a Web page can display, so you usually will need to reduce an image's resolution. Along these lines, not all monitors display the same number of pixels as your monitor; you will need to design your Web pages to accommodate different monitors.

- Variations among monitors can also cause visitors to see your images with the wrong brightness and contrast or with color bias. You cannot control the

IN THIS CHAPTER

● Saving Images for the Internet

● Photography Resources

FIGURE 2:
One photo
pher's Wel
created usi
Macromed
Flash and
Dreamwea

DIGITAL PHOTOGRAI
AND THE WEB

This chapter assumes that readers have an understa
Internet is and how to connect and navigate Wet
unfamiliar with the Internet, it's about time you lear

The Internet is an inexpensive way to display your w
an amateur, budding expert, or a professional co
pher. The best way to use the Internet is as a showc
In some ways, a Web site resembles a book; you
layout of the pages and help the viewer by using
ments that explain the pictures. Unlike a book, a \
updated; old images can be removed and new im

way other people's monitors display color, but you can reduce the problem. Make sure the monitor on which you develop your Web images is calibrated with Adobe Gamma or equivalent software.

■ Most computers receive information sent over the Internet at a very low speed. Under typical conditions, it takes a fast modem more than four minutes to deliver a full-screen, 16 million-color image. Very few Web site visitors will tolerate that sort of wait. File compression formats have been developed to speed up the transmission of images, and new formats are being developed.

■ JPEG is the only universally accepted 24-bit photographic compression format (see Chapter 7, "Files and File Formats") for the Web. JPEG is designed to minimize the visible irregularities of brightness while allowing large color errors. The success of the design is impressive; JPEG images compressed to 25 percent of their original size rarely show signs of compression.

You should plan for compression. It's a good idea to make sure your Web pages (images plus text) are received by viewers in fewer than 30 seconds. You can estimate this by adding together the sizes of all the files on the page and dividing the total by the speed of your visitors' modems. For example, if a page totals 75 kilobytes and an average modem downloads data at 3 kilobytes per second, the download time will be about 25 seconds. If your page takes too long to download, reduce the file size of your photos by compressing them at a lower quality level or make their pixel dimensions smaller.

Creating a Web Photo Gallery

Photoshop and Elements include the same powerful tool for building a Web site of images, complete with navigation and separate pages. The Web Photo Gallery tool creates a complete Web site of a directory of images. If you have a number of images stored in a directory, follow these steps to create a photo gallery:

1. In Photoshop Elements, choose File, Create Web Photo Gallery to display the Web Photo Gallery dialog box. In Photoshop, choose File, Automate, Web Photo Gallery. The Web Photo Gallery dialog box appears (see Figure 23.2).

2. Select a Web site style, such as Horizontal Dark or Simple. A thumbnail of the site will appear on the right side of the dialog box.

note

Be sure to uncheck Include All Subfolders if the images you'd like to use are only in one directory.

FIGURE 23.2

The Web Photo
Gallery dialog
box in
Photoshop
Elements.

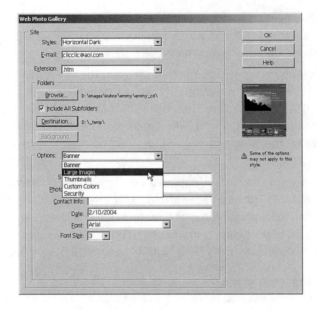

3. Click Browse and specify the directory with the images you'd like to use. Click OK, click Destination, and then specify a destination directory for the Web pages. Click OK again. Now you can customize the Web pages using options available in this dialog box.

4. Click the down arrow next to Options and select Large Images. The Web Photo Gallery tool will create two sizes of each image it is told to place in a Web page: a thumbnail of the image, and a larger version specified here. The large size default is 350 pixels wide.

5. Click the down arrow next to Options and select Thumbnails. Ensure that the default is acceptable and then select Banner under Options.

6. Enter any information in the Banner portion and click OK. Photoshop/ Elements will churn away for a minute or two creating a complete Web package: thumbnails, larger images, HTML pages, and navigation icons.

7. When the Web photo gallery is complete, find it on your computer and then double-click index.htm to open the front page of the gallery. Now you have a complete Web gallery you can upload to a Web site (see Figure 23.3).

FIGURE 23.3

Upload your new Web photo gallery to your personal Web page on any Web site.

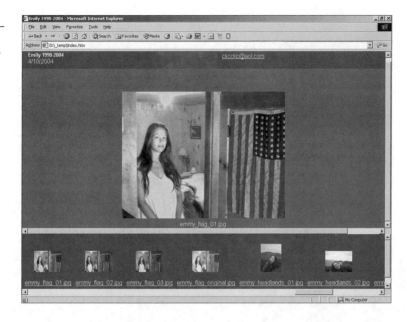

DUELING GAMMAS?

The monitors of Apple Macintosh and Microsoft Windows computers are set to different gammas at the factory. (Gamma is a measure of contrast.) Photographs look different on the two systems.

Macintosh monitors are set to a gamma of 1.8, ideal for creating printed documents. Windows monitors are set to a gamma of 2.2, the U.S. broadcast television standard. You can prepare your Internet images on a monitor set with Adobe Gamma for a gamma of 1.8 or 2.2, or you can compromise and use a gamma of 2.0.

You can preview the effects of the gamma change. Choose View, Proof Setup, Windows RGB to preview how the image will look on a Macintosh (see Figure 23.4) or View, Proof Setup, Macintosh RGB to preview how the image will look on a Windows computer.

continues

FIGURE 23.4
Use Windows
RGB mode to
preview how an
image would
look on a
Macintosh.

Compressing Images for the Internet with JPEG

The best way to speed up your Web page is to use more image compression. Slow
download speed is often more of a drawback to a Web site than compression arti-
facts (visual irregularities) in images. The Save For Web dialog box of Photoshop and
Photoshop Elements allows you to get the best performance from JPEG images.
Follow these steps to experiment with compression:

1. Select the Save For Web command from the File menu. The Save For Web dia-
 log box enables you to experiment with compression and color settings for
 images. These settings enable you to find the best compromise between
 image quality and download speed.

2. Click the monitor color and download rate button.

3. A pop-up menu appears. Check the settings you want to use. When choosing
 a download rate, remember that many viewers' modems work much slower
 than they are supposed to work.

4. Choose how many versions of your image you want to view. You can open
 two- or four-image windows at once; click an image window.

5. Select a JPEG quality setting for the image window you selected. Do this for
 each window.

6. Compare the quality of the images. To approximate what you see on a monitor, compare these two images from twice your normal reading distance. An estimate of the time it requires to download appears under each image.

The Internet: Resource and Gallery

Photographers are increasingly using the Internet. There are two good reasons why: There are interesting places to visit, and you can show your own work there. Many groups, companies and individuals have created sites that provide material such as online magazines, product advertising, educational information, and more. Newsgroups let you post and receive material about photography. Some groups let you participate in online discussions with people interested in topics like the history of photography and photographic techniques and equipment.

The Web displays pages with text, graphics, photographs, sound, and video. You can view photographs from individuals, stock agencies, and museums. You can put your own work up for display. If you have a site on the Web, you don't need to convince a curator or gallery owner that your work should be shown. At a low cost, you can create your own electronic gallery for people around the world to visit, where you can show what you want.

Exploring the Web

How do you find photography sites on the Web? You'll find some addresses listed in books and magazines, and you can link to many sites from other Web pages.

Suppose you are interested in a topic, but don't know the exact address of a related Web site. Try using search engines like Yahoo! (www.yahoo.com) or Google (www.google.com). Using these sites is like doing a subject search in a library catalog. Type in a subject or keywords, and a list of sites related to that topic is displayed.

Photography Sources

■ The site for the book *Photography, 7th edition* by Sherry London features simulations and, chat rooms demonstrations of various photographic processes, a study guide, and links to other sites (www.prenhall.com/london).

■ The Web site for the magazine *Photo District News* features commercial photography and digital imaging (www.pdn-pix.com).

■ The National Press Photographers Association has issues of interest to news photographers, including information about NPPA workshops (www.nppa.org).

Museums

Many museums have Web sites. The following are only a few of the highlights:

- California Museum of Photography, Riverside, California (www.cmp.ucr.edu).
- Friends of Photography, San Francisco, California (www.friendsofphotography.org).
- George Eastman House, Rochester, New York (www.eastman.org).
- International Center for Photography, New York, New York (www.icp.org).
- Library of Congress Prints and Photographs Reading Room, Washington, D.C. (www.loc.gov/rr/print).
- Museum of Contemporary Art, Los Angeles, California (www.moca.org).

Manufacturers

Manufacturers have Web sites that provide product information and often other features that can be helpful. For example:

- Nikon provides considerable technical information, such as their introduction to digital cameras, "Who's Afraid of Digital Cameras?" (www.nikon.co.jp/main/index_e.htm).
- Polaroid's Artist's Studio has an extensive collection of work by artists using Polaroid materials. (www.polaroid.com)

Other Sites

Individuals and organizations have Web sites large and small, dealing with everything from the art of pinhole photography (www.pinhole.com) to all about Kirlian photography (www.kirlian.com).

Your Own Virtual Gallery

You can create your own Web page. Do you have photographs you'd like to show to a wider audience?

A personal Web page is one way to do so. Most Internet service providers let their subscribers have their own Web page—that part is easy. Now all you have to do is create your own page or pay someone else to do so. The simplest pages contain text plus photographs and graphics (see Figure 23.5). More advanced designs can include music, video, and animation. You will want to investigate different software programs that are available for building Web sites, such as Microsoft FrontPage, Macromedia Flash and Dreamweaver.

FIGURE 23.5

Yahoo! Images is a great place to start uploading your images to create your first photo gallery Web page.

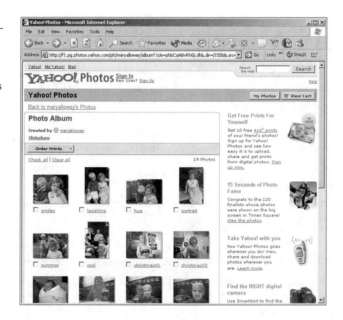

You must change your photo files into a form usable on the Internet. Software such as Adobe ImageReady or Macromedia Fireworks automatically converts a photograph that is already in digital form (for example, in a Photoshop file) into a Web-compatible format. JPEG compresses your image file for the Web in low, medium, or high quality. The higher the quality, the bigger the file size. Try saving in all three and see which versions are acceptable. The goal is to use the smallest file size acceptable for viewing. GIF was developed for graphics, but works for Web photos as well.

THE ABSOLUTE MINIMUM

This chapter barely scratched the surface of possible uses of the Internet for photographers. If you don't have your images up on the Net yet, consider a simple photo site, such as at Yahoo! or MSN.

- Use Elements or Photoshop to create your Web galleries. In Photoshop, choose File, Automate, Web Photo Gallery. In Elements, choose File, Create Web Photo Gallery.

- After developing a Web site that has a number of graphics, focus on reducing the size of files. Use JPEG compression to see how much compression is feasible without destroying an image.

- Promote yourself using a Web site. Register your name or a catchy company name through www.register.com, www.yahoo.com, or www.networksolutions.com.

- GIF files are mainly used for graphics, such as company logos and banners. This format only stores 256 colors and is called Indexed Color mode in Photoshop and Elements.

Glossary

1-bit color A system for creating raster (bit map) images on a computer in which each pixel uses only one bit of memory and disk storage. In 1-bit color, a pixel is either black or white.

24-bit color A system for creating raster images in which each pixel uses three bytes of memory and disk storage. In RGB color, one byte is used by each of the red, green, and blue components (channels) of a pixel.

8-bit color or 8-bit grayscale A system for creating raster images in which each pixel uses one byte of memory and disk storage. This produces 256 colors or shades of gray, which is enough for a high-quality black-and-white image or a low-quality color image.

additive colors Red, green, and blue are the additive colors of film-based photography and digital imaging. When red, green, and blue lights are mixed in equal amounts, the result is white light.

aliasing In a digital image, the appearance of jagged, "staircase" effects along lines and edges, especially diagonal lines. Aliasing is accentuated when the pixels in the image are highly enlarged and visible to the viewer.

alpha channel In Adobe Photoshop software, the palette where masks are stored.

analog-to-digital conversion The process of converting the analog information captured by a scanner or camera into computer-readable form. The analog signal is translated into digital numbers by a computer chip.

antialiasing The process of reducing jagged, aliased edges by smoothing (gently blurring) pixels along the edges.

archival paper A high-quality inkjet paper, usually with a matte or semi-gloss finish, designed for pigment-based inks. Images on this paper can be displayed behind non-glare archival glass for many decades or more without any noticeable fading.

artifact Any visible degradation of the details of a digital image caused by the methods used to capture, store, or compress the image. A common form of artifact occurs during lossy compression when bogus details appear near the edges of objects. In other artifacts, bands of solid colors appear in places that should exhibit subtle gradations.

banding An artifact that spoils the appearance of an image's subtle gradations of color and tone. In banding, bands or blocks of solid color appear in place of gradations.

binary number A number that is the result of changing information into computer-readable form. A binary number is composed of one or more single digits, each of which can represent either one or zero. All information in a computer is stored as binary numbers.

bit A single digit of a binary number, a quantity representing either 0 or 1.

bit depth The number of bits used to represent the color of each pixel.

bitmap An image made up of rows and columns of pixels. Also called a raster image. Each pixel represents a spot of solid color.

brightness (value) In digital images, numerical value of a pixel that represents its brightness level from black to white. In gray scale images it ranges in value from 0 (black) to 255 (white). In color images, it is a combination of the values of each color channel. Brightness is one of the three terms that are used to exactly describe a color (the others are saturation and hue).

Brush An imaging software tool that paints colors or special effects on a layer.

byte In a computer, an organized grouping of eight bits of memory or storage. A byte is often used to represent the

brightness value of a single pixel in a gray scale image or a single character (number or letter) in word processing.

calibration The act of adjusting the brightness and colors of one device, such as a monitor, to match those of another, such as a printer. Calibration may also be used to simply adjust a device to some standard of performance.

CCD (charge-coupled device) In a digital camera, a charged-coupled device is a light-sensitive silicon computer chip that converts the light from the camera lens into electrical current. The chip may have millions of separate sensors, each of whose current reading is translated (by an analog to digital converter) into a digital brightness value.

CD-ROM (Compact Disc, Read-Only Memory) A nonrewritable compact disc used as a storage medium for digital data.

CD-RW (Compact Disc, Rewritable) A rewritable compact disc.

clipping In image capture with a scanner or digital camera, an exposure error that causes a loss of information at the highest and/or lowest brightness levels.

CMY Cyan, magenta, and yellow are three subtractive color primaries. Used by some printing processes, notably color photographic paper.

CMYK Cyan, magenta, yellow, and black are the colors used in offset printing. Although CMY ideally would be a better set of inks for printing, adding K (black) is a practical necessity because CMY inks do not produce satisfactory black tones by themselves.

color cast An unwanted color tint to an image caused by exposure of the film or digital capture under inappropriate lighting conditions.

color channel One of the ways information is organized within an image. Color channels store the brightness values of the pixels in each of the primary colors. Contrast with alpha channels.

Color Management A software system designed to deliver accurate color calibration and consistent color matching among computer monitors, scanners, and any output devices such as printers and offset presses.

color space A scientific description of a set of colors. A color space numerically describes all the colors that can be created by a device, such as a camera or a printer.

compression A software process in which image data is "squeezed" to reduce the size of the image file. Compression methods can be lossless, as in compressed TIFF images, or lossy, as in JPEG compression.

continuous tone printer A color printer whose smallest color markings can be any of millions of distinct colors. Dye sublimation printers are the most common type of continuous tone printer.

data Anything put into, processed by, or stored in a computer. Data can also be the input from a camera or scanner or the output to a computer accessory, such as a printer or modem.

default A predetermined setting in a computer program that will be used unless the user chooses another.

device profile A database used by color management software. It contains information about the actual colors that a device (such as a monitor or printer) produces. The color management software uses the information to ensure that the device produces the desired colors.

digital camera A camera that captures an image on a CCD chip and digitizes it so that it can be downloaded to a computer or a digital printer.

digital image An image created by a digital camera or a computer scanner. Digital images are composed of pixels.

digitization The process of converting analog information into digital data that a computer can use.

disc or disk Terms used to describe computer media that store data on a revolving platter. Magnetic storage media are called disks (floppy disks, Zip disks and hard disks), while media that use lasers (CDs and DVDs) are called discs.

dithering A process used by some types of printers to create the appearance of millions of distinct colors from as few as four basic (CMYK) colors. In dithering, nearly invisible dots of each basic color are placed so close together (and the basic colors mixed without any visible pattern) that the eye is fooled into seeing a solid distinct color at that spot. Inkjet printers are the most common dithering printer.

download To transfer files or other data from one piece of computer equipment to another.

dpi (dots per inch) Originally, a measurement of the resolution of a printer or monitor. A printer that can print 1,440 dots in a row in a single inch is a 1440 dpi printer. dpi is often used interchangeably with other more accurate terms: pixels per inch (ppi) is a measure of the number of pixels (lined up in a row) per inch that appears on a monitor or in a print. An image may have only 200 pixels per

inch, but the printer may use 1,440 dots per inch to represent those 200 pixels per inch. Thus, the resolution of the printer (1440 dpi) is not the same as that of the image that it prints (200 ppi). Confusion results when dpi is used interchangeably with pixels per inch.

DVD, DVR, DV-RAM, DVD-RW A family of optical storage discs that offer higher capacities (many gigabytes) than the CD-ROM.

dye-sublimation printer A high-quality, continuous-tone color printer. Each multicolored dot is created when dyes of the basic colors are vaporized and then condensed on a precise location on the printing paper or plastic sheet. Because the amount of vaporization is highly changeable, each condensed dot can be any one of 16 million colors, and is thus called a continuous tone.

dynamic range A measurement of image density for a scanner from 0 (pure white) to 4 (very black). The dynamic range scale is logarithmic; a value of 3.0 is 10 times greater than a value of 2.0. This scale is valuable when measuring a scanner's ability to capture detail in shadows on slides and detail in highlights on negatives. The greater the dynamic range, the greater the capability to capture detail and not electronic noise. You may see the terms *Dmin* and *Dmax* for the minimum and maximum values of density that a scanner can detect. If a scanner has a Dmin of .3 and a Dmax of 3.3, the total dynamic range would be 3.0.

emulsion The dye or silver halide layer on the plastic (acetate) base that captures the light and image you shoot through the camera. Emulsion is also the name used for chemicals applied to photographic paper used in the darkroom.

export The process of transferring data from one program (for example, Adobe Photoshop) to another (for example, Adobe Illustrator).

exposure latitude The capability of films or digital cameras to accurately record a range of brightness values in the scene being photographed. A film that can accurately record scenes with extremely large brightness ranges (for example, very bright highlights and very dark shadows) is said to have a wide exposure latitude.

file format The unique and systematic way in which information is organized in a file. Formats differentiate one kind of file from another. Some common image file formats include TIFF, JPEG, and PSD (Photoshop file).

file A collection of data, such as an individual image, saved on a computer storage device, and given a name to assist in retrieval.

film recorder A device that records a digital image onto photographic film.

film scanner A device that converts images from photographic film into digital form so they can be stored in a computer and edited by software.

filter In imaging software, a filter is a command that will produce special effects in an image. There are hundreds of filters available as plug-in software for Adobe Photoshop.

flatbed scanner A digital scanner in which the object to be scanned is held flat on a glass plate while the imaging sensor (usually three CCDs) moves under it. A flatbed scanner can be used as a camera to record three-dimensional objects placed on its glass plate.

gamut The entire range of colors that a device (for example, a digital camera or a printer) can record or reproduce.

GIF (Graphic Interchange Format) an image file format. GIF is an older bitmap file format. It is an 8-bit format, so GIF images have only 256 colors. It is the standard format for creating non-photographic graphics for use on the Internet.

gigabyte (GB) A measure of computer memory, disk storage, or file size consisting of approximately one billion bytes (a thousand megabytes). The actual value is 1,073,741,824 bytes.

grayscale image A digital image containing only black, white, and shades of gray.

halftone A method of creating images on paper using a grid of ink dots of various sizes to simulate shades of gray in a photograph. For color printing, four grids of colored dots (using the colors CMYK) are printed. Newspapers and magazines use the halftone process to reproduce images.

hue One of the three terms used to exactly describe a color (the others are brightness or value and saturation). Informally, hue is the name of the color, such as red or green-yellow. In a 360° color wheel, the hue can be exactly specified as one of the points on the outside of the wheel.

import The process of bringing data into a program from another program. For example, the images created by many kinds of scanner software are imported into Adobe Photoshop.

inkjet printer An inkjet printer creates images out of millions of nearly invisible colored dots. The dots are created by squirting ink through extremely small nozzles. *See also* dithering.

JPEG (Joint Photographic Experts Group) A software procedure that compresses files. JPEG is a "lossy" compression algorithm that degrades image quality, although the apparent effect is small unless the image is highly compressed.

JPEG 2000 A revision of the JPEG image compression standard. Along with slightly improved image quality, new features permit images to be viewed with greater color accuracy and allow encoded copyright protection, as well as embedded keywords to assist Internet searches.

kilobyte (KB) A measure of computer memory, disk storage, or file size consisting of approximately one thousand bytes. The actual value is 1,024 bytes.

laser printer A computer printer that uses laser copier technology to print from computer data. Printing is much faster than with inkjet and dye sublimation printers, but image quality is often compromised by banding.

layer A software feature that permits an image to contain a number of separate images, viewed as though they are stacked upon each another. Some software allows specialized layers such as adjustment layers, which contain no visible images but contain commands that change the tones and colors of the layers below, or type layers, which contain editable letters and numbers.

LCD panel (liquid crystal diode) Many digital cameras have illuminated LCD screens that are used as viewfinders. They also permit the editing of pictures after they have been captured.

lossless compression A file compression technology that reduces the size of files in ways that result in the original file being intact after decompression. There is no loss of the original data. TIFF compression is lossless.

lossy compression A file compression technology that reduces the size of files in ways that result in permanent changes to the original file after decompression. Depending on the degree of compression used, the image may exhibit noticeable artifacts. JPEG compression is lossy.

marquee An outline of moving dashes that appears on the monitor to show the boundaries of selected areas within an image. *See also* selection.

mask An image-editing tool used to limit the effects of image editing to certain areas of the image. Masks appear on the monitor as overlays of color. Unlike a selection, masks can be stored and can be edited for later reuse. Masks are stored in the channels palette of Adobe Photoshop.

megabyte (MB) A measure of computer memory, disk storage, or file size consisting of approximately one million bytes. The actual value is 1,048,576 bytes.

megapixel camera A digital camera whose CCD chip has over one million individual sensors. Each sensor usually creates one pixel in the camera's images.

metadata Data about data. EXIF information included in digital camera images is one example. The EXIF standard states what information is stored in a JPEG image and in what order. This data describes the image itself.

modem (modulator/demodulator) A device that converts outgoing digital data into analog signals for transmission over telephone lines, and digitizes incoming analog signals.

network A group of computers connected electronically so they can exchange data and share peripheral devices, such as printers and modems.

palette On a computer monitor, a software component that appears as a box containing icons of tools and controls that modify the way tools operate (options). A command center for image-editing tools.

PhotoCD and PictureCD Kodak scanning services available from many photography stores and mini-labs. PhotoCD Master scans offer high-quality images from 35mm film with resolutions up to 3072×2048 pixels. Less expensive PictureCD scans of 1536×1024 pixels are saved as JPEG files.

pixel (picture element) The smallest visible component of a digitized image. The basic dot that contains a single color.

plug-in A small, specialized software program that is opened and operated by image-editing software, and closed when its task is finished. For example, scanner software is used to capture and import images, and filters are used to modify the image. Plug-ins may be manufactured by companies unconnected with the manufacturer of the imaging software.

ppi (pixels per inch) *See* dpi.

quantization coefficient A variable number related to the Quality setting used when a JPEG file is saved. The quantization coefficient is used with JPEG quantization tables in the compression process.

RAM (random access memory) The silicon chips that are used to contain the computer's memory. The memory is used to hold and process the software programs, data files, and commands that the computer is currently using. Generally, the more RAM that a computer has for image processing, the more quickly the editing can be accomplished.

raster image Raster images (also called bitmaps) are made up of rows and columns of pixels.

resample To change the pixel dimensions of an image. For example, to downsample an image from 2000×1000 pixels to 500×250 pixels, or to upsample an image from 400×600 to 800×1200 pixels. Resampling permanently alters the image.

resize To alter the physical size of an image (how big it is printed or how large it appears on the monitor) without resampling its pixels.

resolution Resolution determines the apparent sharpness of an image. Resolution is the number of pixels per inch (or other measure, like millimeters) in an image. For example, an image printed 8×10 inches with 200 pixels per inch will appear much sharper than an 8×10 print printed with 30 pixels per inch. When the capabilities of printers are discussed, the resolution of the printer is described as the number of dots per inch that the printer can put on the paper. *See* dpi.

RGB Red, green, and blue; the primary additive colors of photography and digital imaging. Computer monitors create images using the RGB colors.

samples per inch The number of times per inch that a scanner samples an image. Note, however, that if a scanner records 2,000 samples per inch, but its software enlarges the image by 10 times, the final image will have only 200 pixels per inch. *See* dpi for related information.

saturation The degree to which a color is pure and undiluted by light of a different hue. If a color is 100% saturated, it contains no light of another hue. If a color has no saturation, it appears gray, with no apparent hue. One of the three terms used to exactly describe a color (the others are brightness or value and hue).

scanner A device that converts photographs (on film or on paper) into digital form so they can be stored in a computer and edited by software.

screen lines per inch Also referred to as lines per inch. Used in the offset printing industry, lines per inch refers to the number of rows or columns of halftone dots (a "screen") appearing in each inch of the printed matter. Do not confuse screen lines per inch with dots per inch (*see* dpi).

selection A part of the area of a digital image that has been isolated from the rest of the image for the purposes of editing operations, such as changes to color or tones. A variety of software tools are used to indicate to the computer which area is to be selected.

service bureau A retail business that offers a variety of computer-related services. Many have extensive imaging capabilities, such as scanning, printing, and rental computers with imaging software. Some offer offset printing services that may include the production of large negatives.

subtractive colors Cyan, magenta, and yellow are the subtractive colors of photography and digital imaging. When equal amounts of cyan, magenta, and yellow inks are mixed on a sheet of white paper, a gray or black tone results.

TIFF (Tagged Image File Format) A file format for bitmap images that is readable by all major imaging software programs. TIFF allows moderate amounts of lossless compression.

unsharp masking A software process that increases the apparent sharpness of an image. Actual image detail is not increased.

vector image An image formed without pixels. Lines and solid-filled areas are created by specifying the location of line endpoints and the positions of lines (straight or curved) between them. Adobe Illustrator creates vector graphics, and there are some vector elements (such as paths) in Adobe Photoshop that coexist with the bitmap features.

virtual memory disk Space on a hard drive that is used as a substitute for RAM by image-editing software when the software runs out of real RAM. Because hard disks operate more slowly than RAM, using virtual memory slows the computer down.

Index

Numbers

0000H flag, FAT (File Allocation Table), 105

12-bit scan rates, 184

16-bit scan rates, 184

35mm film, 33, 76

38-bit depth, JPEG2000 file format, 90

48-bit scan rates, 184-186

220 film, 34

A

Acquire command (File menu), 74

active tracking system, AF (autofocus), 56

Add Anchor Point tool, 161

additive color processes, 293-294

Adjust Color, Hue/Saturation command (Enhance menu), 328, 332

Adjust Levels command (Image menu), 146

Adjust, Brightness/Contrast command (Image menu), 206

Adjust, Color Balance command (Image menu), 148, 240

Adjust, Curves command (Image menu), 140, 186, 206, 226

Adjust, Desaturate command (Image menu), 328

Adjust, Hue/Saturation command (Image menu), 140, 148, 240

Adjust, Levels command (Image menu), 140, 148, 186, 206, 214

Adjust, Variations command (Image menu), 149

adjustment layer masks, 252-253, 263

adjustment layers, 236-237
color banding, 242-243
compatibility, Photoshop file formats, 84
curves/levels, 231-232
data loss, 242-243
images, printing without color management, 301

Adjustments, Auto Levels command (Image menu), 220

Adjustments, Color Balance command (Image menu), 198

Adjustments, Curves command (Image menu), 219, 231

Adjustments, Hue/Saturation command (Image menu), 332

Adjustments, Levels command (Image menu), 207, 219, 231

Adobe Gamma, 297

Adobe ImageReady, creating Web images, 345

Advanced Photo System (APS) film, 34

AF (automatic focus), 54-56

aliasing
antialiasing, selections, 168
digital camera limitations, 21-22

allocation, FAT (File Allocation Table), 103-106

alpha channels, 163, 263-264

American Standards Association (ASA) film rating system, 36

Amount option (Unsharp Mask dialog box), 193, 196

angles, view, 47

annotations, TIFF (Tagged Image File Format), 91

Anti-aliased option (Magic Wand), 141

antialiasing, selections, 168

aperture, 59-61

APO (Apochromatic) lenses, 14

Apple iPhoto
images, 128-131
launching, 126
locating images, 114-115
Print dialog box, 127-130

Apple Macintosh, gammas (Internet images), 341

applications
Apple iPhoto
images, 128-131
launching, 126

locating images, 114-115
Print dialog box, 127-130
Photoshop Elements, 116
resampling, 118-121
rescanning, 119
*images, 114-118,
121-125*
printing resolution, 116

APS (Advanced Photo System) film, 34

archival paper, 288

area-specific encoding, JPEG2000 file format, 91

art, line art, 274

artifacts, adjusting, 21-22

artificial lighting, 313-314, 320

ASA (American Standards Association) film rating system, 36

aspherical lenses, 14

authoring software, 292

Auto Levels feature, 220

Auto option (white balance settings), 64

auto-sharpening, turning off, 197

Automate, Web Photo Gallery command (File menu), 339

automatic focus (AF), 54-56

available light, 310-313, 320

axis lighting (front lighting), 316

B

back lighting, 319

background images, component image selections, 247

backgrounds, blurring, 59

balance
color, 32-34, 63-66
white, setting, 64

bar graphs, histograms, 221
adjusting pixels, 207-209
exposure problems, 210-217
levels, 222-223

baseline optimized compression method, JPEG (Joint Photographics Experts Group), 88

baseline sequential compression method, JPEG (Joint Photographics Experts Group), 88

battery life, continuous autofocus, 56

Bayer mask, limitations, 18-20

Bezier curves, 249-251

bicubic resampling, 245

Bilinear option (interpolation), 187

bit depth
input resolution, 183-186
TIFF (Tagged Image File Format), 91, 95

Bit Depth option (scanners), 182

black points, setting, 212-214

black reflectors, adding fill light, 321

black-and-white
converting to color, 32
fill light, 319
film, 34
images, converting color images to, 328-330

black slider triangle, 225

Blend If option (Layer Style dialog box), 239

blending image layers, 238-239

blooming, adjusting, 23

blur filters, Bayer masks, 20

Blur, Gaussian Blur command (Filter menu), 198, 331

blurring backgrounds, 59

blurs, 197-198

BMP (Windows Bitmap) file format, 83

boot records, FAT (File Allocation Table), 104

Borderless Printing option (Print dialog box), 130

borders, images (Apple iPhoto), 128

bracketing, portraits, 327

brightness
image editing, 145-147
information (Curves dialog box), 230-231
plain paper, 287

brightness/contrast, histograms, 205-206
adjusting pixels, 207-209
exposure problems, 210-217

Brightness/Contrast dialog box, 206

Brightness/Contrast, Levels command (Enhance menu), 219

browsers, locating images, 114-115

brushes, Selection Brush, 170-171

buttons, navigation or Web site, 291

Byte Order: IBM PC option (TIFF Options dialog box), 93

Byte Order: Macintosh option (TIFF Options dialog box), 93

bytes, 183

C

C-41 process (chromogenic), 42

California Museum of Photography Web site, 344

cameras. *See* digital cameras

Canon Web site, 14

capture delays, digital camera limitations, 13-14

catadioptric lenses, 54

CCD (charge-coupled device) image sensor, 4-5, 17-20

CD-ROMs, saving images to, 80, 288-292

CDs, saving images to, 79

cells, halftone, 189

center-weighted autofocus locks, 56

channels, 255
 alpha, 163, 263-264
 color, 255-257, 263
 color images, converting to black-and-white, 330
 composite, 257
 creating, 262
 masks, 257-263
 red-eye, fixing, 333-335

Channels command (Window menu), 163, 257

Channels palette, accessing, 163, 257

charge-coupled device (CCD) image sensor, 4-5, 17-20

chromes, 31

chromogenic film, light responses, 42

CiéLAB color space definition, 16

clipping paths, 252

Clone Stamp tool, removing dust & scratches, 203

clusters, FAT (File Allocation Table), 104-105

CMOS (Complementary Metal Oxide Semiconductors), 4, 20

CMY (cyan, magenta, and yellow), subtractive color processes, 293-296

CMYK (cyan, magenta, yellow and black)
 color channels, 255
 color space definition, 16
 printers, 271
 printing, color management, 302-304

collages, 239-241

color
 converting to black-and-white, 32
 device profiles, 299
 gamut, troubleshooting, 303
 masks, 259
 reproducing (monitors/printers), color management, 297-306
 YUV color space, 88

color balance, 63, 148-149
 color film, 32
 digital cameras, 64-65
 film, 33-34, 66
 slide film, 66

color banding, adjustment layers, 242-243

color channels, 255
 adjusting, 231
 versus alpha channels, 263
 editing, 256-257
 RGB, 257
 thumbnails, 257
 turning on/off, 257
 viewing, 256-257

color film, 30-32, 295

color gamuts
 color management, 297-306
 human vision, 298

color images
 converting to black-and-white (portraits), 328-330
 creating, three image layers, 295-296
 gray tones, 222

color management, color gamuts, 297-298
 multiple printers, 305-306
 printing, 299-301
 printing RGB/CMYK, 302-304

Color Management Policies option, 279

color masks, CCD (charge-coupled device) image sensor, 18-20

Color Mode option (scanners), 181

color negative film, development process, 295-296

color negative printing paper, printing process, 296

Color Options option (Print dialog box), 129

color processes, 293-296

Color Range command (Select menu), 164-165

Color Range dialog box, 164

color reversal film, developing, 296

Color Settings command (Edit menu), 279

Color Settings option (scanners), 182

Color Settings, CMYK Setup command (File menu), 305

Color Settings, Working Spaces command (Edit menu), 302

color space. *See* gamuts

color temperatures, measuring, 65

color transparencies, fill light, 319

ColorSync option (Print dialog box), 129

columns, Single Column Marquee tool, 155-156

compatibility, Photoshop file formats, 84-85

Complementary Metal Oxide Semiconductor (CMOS), 4, 20

component images, composite images, 244-247

composite channels, 257

composite images, 244-247

compression
file formats, 95
Internet images, 339
JPEG, YUV color space definition, 16
JPEG2000 format, 90-91
lossless, 87, 91
lossy, JPEG (Joint Photographics Experts Group) file format, 86-88
RLE (Run Length Encoding) file format, 94
step by step, 88-90
wavelet-based, JPEG2000 file format, 90
Web Photo Gallery, 342-343

compression artifacts, 86

CompuServe, GIF file format, 82

Constrain feature, resizing images (Apple iPhoto), 130-131

Contiguous option (Magic Wand), 142

continuous autofocus, 55

contrast, image editing, 145-147

contrast/brightness, histograms, 205-217

conversion factors, lenses, 49

Convert Point tool, 162

converting pixels, RIP (Raster Image Processor), 189

Copies & Pages option (Print dialog box), 129

costs, digital versus film photography, 7-9

crawling ants, turning off, 335

Create Web Photo Gallery command (File menu), 339

Crop command (Image menu), 170

Crop tool, 170

cropping scanned images, 74

Cubic option (interpolation), 187

curved paths, creating, 159-160

curves, 219-220
adjustment layers, 231-232
Bezier, 249-251
S curves, 226

Curves dialog box, 226-231

cut film, 34

cyan, magenta, and yellow (CMY), subtractive color processes, 293-296

cyan, magenta, yellow and black. *See* CMYK

D

dark tones, correcting with curves, 228-229

data loss, 106, 242-243

Daylight option (white balance settings), 64

DCF (Design Rule for Camera File Systems), 26

DCS (Desktop Color Separations) file formats, 83

DCT (Discrete Cosine Transform), 88

defragmentation, 107-109

delays, capture delays, 13-14

Delete Anchor Point tool, 161

depth of field, 58-61

desaturation, converting color images to black-and-white, 328-329

Deselect command (Select menu), 142-143, 154

Design Rule for Camera File Systems (DCF), 27

Desktop Color Separations (DCS) file formats, 83

Despeckle filter, 200-201

Deutsche Industrie Norm (DIN) film rating system, 38

developing film, 295-296

device profiles, 299

devices, CCD (charge-coupled device), 4-5

diffused lighting, 307-309

digital cameras
color balance, 64-65
color masks, 18-20
DCF (Design Rule for Camera File Systems), 26
Direct Print, 26
DPOF (Digital Print Order Format), 27
EXIF 2.2 (Exchange Image Format), 24-26
Exif Print, 26
focal length lenses, 49-52
formatting flash media, 108-109
Foveon, 20
limitations, 11-14, 17, 21-22
media types, 5
PictBridge, 26
resolution, 176-177

versus CMOS
(Complementary Metal
Oxide Semiconductor),
14-17, 20, 23-24

Digital ICE, 202

**Digital Print Order Format
(DPOF),** 27

**DIN (Deutsche Industrie
Norm) film rating system,**
38

direct lighting, 307-308

Direct Print, 26

directional lighting, 314

directional-diffused light, 309

**Discard Layers and Save a
Copy option (TIFF Options
dialog box),** 94

**Discrete Consine Transform
(DCT),** 88

**discussion groups (forums),
film,** 30-31

displays, viewing images, 282

**distorting images, Photoshop
Elements,** 125

dithering, printers, 272

dots, halftone, 189

dots per inch (dpi), 175
inkjet printers, 270
output resolution, 176,
186-189

**downloading PC Inspector
File Recovery,** 99

dpi (dots per inch), 175
inkjet printers, 270
output resolution, 176,
186-189

**DPOF (Digital Print Order
Format),** 27

**drawing straight lines, Pen
tool,** 248

**Drive command (Object
menu),** 100

drivers, printers, 127

drives, 100-105

dust, removing, 201-203

Dust & Scratches filter,
201-203

DVDs, saving images to, 292

dye-sublimation printers, 270
paper, 288
scanning images for, 78
settings, 273

E

**Edge Contrast option
(Magnetic Lasso tool),** 155

**EI (exposure index) film rat-
ing system,** 36

Elliptical Marquee tool, 144

**Encapsulated PostScript (EPS)
file format,** 83

**encoding, JPEG2000 file for-
mat,** 90-91

**EPS (Encapsulated PostScript)
file format,** 83

Epson ink cartridges, 280

error diffusion, printers, 272

**error resilience, JPEG2000 file
format,** 91

**EXIF 2.2 (Exchange Image
Format),** 24-26

Exif Print, 26

expanding selections,
165-168, 335

exposure
color film, 32
portraits, 327
troubleshooting, 210-217

**exposure index (EI) film rat-
ing system,** 36

F

f-stop. *See* aperture

fast film speed, 39

FAT (File Allocation Table),
103-108

FAT12 file system, 108

FAT16 file system, 108

FAT32 file system, 108

feathering selections, 168,
259, 335

**FFF7H flag, FAT (File
Allocation Table),** 105

**FFF8-FFFFH flag, FAT (File
Allocation Table),** 105

File Allocation Table. *See* FAT

**File Browser command
(Window menu),** 114

file formats
BMP, 82-83
compression, 88-90, 95
CT, 82-83
DPOF (Digital Print Order
Format), 27
EXIF 2.2 (Exchange Image
Format), 24-26
GIF, 82-83
JPEG, 339, 342-343
JPEG2000 format, 90-95
Photoshop, 82-83
compatibility, 84-85
*JPEG (Joint Photographics
Experts Group), 86-91*
PSD, 95
*TIFF (Tagged Image File
Format), 91-95*
Photoshop Elements, 82-88
PNG, 82-83
PST, 82-83
PXR, 82-83
RLE (Run Length Encoding),
94

file recovery, 97-98
defragmentation, 107-109
FAT (File Allocation Table),
103-106

PC Inspectory File Recovery, 99-103
USB (Universal Serial Bus), 109-110

files
storing. *See* FAT (File Allocation Table)
TIFF, saving images as, 274

Fill command (Edit menu), 155-156

fill lighting, 319-321

film
35mm, 33, 76
220, 34
APS (Advanced Photo System), 34
black-and-white, 34
color, 30-32
color balance, 33-34, 66
exposure latitude, 67-69
forums (discussion groups), 30-31
high-contrast, 34
infrared, 34
ISO ratings, 30
light, responding to, 41-42
overview, 29
pixels, resolution, 178-179
roll, 33
scanning images, 178
sheet, 34
slide, color balance, 66
speed, 35-41
storing, 35
technologies, 34

film development process, 295-296

film photography versus digital, 7-9

film scanners, printing large images, 282-284

Filter Processing option (scanners), 181

filters, 191
blurs
adding, 198
Bayer masks, 20

Gaussian Blur, 197-198
halftone dots, removing, 197-198
moiré patterns, removing, 197-198
dust & scratches, 201
Noise, 200-203
unsharp mask, 192-197

Fireworks (Macromedia), creating Web images, 345

fisheye lenses, 52-53

flags, FAT (File Allocation Table), 105

flash
fill light, adding, 321
media, formatting, 108-109
memory, 6

Flatten Image command (Layer menu), 241, 247, 332

flattening composite images, 247

floodlights, adding fill light, 321

Fluorescent option (white balance settings), 64

fluorite lenses, 14

fly-out menus, Selection tools, 137

focal length, lenses, 46
depth of field, 60-61
digital cameras, 49-52
normal, 47-48

focal length multiplier, 177

focus
AF (automatic focus), 54-56
depth of field, 58-61
wide-area, 54

focus priority, 55

formats. *See* file formats

formatting flash media, 108-109

forums (discussion groups), film, 30-31

Foveon, CCD (charge-coupled device) image sensor, 20

Free Tranform tool, 124-125

Free Transform command (Edit menu), 124, 262

Freeform Pen tool, 160

Frequency option (Magnetic Lasso tool), 155

Friends of Photography Web site, 344

front lighting, 316

full diffused light, 309

full-frame fisheye lenses, 52

Fuzziness setting (Color Range dialog box), 164

G

galleries
online, 343-345
photo, creating, 290-292
Web Photo Gallery, 339-343

gammas, monitors (Internet images), 341

Gamut Warning feature, 302-304

gamuts
color management, 297-306
determining, Photoshop, 279
definition, digital camera limitations, 15-17
human vision, 298
troubleshooting, 303

Gaussian Blur filter, 197-198

General Blending option (Layer Style dialog box), 239

George Eastman House Web site, 344

GIF (Graphics Interchange Format) file format, 82

Google Web site, 343

grain
film speed, 37-39
removing, 200-201

Graphics Interchange Format (GIF) file format, 82

graphics. *See also* images; photos

graphs, bar (histograms), 207-217, 221-223

gray tones, color images, 222

gray slider triangle, 225

grayscale images
converting to black-and-white, 328-329
masks, 259

Group with Previous command (Layer menu), 243

grouping layers, 243

Grow command (Select menu), 166

H

halftone cells, 189

halftone dots, 189, 197-198

halftone screens, lines per inch (lpi), 188

hiding selections, 163

high-contract film, 34

high-side lighting, 316

highlighting digital camera limitations, 23-24

Histogram command (Image menu), 207, 221

histograms, 221
exposure problems, 210-217
fixing, images, 223
image editing, 148
levels, 222-223
pixels, adjusting, 207-209

hue/saturation
image editing, 148
red-eye, fixing, 332-333

Hue/Saturation command (Adjust menu), 165

I

ICC profiles, third-party ink, 277-279

iDVD authoring software, 292

Image Compression
JPEG option (TIFF Options dialog box), 92
LZW option (TIFF Options dialog box), 92
None option (TIFF Options dialog box), 91
ZIP option (TIFF Options dialog box), 92

image editing
brightness/contrast, 145-147
color balance, 148-149
Selection tools, 133-136, 151-152
fly-out menus, 137
Lasso tools, 139, 142-143
Magic Wand, 138-140
Magnetic Lasso tool, 154-155
Marquee tools, 138, 143-144
modifying images, 140
Pen tools, 157-162
Polygonal Lasso tool, 153-154
Quick Mask, 156-157
resizing images, 136-137
saving selections, 163
Single Column Marquee tool, 155-156
Single Row Marquee tool, 155-156
toolbox, 137
troubleshooting, 163-170

image-editing applications
Apple iPhoto
launching, 126
locating, 114-115
Print dialog box, 127-130
resizing, 130-131
white borders, 128
Photoshop Elements
features, 116
Free Transform tool, 124-125
locating, 114
Magnetic Lasso tool, 170-171
perspective corrections, 121-122
printing resolution, 116
resampling images, 118-121
rescanning images, 119
resizing, 116-118
rotation, 122-124
Save Selection command, 170-171
Selection Brush, 170-171
troubleshooting, 265-266

image layer masks, 252

image layers
blending, 238-239
color images, creating, 295-296
creating, 237-238
opacity, 238-239

Image Size dialog box, 117-118

ImageReady (Adobe), creating Web images, 345

images. *See also* **photos**
adding people via layers, 241-242
background, component image selections, 247
black-and-white, converting color images to, 328-330
color
converting to black-and-white, 328-330
creating, three image layers, 295-296
gray tones, 222
component, composite images, 244-247

composite, 244-247

creating, Internet, 338-339

editing, 136, 177

fixing histograms, 223

grayscale, masks, 259

importing, 274

large, printing, 282-284

locating, 114-115

merging, 262-263

pixels, selecting, 164-165

printer settings, 273

printing, resolution, 177

resizing, Selection tools, 136-137

saving

 CD-ROM, 288-292

 DVDs, 292

 TIFF files, 274

saving to CD-ROMs, 80

saving to CDs, 79

scaling, 245

scanned, cropping, 74

scanning, 71-72

 film, 178

 step by step, 74-79

viewing, monitors, 282

Import command (File menu), 73, 84

importing

images, 274

plug-ins, scanning software, 73

RAW file formats, 84

indoor available light, 312-313

Info command (Window menu), 215

Info palette, accessing, 215

infrared film, 34

ink, printer resolution, 275-276

Epson, 280

ICC profiles, 277-279

photo paper, 281-282

inkjet printers

dpi (dots per inch), 270

error diffusion, 272

scanning images for, 78

settings, 273

Input levels, 225

input resolution

bit depth, 183-186

digital cameras, 176-177

film pixels, 178-179

scanner software, 180-183

inspectors, PC Inspector File Recovery, 99-103

interactivity, CD-ROMs, 290

International Center for Photography Web site, 344

International Color Consortium Web site, 277

International Organization for Standardization (ISO) film rating system, 36

Internet, 337

displaying photos, 6

images, creating, 338-339

online galleries, 343-345

resources, 343-344

scanning images for, 77

Web Photo Gallery, 339-343

interpolation, 117

output resolution, 186-188

software, Bayer masks, 19

Inverse command (Select menu), 142-143, 167

inverting masks, 261

iPhoto (Apple)

images

 locating, 114-115

 resizing, 130-131

 white borders, 128

launching, 126

Print dialog box, 127-130

iPhoto option (Print dialog box), 130

ISO (International Organization for Standardization) film rating system, 36

ratings, 30

size (paper), 287

J

JEITA (Japan Electronics and Information Technologies Industries Association), 24

JPEG (Joint Photographics Experts Group) file format, 82, 86-88

compression

 step by step, 88-90

 Web Photo Gallery, 342-343

 YUV color space definition, 16

Internet images, 339

JPEG2000 format, 90-91

JPEG2000 file format, 90-91

K

Kelvin scales, measuring color temperatures, 65

key lights, 315-318

Kirlian Web site, 344

Kodak Photo CD, 79

Kodak Picture CD, 79

L

LAB mode, converting color images to black-and-white, 329

laser printers, scanning images for, 79

Lasso tools, 139, 142-143

latitude, 63, 66-69

Layer Compression: RLE option (TIFF Options dialog box), 94

Layer Compression: ZIP option (TIFF Options dialog box), 94

layer masks, 252-253

layer sets, compatibility (Photoshop file formats), 85

Layer Style dialog box, 238-239

layers, 235
 adjustment, 236-237
 color banding, 242-243
 curves/levels, 231-232
 data loss, 242-243
 images, printing without color management, 301
 adjustment layer masks, 263
 collages, 239-241
 compatibility, Photoshop file formats, 84-85
 composite images, 244-247
 creating, 331
 grouping, 243
 image
 adding people, 241-242
 blending, 238-239
 color images, 295-296
 creating, 237-238
 opacity, 238-239
 merging, 240
 naming, 238
 opacity, 238
 red-eye, fixing, 331-332
 resolution, 241-242
 saving, 241
 selecting, Pen tool, 247-252
 semitransparent, 238
 storing, 237
 type, 236

Layers command (Window menu), 331

Layers palette, accessing, 237

Layers tab, 331

Layout option (Print dialog box), 129

Leica Web site, 14

lenses
 AF (automatic focus), 54-56
 catadioptric, 54
 conversion factors, 49
 depth of field, 58-61

digital camera limitations, 14-15
fisheye, 52-53
focal length, 46
 depth of field, 60-61
 digital cameras, 49-52
 normal, 47-48
macro, 53
perspective-control, 53
soft-focus, 53
tele-extenders, 51
telephoto, 51
terminology, 14

levels, 219
 adjustment layers, 231-232
 Auto Levels feature, 220
 color images, gray tones, 222
 histograms, 222-223
 images, fixing histograms, 223
 Input, 225
 Output, 225
 slider triangles, 224-225

Levels dialog box, 207, 214, 221, 225

Library of Congress Prints and Photographs Reading Room Web site, 344

light tones, correcting with curves, 229

lighting
 artificial, 313-314, 320
 available, 310-313, 320
 back, 319
 depth of field, 60-61
 diffusion, 307-309
 directional, 314
 fill light, 319-321
 film responses, 41-42
 film speed, 35-41
 frontal, 316
 high-side, 316
 key lights, 315-318
 portraits, 325-327
 side, 318
 specular (direct), 307-308

top, 317
under, 317

line art, printing, 274

line screen, printing presses, 188

lines, drawing, 248

lines per inch (lpi), 175, 188

Load Selection command (Select menu), 171, 261

logical drives, 105

long focal-length lenses, digital cameras, 49-51

lossless compression, 87, 91

lossless encoding, JPEG2000 file format, 90

lossy compression, JPEG (Joint Photographics Experts Group) file format, 86-91

lpi (lines per inch), 175, 188

Lura Tech Web site, 90

M

Macintosh, gammas (Internet images), 341

macro lenses, 53

Macromedia Fireworks, creating Web images, 345

Magic Wand, 138-140

Magnetic Lasso tool, 139, 154-155, 170-171

magnification
 lens focal length, 46-47
 uncropped 35mm film, 76

main lights. See key lights

managing colors, color gamuts, 297-299
 multiple printers, 305-306
 printing, 299-304

managing layers, 240-241

manufacturers, Internet resources, 344

Marquee tools, 138
Elliptical Marquee tool, 144
Rectangular Marquee tool, 143

masks
adjustment layer masks, 263
color, 18-20, 259
grayscale images, 259
inverting, 157, 261
layer, 252-253
opacity, 259
Quick Mask, 156-157, 264
selections, 257-259
storing. *See* alpha channels
unsharp mask filter, 192-197
visibility, 259-263

master boot records, FAT (File Allocation Table), 104

media
digital cameras, 5
flash memory, 6

medium film speed, 39

megapixels, 175

memory, flash, 6

Merge Down command (Layer menu), 240

Merge Visible command (Layer menu), 241

merging
images, 262-263
layers, 240

micro lenses (macro lenses), 53

Microsoft Windows, gammas (Internet images), 341

mirror lenses, 54

Mode command (Image menu), 163

Mode
8 bits/channel command (Image menu), 184-186
CMYK Color command (Image menu), 305
Grayscale command (Image menu), 328-329

LAB command (Image menu), 329
RGB Color command (Image menu), 257

modes
LAB mode, converting color images to black-and-white, 329
Quick Mask, 260-261

Modify, Border command (Select menu), 167

Modify, Contract command (Select menu), 166

moiré patterns, removing, 197-198

monitors
color reproduction, color management, 297-306
gammas (Internet images), 341
images, viewing, 282

multimedia, CD-ROMs, 289

multiple printers, color management, 305-306

Museum of Contemporary Art Web site, 344

museums, Internet resources, 344

N

naming layers, 238

National Press Photographers Association (NPPA) Web site, 343

navigation buttons, creating, 291

Nearest neighbor option (interpolation), 187

negative color films, 295

negative film, 31
color balance, 66
exposure latitude, 67
professional, 32

New Adjustment Layer, Curves command (Layer menu), 231-232

New Adjustment Layer, Levels command (Layer menu), 231

New Channel icon, 262

New dialog box, 277

New Layer command (Layer menu), 237

New Layer icon, 237

Nikon Web site, 14, 344

noise, adding, 335

Noise filters, 200-203

Noise, Add Noise command (Filter menu), 335

Noise, Despeckle command (Filter menu), 200

Noise, Dust & Scratches command (Filter menu), 203

normal focal-length lenses, 47-48

NPPA (National Press Photographers Association) Web site, 343

O

objects, vector, 249

offset printers, scanning images for, 79

online galleries, 343-345

opacity
layers, 238-239
masks, 259

Open Drive icon, 100

Options, Files command (Object menu), 102, 106

outdoor available light, 310-312, 320

Output levels, 225

Output Options option (Print dialog box), 129

output resolution, 176
digital cameras, 177
interpolation, 186-188
printing presses, 188-189

Output Resolution option (scanners), 181

overexposure, portraits, 327

P

palettes
Channels, accessing, 163, 257
Info, accessing, 215
Layers, accessing, 237
Paths, accessing, 157, 248

paper, 285
archival paper, 288
dye-sublimation printers, 288
ISO size, 287
multiple printers, color management, 305-306
photo paper, 281-282, 286-287
plain paper, 287

Paper Handling option (Print dialog box), 129

passive tracking system, AF (autofocus), 56

paths
clipping, 252
compatibility, Photoshop file formats, 85
creating, 157-162, 247-251
curved, creating, 159-160
saving, 248

Paths command (Window menu), 157

Paths palette, accessing, 157, 248

patterns, moiré, 197-198

PC Inspector File Recovery, 99-103

PCX file format, 83

PDF (Portable Document Format) file format, 82

Pen tool, layer selections, 247
drawing straight lines, 248
paths, 249-252

people, adding to images, 241-242

perspective, correcting (Photoshop Elements), 121-122

perspective-control lenses, 53

Photo District News Web site, 343

photo galleries, creating, 290-292

photo paper, 281-282, 286-287

photography, Internet resources, 343

photos. *See also* **images**
color, converting to black-and-white, 328-330
displaying, Internet, 6
exposure, 327
lighting, 325-327
red-eye, fixing, 330-335

Photoshop
color space, determining, 279
EPS file format, 83
EXIF 2.2 (Exchange Image Format), 24-26
file formats, 82-83
compatibility, 84-85
JPEG (Joint Photographic Experts Group), 86-91
PSD, 95
TIFF (Tagged Image File Format), 91-95
navigation buttons, creating, 291
PDF file format, 82

Photoshop DCS 1.0 file format, 83

Photoshop DCS 2.0 file format, 83

Photoshop Elements
features, 116
file formats, 82-83
compatibility, 84-85
JPEG (Joint Photographic Experts Group), 86-91
PSD, 95
TIFF (Tagged Image File Format), 91-95
images
Free Transform tool, 124-125
locating, 114
perspective corrections, 121-122
resampling, 118-121
rescanning, 119
resizing, 116-118
rotating, 122-124
Magnetic Lasso tool, 170-171
printing resolution, 116
Save Selection command, 170-171
Selection Brush, 170-171

physical drives, 105

PICT file format, 83

PictBridge, 26

pictures. *See also* **images; photos**

Pinhole Visions, The Art of Pinhole Photography Web site, 344

Pixar file format, 82

pixels. *See also* **resolution**
adjusting, 21-22, 207-209
converting, RIP (Raster Image Processor), 189
film, resolution, 178-179
interpolation, output resolution, 186-188
megapixels, 175
samples per inch, 175
selecting, 164-165
virtual, Bayer masks, 19

pixels per inch (ppi), 174, 271
input resolution
bit depth, 183-186
digital cameras, 176-177
film pixels, 178-179
scanner software,
180-183
resolution, 273-274
film scanners, 282-284
ink, 275-282
monitors, 282
settings, 273

plain paper, 287

plug-ins
ICC profiles, third-party ink,
277-279
software, scanning, 73

PNG file format, 83

Polaroid Web site, 344

**Polygonal Lasso tool, 139,
153-154**

**Portable Document Format
(PDF) file format, 82**

portrait lenses, 53

portraits. *See also* images;
photos

**positive (reversal) color films,
295**

ppi (pixels per inch), 174, 271
input resolution
bit depth, 183-186
digital cameras, 176-177
film pixels, 178-179
scanner software,
180-183
resolution, 273-274
film scanners, 282-284
ink, 275-282
monitors, 282
settings, 273

**Print command (File menu),
127**

Print dialog box, 127-130

**Print Size option (scanners),
182**

printers
CMYK, 271
color reproduction, color
management, 297-306
dithering, 272
drivers, 127
dye-sublimation, 78, 270,
288
error diffusion, 272
inkjet, 78, 270
laser, scanning images for, 79
multiple, color management,
305-306
offset, scanning images for,
79
ppi (pixels per inch) ratings,
271-284
resolution, 269, 273-282
settings, 273

printing
images, resolution, 177
large images, 282-284
line art, 274
paper, 285-288
resolution, Photoshop
Elements, 116

**printing presses, output reso-
lution, 188-189**

printing process, 296

professional film, 31-32

profiles, device profiles, 299

**Proof Setup, Macintosh RGB
command (View menu), 341**

**Proof Setup, Windows RGB
command (View menu), 341**

**PSD Photoshop file format,
95**

Q-R

**Quality & Media option (Print
dialog box), 129**

**Quick Mask, 156-157,
260-261, 264**

**Radius option, 193, 196,
201-203**

**Raster Image Processor (RIP),
189**

**rating systems, film speed,
36-38**

RAW file format, 82, 84

recovering files, 97-98
defragmentation, 107-109
FAT (File Allocation Table),
103-106
PC Inspector File Recovery,
99-103
USB (Universal Serial Bus),
109-110

**Rectangular Marquee tool,
143**

red, green, and blue. *See* RGB

red eye, fixing, 330
channels, 333-335
layers, 331-333

Redo feature, 135

**reflectors, adding fill light,
320-321**

relative aperture, 60

**Remove Hardware button,
109**

resampling
bicubic, 245
images, Photoshop Elements,
118-121

**rescanning images,
Photoshop Elements, 119**

**Reselect command (Select
menu), 163**

**Resize, Image command
(Image menu), 117, 120**

**Resize, Scale command
(Image menu), 125**

resizing images
Apple iPhoto, 130-131
Photoshop Elements,
116-118
Selection tools, 136-137

resolution, 173
collages, 240
defined, 174
digital camera limitations, 14-15
dpi (dots per inch), 175
dye-sublimation printers, 78
images, 177
inkjet printers, 78
input
 bit depth, 183-186
 digital cameras, 176-177
 film pixels, 178-179
 scanner software, 180-183
large images, printing, 282-284
laser printers, 79
layers, 241-242
line art, printing, 274
lpi (lines per inch), 175
megapixels, 175
monitors, 282
offset printers, 79
output, 176, 186-189
ppi (pixels per inch), 174
printers, 269, 273-282
printing, Photoshop Element, 116
samples per inch, 76-77, 175

resources, Internet, 343-344

reversal (positive) color films, 295

reversal film, 31
color balance, 66
exposure latitude, 67-69
professional, 32

Revert command (File menu), 193

RGB (red, green, and blue)
additive color processes, 293-294
bit depth, 183
color channels, 255-257
color space definition, 15-16
printing, color management, 302-304

RIP (Raster Image Processor), 189

RLE (Run Length Encoding) file format, 94

roll film, 33

rotating images, Photoshop Elements, 122-124

rows, Single Row Marquee tool, 155-156

Run Length Encoding (RLE) file format, 94

S

S curves, 226

Safely Remove Hardware dialog box, 110

samples per inch, 76-77, 175

saturation/hue, image editing, 148, 332-333

Save As command (File menu), 277

Save As dialog box, 277

Save for Web command (File menu), 342

Save for Web dialog box, 342

Save Image Pyramid option (TIFF Options dialog box), 93

Save Selection command (Select menu), 163, 170-171, 246, 261

Save Transparency option (TIFF Options dialog box), 93

saved selections, compatibility (Photoshop file formats), 85

saving
editing images, 136
images
 CD-ROM, 80, 288-292
 CDs, 79
 DVDs, 292
 TIFF files, 274
layers, 241
paths, 248
selections, 163, 259

scalability
collages, 240
images, 125, 245
JPEG2000 file format, 90

scanners, 71-72
large images, printing, 282-284
options, 181-182
software, 73, 180-186
step-by-step scans, 74-79

scanning drives, PC Inspector File Recovery, 100-103

scanning images
cropping, 74
film, 178

Scheduler option (Print dialog box), 129

Schneider Web site, 14

Scitex CT (Continuous Tone) file format, 83

scratches, removing, 201-203

screens, halftone, 188

search engines, Internet resource, 343

sectors, FAT (File Allocation Table), 104

Select Directory dialog box, 102

Select Drive dialog box, 100

Select Sector Range dialog box, 101

Selection Brush, 170-171

Selection tools, 133, 135, 151-152
fly-out menus, 137
Lasso tools, 139, 142-143
Magic Wand, 138-140
Magnetic Lasso tool, 154-155

Marquee tools, 138, 143-144
modifying images, 140
Pen tools, 157-162
Polygonal Lasso tool,
 153-154
Quick Mask, 156-157
resizing images, 136-137
saving selections, 163
Single Column Marquee tool,
 155-156
Single Row Marquee tool,
 155-156
toolbox, 137
troubleshooting, 163
 antialiasing selections, 168
 Color Range command,
 164-165
 Crop tool, 170
 feathering selections, 168
 selection modifications,
 165-168

selections
compatibility, Photoshop file
 formats, 85
creating, masks, 257-258
expanding, 335
expanding/shrinking,
 165-168
feathering, 259, 335
hiding/showing, 163
layers, Pen tool, 247-252
restoring, 163
saving as masks, 259

semitransparent layers, 238

sensitivity specks, 41

**sensor resolution, digital
cameras, 176-177**

**sensors, CCD (charge-coupled
device), 17-20**

shadows, fill light, 319-321

**Sharpen, Unsharp Mask com-
mand (Filter menu), 193,
196**

sheet film, 34

**short focal-length lenses,
digital cameras, 51-52**

**Show Channels command
(Window menu), 330**

**Show Layers command
(Window menu), 237**

**Show, Selection Edges com-
mand (Select menu), 168**

**Show, Selection Edges com-
mand (View menu), 163**

showing selections, 163

shrinking selections, 165-168

side lighting, 318

silver halide crystals, 41

**Similar command (Select
menu), 167**

**Single Column Marquee tool,
155-156**

**Single Row Marquee tool,
155-156**

single-shot autofocus, 55

sites. *See* **Web sites**

**skewing images, Photoshop
Elements, 125**

slide film, 31
color balance, 66
developing, 296

**sliders triangles (levels),
224-225**

slow film speed, 41

soft-focus lenses, 53

softboxes, artificial light, 314

software
Adobe Gamma, 297
Adobe ImageReady, creating
 Web images, 345
authoring, 292
image-editing, troubleshoot-
 ing, 265-266
interpolation, Bayer masks,
 19
Macromedia Fireworks, creat-
 ing Web images, 345
scanners, 73, 180-186

**Special Effects option (Print
dialog box), 130**

**specular lighting (direct),
307-308**

speed, film, 30, 35-41

**sRGB color space definition,
15**

**standard focal-length lenses,
47-48**

**Stop a Hardware Device
dialog box, 110**

storing
files. *See* FAT (File Allocation
 Table)
film, 35
layers, 237
masks. *See* alpha channels

**subtractive color processes,
293-296**

**Summary option (Print dialog
box), 130**

T

**Tagged Image File Format
(TIFF), 83, 91-95**

TARGA file format, 82

tele-extenders, 51

teleconverters, lenses, 51

telephoto lenses, 51

tenting, diffused light, 308

**text layers, compatibility
(Photoshop file formats), 85**

**third-party ink, printer reso-
lution, 276**
Epson, 280
ICC profiles, 277-279
photo paper, 281-282

**Threshold option, 193, 196,
201-203**

**thumbnails, color channels,
257**

TIFF (Tagged Image File Format), 83, 91-95, 274

TIFF Options dialog box, 91-94

Tolerance option (Magic Wand), 141

tones, correcting with curves, 228-229

toolbox, Selection tools, 137

tools
Add Anchor Point, 161
Clone Stamp, removing dust & scratches, 203
Convert Point, 162
Delete Anchor Point, 161
Free Transform, 124-125
Freeform Pen, 160
Magnetic Lasso, 170-171
Marquee, 138, 143-144
Pen, layer selections, 247-525
Selection, 133-135, 151-152
fly-out menus, 137
Lasso tools, 139, 142-143
Magic Wand, 138-140
Magnetic Lasso tool, 154-155
Marquee tools, 138, 143-144
modifying images, 140
Pen tools, 157-162
Polygonal Lasso tool, 153-154
Quick Mask, 156-157
resizing images, 136-137
saving selections, 163
Single Column Marquee tool, 155-156
Single Row Marquee tool, 155-156
toolbox, 137
troubleshooting, 163-170

top lighting, 317

tracking system, AF (autofocus), 56

Transform, Distort command (Edit menu), 125

Transform, Free Transform command (Image menu), 122-124

Transform, Perspective command (Edit menu), 122

Transform, Scale command (Edit menu), 247

Transform, Skew command (Edit menu), 125

transparencies, color, 319

transparency film, 31

triangles, sliders (levels), 224-225

troubleshooting
exposure, 210-217
gamut, 303
image-editing software, 265-266
images, histograms, 223
red eye, fixing, 330-335
Selection tools, 163
antialiasing selections, 168
Color Range command, 164-165
Crop tool, 170
feathering selections, 168
selection modifications, 165-168

true fisheye lenses, 52

Tungsten option (white balance settings), 64

type layers, 236

Unsharp Mask filter, 192-197

USB (Universal Serial Bus), file recovery, 109-110

V

vector objects, paths, 249

view angles, lens focal length, 47

viewing
color channels, 256-257
images, monitors, 282

virtual pixels, Bayer masks, 19

visibility, masks, 259-263

W

wavelet-based compression, JPEG2000 file format, 90

Web browsers, locating images, 114-115

Web Photo Gallery, 339-343

Web sites
Canon, 14
Google, 343
International Color Consortium, 277
Kirlian, 344
Leica, 14
Lura Tech, 90
museums, 344
Nikon, 14, 344
PC Inspector File Recovery, 99
Photo District News, 343
Pinhole Visions, The Art of Pinhole Photography, 344
Polaroid, 344
Schneider, 14
tips for creating, 338-339
Wilhelm Imaging Research, 288
Yahoo!, 343
Zeiss, 14

Web site buttons, 291

U

umbrella reflectors, artificial light, 314

under lighting, 317

underexposure, portraits, 327

Undo feature, 135-136

Universal Serial Bus (USB), file recovery, 109-110

How can we make this index more useful? Email us at indexes@quepublishing.com

white balance, setting, 64

white borders, images (Apple iPhoto), 128

white points, setting, 212-214

white slider triangle, 225

wide-angle lenses, 51-52

wide-area focus, 54

Width option (Magnetic Lasso tool), 154

Wilhelm Imaging Research Web site, 288

Windows
 defragmentation, 107
 gammas (Internet images), 341

Windows Bitmap (BMP) file format, 83

Working Spaces option, 279

X-Z

Yahoo! Web site, 343

YUV color space (YCbCr), 15-16, 88

Zeiss Web site, 14

Zoom In command (View menu), 198

zooming, 198